of Glory

wn
the sky
st slow goodbye

rich as velvet

ce Gold, but better —

Rumours of Glory

# rumours

*a memoir*

## of
## glory

## Bruce Cockburn
### and Greg King

HarperOne
*An Imprint of* HarperCollins*Publishers*

HarperOne

RUMOURS OF GLORY: *A Memoir.* Copyright © 2014 by Bruce D. Cockburn Enterprises Limited. All rights reserved. Printed in the United States of America. No part of this book may be used or reproduced in any manner whatsoever without written permission except in the case of brief quotations embodied in critical articles and reviews. For information, address HarperCollins Publishers, 195 Broadway, New York, NY 10007.

HarperCollins books may be purchased for educational, business, or sales promotional use. For information please e-mail the Special Markets Department at SPsales@harpercollins.com.

HarperCollins website: http://www.harpercollins.com

HarperCollins®, 📚®, and HarperOne™ are trademarks of HarperCollins Publishers.

FIRST EDITION

*Designed by Terry McGrath*

All song lyrics reprinted in *Rumours of Glory* are written by Bruce Cockburn and used by permission of Rotten Kiddies Music, LLC, except for "Bird Without Wings," "Going to the Country," "It's an Elephant World," and "Change Your Mind," which are written by Bruce Cockburn and used by permission of Bytown Music Ltd.

Library of Congress Cataloging-in-Publication Data
Cockburn, Bruce.
Rumours of glory : a memoir / Bruce D. Cockburn.—First edition.
    pages cm
ISBN 978–0–06–196912–6
1. Cockburn, Bruce. 2. Singers—Canada—Biography. I. Title.
ML420.C6116A3 2014
782.42164092—dc23 2014017622

14 15 16 17 18   OV/RRD   10 9 8 7 6 5 4 3 2 1

*To everyone who, through lo these many years,
has done me the honour of paying attention.*

*This book would not exist were it not for Greg King,
who fed me back my recollections with insight and
a sense of order that allowed me to take them and run.
He was not a ghost writer but a close cocreator of
the work you are about to read.*

Rumours of Glory

# OVERTURE

This is not your standard rock-and-roll memoir. You won't find me snorting coke with the young Elton John or shooting smack with Keith Richards; dangling babies from hotel balconies or fleeing rehab; shooting guns or sleeping with someone else's wife. Well . . . you *will* find me shooting guns and sleeping with someone else's wife, and these are significant elements of my tale.

Since 1966 I have worked as a musician and performing songwriter, making music, making love, making mistakes, making my way across this beautiful and dangerous planet. I have witnessed the sweet promise of human achievement and the grim spectre of our ignorance and greed. Along the way I found Jesus Christ, then let go of his hand amid the din of disingenuous right-wing Christian exploitation. I have attempted to live my life somewhat in line with his Word, without necessarily taking it as, well, gospel. I have learned a lot about humanity and spirit from other faiths as well. Yet I still feel that I, and most of us, understand little about the Divine.

Whole wars have been fought in Jesus's name. In the end these conflicts usually have little or nothing to do with God. These days, at least in the West, wars are justified less by religion than by fear, but almost always they are attempts by the wealthy to monopolize resources held by others, even if those others are desperately poor.

In the late seventies I became known, among some, as "that Christian singer," which brought me a like-minded following. In 1971, 1972, and 1973, when I received Juno Awards for Canadian Folksinger of the Year but before I had "found" Jesus, I was known more for the music itself than for any religious affiliation. (I did get a bit of "the Canadian John Denver," though, because of my round glasses.) I played a decent guitar. I wrote songs as explorations of culture and nature, and of the spirit. When Jesus came into my life, in 1974, he also made it into the music. Since then our relationship, like most relationships, has ebbed and flowed. I have tried to keep Jesus the compassionate activist close to my heart, along with Jesus as portal to the cosmos, but I have long been leery of the dogma and doctrine that so many have attached to Christianity as well as to most other religions.

I honour nonviolence as a way of being, and as a political tactic, but I am not a pacifist. As we continue to watch the world's greatest military powers plunder weaker states and peoples as an integral, almost pro forma method of planetary domination, it's clear that a violent response to such injustice, and carnage, would be useless and ever more destructive. But that's easy for me to say as I sit on my peaceful deck in my peaceful city in my relatively peaceful country. Here the secret police are not (yet) routinely kicking down doors and dragging off dissidents. The government is not bombarding towns and cities as a tool of pacification. We are spared the horror of internment camps and mass graves being filled with union leaders, community activists, those who worship the "wrong" god, or simply those who happen to live atop some coveted natural resource (at least since the end of the era of westward expansion). I can't tell people who are experiencing these realities that a violent response is unjustified. When it's fight or die, what do you do? Gandhi and MLK would tell us to just take it, and they were wiser for it than I am. And deader. (Though of course I expect to be catching up with them on that score.)

Today I sit in the San Francisco home I share with my wife, M. J. Hannett, and our daughter, Iona, working on a book thirty years

after writing "If I Had a Rocket Launcher," the song with which I will probably be most closely associated in the public's memory. Those lyrics came to me in a Mexican hotel room after my first visit to a refugee camp on the fringe of the free-fire zone that was 1980s Guatemala. That experience was to be the beginning of a series of journeys to regions afflicted by war, and the first attempt to share my experience of, even fascination with, that thing which some would call the great human aberration, but which is perhaps more accurately described as the default condition of mankind.

Through design and circumstance, my songs are multifaceted. They are not just about war, injustice, and exploitation, though these subjects are well represented. They are certainly not just about Jesus, though faith and grace frequently find a place in the lyrics and in the tunes themselves. Mystery, beauty, love, pain, joy . . . the power of a wild place . . . the power of people to rise above oppression, above pettiness: these are things I have worked to portray. The songs derive from life itself. They're not a reproduction of life. They're not an attempt to pin life down. They ought to assume a life of their own.

Change has come to me often, with seminal alterations of course and consciousness. With some strange precision, many of my most profound changes have occurred at the turn of each decade. In 1970, after a few years in Canadian rock bands that shared the stage with the likes of Jimi Hendrix and Cream, I released my first solo album. In 1980, fresh from the breakup of my first marriage, I moved to Toronto and for the first time sought connection with, and solace from, community. In 1990 I began working with a big-league producer, T Bone Burnett, and spent more time in the United States. During that fecund decade I became embroiled in a brief, secret, and transformative romantic relationship; made friends with firearms and horses; produced a couple of albums that some consider to be my best; and achieved a level of fame and acclaim that made me—a seeker of privacy and introspection, a disdainer of awards—somewhat uncomfortable.

I am blessed with two children, both girls, one being thirty-five

years older than the other. Relationships with women have had a huge influence on how I think and feel; they have opened portals to worlds I might not have otherwise discovered. It might be said that my relationship with music has been even more intimate and profound. In a way we, and all living things, are made of music. The time and psychic space required to produce music to any depth can also generate understandings that might otherwise remain elusive. Music eased my searching and often angry adolescent soul. My grown-up wanderings, sometimes no less angry, are largely catalyzed by, and reflective of, music. Music is my diary, my anchor through anguish and joy, a channel for the heart.

Seventeen years ago I wrote, "Haunting hands of memory / Pluck silver strands of soul." This book is made of memories. Some are more exact than others, but they're all mine. Not all I recall is in here. There are people who were and are dear and important to me, whose names and roles do not come up. Sometimes what comes up are only pictures, feelings, musings. The soul, as we experience it, is a nucleus surrounded by an accretion of experiences, of traumas, not just mine but everybody's, those of other generations, other cultures, other faiths. In witnessing the same events, those strands are plucked at in a way unique to each of us. In each of us lives a different story. This one is mine.

I

When I was born on 27 May, 1945, my father, Doug Cockburn, was not around. That was not by choice. The Canadian army had put him through medical school during World War II, and Dad was sent to Europe just before the end of hostilities. While he was stationed in England waiting to be transferred to the European mainland, Germany surrendered. Dad then became part of the occupying force. I was about a year and a half old when he saw me for the first time. I suspect I was not happy to have to share the attention of my mother, Lois, with this guy I had never set eyes on. I do remember, though, a fair amount of jollity in those early years. (The arrival of the first of my two brothers when I was five was the occasion for a better-remembered resentment.)

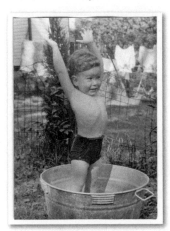

*Union Street, Kingston, Ontario, 1948*

On my father's return to Canada, we moved from my maternal grandparents' place in Ottawa to Kingston, Ontario. Dad went back to school to continue his studies, specializing in radiology. We had a ground-floor apartment on Union Street, where we lived for what I suppose was the next couple of years. I have

a clear picture of my dad hauling me around in a sleigh, bundled up in a brown snowsuit and swaddled in a blanket, over frozen sidewalks. He'd be jogging along in his Queens University jacket with the leather sleeves, taking the corners too fast. The sleigh would tip over and the bundle of me would roll out into the road. In my memory this happened more than once. I'm told I was too young to really remember this—that it's a recollection made from having heard the story repeated. Maybe.

I guess as the firstborn, I inspired my father to ensure that I was exposed to the finest of what Western culture could offer. He subscribed to some sort of record-of-the-month thing as well as the Book-of-the-Month Club. Twelve times a year, an album would arrive in the mail. Originally, it was actually an album—a book like a photo album whose pages were sleeves for 78-RPM Bakelite discs. These were played on the hi-fi (we didn't have a windup Victrola, as I recall, though relatives did, and I was familiar with them).

*Aside: When my mother's brother Gerald was little, he confused the words for "Victrola" and "toilet." This resulted in her side of the family referring to the latter fixture as the "troley" till I was well into my teens.*

In the evenings my mom and dad and I would sit in the living room and listen to this music. Mostly it was performances of great classics by somewhat second-rate orchestras. Let it be said that my father had a good ear for music and a keen sense of pitch. It always bothered him that the brass band of the Governor General's Foot Guards, which had a weekly radio show, tended to play out of tune.

There we would sit, music filling the room. The vocal pieces, sung in formal classical style, were a total turnoff to me, especially the high female voices laden with vibrato. The men, too, though. What I remember being particularly taken with was Manuel de Falla's "Ritual Fire Dance." When that piece played I could *see* human figures leaping in silhouette, circling the flames of a huge bonfire. Had I even seen a bonfire at the age of two or three? Maybe, maybe not, but the association of fire and ritual and human action slipped

in from who knows where. That piece of music fired me up every time I heard it.

Other memories from Kingston in the 1940s: running under the front porch—refusing to go in for either dinner or bed, I forget which. My dad couldn't get me to come out. I only screamed "No!" when he suggested, then asked, then ordered me into the house. It took a gentle intervention by an older man who lived next door to coax me out of my hiding place. Even with my fear of cobwebs, I felt that squatting in the dirt—having crawled through an opening in the latticework on one side of the veranda, under sticky-soft stalactites of spider silk—was better than going inside, admitting that the day was over. I always hated the ending of the day. I felt like not enough had happened. Still do.

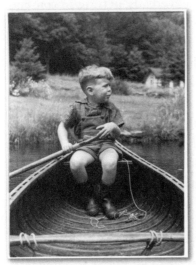

*The pond at Grandpa's farm*

One morning I deliberately locked my mother out of the house. I remember standing in the hall in my short pants and beige knitted cardigan with images of cowboys on it. Mom must have ducked out briefly, for what reason I don't know, and I thought it would be a good joke to latch the door behind her. When she demanded that I let her in, I refused. I thought this was the funniest situation I'd ever seen, and I laughed and laughed—and kept laughing till I saw the expression on her face as she climbed in the little bathroom window, over the back of the *troley*. She was hopping mad. My amusement instantly turned to gut-melting fear. I guess I got spanked. Can't really recall. Later I learned that she had been six months pregnant. That pregnancy ended in miscarriage. I was assured that climbing in the window was not a factor.

When Dad's schooling was done with, we moved back to Ottawa. He got a gig at what was then the Ottawa Civic hospital. Eventually he became head of diagnostic X-ray there. Now and then as a schoolboy I would go with him to work, or meet him there for a ride home after my trumpet lessons. He would show me the X-rays he was reading, and I could sit and try to follow along as he dictated his findings into the then state-of-the-art Dictaphone, verbally putting in commas, periods, and paragraph indentations.

To a little kid in Ottawa in the late forties, diversity meant there was a French boy who lived down the block. That, and once on Bank Street with my mother I saw a black man. I pointed and stared, and was instantly shushed and admonished against commenting on people's appearance (especially if they were within earshot). This lesson was repeated another day when we encountered an old man with a gin blossom nose, which caused me to point and laugh and cry out, "Look at his *nose!*" Major disapproval.

Mostly everyone was the same. There were Protestants, Catholics, and Jews, but nobody ever mentioned that. Everybody was just people. I played with Billy from across the street and Donnie M. There was a "bad" kid named Norman who was maybe a year older than my playmates and I. My parents chased him away whenever they saw him around. Gilles, the francophone kid, was a bit older and quite polite.

What constituted a "bad" kid? We lived on the upper floor of a duplex. Downstairs were people called the Meldrums. Next door to us lay a vacant lot overgrown with shrubs and one or two big trees. For us it was a jungle, or the northern bush. Many games unfolded there: war games, cowboys and Indians, Tarzan. Guns were crooked sticks or cap-firing toys. My friend John Whynot, the engineer who has recorded many of my albums, once voiced the observation that boys are all about projectiles. We certainly were, though we were cautioned never to throw anything at each other that could inflict harm. Now and then I could play with my mother's BB gun, but I'd better not shoot anyone in the eye.

One day Donnie and I were playing next to the Young Stick Tree, so called because around its base grew a large number of shoots that we could break off to use for swords and the like. Nearby stood a sawn-off stump. Norman appeared with a kid I didn't know and the kid's little brother, who must have been two. Norman cajoled the two-year-old into putting his hand on the stump and then pounded on it with a brick. Blood shot across the rough-looped annual rings. The little guy screamed. Norman grinned happily. Bad kid. I remember him urinating in our yard as some kind of gesture. I can't recall the circumstances, but there he is pulling out his penis and pissing on the lawn, and my mother calling him a dirty dog.

Now and then Billy would intentionally foul his trousers. I have a very vivid memory of us playing on the lawn outside the Meldrums'. We're squatting there fiddling around on the grass, and he gets a kind of reflective look on his face and goes vacant on me. We're wearing shorts. Next thing I see is brown matter oozing out of his pant leg. I say, "What are you doing?" "Oh," he says, "I just wanted to do that." I guess that was a gesture too. When I told Mom about it, she said something like "Oh, the poor child." At that age we knew nothing about what went on in the adult world. Nobody said. If Billy was abused at home, I have no idea. Maybe he was. There were murmurs of disquiet about what kind of parenting Donnie received.

Clothes were different then. I was sent to kindergarten, which was a few blocks away, wearing breeks and knee socks. The breeks were like riding breeches, made of wool, warm and scratchy. They had a button fly. I had a lot of trouble with that. Being left-handed, I lacked the dexterity to button myself up after going to the bathroom at school. I could unbutton myself well enough, but not the reverse. I got teased for having my fly open. That resulted in me holding it in until, on my way home, I could disappear into the vacant lot and relieve myself. Thus I was saved from embarrassment at school, but my mother always knew I'd peed outside, and I got scolded for that.

There was music. One day Billy and I went marching past the store-fronts on Bank Street, with saplings from the Young Stick Tree over our shoulders, singing "Onward Christian Soldiers" at the top of our lungs. Old ladies stopped and smiled. Now and then at school they had "rhythm band." We were issued tambourines and bells and other percussion toys, and we were supposed to play organized parts while the teacher sang or played the piano. I guess we were supposed to sing too. I was completely at sea. I had no idea what was meant to happen, though the other kids

*My head was already too big for my dad's homburg.*

seemed to know. I was given two wooden sticks, sort of like drumsticks, and told to hit them together on a particular beat. Not knowing what that meant and being too nervous to feel the rhythm even if there had been any, I just whacked away when it seemed like I should. I remember the teacher being a rather sour woman.

For me school consisted of feeling centered out and humiliated, right from day one. I discovered a gift for constructing alternate realities. When my dad got home from work after my first day of kindergarten, he asked me how it was. I very enthusiastically replied, "It was great. We got to wear cowboy hats and chaps, and there were guns hanging all around the walls!" At that moment I completely believed what I was saying. Dad said, "Are you sure you're not imagining that?" "No! That's how it was!"

My dad and I had a routine. When we sat down at the dinette for dinner, I'd say to him, "What have you got to tell me today?" He'd have to come up with something to explain to me: how volcanoes were created, for example, or the order of the planets, or how in World

War I soldiers had to pee in their handkerchiefs and then breathe through them to survive poison gas attacks. He was pretty good at it. I remember only once or twice when he seemed too tired to get into it. He did it anyway, though: he told me about being twelve and seeing a boy on a bicycle get hit by a truck. The vehicle ran over the boy's head, causing it to split open like a melon. He told me about history, and about Greek mythology. That would have been my first invitation to consider the possible interaction between the Divine and the human day-to-day.

I was fed some Bible-derived stuff too, pretty much in the same tone as that in which the Greek myths were presented. Mom and Dad were trying hard to be believers, I think he more than she. The grandmothers, especially my dad's mom, Mayme, and her sister Margaret, aka Auntie, were serious devotees of the United Church of Canada. So we went sometimes.

Somehow I missed being baptized. It wasn't till after my brother Don was born that they got around to that.

Another humiliation and cause for resentment: me, in the summer I was five, having to walk the length of the church aisle at Southminster United next to my squalling infant brother, to have done to me what they did to *babies*! If I'd been braver, these outrages would surely have driven me to a life of crime.

During those preschool years I had a recurring dream in which a seagull flew into our apartment. It did nothing but be a big white bird flying around, but it was utterly terrifying. I woke up screaming and sweating from that one every time. Of course, there were also monsters under the bed. I always slept with my little black tin revolver and a rubber knife under my pillow.

I found it impossible to hide embarrassment or guilt. I had a face that would turn red at the slightest provocation. Whenever I was active, it would glow in a way that prompted Grandma to offer an aside to Mom: "Poor Bruce." She figured I had high blood pressure at the age

of four or five, but I didn't. I was, however, born with a mild case of spina bifida, resulting in a right leg that was an inch and a half shorter than the left, as well as a deformed pelvis and hammertoes on the corresponding foot.

For a brief period I wore metal braces on my lower legs. The difference in leg length was minor and no one else seemed to notice, but I have always been acutely aware of it—especially as a kid, and particularly when wearing the braces. I maintain a vivid memory of walking along Second Avenue in Ottawa wearing short pants and being very self-conscious of the braces, metal devices with leather around the top and bottom that clamped onto my legs, holding my ankles straight. Later my parents told me it was a false memory—that I was made to wear a brace only on the right leg, and only when I went to bed at night—but the picture remains. My aunt Jean, Dad's sister-in-law, remembers me going around in the daytime with a brace on each leg.

My left foot grew to be almost two sizes larger than my right, which I could see very well, right down to the bones, through the fluoroscope on visits to the shoe store. Radiation was popular in the fifties. One hundred roentgens per minute was a small price to pay for an accurate fit. (Some fluoroscopes reportedly delivered more than 350 roentgens per minute.) Dad was a radiologist, so he probably kept us from spending too much time on the fluoroscope.

*Aside: There's a good chance he was one of the few people in North America who read the 1949 paper on fluoroscopes by Louis Hempelmann, M.D. Hempelmann had previously worked with the health division of the Manhattan Project, which developed the first atomic bomb. In his paper, he said the unsupervised use of low-voltage fluoroscopes would most likely result in the malformation of children's feet, as well as skin damage in adults and damage to blood-forming tissues of store employees. What scientists hadn't yet discovered is that the fluoroscope also contributed significantly to breast cancer, as mothers hovered near children who gleefully pushed the button over and over to repeat the exposure.*

Back then the Ottawa River ran wide with enormous log booms. Lumbermen in spiked boots skipped across the bobbing trunks, jabbing them with long pikes to keep them from jamming. The E. B. Eddy Paper Co. sat suspended in spray on an island in the rapids between Ontario and Quebec, and now and then, when the wind was right, the Ottawa air reeked with sulphur fumes from the pulp mills downriver at Thurso. During the hot summers people packed popular swimming beaches on the Ontario side, at Britannia and Norway Bay, but we seldom went to them. Mom and Dad preferred a spot on the Rideau River near Carleton University, a place called Hog's Back that offered a series of pools above a narrow gorge through which the river churned and foamed. A trip there was always accompanied by admonishments to stay away from the outflow of the pools.

Big Timber has thrived along the Ottawa River for centuries—ever since Canada began supplying logs to Great Britain during England's twenty-two-year war against France, which ended with Napoleon's defeat in 1815. The logging industry is still huge in Canada, which holds 10 percent of the world's forests, and clear-cutting remains the rage.

According to *National Geographic,* Canada is home to "the largest intact forest on earth. [The forest] supports 25 percent of the world's wetlands, as well as millions of pristine lakes and thousands of free-flowing rivers. It contains 197 million acres of surface fresh water, an area twice the size of California. It harbors more surface area of fresh, clean water than any other ecosystem on earth." All of which remains true, for now. Canada's national and provincial governments have not shown much propensity for protecting increasingly important resources. Our 1.2 million square miles of bush have been allowed to become a net contributor to climate-altering greenhouse gasses.

Of course, when I was a child, "climate change" meant that the first nip of fall was drifting down from Hudson Bay, or spring buds were blinking from the seasonally bare sugar maples and magnificent

elms near our home. Our elders believed the forest to be so vast that it would last forever. Mom's father, Arthur Graham, was, in the terms of the day, a protector of the forest. He served as district fire inspector for the Canadian Pacific Railway between Montreal and Ottawa during the early twentieth century, and later became chief fire inspector for the Lower Ottawa Forest Protective Association. The idea was to guard forests against fire so they could later be cut down for industrial uses. In 1915 the Commission of Conservation/Committee on Forests issued a report, *Forest Protection in Canada*, with such chapters as "Financial Losses by Forest Fires" and "Great Loss of Stumpage Values," in which Grandpa's efforts were commended.

Seventy-three years later, in Toronto, I wrote "If a Tree Falls," a lament for forest loss worldwide. The song is mostly focused on the rapid destruction of tropical rain forests, but it was clear by then that temperate and boreal forests—in Canada and around the world—were also falling at rates that might be described as biblical. In a 2008 interview the great Canadian scholar and environmental activist David Suzuki said that "If a Tree Falls" was one of his two favourite songs; he cried when he heard it. (The other was "Beds Are Burning," by Midnight Oil. Good company.)

I wonder what Grandpa Graham would think of my tree song. Would he lament or applaud the current conditions of North American forests? When he retired, Grandpa and my grandmother, Eleanor, moved onto a farm near Chelsea, Quebec, just beyond what was then the outskirts of Ottawa/Hull, where they raised much of their own food and produced maple syrup and soap. But it wasn't long before the agency charged with overseeing relations between the federal government and the City of Ottawa expropriated the farm as part of a forward-looking but poorly planned scheme to create a greenbelt around the city. My grandparents had their farm taken from them in an act of eminent domain.

They loved that farm. It was their dream to retire there. I was nine years old, I think, when they were forced out, and I remember the event as sad and a little confusing. The place left a big impression on

me: Grandma in the kitchen doing something at the sink; the cats meowing and rubbing themselves on her legs, which caused groans from my mother, who was always nervous about cats; Tom the Hired Man collecting eggs in the henhouse; Grandpa plowing the field with his Massey Ferguson tractor. I can still see someone milking Daisy Mae the cow, white froth splashing into a pail below pumping fists; Dad and Grandpa going to work repairing the little dam that created a trout pond in the creek flowing between the barnyard and the bush. In high summer Grandpa took me walking through the woods, and I got lessons in how to tell a red pine from a white pine or jack pine by the number of needles in a cluster.

In a favourite memory it's early spring and Dot, the big black horse, is hitched to the sleigh. We plod through deep snow, collecting sap from buckets hung on spigots hammered into the sugar maples. The jugs of sap are hauled to the sap house, a small structure in the bush behind the main house, where it gets poured into an oversized fire-heated vat. The pale brown sap bubbles and darkens, morphing into that most Canadian of condiments, maple syrup. (No offense to Vermont's maple syrup producers.) Grandma Graham would sometimes bake us a maple syrup pie.

Halfway through my kindergarten year we moved again, to the Westboro neighbourhood. Our house, at 483 Highland Avenue, was a two-storey brick structure built in, I'm guessing, the twenties. There was a room in the basement that had been a coal cellar, and another small cement-walled space that had seen service as a cold storage, which I got to set up as a "hideout." The house stood on a double lot, the other half of which was lawn, with two or three tall spruces and a pergola with seats, mostly hidden from the street by the trees. We were less than a mile from the river, which from there flowed southeast to the St. Lawrence and the work in progress that was the St. Lawrence Seaway.

The Ottawa forms the boundary between the provinces of Ontario and Quebec, and between the cities of Ottawa and Gatineau, which

until recently was known as Hull. Just north of the urban zone, which today holds more than one million souls, the landscape transforms quickly into the largely unpopulated Canadian Shield, or Laurentian Plateau, a vast expanse of forest and rock that surrounds Hudson Bay and extends into the northeastern United States. As a child and teenager I enjoyed many adventures in this wildland. My parents had a cottage on Grand Lake, north of town, which was one lake over—in a land of thousands of lakes—from the cottage my grandparents had acquired on MacGregor Lake, which took the place of their expropriated farm.

For several years I attended a month-long summer camp in Algonquin Park, about a hundred miles from Ottawa, with as much as two weeks of it spent canoeing through a wilderness of rock, water, and evergreens. We kept the company of bears and otters, raccoons, deer, chipmunks, bass and sunfish, bloodsuckers, woodpeckers, raptors, and ravens. It was in Canadian Shield country that I learned to love the peace and expansiveness of the world as it was made. I have lived a mostly urban life, but the nearby wilderness fixed itself in my brain as the essence of how things should be. When I think of "nature," I think of the Canadian Shield, which returns me to a sense of freedom of spirit. When I am confronted by the degradation of our surroundings, I feel that freedom being threatened, eroded.

Love of the wilderness, love of knowledge . . . there was never much talk about love of each other. My dad, Doug, and my mom, Lois, expressed very little deep feeling while raising me and my younger brothers, Don and John, other than what could come through laughter. Love was present, certainly, but was never stated and rarely shown. My parents expressed the normal amount of anger at inappropriate behaviour on our part, but never at one another. They never kissed in front of us, not more than a peck anyway, and never embraced. When my grandfather, Arthur, died in 1961, my dad hugged my mom. She then ran upstairs crying. That was the most emotion I saw out of either of my parents growing up.

*Aside: I don't remember hearing the word "love" in a family context until I was nineteen, and then only through circumstance. I was in music school in Boston. I met a friend of a roommate, recently back from the war in Vietnam, who was planning on spending the summer running guns from Central America to Cuba. He needed someone to watch his back and offered me the job. I thought about it. I think he became interested in me because the roommate told him I was in the habit of going for long walks late at night, haunting the alleys with the rats and the other skulkers, armed with a bayonet in case of trouble. My lack of training in anything martial was on a par with the would-be gunrunner's lousy judgment. I declined. When my dad came to Boston to drive me home for summer break, I told him about the job. He was shocked to hear of the offer and appalled that I would consider accepting it. "What do you care what I do?" I said, filled with both indignation and anger— emotions with which I was on intimate terms. Dad stared forward and faltered, stumbling on his words. "A father loves his son," he said. Never had he uttered anything like this in my hearing. He didn't even know how to say it. I was stunned. I had no way to express how deeply moved I was, how bittersweet the feeling. We drove on in silence.*

Ours was a secular household, in spite of the exposure we all had to the surface ideals and imagery of Christianity. We went to church on the Sundays when we weren't at the cottage or skiing, because that's what was expected of us. This was the fifties. There was a need to observe the social norms to keep people from calling you a Communist. Canada didn't suffer the same problems as the United States did—lives and careers ruined, friends and family ratting each other out even when no actual rat was to be found—but similar sentiments infiltrated our culture. We had no counterpart for the McCarthy witch hunts, but it was not wise to be different. We went to church partly out of concern for that convention, but also because

Auntie would have been upset if we didn't attend. It was a conservative time.

Most church experiences during my youth were simply endured. My parents provided crayons and paper to keep me quiet during sermons. Some years later—I may have been ten or eleven years old—I voluntarily eschewed the crayons and actually listened to the sermon, and a lightbulb went on. *What's this? Something interesting?* I don't remember what the minister was saying, but he was nailing something. For the first time I realized that they actually talked about real stuff during the sermons. This newfound interest, however, was brief. It wasn't long before I was a preteen joining other kids spending our collection money on candy at the corner store instead of depositing it into the plate.

Southminster United Church was part of the United Church of Canada, which was created in 1925 out of three Protestant denominations: Methodist, Congregationalist, and two-thirds of the existing Presbyterian churches. This "amalgamation" was officially sanctified by an act of Parliament, a union of church and state that our southern neighbours—except, of course, America's growing class of reactionary fundamentalists—might frown upon. Today the United Church of Canada is the largest Protestant denomination in the country, though these days attendance is down about 50 percent from a high of 1.1 million in 1965. In those years the United Church accentuated the "protest" in Protestant, and today the church continues to pursue programs that address several critical social and environmental issues, including resource extraction, Indian residential schools, and globalization.

Of course these concerns were absent, from the public radar at least, in 1950, when at the age of five I was finally baptized. What did happen that year was that the United Church of Canada became the first major denomination to eschew the "doctrine of inherent immortality." No longer would parishioners be required to exile nonbelievers to a place of "eternal torture and punishment" for their "failure to accept Christ." Thank God! That day, though, when I was marched

down the aisle along with my infant brother, Don, I felt thoroughly tortured and punished. I didn't like attention anyway, except on my own terms. I still don't. Even positive attention can be oppressive. Early in my solo music career, I had to affect a disdain for audiences in order to make myself get up onstage and perform without being overcome with nerves. Fortunately, this dance between alienation and the need to be loved in order to connect with my audience only lasted about thirty years.

When we moved to Ottawa we settled into an apartment on Sunny-side Avenue, in the area called Ottawa South. Halfway through my kindergarten year we moved again, to the west end, and I had to switch schools, which meant reliving the feeling of alienation I'd had a half-year earlier. I remained an outsider, the shy kid with a lopsided walk. Though it probably wasn't true, I felt like everyone was always staring at me. I was among strangers in a strange place, a gnawing discomfort I have never shaken. Throughout my young childhood, though I played with other kids, I remained mostly a loner, an intro-vert. School report cards contained observations like "Bruce would be a good student if he would just stop daydreaming." I had a gift for constructing alternate realities: one that dealt with the external world, and another that was all my own. They became so sharply divided that often my day-to-day self didn't know what my inner self was doing. Even so, the world in my head was vivid to me, despite, or perhaps because of, its hidden chambers and secret stairways.

Music continued to creep in. In grade three the school held invol-untary auditions for the choir. The woman in charge of the choir program visited every classroom. She and my teacher, Miss Beau-champ, walked up and down the aisles while the class sang, stopping next to each of us to listen and judge whether we qualified for the job. I sang terribly on purpose. No way was I going to be in that choir. I guess I overdid it. My deliberately out-of-tune voice took on a cater-wauling tone reminiscent of Jerry Lewis. That got me in trouble, and

I had to write lines. At least I was off the hook. (A greater lesson I learned from Miss Beauchamp was that a "radical" is a person who addresses social problems at their root, and she cited Pete Seeger as one of North America's great radicals. More than fifty years later, in 2009, I would be honoured to sing at Seeger's ninetieth birthday celebration at Madison Square Garden in New York.)

I didn't mind singing with the class, though, maybe because there was no audience and we were all in it together. Misery loves company. I remember being particularly touched by the Welsh folk melody "All Through the Night":

> *While the moon her watch is keeping*
> *all through the night*
> *while the weary world is sleeping*
> *all through the night*
> *O'er thy spirit gently stealing*
> *visions of delight revealing*
> *Breathes a pure and holy feeling*
> *All through the night.*

I look back on this song with some fondness. All through my life I have embraced and questioned the night, and loved its random light: the aurora borealis, the starry reaches of the cosmos, streetlight ricochet off car metal and darkened windowpanes . . . the light of friends and lovers.

We are on a great journey, through darkness and dawn, across time, though sometimes I fear that our journey is about to end. We must not succumb to fear or avarice; we must continue to embrace life, seek light, and gather in the charity of night. This is what God wants from us and for us. Mirrors of the past shine with the hue of unborn days, just as stars glitter in the dark night to light our way.

When I was ten years old, Mom and Dad raised the subject of music

lessons. Would I like to play an instrument? I was not opposed to this.

Both Mom and Dad played piano: Mom, light classical pieces from printed sheet music, and Dad, the pop music of his youth, by ear, in any key as long as it was F. They both embraced musicals, and when I was really little they were given to singing together. We'd be going somewhere in the car, and they'd croon show tunes from *My Fair Lady* and *Oklahoma*, "Home on the Range," and music-hall songs like "Barnacle Bill the Sailor." When I was a toddler I liked it, but as growing boys my brothers and I found it embarrassing. What if our peers were to hear this? "Oooooklahoma, where the wind goes . . ." I'd want to shoot them. Eventually they stopped singing, probably because my brothers and I became intolerable about it. We had a special loud groan we used just for such occasions.

My uncle had an unused clarinet lying around, so this became my first instrument. I didn't really relate to the clarinet, but I did enjoy playing music. Later my parents bought me a trumpet, and I played that until I was thirteen. When I hit grade nine, the first year of high school, I felt entitled to advance to grade ten music. The music teacher disagreed, so I spent months of music classes bored with the basics that I already knew. At the end of the year I dropped the trumpet, and the study of music, though I continued to consume it through the tinny earpiece of my little transistor radio, covertly tuning in late-night rock and roll. I also discovered Igor Stravinsky in my parents' record collection. It was a second-rate performance of *The Firebird*, and I'd spin it frequently on the family hi-fi. My dad would have preferred Vivaldi or Mozart, and he'd drolly condemn the Russian composer as "Bruce's tone-deaf hero."

When I wasn't absorbing music, I was devouring books. Never drawn to academics, I nonetheless have always loved words. By grade six we'd evolved from rhyming ballads, such as Alfred Noyes's "The Highwayman," to more modern material. On one occasion we were assigned the task of memorizing a poem of our choice from an English textbook. I stumbled on "Ars Poetica," by the Illinois poet Archibald MacLeish:

*A poem should be motionless in time*
*As the moon climbs*
*Leaving, as the moon releases*
*Twig by twig the night-entangled trees*
*Leaving, as the moon behind the winter leaves*
*Memory by memory the mind.*

Here was a juxtaposing of imagery, of evocative impressions, suggesting the vastness of things. I was hooked. Soon I'd visit T. S. Eliot and Dylan Thomas, masters of beauty and depth.

Much of the rest of my reading time was filled with sci-fi. Ace Doubles offered two stories; you'd finish one and then flip the paperback for the other. I'd read Jack Vance's *Big Planet/The Slaves of the Klau*, then immediately crack Andre Norton's *Sargasso of Space*, backed by Philip K. Dick's *The Cosmic Puppets*. Though I have never given up sci-fi, I was soon on to Beat writers like Jack Kerouac and Allen Ginsberg. Burroughs would come later, but he would definitely come. Later, too, came the darkly transfigurative travelogues of poet Blaise Cendrars and Ginsberg's roiling *Fall of America*.

*Aside: Our next-door neighbour, Mrs. Peddie, the mother of Ian, who was my age and with whom I played, wrote regular letters to her parents in her native England. Ian's sisters were kind enough to share some excerpts from those letters. . . .*

Sun. 30. V. 54

. . . [Ian] and the boy next door are crazy about space ships and you should see all the contraptions they have fixed up. Bruce has an outer space outfit which his father bought in the States and Ian has his own crystal set complete with earphones . . . they pretend [the programs] come from Mars. . . .

In 1959 my parents realized that my brothers, ages nine and seven, needed to stop sharing a room. So we moved across town to the house my dad had grown up in while a new structure was built on the lot

next to our existing house, which was sold. Grandma Cockburn occupied that home with Auntie, her sister. It was at Grandma and Auntie's house that I would find my holy grail, the North Star and trail guide of my life.

As a younger child I had always loved going to the sisters' house. They were kind ladies who made a fuss over me and produced delectable Sunday dinners of roast beef and browned potatoes, with vanilla ice cream and chocolate sauce for dessert. It was a three-story house, with access to the top floor provided by a narrow stair that opened onto a landing, on either side of which lay a small bedroom. Historically Grandma and Auntie had rented these rooms to young, single working women. (I had had a little boy's crush on Alma, the blond airline stewardess.) There was a single bed and a dresser, a small table for homework. The wall on the street side sloped inward, following the slant of the roof, and opposite that was a low, mysterious doorway, which led to a large attic closet. Something to explore! The attic was piled with boxes, a decrepit tennis racket, some folding chairs, and in the shadows—my heart leapt!—a beat-up cardboard guitar case.

I dragged the case into the room and opened it. Inside was a small, dark brown guitar with strings discoloured by rust. Whose it had been was a mystery. Who it was meant for was not.

History and family and experience and hormones collided in a singular molten moment. A guitar! It was a beat-up old no-name thing, set up for playing with a steel, Hawaiian style. It had not been strummed for a long time, so no one minded if I abused it. I was terribly excited. I painted gold stars on its top, posed with it, and banged away on it seeking the rudimentary grooves I'd heard on the radio, without much success. But it pulled me in. I spent a lot of time with that guitar. In my mind I was already a guitar player, and I spent a lot of time in my mind, so what's real is real. I couldn't relate to much of what went on in the outside world, except for rock and roll, and here, suddenly, was a ticket to ride.

Even before finding the instrument in the attic I had become infatuated with the deep twang of Duane Eddy, the jangle of the Crickets, the raunchy crunch of Scotty Moore on Elvis Presley recordings.

Mom and Dad were not especially happy about this development. Like many of their generation, they looked at rock and roll the way a collector of fine automobiles might view a Ford Pinto. They were nervous because rock and roll meant teenage gangs and general bad behaviour, lewd dancing and cigarette packs in shirtsleeves. Dad thought the singers sounded effeminate and didn't even sing in tune. But it was clear to me, as soon as I found that guitar, that this was what I would do. To their credit, my parents were keen on honouring their children's interests.

I wasn't thinking of a career. At first I didn't even know what to do with the instrument, I just sort of hammered at it. I'd figure out one riff and play it all the time. My parents said, "Look, if you're going to play guitar, that's fine with us. But you have to promise that you'll take lessons, and you have to promise that you won't grow sideburns and get a leather jacket, and you won't play rock and roll." They imagined that if I learned the instrument "properly," I would no longer want to play the awful teenage stuff. Eventually they were right.

My guitar teacher, Hank Sims, took one look at that guitar and declared it unplayable, so my parents bought me an inexpensive Kay, a fat-bodied acoustic archtop with flat wound strings. We got a DeArmond pickup to mount on it and make it electric. Some of the old blues greats, such as Jimmy Reed, Buddy Guy, Lightnin' Hopkins, Howlin' Wolf, John Lee Hooker, and many others, played Kay guitars because they were cheap but also because they produced the sound they wanted. Mine went underappreciated. That music was still waiting to be discovered.

I took my lessons. I learned some standard tunes and a lot of basic guitar techniques. Hank introduced me to the music of Chet Atkins and Les Paul. And, though I waited until I thought my parents wouldn't care anymore, in the fullness of time I acquired sideburns and a leather jacket, and I played in a rock-and-roll band.

# 2

I don't think I'm alone in remembering high school as a prison sentence. Nepean High was adjacent to my old public school, and both were only three blocks from my house, so in transitioning to high school I didn't feel like I'd really gone anywhere. There was a change, though. Academic demands weren't the issue. In spite of being lazy and a daydreamer, I have always loved words and non-mathematical intellectual challenges. Rather, it was the banal yet intimidating pressure to compete with peers, to fulfill someone else's ideas of what, exactly, needed to be learned, and to look and act in ways that felt antithetical to my dawning sense of personhood that made high school such a drag. Never mind the minefields laid by the hormonal rush of puberty. I still wince

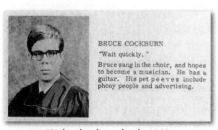

*High school yearbook, 1963*

at the memory of sitting in French class, after an hour of physical education, in a state of horrified embarrassment at the smell emanating from my sweaty crotch, which I was certain was offending every person (read: girl) in the room.

All through school I resided to a large degree in a world of my own making. Though I always had a couple of friends, I was shy, a loner

in my heart. Nowadays I would likely be diagnosed with ADD, but alas, I missed out on the Ritalin.

In those days everyone seemed afraid of something. There were rules for everything. I have never much liked other people's rules, which is maybe why I was drawn to the Beat poets and their predecessors in the first place. Their poems often broke establishment "rules" for poetry and mocked the safe subjects that pundits deemed acceptable for the written word. In 1956, when I was eleven years old, Ginsberg published his famous broadside *Howl and Other Poems*, which didn't so much break rules as crush them. *Howl* was a paratactical deconstruction of an illusory American dream, a demythologizing chapbook standing squarely on the shoulders of dissident greats like Walt Whitman and William Carlos Williams. It signalled the end of *Father Knows Best* and the beginning of Elvis, and challenged the powers-that-were with the understanding that their social control structures were so weak that a mere poem could undo them.

For me it was an opening of worlds, adrenaline delivered in letters. I found the poetry itself to be powerful, but I was also very much taken with the style of the Beats (which at the time was portrayed bemusedly by *Time* magazine). It contained a fierce rejection of conventional mores and a willful embrace of the artists' poverty, which was thrust on them, at least in the beginning. I got a sense of headlong motion, breathless in the verbal paragliding.

Fear of poetry on the part of the powerful seems to have always been with us, and it doesn't go away. Communist Russia was in the habit of confining dissident poets in insane asylums. North American society marginalized them as having no commercial value. And yet we were taught the works of the previous generation's iconoclasts as part of a government-approved curriculum.

T. S. Eliot, Dylan Thomas, Ezra Pound, e. e. cummings, and William Butler Yeats set the literary scene for me. The Beat poets and writers shortly followed, and then I began dabbling at poetry of my own. I filled a notebook with derivative poems, full of veiled sexual fantasy and not-so-veiled imagery from horror stories I was reading.

I took the work seriously but maintained a sense of irony. I drew a picture in ink on the cover—a man's head with a big worm coming out of the forehead—and gave it a title: "Excretions of a Mental Leper." The notebook lived in my top left desk drawer so I could retrieve it while I was supposed to be doing homework. One evening my father told me he had found it and was very concerned lest my younger brothers lay hands on it. I was really offended that he'd gone through my drawers, but I said I would make sure that they didn't see it. He said he had already made sure by destroying it. I maintained a poker face in my absolute outrage, but I knew from that point that I could not trust him, or by extension any authority, ever again.

Toward the end of grade nine I got word from my friend Alan Greenberg that a certain day had been declared Beatnik Day. It was a subversive, unofficial declaration that felt to me like a safety-in-numbers opportunity to fly my true colours. (It occurs to me now that it may have been a declaration only by Alan, and only to me. No matter: I went for it.) I had seen a TV interview with an "actual beatnik," who said she wore black as a gesture of mourning for the world. I didn't have any black clothes. I had to improvise. I went to class on the appointed morning in a V-neck sweater, a tie without a shirt, and sunglasses. *Hey, I'm a beatnik!* I don't recall seeing many other manifestations of latent Beatness, maybe a couple of kids wearing shades in the hall. I was not lauded for my uniqueness. I was ordered to the principal's office, and then sent home to dress myself properly.

I was born into a generation of North American youth who enjoyed enormous privilege. But like most teenagers, we were aware of what was happening around us. Sheltered as we were in 1950s Canada, we could still see the rapid expansion of suburban life and world populations, the delirium of anti-Communist witch hunts, the mushrooming wars of empire, and especially the looming shadow of the crazy nuclear arms race. And while we may not have realized it, it was clear something was going on with the church, which I later understood to be an incremental but consistent diminishment of the institution's

authority in the face of state dominance. These were huge changes symbolized and catalyzed by the Big Bang of World War II, the results of which are only now coming to bear. Climate change and other environmental transformations may be irreversible, and human misery has never been more widespread as wealthy nations maintain their mad scramble to monopolize scarce resources such as fossil fuels, arable land, and water. Back then we couldn't have predicted these changes, but even as teenagers, if only through the osmotic absorption of energetic shifts, we were aware of the nature of the path. We also understood, if only by intuition, that there wasn't much authentic spirit to be encountered along the way.

I had my friend Alan, and a couple of others. Really I looked up to the tough kids. I'm not sure exactly why; maybe I envied what looked to me like their freedoms. I found them appealing and, indeed, authentic. They smoked and drank. They talked back. They had parties where girls and boys made out. They cut tattoos into their arms with razor blades, got into kicking duels during lunch period, shoplifted as a matter of course, occasionally stole cars for a joyride. Had I asked, one or two of them would have taught *me* how to steal a car, and informed me with a high level of acumen how to joyride, ditch the vehicle, and avoid getting caught (and probably what to do if I did get caught). I found them interesting. I was eager and angry enough, but too aware of the consequences, to act with such drama, and I wasn't tough at all. (Though I did go through a shoplifting phase, eventually working up to pocketing .22-calibre ammunition and selling it at school to the boys whose fathers taught them to hunt.) I didn't try to be one of them, which is probably why they didn't beat me up. Had I tried to be like them, they would have had to fight me.

They were mostly working-class boys who took shop and auto mechanics instead of Latin, as I did. In grade ten I was in a French class with four or five of them. I made sure I sat in their corner at the back of the room. We told jokes and harassed the teacher in stage whispers whenever his back was turned.

I remember Ed the best. He was the tallest of the bunch, and could

"shoot the boots" (fight the kicking duels) better than anyone else. He was also a fairly nice guy, though quick to anger and always ready to defend his position at the top of the pecking order. At the other extreme of this little posse was Tommy, a short kid with an aggressive attitude who would attack you one minute and befriend you the next. He sat beside me in English, and one day pulled out his penis and whispered to me: "And that's only pissin' size!" It certainly loomed large in context.

My tough friends were damaged goods. None of them seemed to have great hopes for the future. In contrast to mine, their parents were poor, uneducated, working-class. Their lives were hard, and when your life is hard it's not easy to make the best choices, especially when so many important choices are made for you. I treated them with respect, and they gave me back the same.

In his novel *A Perfect Spy*, John le Carré tells the story of a boy brought up by a con artist father. He grows up to be a chameleon, blending in with whomever he's with, so much so that his genuine self disappears under all the quick-change facades, leaving the guise of the moment to be the truth. The tough kids believed I was real with them. Still, I was not *one* of them. I was a fellow traveller in their company. Not an impostor, but an observer, a contributor, some-one who authentically cared—but never a true insider. I would find myself in this role throughout my life.

*I'm looking to be by a window*
*That looks out on the sea*
*Anybody here know*
*Where such a place is?*
*Surf of golden sunlight*
*Breaking over me*
*Man of a thousand faces*

*In the Garden paths take form*
*But the hailstorm guards its own*

*Things forbidden, things unknown*
*You must travel on alone*

*In memoriam friends come round*
*But the hard ground holds its own*
*Time for pulling, time to ride*
*It's my turn but where's the guide?*

*On the jetty shadows lie*
*And the gulls cry once or twice*
*Swelling thunder, truth is hid*
*Behind the glass eye of the idol. . . .*
*Anybody here know*
*Where such a place is?*

*You know, these city towers*
*Jewels on the serpent's crown*
*Twist the space between them*
*Till every eye is blinded*
*Lord will you trade your sunlit ocean*
*With its writhing filigree*
*For any one of my thousand faces?*

"MAN OF A THOUSAND FACES," 1969

The people I spent time with outside school, when I wasn't spending time alone, were my musical friends. Dave Milliken, who had been my best friend through what would now be called junior high, was still in the picture, though adolescent tensions were pushing us apart. Early on we played war games. Those evolved into fantasies about the girls we knew, about women in magazines. Girls were pretty much out of reach, but when we both began guitar lessons around the same time and played a lot together, rock and roll presented the distinct advantage of being accessible. As time went on

and the world expanded, Dave got a girlfriend and we gradually stopped hanging out.

My musical tastes evolved quickly, and I found myself increasingly in the company of Bob Lamble, whose house I walked past every day on the short hike to school. Bob was studying bass, and we had a common interest in jazz and poetry. He was bright and thoughtful, and eventually pursued a career as a scientist.

At first we studied the safe stuff. In those days it was possible to pick up budget records at the corner store, like videos at truck stops today. These albums consisted primarily of outtakes and deleted overstock by known artists, discarded onto cheap vinyl sets. They were probably bootlegs . . . bad recordings of second-rate Charlie Parker performances and such. I found an album of jazz TV themes arranged by guitarist Mundell Lowe, in a big band with horns and a four-piece rhythm section. I thought it was a beautiful sound, and he played TV themes that I was familiar with, so I could appreciate the imagination brought to bear in his arrangements. I bought *Belafonte Sings the Blues*, which featured the artist singing a collection of great songs, some of them actually blues.

The first piece I learned by ear off the radio was "Walk Don't Run," which was a huge hit in 1960 by the Seattle instrumental rock band the Ventures. I was so proud to have "nailed" that song! While the Ventures played it as a delightful little surf tune, it had first emerged in 1954 as a jazz number written and recorded by Johnny Smith. Within a year of hearing "Walk Don't Run," I began trying to learn jazz tunes. I laboured through the drudgery of schoolwork until I could retreat to my real studies: *DownBeat* magazine and jazz on records and the radio.

My musical tastes morphed from mainstream to edgy, the latter in large part because it was just that, out of the mainstream. At that stage, with a broadening but still narrow view of the overall landscape, "edgy" meant the intellectualism of the Modern Jazz Quartet, the raw energy of Wes Montgomery (before he toppled into proto–smooth jazz), the spacious, exotic harmonies of Gil Evans with Miles

Davis. Much of this music shows up in supermarkets and airport lounges now, but in the early sixties it was cutting edge.

The album *The Incredible Jazz Guitar of Wes Montgomery* got a positive review in *DownBeat*, so I bought it and listened with my friends. When we learned that Montgomery played with his thumb, it was like finding a secret compartment to an old music box you've had for years. He didn't use a pick. We had never heard of such a thing. It was new and different for our times, for our community of adolescent explorers, and not everyone around me liked the sound. I was drawn to new and different, and the bottom line was that it was *great*, a fat sound that felt like you could eat it. He was deeply soulful and, in his tone and his use of parallel octaves, masterfully inventive.

Bob and I attempted to play jazz out of books. We didn't really understand what it meant to improvise, but we were moved by what we heard on records. We liked guitar players, but also appreciated the delicate counterpoint of piano and vibes from the Modern Jazz Quartet, the velvet trumpet of Miles Davis on the brilliantly cast *Kind of Blue*, and the roughneck sophistication of Charles Mingus. Thanks to a *DownBeat* review I discovered the Chico Hamilton Band, featuring the playing and composing of Charles Lloyd and Gabor Szabo. These guys profoundly shaped my sense of what music could be. Szabo played a Martin D-18 or D-28 acoustic with a DeArmond pickup mounted on it, giving him a sound unlike any other jazz player. He was a refugee from Hungary, and his playing evoked strange and mysterious elements of Eastern Europe. I found the sound fresh and enticing, no matter the jazz establishment's disapproving grumbles. Both Szabo and Lloyd effectively employed elements of pop, at times tongue in cheek, but the tunes were imaginative and original. (Carlos Santana cited Szabo as a major influence, along with Bola Sete and Wes Montgomery. Santana's 1970 album, *Abraxas*, features the hit "Black Magic Woman." The famous guitar solo at the end of this song is a dynamic cover of Szabo's song "Gypsy Queen," from his 1966 album *Spellbinder*.)

Decades later we tried to get Charles Lloyd to play reeds on my album *The Charity of Night,* but he wanted such a fat fee, more or less the entire recording budget, that we had to abandon the idea. (This turned out to be a blessing, for we were ultimately led to the great vibist Gary Burton.) Lloyd continues to create powerful music. Gabor Szabo died in 1982. In 1965 Szabo and Hamilton collaborated on the score for Roman Polanski's psychotic film *Repulsion,* which, coincidentally, became an important and disturbing contributor to my youthful self-analysis.

Folk music began to infiltrate my musical world vision. I first heard the term in connection with Harry Belafonte's album of calypso songs, which every household in North America must have possessed. My dad used the term to justify buying the record after I accused him of secretly liking modern music. It was the one place where my parents' tastes and mine overlapped.

I didn't connect folk music to the guitar until I was fifteen, during my last summer at Camp Ahmek, a venerable institution on the shores of Canoe Lake in Algonquin Provincial Park, about a hundred miles from Ottawa. That year I worked in the kitchen, where I met a kid my age who practiced rudimentary fingerpicking. I had not seen anyone play that way. He played a song called "Black Fly," about the vicious little creatures that tormented us on two-week canoe trips through the bush of northern Ontario. When I asked him what he was playing, he said it was folk music. (Wade Hemsworth, part of the original wave of Canadian folksingers, wrote "The Black Fly Song" in northern Ontario while working with a survey crew before the damming of the Little Abitibi River.) Soon enough, like a lot of people during the 1960s, I was playing folk music as well. The era and the possibilities continued to expand.

The expansion included vocals. I was very shy about singing, but my mother said, "If you're going to play guitar, you should sing. People who play guitar sing too." I knew my dad would be skeptical, as he had very high standards when it came to most things, including what constitutes a good singing voice. I had absorbed his way of judg-

ing things, but with my own set of understandings. Mom could see better than I could how much I wanted to be more than just a guitar player.

To overcome my fear of singing, I joined the high school choir. I was nervous trying out, but I got in. I was sixteen years old. I spent the school year going to rehearsals where I sang tenor parts in Gilbert and Sullivan songs, while keeping a keen eye on my future in rock and roll.

The first band I saw live was a group from Montreal called the Beau-Marks, a play on the name of a long-range anti-aircraft missile. (Bomarc missiles could carry conventional and nuclear warheads, and they caused a political storm in Canada because the United States deployed them there without the approval of Parliament.) In 1960 the Beau-Marks released "Clap Your Hands," which became an international hit. It was thrilling to hear them the next year at an Ottawa dance hall, but most exciting was a revelation by the band's guitarist. It appeared that he played rhythm and lead at the same time! One of my companions called it "rhythmo-lead," and we all aspired to know how it worked.

During my second year in grade eleven (that math!), I met Peter Hodgson, who was a fingerpicking guitar player. Peter played an eclectic repertoire of blues, Woody Guthrie, and old-time country music, as well as a range of songs from across the folk world. When we played together I'd inject little bits of jazziness while drawing out of the experience an understanding of song as a representation of the human spirit. I also worked on making my thumb play rhythm while my fingers played lead, which would become central to my later playing style.

Through Peter—who later morphed into the Ottawa folksinger Sneezy Waters—I began meeting people in the local folk scene, which was still fairly nascent but would evolve into a strong community of performers and promoters. Peter introduced me to Sandy Crawley, who became as much of a friend as I was able to permit myself back then. Sandy was another good picker with a varied repertoire. He and

I played together as a duo at parties, and once or twice onstage. Through them, and the various connections they had, I encountered sounds and performers that would become major influences on my music: Fred Neil, Ramblin' Jack Elliott, Big Bill Broonzy, the Folkways record label, the Reverend Gary Davis, Brownie McGhee, and Sonny Terry. I have Peter to thank most of all for introducing me to a girl he was going out with at the time, Barb Luther, who in turn introduced me to the consumption of wine and the music of Mississippi John Hurt, two things that have had a profound and positive effect on my life.

Bob Dylan came on the radar at about the same time that Peter Hodgson brought me to a coffeehouse, now legendary, called Le Hibou, which is French for "The Owl." Le Hibou (pronounced *luh eeboo*; non-francophones who hadn't paid attention in French class pronounced it *lay hee-boo*) grew out of the creative drive of an artsy set of students from the University of Ottawa. By the time I came along, the club had acquired the role of galactic hub around which most of the Ottawa folk scene revolved. Bill Hawkins, a "real" poet dedicated to the craft, was Le Hibou's manager, and he would change my life. Bill was five years older than I, but there was something about my playing, even in those early days, that he seemed to like. By the end of high school I was washing dishes on weekends at Le Hibou, running the espresso machine, and playing at the weekly open mikes, which for some reason were called hootenannies.

I was quickly drawn into the musical and interpersonal scenes of Le Hibou. The coffeehouse opened in 1960, which was good timing because in 1961 I was in my first year of grade eleven and utterly bored with school. All I wanted to do was read and play music, and have it take over my life, and I thank God I was able to make that happen.

One of the first performances I saw at Le Hibou was by Brownie McGhee and Sonny Terry, blues greats who exuded a style and verve that I had never before experienced. They gave me goose bumps: Brownie, dark and intellectual, and Sonny, joyful and deceptively

simple, both of them solidly musical and generous of spirit.

Another Peter who had an even bigger influence on my life in general, as well as musically, was Peter Hall, the organist at Westboro United Church, where we attended Sunday school as kids. A tall and physically soft gay man with a pronounced widow's peak, he taught piano and theory under the standardized courses offered by the Royal Conservatory of Music in Toronto. I took lessons from Peter with an eye toward proficiency in musical composition. Somehow he managed to get me through the conservatory's Grade III theory course and the Grade VI piano exam. The examiner took pity on my nervously quaking hands and passed me even though I turned in a truly wretched performance.

Peter also encouraged my continued exploration of jazz. While he was necessarily steeped in the music of the church—Bach and other composers whose works soar on the pipe organ—he loved jazz, and encouraged me to love it too and master it if possible. Bob Lamble and I spent a lot of time with him, listening to jazz, discussing theory, playing music—experiences that were the polar opposite of high school. If one was a prison sentence, the other was a breakout.

On Saturdays Bob and I went to Peter Hall's house to soak in the sound: Mahalia Jackson; *musique concrète*; Mose Allison; the Third Stream music of Gunther Schuller and the Modern Jazz Quartet; and electronic music, which was very new. Peter also led me to an appreciation of film. Early in high school my friend Al Greenberg and I spent nearly every Friday night in a movie theatre, bug-eyed over sci-fi and horror films or *noir* crime pictures. In contrast, Peter thought I should see Fellini's visually and conceptually innovative *8½*. We also took in Ingmar Bergman's *Through a Glass Darkly*, with its questions about God and a gorgeously sparse score of Bach cello pieces. We saw *Freud: The Secret Passion*, with Montgomery Clift. (Jean-Paul Sartre, a leader of the French Underground during World War II and a subsequent existentialist muse, was the original *Freud* scriptwriter, but his story came in at over five hours long. When director John Huston asked Sartre to shorten it, Sartre made it three

hours longer. After a brief but fiery argument, Sartre left the project and told the American director to drop his name from the credits.)

There was a lot of psychology in these films, and as Peter and I became closer he began to reveal his own struggle to deal with his sexuality. I was utterly ignorant in this area, but in typical teen male fashion was convinced I had a handle on the *concept* of having sex with girls. Not that I hadn't had some experiences that one might call physical, but the girls I went out with either sensed the limits of my capacity for intimacy and were wary, or were too forward and scared me off. I had the ability to empathize with females, though. The callous attitudes expressed by many of my male peers disgusted and embarrassed me. The world-in-my-head where I mostly lived was held together by a belief in how things ought to be, and I could not yet recognize the degree to which deep down I was just one of the boys.

In the early sixties it was possible to discuss homosexuality, at least in circles that fancied themselves hip. Not with my family, certainly, where anything to do with sex was forbidden territory, but among "arty" people and intellectuals. Peter, as I understood it then, was undergoing counseling in order to "convert," or cure himself of homosexuality. The prevailing view at the time was that queer behaviour was a moral choice, and that those who engaged in it were perverts, or "sex deviates," as they were referred to in news reports. The idea that one could be Christian and gay, or a whole person and gay, was to many an oxymoron. The notion that love could be involved was more or less heretical. I didn't get it at the time, but I'm pretty sure Peter loved me. Though he behaved toward me with perfect decorum, there was an emotional depth to our relationship that I recognized only dimly but that I think was pretty intense for him. I wonder what strength it must have taken to maintain the correctness with which he treated me.

With Peter's mentoring and support I began writing jazz-based instrumental music, producing many pieces that have since, mercifully, faded into the fog of time. I can't remember whose idea it was,

mine or Peter's or Dan Matheson's, but I composed a jazz liturgy on the understanding that it would be performed as one of the regular Sunday evening youth services. The Reverend Matheson, the minister at Westboro United Church, was a lively man, well groomed to the point of shininess the way clergymen can be, youthful-looking in spite of his wavy white hair. He also happened to be our backyard neighbour. I think he felt that an enterprise like this would inject some energy into the youth aspect of his ministry.

Mom and Dad attended the service, along with Peter Hodgson, Sandy Crawley, and some other folkie friends. There was a reasonably good turnout from among my high school peers. A surprisingly large number of mature adults from the community also showed up. I put together a four-piece band: Rick Locatelli on alto saxophone, Bob Lamble on bass, Paul Barette on drums, and me on guitar. I had composed an offertory and sundry other instrumental music, following the standard order of service. The choir sang anthems I had written, and some modern-sounding hymns carefully chosen by Peter Hall. The performance went reasonably well, though some of my choral harmonies had the older folks poking at their hearing aids, wondering if they'd broken.

The music earned praise from the grown-ups and from my musician friends. Overall, though, the young people from my own demographic were less enthusiastic. They seemed to find it inappropriate. One girl accused me of sacrilege, providing an interesting, and at the time surprising, lesson in human nature.

My only religious studies during high school were self-directed. I liked to read the Bible for the juicy bits. People rape, they pillage, they impale each other, they dash infants' brains against walls. One memorable episode was in Judges 3, in which a dude named Ehud fashions an eighteen-inch dagger and assassinates the apparently very obese Eglon, the king of Moab. Ehud manages to bury the knife in his belly until "the fat closed upon the blade, so that he could not draw the dagger out of his belly; and the dirt came out." ("Dirt"? We read the King James Bible, but the English Standard Version is clearer

on this point: " . . . the dung came out.") Ehud then leads a mob of Israelites into Moab, where they "slew . . . about ten thousand men, all lusty, and all men of valour; and there escaped not a man." Such carnage fit well into the vast aquifer of my suppressed adolescent rage. Ehud reminds me of a young Vito Corleone in *The Godfather Part 2*. In Sicily, Corleone visits Don Ciccio, the fat old guy who killed his dad. Corleone makes nice with the killer, playing a friendly olive oil importer until he plunges a dagger into the old man's gut and slices nearly to the nipple. (One suspects that Mario Puzo, who wrote the book *The Godfather* and co-wrote the screenplay, was also familiar with the Bible's juicy bits.)

The story of Sodom and Gomorrah was also appealing. The authors certainly outdid themselves here. Imagine: Two male angels show up at Lot's house, and they become Lot's honoured guests. But the town is full of hooligans, and sure enough, a posse of men descends on Lot's house and demands that he "bring [the men] out unto us, that we may know them" ("know" of course meaning "experience sexual congress with"). Lot says, "Look, these men are guests, they're under the sacred umbrella of hospitality that we're obliged to provide." He says, "Behold now, I have two daughters which have not known man; let me, I pray you, bring them out unto you, and do ye to them as is good in your eyes: only unto these men do nothing." Hospitable! But the hooligans aren't interested in the virgin girls; it's male flesh they want.

The angels intervene and temporarily blind the would-be rapists swarming outside. They tell Lot to collect his family and get out of town because God is going to nuke Sodom, and he'll destroy Gomorrah as well just for good measure. "Then the Lord rained upon Sodom and upon Gomorrah brimstone and fire from the Lord out of heaven. And he overthrew those cities, and all the plain, and all the inhabitants of the cities, and that which grew upon the ground." The angels had also admonished Lot's family to "look not behind thee," but as we all know, Lot's wife does look back and is turned into a pillar of salt, which sounds very nuclear . . . reminiscent of Hiroshima and

Nagasaki, when people were turned to pillars of ashes to be blown away by the wind, leaving human shadows on the concrete.

From homosexual rape, fathers offering their virgin daughters to the mob, and nuclear annihilation, the story moves right along to . . . incest! After everyone is killed and Lot and his daughters escape Sodom to live in a mountain cave, the girls lament a lack of men to give them children. "And the firstborn said unto the younger, our father is old, and there is not a man in the earth to come in unto us. . . . Come, let us make our father drink wine, and we will lie with him, that we may preserve the seed of our father. And they made their father drink wine that night: and the firstborn went in, and lay with her father." Next night: same thing, different daughter. "And they made their father drink wine that night also: and the younger arose, and lay with him. . . . Thus were both the daughters of Lot with child by their father."

My friends and I read the Bible for that stuff because it was enticing and, while not exactly suppressed, was certainly *de-emphasized*—the irony of which, like the study of faith itself, can become the lesson. We'd trade stories. "You wouldn't believe what I read last night." You'd show somebody where it was. Judith, one of the few heroines—one of the few women even named in the Bible, has sex with King Holofernes, who was attacking Israel, and when he falls asleep she decapitates him. Simple as that. Similarly, there's an Old Testament account of a woman saving her husband from murder by grabbing the testicles of his assailant. But this turns out to be a tactical mistake, at least for her, because women aren't allowed that close to non-spousal loins. Her people are left with no other choice than to stone her to death, which they do. Maybe the guy wasn't enough of an enemy of Israel.

These stories and others added up to a chronicle of horrors that fed our shared suspicion that "religion" was hypocritical bullshit. What about love? The Prince of what peace? Of course love and forgiveness are well represented in the Bible, and that was the content that was mostly taught to us. However, they're mixed with, even overshad-

owed by, a misguided attachment to a culture dominated by male insecurity and human hubris (which is nearly *all* cultures, isn't it?). The tendency has not weakened with the passage of time. The current swelling wave of fundamentalist fanatics of various stripes invoke the ideals of wholesomeness, love, benevolence, sharing, caring, hugging, praying, all the while hewing tightly to passages in the Bible that appear to sanctify violence and hatred in order to justify messing with the lives of people the fanatics don't like.

This was the Christianity of my childhood, the slogging through church until we didn't have to go anymore, the groping of the Bible for juicy bits. Jesus instructs us to love, to seek the Divine in the everyday, to foment real peace and real freedom, to share bounty among the poor, and to challenge malevolent power even if it means placing yourself at great risk. Now and then we run across a human being who actually does that. They don't always identify themselves as Christian.

# 3

To this day I don't know if I graduated from high school. Grade twelve, which I did pass, was not the end. In Ontario at the time one could, and was encouraged to, take grade thirteen, providing an extra year of college-prep high school. I took the courses and wrote the exams but never went to a ceremony, never received a letter, don't recall seeing a diploma. Which was fine with me. I was glad to escape.

The arts, languages, history; these subjects I enjoyed, and found relatively easy to learn. I did not appreciate regimentation, ill will, and capriciousness on the part of some teachers, and all things mathematical. I hated being asked questions in class to which I could not give an answer. It was humiliating to be tittered at by classmates. I tended to retreat further into my private universe, and adopted a "so what" attitude toward the formalities of school. Once we were given a mandatory IQ test. Intelligence Quotient? The idea of it made me resentful, so I filled in the multiple-choice ovals in a random pattern down the side of the page, without even reading the questions. Whatever my score was, it wasn't bad enough to get me institutionalized. During the first of my two years in grade eleven, my attitude got me a score of eleven out of one hundred on the math final. The next year, on my second go-round, I scored almost three times better: thirty. After that, they didn't make me take math anymore.

Of course my parents were dismayed. They had strong academic backgrounds—my dad was a radiologist, my mom had been a medi-

cal lab technician—and they expected their children to do well in school. An education was considered the only road to a decent future.

They expected their three boys to attend college. When confronted with the idea of more school, I was horrified. There was nothing I wanted to be. I had no hopes or dreams that I recognized. I just wanted to hang out and play guitar. I said so. "What about music school?" they asked. I needed to pursue some form of higher education so I would "have a degree to fall back on," the logic went.

"Music school would be okay," I said.

I imagined, based on my formal piano and theory training, that the classical schools, Julliard, Oberlin, or the Royal Conservatory itself, would require a rigid, technical commitment. That was intimidating. It wasn't at all clear to me that I had the qualifications to get into those places. We were planning to visit Oberlin when I came across a reference in *DownBeat* to the fact that Boston's Berklee College of Music, which the magazine frequently lauded, was now offering a degree program. The sinking feeling in my gut began to abate. I pointed out the new information to Mom and Dad, and they went for it! I suppose they were so relieved that there was a program of study I would actually embrace that they got into it too. They had considerable skepticism about the life of a musician: smoky bars, no money, the company of those with low moral standards—an atmosphere that had a certain appeal for me. A bachelor of music degree, however, would allow me the safe prospect of teaching music in high school. Berklee it would be.

In the mid-sixties it had a solid reputation in jazz circles, but was not known much beyond that. Academic issues didn't matter a great deal to the Berklee administration. Robert Share, the registrar, was sufficiently impressed with my theory studies, including a book called *Composing for the Jazz Orchestra* by William Russo (Share said: "If you can make it through Bill Russo's book, you won't have any trouble here!"), to consider me qualified. They also may have noticed that my father would be good for the tuition.

It was clear to me that before getting locked into another educa-

tional regimen, I needed to travel, something bigger and freer than a family vacation. We'd had some good ones, but they were safe and controlled. I was all pumped up with the headlong trajectory of Kerouac and Ginsberg. I craved adventure. I needed to throw myself into something unknown, travel with only vague destinations, expose myself to the elements, sail the seas. I was already a wanderer in my mind; I wanted to be one physically. Without realizing it I was inaugurating a peripatetic life, sowing the travel seed deep in my psyche, where it would thereafter thrive. I was on my way.

At the Port of Montreal I hauled my duffel bag and an ugly-sounding but indestructible Stella guitar (nestled in a vinyl-lined canvas case my mother had sewn) aboard a small freighter (nine-thousand-ton displacement), which I expected to deliver me to Kristiansand, on the southern tip of Norway. At five in the afternoon we set sail, sliding through the languid June twilight into the St. Lawrence current, under the steel webbing of Pont Jacques Cartier and down the ancient passage toward the Gulf of St. Lawrence, the world's largest estuary. After a brief stop to pick up cargo at Port Alfred, near the north of the Saguenay (where we were boarded by customs agents who, on a pretext, confiscated or perhaps simply stole much of the crew's liquor supply), the ship sailed on to the Strait of Belle Isle, past the forbidding cliffs of Labrador and into the infinite, stormy Atlantic, reversing a journey initiated by Norse Vikings a millennium before.

The trend in shipping had begun to swing toward massive container vessels, but the *Mokefjell* was old school. In design it followed the pattern of previous generations of steel ships, with a central superstructure that contained the bridge, the officers' quarters and mess, and accommodations for twelve passengers. I liked the ship. It was graceful and fast, capable of twenty-five knots, and inherently romantic. Freighter passengers could fraternize with the crew, a seemingly logical contact that was disallowed on luxury liners, such as the one I'd been on during a family vacation a couple of years before. On the *Mokefjell* I was free to explore the ship, and in the process discovered

the cavernous, storeys-deep engine room. The chief engineer allowed me the run of the clanky steel ladders and precarious walkways. With its constant roar and throbbing resolve, and spare pistons the size of whales bracketed to the walls, the engine room was a massive display of industrial power even on this relatively small vessel. It wouldn't be long before giant container ships, with their thirteen-hundred-foot decks and "intermodal" transport boxes, would bully the tidy freighter into oblivion.

Canada Customs notwithstanding, there was still a lot of booze aboard. The sailors ate and drank almost constantly, as a preventive for seasickness, I was told. I followed their example assiduously, and it seemed to be effective. Gale-force winds buffeted the ship during the entire journey. The vessel pitched and yawed, waves frequently broke over and doused the decks, but I felt no discomfort. I made friends with Terje Holst, an oiler in the engine room. (The chief took it upon himself to warn me against this, as in his opinion Terje did not come from a very good family and was likely to get me into trouble.)

One night my new friend invited me to drink aquavit, a vodka-like Norwegian beverage, with him and his mates in his four-man cabin in the sterncastle. After midnight, when the party wound down, I stumbled across the deck toward my quarters amidships. The wind screamed just as we slipped into a deep trough, and a great wave swept across the steel plating. When it passed, I found myself dripping wet, hung on the railing, my arms overtop and my feet stuck underneath. I felt only a small rush of adrenaline, but the awesomeness of my situation was clear. We were in deep ocean. The nearest land was two miles down. Even if someone had seen me go overboard, there would have been nothing they could do except write that sad letter to my folks. I dragged my soggy feet the rest of the way to my bunk. I was calm. I was so drunk it didn't even scare me. But the next day I thought about it a lot.

My cabin mate on the ship was a flamboyant man named Richard, a blustery German in his thirties who was going back to visit family for the first time since emigrating to Canada as a youth after the war.

He was travelling with his girlfriend, but in keeping with the moral imperative of the era, they were not allowed to share the same quarters because they were not married. This arrangement upset both of them, and I had to listen to a fair amount of grumbling. The girlfriend was Eastern European, older, in her fifties and self-conscious about it. Richard was shipping his 1956 Lincoln Premiere convertible back to Germany so he could show off his Canadian success to the relatives back home. He may have also wanted to wind it out on the speed-limitless autobahns, but he would have to navigate some pretty tight roadways to get to them from Norway. When we docked at Kristiansand, Terje and I caught a harrowing ride with this odd couple along Norway's narrow mountain roads (where an oncoming bus almost finished the job started by that wave) to Oslo, and a warm welcome by Terje's parents to their home. Fru Holst was very sweet, but insisted on adding a syllable to my name—*Bru-seh*—because Bruce sounded like Brus, which was the name of a popular soft drink.

Terje and his father took me around. I have a vague memory of eyeing an enormous ski jump built for the recent Winter Olympics, but what made a deeper impression was the visionary Vigeland Sculpture Arrangement, one of the great wonders of human creation: 212 beautifully executed sculptures of robustly healthy humans, all of them nude, appearing to thrive on life itself in an eighty-acre section of Frogner Park, Oslo's largest public space. The sculptor, Gustav Vigeland (who also designed the Nobel Prize medallion), began installing the sculptures in 1939, one year before the Nazis occupied Norway. The project was completed in 1947. His sculpture garden might best be viewed as a war memorial, commemorating man's regenerative spirit.

The Holsts owned a cottage on a pretty lake in the wild and densely forested Holmenkollen area north of Oslo. We travelled there for a weekend, bought two cases of beer, and ended up drinking it all with a hulking handyman who at first glance presented a frightening mien until you realized he was harmless in the way that a Doberman is harmless enough to its owner. He had massive hands that looked like

they could punch through steel plate. Terje described him as "a really good guy who doesn't do well in the city," owing to fights and other such troubles.

In due course Terje's father repaired to his bunk, leaving me and Terje and the big guy chatting at the table. While the dad snored and farted, we philosophized about the existence of God in the way young people do when they've been drinking all that beer. Terje translated for me and the hulk. At a certain point he said, "This is really weird. I don't know what's going on here, but I'm not having to translate. You guys are understanding each other without me having to do anything." Our friend would say something in Norwegian and I'd respond in English, but it was the appropriate response, and vice versa. It was my first encounter with that aspect of alcohol—the telepathic, or perhaps empathetic, factor. It wasn't the only time I have experienced it, but it's probably the most memorable.

Leaving the Holsts', I took a train through the marshlands from Oslo to Stockholm, across the Scandinavian Peninsula, which is the largest peninsula in Europe, and edged along Lake Vänern, the biggest lake in Europe outside Russia. (It was here around the year 530 that the Swedes and the Geats fought each other on horseback in the Battle on the Ice of Lake Vänern, as described in the Norse sagas and in *Beowulf*.) The journey took a day. I was met at the station in Stockholm by Per Fagerholm, a young man my age who had visited Ottawa the previous summer, which is when I met him, through our mutual friend Bob Lamble. I don't recall if it was my parents' idea or mine, but somehow it was decided that for my post–high school adventure I should travel to Scandinavia and visit Per. Sounded great to me. When I finally got there, the Fagerholms welcomed me to their Stockholm apartment and I stayed a couple of weeks.

When we weren't spending time with his family, Per and I went to parties and clubs. We especially enjoyed Stockholm's folk music venues, the most interesting of which were carved out of mothballed Baltic fishing boats moored along the jetties in the older part of town. One night I stayed out very late at one of the boat clubs, exchanging caresses in the shadows with a girl I'd met at a party some days ear-

lier. She called herself Miss Sand. She had befriended me out of pity for my inability to follow the flow of Swedish conversation. As with most of the Swedes I met, her school English was very good. She was pretty and gave me the time of day, and I became desperately enamored of her. I spent as much time as I could in her company, hoping with equal desperation to lose my virginity, by which I felt greatly burdened. On this particular night Per went home around midnight, but I lingered with Miss Sand, eventually making my way on foot, some hours later, toward the Fagerholms' apartment.

At that lonely hour the waterfront took on an edgy, slightly dangerous atmosphere. Per's place lay about forty-five minutes away. The night was unseasonably cold, even for that latitude, and I burrowed into my borrowed overcoat. I was stepping briskly across one of the city's many bridges when a solitary car approached. I was aware of a man's sallow face, obscured by reflected streetlight, behind the driver's window as he passed. I didn't want to make eye contact, but when I heard him make a U-turn I knew I was in trouble even before he pulled alongside to keep pace with me. The imagery of this encounter remained vivid, so that more than thirty years later I rendered it into the first verse of "The Charity of Night," the title cut from my 1996 album of the same name. The song is an audio triptych that connects three formative events of my life during a thirty-year period, shaped into the abstraction of a love story. People have asked me to elaborate on the predator on the bridge, but I have declined. Let it be known, however: no shots were fired.

> *Big city Europa—July of '64—It's 5 A.M.*
> *Weather blowing bitter off the Baltic.*
> *Car slows beside him as he walks*
> *Hubcaps slow revolution*
> *Jaundiced-looking pockmarked face, round in window*
> *Short greasy black beard*
> *Couple of language stabs settle on English*
> *"It's cold—I give you ride.*
> *Don't you want to kiss me?"*

*This goes on halfway across the cobbled bridge*
*Driver pulls ahead—gets out by the construction fence*
*Ambles toward him rubbing the bulge in his pants*

*In his jacket is the revolver*
*The hand is already in the pocket for warmth and fingers*
*slide easily*
*around wood grips*

*Slow as that predator's footsteps the gun comes out*
*Arm straightens, sight blade bisecting yellow forehead*
*Wind—*
*blue metal streetlight—*
*Faint twilight shining*
*on the corners of stones*

*Wave on wave of life*
*Like the great wide ocean's roll*
*Haunting hands of memory*
*Pluck silver strands of soul*
*The damage and the dying done*
*The clarity of light*
*Gentle bows and glasses raised*
*To the charity of night*

"THE CHARITY OF NIGHT," 1994

It was time to get out of Stockholm. Per and I hit the road south-ward, thumbing our way through Copenhagen to Bremen, then to Amsterdam and Brussels, thence to Paris, where danger also lurked. You wouldn't have known just by walking around that the city had recently been a war zone, and although I'd heard stories of bombings and other disorder, I hadn't given it much thought before arriving. The Algerian revolution against colonial France had ended two years

before, but attacks from both sides remained commonplace. The French, who had occupied Algeria since 1830, were still on edge.

All wars are brutal, and the French fight to quell the Algerian revolution—which, perhaps not coincidentally, began the same year (1954) that Vietnamese forces pulverized the French Far East Expeditionary Corps at Dien Bien Phu—was particularly vicious. The war lasted eight years, and both sides, but especially the French, tortured and terrorized thousands of people. Nearly one million lives were lost in all, most of them Algerian, and almost all of the fighting occurred in that huge desert nation. (Algeria is the largest country in Africa.) But the Algerian National Liberation Front also routinely carried out attacks in France, and the French killed Algerians in France as well.

In 1961, just three years before I made the city's acquaintance, the head of the Paris police, Maurice Papon, ordered his officers to attack a protest march of thirty thousand Algerians. Large numbers of demonstrators were herded into the River Seine. Some were thrown from bridges. Many drowned. Many more were simply shot after being transported to police headquarters. Some two hundred Algerians died in the police massacre. (Before becoming the Paris police chief, Papon was a prefect in northern Algeria, where he acquired a reputation for torturing prisoners. And before that, during World War II, he deported at least sixteen hundred Jews from France to Nazi concentration camps, for which a French court, in 1998, convicted him of crimes against humanity.)

In 1962 French President Charles de Gaulle signed an agreement granting Algeria independence and ostensibly ending the war. But the Organization of the Secret Army, or OAS—a violent paramilitary group dedicated to keeping Algeria in French hands—responded to the agreement by trying to kill de Gaulle. In August 1962 de Gaulle, a military hero of World War I and World War II, survived a machine-gun attack in a Paris suburb. The OAS kept at it, gunning for de Gaulle three times in 1963, five times in 1964, and three more times in 1965. They never got him.

PAR AVION
PER VLIEGTUIG

BELGIQUE-BELGIE

EXPRES
SPOEDBESTELLING

Dr & Mrs. D.W. Cockburn
479 Highland Avenue.
Ottawa 13, Ontario
CANADA

EXPÉDITEUR (Nom et adresse) :
AFZENDER (Naam en adres) :

Brussel Cockburn

Hi: here I am in Brussels. And here I have enough room + time and the rest of it to write a letter. Man, its going to be nice to get home and have a bath! We've been sleeping in fields, on kitchen floors, livingroom floors, and in cars hitchhiking, all for nothing so I still have stayed in a youth hostel. I don't know how much I told you in my last postcard but it wasn't much so I'll tell you a little more now. We left Stockholm quite early (about 7 A.M.) and got a ~~few~~ few rides halfway to Hälsingborg, where we had planned to cross into Denmark. ~~there we~~ Our last ride that day was with ~~a~~ truck drivers, so there were 4 people plus our luggage in the cab of the truck. The highway police saw us so we had to stop and get out right in the middle of nowhere. It was raining so we went under some trees, spread out Per's plastic groundsheet and slept. We got a ride next morning.

When we finally got to Copenhagen, we stayed there 2 days and slept at night in a dirty cold-water flat owned by a Danish artist. There were about 20 people in 2 rooms 10 ft.² each. We were on the floor in the kitchen, which was about the size of a large telephone booth. In the daytime we went around with the same crowd (2 Americans, 4 English, 1 Swedish, Danish, French, and assorted other things) and saw most of the city. Its beauty is greatly overrated but it is nice. The 2 Americans and I sat on the street and played for pennies and placed a hat (which was mine) on the pavement. We soon had a crowd of about 150 people who were dropping coins in the cap. The day before, the Americans had got a bar of soap with their money. We went on from there to Amsterdam where we met a kid whose parents were away and we slept at his house. Here in Brussels we went to a party at the home of Derroll Adams, an American folksinger — contemporary of Woody Guthrie, Leadbelly, etc. — and stayed there the night. I also made enough for a meal playing in a bar with an English blues-singer. All things go as below; never underestimate the power of a guitar, without it all my money

would be gone on places to sleep. We've been living on one meal a day, and sometimes no meals — only a snack. Which brings me up to now. I'm going to take the train to Paris, on the 23rd in a Sunday (office closed) and in the summer the office is also probably closed on Saturday the 22nd, Which means I have to be in Paris on Friday to be sure of my ticket and I would appreciate it greatly if you could wire about $20.00 to the Am. Express office in Paris, because I might have to stay in a hotel there or something, and food is quite expensive, besides not being able to afford to see Paris. I'm going to try street-singing there, too, but I don't think I'll get much money, there's too much competition and people are very unsympathetic. In Amsterdam I got nothing at all.

Well, now I've got to go and get my train ticket (there are no buses or I'd take one of those to Paris)

Bye for now,

Bruce

(I am not only the greatest I am the supreme).

Tensions still rippled just below the city's surface when Per and I descended on Paris. Locals warned us never to run from the police or we'd be shot. An Irish guy we met on the Left Bank had just come from visiting his travelling companion in the hospital. A gendarme had asked the man for his papers, and when he reached into his jacket for his wallet, the cop thought he was going for a gun and shot him in the stomach.

You'd be walking down some street and suddenly all around you would be a rustle of something like apprehension—a gust of unseen energy. You could feel it coming. All at once an entire block would be lined with steel crowd-control fences, placed and manned by a line of blue uniforms blocking the view of the road. This would happen in minutes. The roofs of a caravan of black sedans would hurtle past: de Gaulle or someone else of grave importance moving through the city. As soon as the vehicles were gone, the steel barricades disappeared and the atmosphere would slip back to its normal hum.

We weren't there to cause trouble. Like the many transient young people, from a variety of countries, hanging out along the quays beside the Seine, we wanted to see the sights, play some music on the streets, have some adventures. Our concept of adventure was not quite in sync. Per was more energetic, interested in something like sightseeing, while I preferred to lie around by the river, socializing and drinking and shouting insults at the passing tourist boats. Per and I drifted apart. Or I drifted away from him. We had spent weeks on the road together, but when it came time for him to leave I was reclining on the stone quay by the Seine, too full of cheap wine to even get to my feet and say a proper good-bye.

I met up with an American named Brian who played clarinet and was on summer leave from the Peace Corps in Ethiopia. Brian had been busking with a French guy who played trumpet. They played trad jazz as a duo, but someone rounded up a six-string banjo for me to borrow (because it was loud enough to compete with the clarinet and the trumpet), and suddenly we were a trio. There we were in beautiful, romantic Paris, playing a mixture of jazz and ragtime and

bluesy rock and roll. I couldn't have felt more cool. The problem was that at that time a permit was required to perform on the street. The permits were reserved for the *clochards*, Parisian street people. Of course we had no permit, and the police had already chased my compatriots out of every *arrondissement* except Montmartre. So that's where we went.

Montmartre was a famous red-light district and artists' colony in the later nineteenth and early twentieth centuries, though it had been gentrified by the time we got there. It was a tourist's delight, and tourists love buskers (or so we liked to believe). We planted ourselves on the wide white stone staircase near the top of Paris's highest hill, below the Sacré Coeur Basilica. It was a beautiful summer night and the place was packed with people, foreigners as well as locals. We played a couple of Jelly Roll Morton songs, then switched to something more up-tempo as a lithe young gay guy in a sailor suit danced the Charleston. I reveled in the romance and freedom of the moment. But it was only a moment. Out of nowhere, three grim-faced men in casual clothes materialized in front of us, and one of them demanded, "Let me see your papers."

"Who the fuck are you?" It was just these three guys standing there, no uniforms. They could have been from Amway or the Elks Club. Of course, they weren't. The short one turned away, and I noticed that he had what looked like a Smith & Wesson .38 sticking out of the hip pocket of his jeans. The trumpet player elbowed me hard in the ribs. *"Ils sont des flics,"* he said. "They're cops."

The cops demanded we haul our permitless butts with them to the Montmartre police station. They acted as if we'd committed a serious infraction and there would be a price to pay. The nervousness I felt at that moment was compounded by the presence in my pocket of a switchblade, picked up somewhere along the way, that I became very conscious of. It wasn't very big, but at that moment it felt like a plantain bulging in my corduroys. Brian had a small quantity of marijuana in his clarinet case. The police station was right out of Dodge City, a large room painted a time-darkened institutional green, with

a reception counter on the street side. On the wall behind it hung the cops' gun belts, a nice touch. The opposite wall was made up of bars, demarking a holding cell where four battered-looking old hookers occupied themselves exchanging shrill jokes and insults with the police. They reminded me of the witches from *Macbeth*. I had visions of being thrown into the cage with them, but it was not to be. After maybe an hour of standing in front of the counter, being questioned intermittently, we were told by the desk sergeant, "Okay, you can go. Get out of here, and don't let me catch you at this again."

There were other episodes: a dawn flight from the construction site in which we were sleeping, to avoid discovery by the foreman arriving early for work; narrowly escaping being mugged by an organized gang of North Africans preying on travelling youth; being rescued by a Dutchman from a beating at the hands of a Nigerian boxer who fancied Marie from Manchester, whose company I was keeping. But it was the end of our busking that signaled the end of my first European adventure. Much later there would be many more, with appearances by cops, machine guns, rioters, nuclear radiation, and some really great audiences.

I had mixed feelings about going back to Canada. I wanted to stay in Europe, but I couldn't do it without money from home, and the folks were adamant about the higher education thing. And I was hungry. A Scandinavian menu consisting primarily of fish (I didn't like fish), and a European diet diminished by simple lack of funds, conspired to relieve me of about forty pounds of body weight. That felt pretty good. It contributed to the shock value, though, when my parents met me at the plane in Ottawa. The clean-cut boy they had last seen in Montreal had been replaced by a rumpled, unshaven, shaggy-haired monster. The dismay on their faces was palpable. I landed back home in September 1964, but I didn't stay there long, just enough to revel in the roast beef dinners with pie and do a bit of quiet boasting to the Le Hibou gang about what I'd gotten up to. Then Dad drove me to Boston with a carload of clothes, bedding, the portable record player he'd given me, and a guitar.

*Oh I have been a beggar*
*And shall be one again*
*And few the ones with help to lend*
*Within the world of men*
*One day I walk in flowers*
*One day I walk on stones*
*Today I walk in hours*
*One day I shall be home*

*I have sat on the street corner*
*And watched the boot heels shine*
*And cried out glad and cried out sad*
*With every voice but mine*
*One day I walk in flowers*
*One day I walk on stones*
*Today I walk in hours*
*One day I shall be home*
*One day I shall be home*

"ONE DAY I WALK," 1970

# 4

When I got to Berklee the school was nineteen years old, and so was I. I went there expecting to become a composer of jazz music. I wanted to write for big ensembles. I never got the chops together to be much of a jazz player, especially at that nascent stage. Today if I had to describe my playing technique, I would say it's a combination of country blues fingerpicking and poorly absorbed jazz training. Basically, the right hand is playing country blues and the left hand is using techniques and harmonic notions acquired at Berklee. But that's a generality, as I was and remain easily sidetracked into other directions. One of the reasons the jazz was poorly absorbed is that I got absorbed in Boston's thriving folk scene, in addition to putting as much time into reading and trying to write poetry as into practicing scales. Another reason is that I was a lazy and undisciplined student.

My time at Berklee was short but wide. I did study jazz there, primarily in the form of learning to play scales and, to a limited extent, to improvise. To this day I'm still not much good at the kinds of chord changes that jazz people are expected to be able to play over, though I can improvise convincingly enough when I don't have complex harmonic structures to deal with.

Among the riches I encountered were Indian and Arabic music, which the jazz world was beginning to explore, and which didn't employ harmony in the way the music I had grown up with did. This

was music that was more about rhythm and linear motion than vertical structure, an approach that resonated with me, as did the modal music of medieval Europe.

During these early explorations of sound I began to feel a kind of geometry, a sort of architecture, in the music itself. This sensation remains with me today. It jumps out of the playing of Keith Jarrett or Thelonius Monk, or Erik Satie's piano pieces, but the geometry exists in other music as well. When I first became aware of this physical, structural manifestation of the music, it appeared like a mountain range rising from a prairie, or a building in an urban skyline: angles and movement and sonic shapes formed against a flat plane.

On my second album, *High Winds White Sky*, is a song called "Let Us Go Laughing" that might be a good example of the mixing of styles that I was pursuing. The right hand is my picking hand, the blues hand, and I'm playing in a style that would be recognizable by Mississippi John Hurt or the Reverend Robert Wilkins. They would look at my right hand and see the thumb playing an alternating bass with the fingers playing melodic notes overtop and know what I was doing. But the left hand, the fretting hand, is doing something that owes more to jazz or to early European music, the stuff I was absorbing in the sixties.

*My canoe lies on the water*
*Evening holds the bones of day*
*The sun like gold dust slips away*

*One by one antique stars*
*Herald the arrival of*
*Their pale protectress moon*

*Ragged branches vibrate*
*Strummed by winds from o'er the hill*
*Singing tales of ancient days*

*Far and silent lightning*
*Stirs the cauldron of the sky*
*I turn my bow toward the shore*

*As we grow out of stones*
*On and on and on*
*So we'll all go to bones*
*On and on for many a year*
*But let us go laughing—O*
*Let us go*

*And may the holy hermit's staff*
*On and on and on*
*Guide you to the shortest path*
*On and on for many a year*

"LET US GO LAUGHING," 1969

Boston itself left at least as sharp, and long lasting, an imprint as Berklee did. The region's live music scene was robust and inviting, a ground zero for folk music. We frequented a place off Harvard Square in Cambridge called Club 47. In 1959 a teenage Joan Baez had played there and made it clear that a young and insistent form of folk music was about to take hold in this old eastern city and spread to the four directions. Bob Dylan cut his chops there in 1961, and Bonnie Raitt is said to have attended Radcliffe College in Cambridge so she could live near Club 47 in 1966.

When I think about sitting in a place that had an association with Dylan, I'm reminded of the impact he had. I tend to be influenced creatively by everything I hear that I like, but Dylan remains the songwriter who has had the greatest effect on my music. When *The Freewheelin' Bob Dylan* hit Ottawa in the summer of 1963, our little group of folkies all had to learn "Don't Think Twice, It's All Right," "Blowin' in the Wind," "Hard Rain," and "Masters of War":

these are brilliantly written songs that were shaking not just our world, but *the* world. When Dylan went electric, he did it again. At the time a few folk purists moaned about how they'd been let down by Dylan plugging in, but the rest of the world got it. *This was an electric moment!* And I don't mean the guitar. By this time Dylan's songwriting had evolved to its most masterful level. "Desolation Row," from *Highway 61 Revisited*, came out in 1965, and in my mind it remains one of the best songs ever written. The following year Dylan released *Blonde on Blonde*, with "Visions of Johanna" and "Sad Eyed Lady of the Lowlands." No one has ever written songs better than these. The influence I got from Dylan was less stylistic than it was motivational: *Look at what you can do. Look at how broad the field is; you can do any damn thing. You can be as wordy as you want.* I've always liked words.

At Club 47 (now called Passim) I heard Tom Rush, a pioneer among the young, educated whites interpreting traditional, often rural music and applying it to their writing. In early 2012 Rush told *The Boston Globe*, "The thing that strikes me about that whole time period is just how much ferment and cross-pollination there was between the different artists. Really good art very seldom arrives in a vacuum. It's almost always a bunch of people in communication with each other and basically stealing each other's ideas and then expressing them in a different way." I also frequently attended shows by the Jim Kweskin Jug Band, and Taj Mahal would sit in. Taj dressed like an R&B dude in those days, decked out in a sharply pressed suit for blowing marvellous harmonica.

Bill Monroe, Eric Anderson, the Chambers Brothers, Jesse Colin Young, Sleepy John Estes, and Mississippi John Hurt all played at Club 47 or the Unicorn, the other major folk venue in town, which was only a block from where I lived in Back Bay. In the clubs on Charles Street you could hear Spider John Koerner and a range of lesser but interesting lights. I appreciated the music and manner of Buffy Sainte-Marie, a Cree Indian and fellow Canadian. She was a knockout visually. She had not yet had the hits that would later be

hers, but still she swept away listeners with the power in her music. Buffy accompanied herself on guitar or sang a cappella. She also played the mouth bow, which is possibly the oldest human instrument, as seen in fifteen-thousand-year-old cave paintings. Buffy once said in describing the instrument: "[It] is basically a hunting bow and I guess somebody one day figured out that you can make music on a weapon. Maybe someday there will be virtuoso concertos to be played on M-1s and tanks."

Buffy Sainte-Marie celebrated her Native heritage. Her songs and onstage comments touched on the struggles faced by aboriginal peoples. This was the mid-sixties, before Wounded Knee, before urban Indians joined the American Indian Movement and gathered at outlying reservations to serve and protect their ancestral communities, before Leonard Peltier was illegally extradited from Canada and railroaded into a life sentence in prison for a crime he almost certainly didn't commit. Buffy was among the first "popular" First Nations people to speak out. While I was touched by her story-songs and tales of growing up Native in Canada, I connected more with the historical than the political. It seemed like a "cool thing" she was doing. I didn't get the true significance of her stories until the early seventies, when cross-Canada travel put me in direct contact with the stuff she was singing about. I wasn't paying attention to politics. I didn't like or trust the political world. I still don't, though I did learn to pay attention.

Club 47 held weekly hootenannies. I attended many of these, though I never had the nerve to perform, and enjoyed the successes and failures of all manner of lesser-knowns and unknowns, of varying degrees of musical prowess. All the guitar players seemed to be vying with one another to play something new and impressive that only they could do. Some were insecure about their special techniques and reluctant to share them. One guitar player who would show up sometimes was so afraid of having his licks stolen that he performed with a handkerchief draped over his fretting hand so no one could see what he did. What he did was not that interesting. Gossip swirled around who had stolen what riff or song idea from whom.

On the jazz front, I was privileged to hear a lot of the artists whose music I admired. Around the corner from the school was a club called the Jazz Workshop. I soaked up performances by John Coltrane, Roland Kirk, Mose Allison, and Chico Hamilton among others. I had interesting classmates, too, including guitarist John Abercrombie; Dave Mott, who went on to become head of the music program at York University; and Joe and Pat LaBarbara.

I became friends with a guy named Ed who lived a few doors down from me. We called him Dr. Death because he always wore the same black suit, which had been worn shiny at the elbows, and he was skinny with a bony face and bad skin. He was a really nice guy, a pretty good tenor player. He was quiet and unassuming till he picked up his horn. He played with real fire. He and I used to get together to do Amphex now and then—a nasal inhaler offered over the counter as a cold remedy. Someone discovered, and Ed taught me, that you could break open the plastic tube and remove the tightly wadded cotton cylinder from inside. That would then be cut into aspirin-sized pieces with a razor blade. If you swallowed a couple of those with a cup of coffee, you got a jaw-grinding speed rush that would last hours.

There we would sit, Ed and I, synapses firing madly, talking long and fast, our heads full of a million constantly shifting images. For me it felt as if the whole wheel of life was slowly revolving in my brain, crowded with everything there is. There would be new insights, connections made between things with startling clarity. The insights and connections seldom stayed around after the inevitable crash and the comatose sleep that followed, but as affordable entertainment Amphex was hard to beat. It had to have been hard on the body, but we were young. . . . Eventually the recreational use of the stuff became so widespread that it was withdrawn from drugstores, according to rumour by order of President Lyndon Johnson himself.

Joe Livolsi, a drummer friend who lived down the street in a basement pad, hosted Free Jazz jam sessions on Saturday afternoons,

fueled by cheap wine and Amphex. The regulars included Tom Jones on bass; John someone, also on bass but doubling on cello; and, in time, me. We would be joined by anyone who felt like sitting in whom we considered cool. I'm not sure why I was considered cool enough, but apparently I was. It may have been the connection with Dr. Death. John, the bass player, worked in a pharmaceutical supply warehouse. We mostly knew him as Poppa Pill. Ed would show up with his tenor. A trumpet player named Bobby, who had beautiful tone, would appear from time to time.

I had no idea what I was doing. I loved the frantic energy and absence of form. Every time we played, it felt like a journey into an unknown wilderness. By turns moody, ominous, light-bathed, and triumphant, the music would cascade over itself. Somebody would start to play, a note or a little riff of some kind, and the rest would fall in as inspired. Sometimes we'd decide on a key, but mostly it was pretty random. I had the notion that it would be interesting to align our feelings and mental imagery before launching into the music. I read aloud a poem I'd written about the wind. When I finished reading, we started playing, and the result was pretty satisfying. I think we all felt the exercise was successful, but I don't remember repeating it. I don't think I wrote another poem with enough to it during that semester, which was my last at Berklee. One Saturday, as darkness fell outside and our session wound down, I looked at myself in Joe's bathroom mirror. Under the fluorescent light I was struck by the ugly contrast between the purple veins that seemed to stand out in my eyeballs and the jaundiced pallor of my skin. This had to be the end of the wine and speed adventure. . . .

Although I wasn't there long, there's no question that Boston expanded my horizons in useful ways. In addition to the opportunity to hear some of the best jazz and folk music around, I was approached, while playing on the front steps one day, by a short, wiry young man named Doug Grossman who had some friends at MIT who were working on the Apollo Project—the moon shot—on the side. Their real gig was as a fledgling jug band, which I was invited to join. Book-

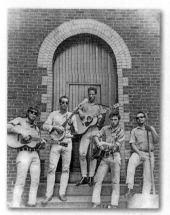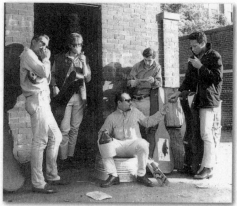

*The jug band, later known as Walker Thompson & His Boys, Boston, 1965*

ings were few but we didn't mind, as we enjoyed playing an eclectic repertoire of blues, Appalachian ballads, and jug band versions of Rolling Stones songs.

(Caveat: I use "enjoyed" as a figure of speech. I didn't allow myself to enjoy. In my mind life was too serious and weighty to actually be "fun." This outlook set in toward my teens and didn't dissipate for the next thirty years.)

The jug band played one outstanding gig. Band member Rick Metzinger owned a Pontiac Grand Prix, which had plenty of room for the 421-cubic-inch V8 engine, but the car itself was kind of tight, crammed as it was with our gear and the five of us as we sallied forth to Ottawa for a homecoming of sorts at Le Hibou. My parents put everybody up at their place. After much debate on a name for the band, we came up with exactly nothing (which, looking at it now on the page, could have served us well as a band name), so the club billed us as the Boston Five Jug Band. We played a five-night stint. Mom and Dad enjoyed their gang of guests, and everyone got on well. At the end of the week, my parents sat through the show. They made polite sounds about it, but much later they told my brother, who then told me, that however much they liked the music, they found our stage presence so amateurish that they were embarrassed. They were afraid to come to see me play again, and didn't for the next five years.

James Walker Thompson was the lead singer of the jug band, and during my one summer in Boston I stayed in an empty room at the frat house where he lived. Together we became acquainted with a warm and effervescent young singer named Zaharia, Zack for short. She was gifted with a precocious voice and an appealing form. Her ragtime repertoire and guitar work were entertaining. She was beautiful, and I was quite taken with her. So was Jim. Where I was awkward and withdrawn, Jim was confident and handsome, a muscular mix of African American and Native American. Guess who got the girl.

On the night that happened, I sat in my third-floor room in the frat house quaffing tequila, looking at the wall and listening to it transmit the creaking and moaning of Jimmy and Zack getting it on in the next room. I grew increasingly fixated on the dark rectangle of the open window, and the space became black wings slowly beating. The wings were an invitation. I pictured myself floating past the frame and descending through the warm summer air. Reason won out, and in the morning the tequila was gone, I had an atypical hangover, and we were all still friends.

Some weeks later Zaharia and I took the subway to Cambridge to see Roman Polanski's movie *Repulsion*. It was the first English-language film for the incisive Polish director who would later create *Rosemary's Baby* and *Chinatown*. Peter Hall had seen the movie and recommended it, casually describing it as the story of a woman slipping into schizophrenia. I spent much of the film in a shivery sweat. Nasty things I hadn't known were lodged in my core came alive as the film infiltrated my psyche. I could hardly breathe when Catherine Deneuve, in the role of a young esthetician losing herself in madness, found her apartment walls cracking around her, the hallway a gauntlet of groping arms, her bed a place of terror.

I left the film feeling that a spot that was previously left blank, or at least darkened, on my psychic map was beginning to define itself. As we exited the theatre onto Massachusetts Avenue, I turned to Zaharia and told her that I now understood that I was paranoid. I

don't remember her response. She seemed to take it in stride. (Since then the film has remained with me. In 2005 I bought the DVD of *Repulsion*, but I still haven't had the nerve to watch it.)

Somewhere around this time I encountered the first of several women who, over the course of a half-century, would joggle my impression of the world. Since those student days, some of my most significant milestones and changes in direction—especially within the realm of my relationship with the Divine—have occurred because I was open to its feminine aspect in the form of friends and lovers. Relationships with women would in large part guide my evolution as a human being. At the risk of sounding trite or clichéd, I wouldn't be the person I am today; wouldn't have journeyed to whatever depth of the spirit I have reached; and might have frequently floundered, shipwrecked and alone, on the psychic shoals that surround the obdurate loner had it not been for the women who have blessed me with their company, their wisdom, and their trust, thereby prying me loose from myself.

Decades later I have forgotten how we met, but she was a girl who would give *me* the time of day, which right away set her apart from the rest. Dark-haired, brown-eyed, and intense in a good-humoured way, she was self-conscious about what she considered to be her wide shoulders. I don't know . . . maybe they were a little wider than most women's, but she looked pretty good to me. She introduced herself as Red Devil. She said she was a member of the Native American Church. As such, she was able to participate in ceremonies in which peyote was taken as a sacrament. She also informed me within minutes of our having met that she was a witch. We began to spend time together. She was in the process of breaking up with another Berklee student, a drummer named Bobby who was older than I and part of an elite group of advanced players who actually landed gigs. He was not in favour of the breakup, and when I came along he was especially not in favour of me. If we happened to find ourselves in the same room he would scowl at me, baring his teeth.

My pattern at the time was to make a nightly pilgrimage to the

gas station around the corner and coax a Coca-Cola from the vending machine. For weeks I hadn't been able to sleep without downing a bottle of Coke. One week, though, something unexpected came to call. As my eyes closed I felt a tidal wave of fear wash over me, a whirl of nameless dread, like a drunk's vertigo. I opened my eyes. The feeling vanished. The moment I closed them again, it was back. I felt myself gripping the edges of my mattress. Eyes open, I lay staring at the springs of the bunk above. The room was darkened to the shade of urban night. Dim light filtered in around the blinds. Calm. The air cool. Eventually fatigue triumphed over both fear and light, and I fell into the black pit of sleep.

This continued for six nights in a row. The seventh morning, as with the others, I felt fine except for the nagging depression that went with being eighteen. Breakfast . . . I'd begun to like oatmeal, which used to make me vomit, even the smell, when I was little. Now it was the most palatable offering the Berklee cafeteria could come up with. There followed an arranging class, a guitar lesson learning scale fingerings and flat-picking technique, and later in the day some more theory and an English class, one of the two or three "academic" courses that were added to the school's curriculum to allow it to confer degrees. I was one of a very few students who appreciated those non-musical classes. I didn't especially appreciate having to play with a plectrum, but it was explained to me at the first lesson that no one on the faculty knew how to play finger style, so I would have to go with the pick.

In the early evening, back in my second-floor dorm room, the pay phone in the hall downstairs began to ring. It was for me. I knew that after one or two rings, as I always did when the caller was Red Devil. Whoever answered the phone called out my name. "It's for you." He was surprised to see me already coming down the stairs. "I know. Thanks." Her voice was cheerful. We hadn't spoken for a few days. When I told her about my nightly terror episodes, she took it far more seriously than expected. "That son of a bitch!" she said. "Who?" "Bobby. I'm coming right over."

It was late spring and the evenings were long. Red Devil arrived and led me to the Boston Public Garden.

"What are we doing?" "Gathering some things to make magic with." Her eyes scanned the grass, coming to rest on a short three-pronged twig. This she picked up. Next it was three white feathers, downy curls from under some bird's wing. With a Swiss Army knife, she cut small slots in the ends of the twig. Into each slot went a white feather. "C'mon," she said, heading for the subway. We travelled to a street I didn't know. She peered around, taking in scene and situation. Apparently all was clear, as we crossed to where a row of well-kept townhouses lined the block. At a grey painted door she handed me the device she had constructed. "Put it in the mailbox." I did. She grabbed my hand and we jogged back to the train, then back to Back Bay.

Curious. *What did we just do?* "It's like voodoo," she said. "Bobby's been sending you that fear. Now you're sending it back. Let's see how he likes it!"

I'd read about things like this. Fascinating to see it up close. I had no expectations. I liked that she wanted to help. I wasn't totally sure I believed that Bobby was responsible for what I'd been feeling. But lo! The fear was gone that very night and never came back. A couple of weeks later I was strolling down Newbury Street on a sunny afternoon and here came the drummer, striding straight at me, heading toward Massachusetts Avenue. He gave me a slight jolt of panic, but about thirty yards out he spotted me, stopped, then quickly scuttled across the street, fear pulsing over his face.

Red Devil . . . she had some stuff going. My sense that there was more to life than the physical was strengthened knowing her. I was, for the first time as an adult, transported to a human realm outside the ordinary. Occult, mystical, spiritual: these are words I have used to describe the experience, but words don't do it justice. There is some deep element that binds us as physical beings to something that we call the spirit world, to the Divine.

And opens the door to power for better or worse. On one occasion we took refuge from a cold late-night downpour in a café on Mass

Ave. We were the only patrons until a thin middle-aged man in a leather windbreaker and brown fedora entered. He sat down a couple of tables away and called for coffee, pushing his hat back on his forehead. Pleasant face. Cheekbones casting hollow shadows in the stark overhead light. "Watch this," said my girl with an impish look and a little chuckle. She stared at the man, but quietly, so he wouldn't feel her watching him. He grasped the steaming cup that had been set before him, lifted it to his lips, but then put it down without tasting it. He did it again. The twinkle in Red Devil's eye evolved into a gleam. A dozen times the cup came up. A dozen times it was lowered without the guy taking a sip. A look of bewilderment appeared in the shadows of his face, as if he knew he was being strange but not why. Red Devil got bored or maybe felt pity. I felt the energy change as she let go. Our friend raised his cup yet again and this time completed the motion, taking a mouthful of his now somewhat cooler coffee. He shook his head, perplexed.

It was the sixties. A lot of us were becoming interested in possibilities beyond what we had been taught in schools and homes: the science, the morality, the subservience, as we saw it, to convention. There was a major folk club called the Unicorn a block over on Boylston Street. I used to hang out there and in my shy way got to know a couple of the people. There was a cute waitress, a tiny girl with long straight blond hair. Her name was Megan. She was friendly but kept to herself. One night at closing time we were talking and she revealed that she had fled Chicago after the coven of witches to which she had belonged held a ceremony in which they called up a demon to kill someone they didn't like. Soon after the performance of the ritual, the target fell to his death from his apartment balcony. Megan had not expected such an unambiguous result, and was frightened enough to sever ties with the coven and light out for Boston. She lived in fear that her former crowd, or whatever they had summoned, would find her. In my memory she seemed to right away regret having shared that piece of her history. Not long after that, she left the waitressing job and was gone.

Red Devil and I had hooked up in the spring. The following summer she was not around, having gone back to California till the fall semester began. We got back together when school started up again, but she got tired of the emotional numbness I wore like a flak vest over my fear of all things intimate, and drifted away. We lost touch.

Fifteen or twenty years later, she turned up at a concert of mine in Northern California. We had dinner together, and it seemed as if it could have gone further, but I was in a relationship and so we said good night and parted company. I never saw her again.

Sometimes the path we're on diverges from what we inherently, and now and then consciously, realize is our true direction. Call it instinct, especially for a young person who has yet to accrue the experience necessary for it to be wisdom, or intuition. In any case it is a knowledge that precedes and exceeds the conscious mind.

Increasingly I was haunted by a gnawing sense that Berklee and I were not meant for each other. I went there expecting to study fingerpicking guitar techniques. I had already become familiar with the flat pick before outgrowing my original guitar lessons, so I could deal with the situation, but it was a disappointment. I was able to hone my fingerpicking skills outside class, with the help of many players in the folk scene.

I was majoring in composition and I took my studies seriously, despite being an undisciplined student. In that era the classes were small—Berklee's entire population was only about three hundred students—and I got to know my professors. During my third and final semester I had an early-morning arranging class with a professor whose demeanour only intensified my desire to leave. James Progris was a gruff, sometimes hostile man in a tweed jacket who insisted on being addressed as "sir." He had no patience for tardiness, which was unfortunate for me because I was frequently late. In these moments Progris demanded that I stand by his desk at the front of

the class and state my excuse. I found this irritating. Eventually I was able to allow the sense of exposure and humiliation to roll off, but the idea that I needed an excuse always grated. I felt that there were no excuses, only reasons for things. One morning I told him I was late because I had fainted upon waking, which threw off my timing. His mien altered perceptibly and he sent me back to my seat. At the end of class he bade me stay.

"Why did you faint?" he asked. I told him that lately my encounters with food, as well as sleep, had been fleeting. Although my parents regularly sent cheques, I tended to spend all the money shortly after it arrived. By now I had probably gone a couple of weeks without a real meal. Occasionally I stole leftovers off plates in the restaurant across the street from my room. Once I bought a bag of potatoes and ate only those until they were gone.

In a quiet tone nothing like the one he used in class, Progris told me that if I was going to go without food, I should do it properly. He pulled a book from his briefcase and handed it to me with an instruction to keep it, read it, and learn how to fast without hurting myself.

His eyes were full of concern. I was bewildered. I didn't know how to respond to this act of kindness coming from a man who had been so off-putting. Of course, I also felt relief that I wasn't being kicked out of his class. I mumbled a "Thank you, sir" and walked out.

I still have the book: *The Autobiography of a Yogi* by Paramahansa Yogananda.

I was growing, learning a little about who I was, and absorbing a lot of music. The cultural life of Boston, the music school, the degree to fall back on: these were fine, even admirable objectives, only not for me. It was clear I needed to be somewhere else, doing something else. It was always going to be about the guitar, but it was no longer going to be about the Berklee College of Music.

I dreaded telling my parents that I was going to leave school. I wrote them a letter, and they took it better than expected. I didn't know exactly where I was supposed to be, but Boston, for sure, wasn't

it. If I ended up playing for change in the subway, so be it. *Here's the door. There's the cliff. Go through. Jump. Just don't forget your guitar.*

Leaving Berklee catapulted me into the next crucial, and completely unexpected, phase of my life. I couldn't have known it at the time, but that's what decisions are all about: each one leads to the next place, each step is connected with the others, and they don't always derive from intellectual machinations but rather from spiritual guidance that we may not even realize is in play.

What are instinct and intuition, really? Maybe they are the fruit of the whole human experience, handed down through the ages to provide us with crucial information that otherwise can't be written or seen or even properly stated. Maybe they are nudges from the finger of God. Leaving music school significantly shaped my life to come, and the decision to leave was far more spiritual in the making than it was intellectual.

Thirty years after I left Boston I would again work with a Berklee professor, now a dean, the brilliant vibraharpist Gary Burton. Gary is a six-time Grammy winner and one of the all-time greatest jazz artists, and he anchored and accentuated half of the songs on my 1996 album *The Charity of Night*. In 1997, in return for a valedictory address, Berklee awarded me an honourary doctorate in music, so I guess I finally graduated.

# 5

Ottawa welcomed me home for Christmas 1965 with a temperature of minus five degrees Fahrenheit and an invitation to join a rock band. I was warm to both.

Almost the entire population of Canada lives in a narrow hundred-mile-wide band, from the east coast to the west, as if we press ourselves as far south as possible to pick up an extra degree or two of warmth. In this way Canada is something like Chile: an excessively long, skinny nation of thirty-five million people (a number reached in 2012, when Canada's population became the fastest growing, due mostly to immigration, in the G8). But unlike Chile, Canada's shoreline is not the majestic South Pacific Ocean but the pounding tide of American influence.

It was a relief to return home. The extraordinary music scene I encountered in Boston was not enough to buffer the wartime and other tensions I felt from the American citizenry. Canada was calmer—I have always appreciated calm—but the rapid influx of Vietnam War–era draft dodgers and deserters (possibly up to one hundred thousand total) was bolstering Canada's already blossoming alternative culture.

Not that I paid much attention to it. I was withdrawn and anti-social, and the movements all around me were overt and inherently social. Even as I participated in the music, I watched the rest from a

distance. Today I pay attention to the news, and I address it in the songs I sing and comments I make at public appearances. But back in 1966 I believed, and did for a long time after, that music was somehow above politics, that art could be held separate from the mundane and tainted rest of human affairs. Growing up Canadian, we saw the United States as just something that happened to us, the same as racism and other historical and current ugliness. Especially in Boston, I would find myself at parties listening to student radicals rant about the kinds of injustice they were confronting. I found them boring and irritating. They seemed like myopic kids on a mission, and I didn't believe their tales of being persecuted, spied on, and set up. Lesson number one: It all turned out to be true. COINTELPRO and the like happened; they *were* being persecuted, spied on, and set up.

My sojourn in Boston revealed the promises and pitfalls found in abundance in the land of the free. Afterward, and especially beginning in 1969, when I began recording, my sense of identification with the concept of Canada, which had existed as a kind of unexamined assumption of belonging, actually grew. I came to realize that there had been forged in me what at first was an unrealized, and what remains an elusive, allegiance to the Canadian landscape, Canadian culture, and the people. This allegiance was not applied to business or government, though as the years unfolded I encountered some exceptions.

Canada has always been the most peaceful country in North America, though certainly not without its violent outbursts. Its genesis as a nation is embedded in a historical loyalty to the British Crown, which wrested Canada from France after the Seven Years' War (which might properly be thought of as the first "world war") that ended in 1763. As opposed to most other countries in the hemisphere, we developed henceforth with the emphasis on consensus rather than confrontation. That said, both Canada and the United States, each in its way, have decimated aboriginal tribes and pillaged the natural landscape. Of late, the Canadian government is prosecuting a hard-rightward dissolution of environmental laws and civil rights. But

there are distinctive differences in the daily and cultural lives of both nations, in particular with regard to violence both at home and overseas, persecution of whistleblowers, and (I think) surveillance and spying.

I spent part of the winter of 1966 in the family home, but it soon started feeling a little cramped, psychically anyway, and I moved into an unheated room on the second floor of a house rented by Bill Hawkins; his wife, Sheila; and their two small kids, Andries and Jennifer. Hawkins, at the time manager of Le Hibou, was the mastermind behind a new band, The Children. He was a member of the band, but except for one occasion, he never performed, at least while I was involved. Hawkins was the lyricist with musical ears. The band's members came from the folk music world I was acquainted with. Neville Wells played guitar and bass, as did my friend Peter Hodgson (now better known as Sneezy Waters), who had introduced me to the music scene blossoming around Le Hibou. Another friend in the band was Sandy Crawley, who played (wait for it) guitar! Eventually Hodgson left and singer-songwriter David Wiffen took his place. Wiffen, of course, also played guitar. Chris Anderson, an old schoolmate of mine, did actually play drums, with great enthusiasm, but was made to walk the plank halfway through the band's life for the sin of having somewhat shaky time. Richard Patterson, a veteran of at least one of Ottawa's more successful young bands, replaced him.

When I told my friends in The Children that I was leaving Berklee, they invited me to join. With all those guitar players, there had to be a division of labour. They decided I would play organ, since I had some piano training. Soulful music was generally made on a Hammond organ, or at least a Lowrey. I was provided with a Farfisa, an Italian atrocity that produced a thin nasal wheeze perfectly suited to, even *cool* in, the sort of sixties Italian lounge music you'd find in Fellini films of the day. As a rock-and-roll instrument it was not satisfying. I couldn't really play it anyway, beyond one or two blues riffs of the English persuasion, and basic rock chords. But it was very portable. And it was free.

Someone, likely Hawkins, had convinced Harvey Glatt to put some money into the band. In addition to being co-owner of Le Hibou, Harvey ran a record store on the Sparks Street Mall called the Treble Clef, and below it, the Bass Clef, a basement shop that sold musical instruments. (He also supervised a song publishing company with which I was briefly affiliated.)

Partway through the band's life Bill left Le Hibou and took a strategic job as manager of the instrument store, which allowed us to borrow gear from time to time. This gave us access to a range of guitars, amps, etc., which suited me, as I was by then playing more and more guitar in addition to my keyboard role. I paid no attention to what "borrow" might mean. Later, after The Children petered out in '67, Harvey surprised me with a bill for the "rented" items. My father volunteered to pay it, overriding my protestations with the comment that lots of fathers set their sons up in business, and I should regard his gesture in that light.

We wrote. We practiced. We played the occasional gig. We were going to be the next Beatles. None of us, except maybe Hawkins, yet knew that there is never a next anything. Other than war.

Hawkins stood out as a poet. He inspired me and the other aspiring lyricists to explore the meaning and power of words, to use them in judicious and unexpected ways. It was a big deal for me to be that close to Bill. He was a voracious reader, a contemporary of Leonard Cohen and other lesser-known but no less accomplished Canadian writers. When I first joined the group I wrote music for Hawkins's words, but he encouraged me to write my own lyrics as well. We shared an interest in philosophy and the occult, exploring mysticism, the Tarot, and some darker things. And we wrote a lot of songs.

The Hawkins home was a hub for all kinds of artists, musicians, poets, and songwriters, especially for those of us in The Children. Bill freely dispensed tips and guidance, usually unsolicited, almost always useful. His life in those days was gritty. He was a drinker with a penchant for extramarital adventures. He announced one night

that he had accomplished one-third of his design to fuck his way through the zodiac. Sometime in the past Hawkins had spent time in jail for some youthful misbehaviour. He had the four points of a cross tattooed in a little constellation on the web between his thumb and forefinger. He was tall, with longish, straight home-cut hair and a Fu Manchu mustache. He had bad teeth, which is how, in part, he justified his use of alcohol, to kill the pain. There was a constant ebb and flow of tension between him and Sheila, a smart, attractive, and harried woman who was stuck with the thankless task of trying to maintain some sort of order in the house.

Eventually they began to see me as dead weight, and they kicked me out. Sandy Crawley and I each took a room in an apartment rented by Bill's then paramour, Barb Luther's sister Gail. She thought she was getting roommates. I thought I was getting a free room. I was seeing a lovely girl named Monique. I liked her a lot and I think it was reciprocated, but I was mired so deeply in my fear and self-disgust that I couldn't make anything happen. I wrote a song about it, later recorded by 3's a Crowd.

> *In the circle of your arms*
> *I could have set the sun in silver*
> *And made for you a ring so fine*
> *If we had grown together babe*
> *We might have made it to the seashore*
> *And left this muddy river far behind*
> *Ah, but I couldn't find the key*
> *That would unlock these chains of mine*
> *And my songs were not complete enough to sing*
> *I could only feel your music one line at a time*
> *And there's no chance for a bird without wings*
>
> *If only I had read*
> *The meaning that your eyes held*
> *As they shone like diamonds burning in the dawn*

*But the raindrops in my own*
*Changed the colour of the sky*
*And I just sat and helplessly looked on*
*So I'll go on worshipping*
*My world of faded dreams*
*Though the church bells are of lead and will not ring*
*And to those who try to tell themselves I'm more than what I seem*
*I say, "What good is a bird without wings?"*

**"BIRD WITHOUT WINGS," 1966**

Life was not easy. I was drawing a salary of ten dollars a week from the band. Some days dinner would be a peanut butter sandwich, some days a couple of carrots. I was anxious all the time.

To walk downtown from Gail's place took about twenty minutes. I had to pass a schoolyard, which during recess was full of milling, scrambling, shouting children. It produced a feeling of panic. Whenever I walked past the school, if the children were outside I would have to cross to the opposite side of the street. That explosive child energy got under my skin in a way I could not then fathom. One night I dreamt I was on foot in something like the macro version of the school grounds. I had to get across. What seemed like a mile away I could make out a grassy bank and a line of trees, but to get there I had to wade through a malignant sea of small, ferocious children who clutched at me, trying to pull me down. I struggled to hack a bloody swath through them with the Indian battle-axe I kept lying around my room.

Harvey Glatt was, and remains, effective in business. He got us gigs, including a slot as cannon fodder opening for the Lovin' Spoonful at Toronto's cavernous Maple Leaf Gardens hockey arena on December 11, 1966. The lineup was us, the well-liked Toronto band the Paupers, and then the Spoonful. This was a seminal event, not only given the

audience size compared to what we were used to, but because we were all to some extent fans of the headliners. We didn't get to meet them, but did hang a bit with the Paupers. Their lead singer was a Scotsman by the name of Adam Mitchell, who had performed in Ottawa and been an occasional guest at the Hawkins abode. The band was managed by a corpulently wild-looking young chain smoker named Bernie Finkelstein.

Hawkins did not typically perform with us, but we all thought it would be a good move if he appeared for this show. As part of our setup we dragged a wooden rocking chair onto the stage in which he sat and read a book while we played, like the éminence grise that he was. The experience confirmed to Hawkins that his place was not on the stage. Forty-two years later he told a reporter, "The house lights went up and I saw all these 14- and 15-year-old kids screaming, and suddenly I felt out of place. I was twice their age. I turned to Bruce [Cockburn] as we walked off the stage and said, 'I'm finished.'"

It was Hawkins's first and last gig with The Children. After that, although we saw each other quite frequently for a while, my life did a slow peel in its own direction, and so did his. In the preface to his 2005 "comeback" book, *Dancing Alone: Selected Poems*, Hawkins wrote, "I just dropped out sometime in 1971, when I woke up in the Donwood Clinic, a rehab centre in Toronto, with no idea how I got there, weighing 128 lbs and looking like a ghost in my six-foot frame."

Bill was a constant drinker back then, but it may not have just been alcohol that compelled him to shun rock-and-roll crowds and opt instead for the life of a popular Ottawa cab driver (a life he continues to live). The public is a ravenous beast. For some people, the spotlight is a dagger.

If in fact it was fear that drove Hawkins to drop out, I know exactly how he felt. An overwhelming dread of crowd scrutiny almost prevented me from pursuing a solo career. It wasn't so bad with a band, especially as a guitar player. I could jump onstage, act aloof, and slap away at the white Fender Esquire I had acquired, which I decorated with *Om mani padme hum* in Tibetan script. If I

didn't interact with the audience, nobody cared. "Oh, the guitar player is cool." That remedy isn't available to the solo performer, or to a band's front person.

There was a lot of time between Children gigs. I played harmonica at Le Hibou every Friday night, from midnight to 4 A.M., with a crazed band called the Heavenly Blue, another brainchild of Hawkins, in which he was lead singer. I did a fair amount of solo acoustic performing, mostly at the club, eventually playing just my own songs. The only way I could get up the nerve to take the stage alone and make my voice work was to mask my psyche with a cultivated lack of concern about how the audience felt about me. *I'm just doing my music. If you like it, great; if not, fuck off.* I didn't really believe that—I actually was desperate for people's love and approval, no matter my penchant for withdrawal—but that's what I told myself because it was the only way to get through a performance. Without that defense I was paralyzed.

One night after a set at Le Hibou, I was greeted by a woman with whom I had become acquainted, one Maury Hayden. She was an attractive, thoughtful songwriter with a powerful, theatrical stage presence who occasionally did a week at the club. She lived in New York and was a former girlfriend of songwriter Tim Hardin. Hardin produced a body of lovely songs, including the worldwide hit "If I Were a Carpenter." (Hardin also had a heroin habit and died of an overdose in 1980.) I was somewhat in awe of her. She took on something of the nature of a Jungian anima figure in my mind.

When I came offstage, Maury approached me with a crinkled brow.

"What was with that song?" she asked. " 'Charlie the Walking Excuse'? What's that all about?"

It was actually a pretty cruel slap at a guy I had met at a party, who I suspected was slumming among the "hippies" hoping to get laid. He worked the room, continually apologizing because he slaved at a bank. My song was what an introverted songwriter who can't relate to people would think was witty. Then she asked, "And that thing with the audience, what's that?" Maury was put off by my

apparent disdain for the people who had paid to hear the music. She said, "Bruce, you have to let them know you love them."

A switch flipped. There was a moment of deep dislocation. It was shocking to me: I'm supposed to love them? (Or at least convince them that I love them?) Her statement actually sounded pretty showbiz, like "Leave 'em laughing when you go" or "The show must go on." But it wasn't showbiz, it was real, a direct and kindhearted truth. From that point, even though I didn't really know what it meant to love anybody, let alone an audience, I acted like I did. It changed everything. It changed the way people perceived me onstage, it changed the feedback I got, and that changed me. At a glacial tempo, but it did.

Chris Anderson, the first drummer in The Children, had introduced me to Kitty Macaulay and her sister Jane backstage at Le Hibou in the fall of 1966. Chris holds the distinction of being the only person I have physically fought with (duking it out in a high school bathroom, with Chris declared the winner for having bloodied my nose), and the first guy I helped kick out of a band. The Children replaced him with a more versatile drummer named Richard Patterson. I found the Macaulay sisters to be interesting and pleasant, but I didn't think about them much, as they had come with Chris and I had no expectation that either of them would be interested in me. Not long afterward, in the spring of 1967, my brother John alerted me that a room was coming up for rent in the down-at-heel downtown mansion where he lived, on Gilmour Street in Ottawa. It was a four-storey fading beauty divided into as many cheap rooms as the owners could fit. It must once have been quite grand, with its large, double oak front doors, the upper halves glazed with heavy cut glass. The doors had been painted over many times, as the scratches in their studded surfaces revealed, and their colour when I moved in was a fecal brown.

The notion of moving into the house was appealing not only in its own right, but also because the Macaulay sisters happened to live there too. It was alive, but falling apart. Nobody cared what you did in your

room. I took an L-shaped studio with a tiny bathroom built into the crook of the L. It was on the third floor, with windows at each end, one of which opened onto the canopy of a big old elm. As the weather warmed I kept the windows open wide, allowing pigeons to fly in and out. Miraculously, I don't remember ever having to clean up their droppings. The walls were painted a pale yellowish colour, and I ornamented them with large renderings of mystical symbols from a grimoire I had, and from the Egyptian *Book of the Dead*.

One day the owners notified us that the house would be razed to make space for a development of some sort. The night before the bulldozers were scheduled to arrive, I came home from somewhere to find an array of toilets on the lawn as furniture, occupied by tenants and friends lounging about, more or less discreetly drinking beer and cheap wine and sucking on joints, watching others disembowel the house. With the wrecking crew due the next day, renters took everything they could wrest from the premises: doorknobs and doors, windows, sinks, banisters, light fixtures. Every time you took a swig of your beer, out of the corner of your eye you'd see somebody sauntering off in one direction or another with a piece of the house.

John and I decided we should have the fine front doors, so we removed them and their massive hinges and stuck them in somebody's van. I stayed around for a while, but I didn't really know the people hanging out, a slightly younger crowd my brothers ran with, so I left early. As a result, I missed the drama that unfolded later, when Tom-who-dwelt-in-the-basement decided a bigger statement had to be made. He set his apartment on fire, burning the house to the ground. I heard that the folks partied, watching the flames, until the firemen chased them away.

*Somebody made off with my favourite toy*
*That I bought with my government grant*
*The world situation seems to be taking*
*A definite turn for the worse*
*Somebody put me in reverse*

*What fence would hold my pride and joy*
*Unless he was a man-eating plant*
*That mother is asking to wind up basking*
*In fame in the back of a hearse*
*Somebody made my bubble burst*

*Call in the guard, he's out in the yard*
*been lax in his duties for real*
*Take him to task for being so crass*
*As to let someone in who would steal*

*Great thrills are in store for us all*
*While the world is on such a slant*
*Though he's a bit funky*
*The girls love his trunk*
*He's a hit without deodorant*
*But somebody stole my elephant*

*If you should meet him please give me a call*
*The number's inscribed on the bathroom wall*
*You're bound to see him*
*At the beach or the be-in*
*Even though some people can't*
*Get used to believing in elephants*

*Call in the guard*
*He's out in the yard*
*He bungled this job up for sure*
*He blew it in style*
*But he's just a child*
*We'll send him away for the cure*
*And we'll all go away for a cure*

"IT'S AN ELEPHANT WORLD," 1967

I was onstage when I fell in love with Kitty. In the last days of The Children, she would come to shows at Le Hibou and sit in the front row. She was impossible to miss, all fluid movement and long blond hair. One night she started extending her arms directly at me, opening and closing her fingers as if to shoot waves of energy my way. That got my attention. After shows we would chat, flirt a little. For a while I found it hard to believe that this beautiful woman was actually interested in me, but she was, and we started dating. Our living arrangements were as convenient as a guy could hope for, until the house burned down.

Kitty made a point of pushing through my emotional barriers and inexperience in the realms of the heart. She was not afraid of the work, nor of me, and she successfully built on some of the discoveries I'd made earlier, on my own and under Bill Hawkins's tutelage. I had become acquainted with many different interpretations of the interface between the physical and the spiritual: the Egyptian and Tibetan books of the dead, the Tarot, the writings of Gurdjieff and Alastair Crowley, the *I Ching*, Lao Tzu. I carried into these readings, and the conversations with Bill and others that followed, an exciting sense of discovery. It wasn't a wholesale buy-in on my part, but the spiritual landscape that began to take shape became ever more inviting.

Kitty brought something new to the mix—the experience of a very fundamentalist Christian faith, which she had adopted as a kind of adolescent rebellion against the spiritually aware but freethinking atmosphere in which she had been raised. What that meant to me was that, although she had left the literalism and rigidity of fundamentalism far behind, Kitty offered a view of the Bible that made it much more than the chronicle of horrors I had taken it to be. Reminders abounded of humanity's connection to spirit, such as the famous passage from I Corinthians 13: "Though I speak with the tongues of men and of angels, and have not love, I am become as sounding brass, or a tinkling cymbal."

Because the juiciest bits are mostly found in the Old Testament, I

had never spent much time with the New, figuring that with Sunday school and the piecemeal bits of religious education I'd received, I knew what it had to say: the Christmas story, the Lord's Prayer, walking on water, and so on. Now, as I followed Kitty's lead, I found there was love and grace, the mystery of the Holy Spirit descending into the human realm. Kitty also introduced me to C. S. Lewis, whose *Narnia* and other books we read to each other at night. Also *Dune*, *The Left Hand of Darkness*, and *The Lord of the Rings*. I liked the tales, and appreciated Lewis's imaginative rendering of the Christian story, which brought it to life. Increasingly, I found myself thinking about God in Christian terms. I was drawn to dig deeper. I read as much as I could.

In his 1997 account of the Toronto music scene of the 1960s, *Before the Gold Rush*, Canadian music critic Nicholas Jennings writes that The Children were "Ottawa's leading folk-rock act, play[ing] cover tunes at Ottawa high-school dances." While Jennings goes on to reveal that The Children "saved their original material for evenings at Le Hibou coffee house," he inadvertently makes it clear, in that tellingly oxymoronic sentence, that if the city's "leading" band was playing covers at high schools, then one of the band's aspiring songwriters needed to get out of Ottawa.

There was a ceiling to the hometown music scene that compelled my exit to more fertile ground. I found it easy to leave. I had become a lifelong nomad as soon as I set foot aboard the *Mokefjell* headed for Norway. My lack of attachment to people and places was very strong at that time, and I felt quite at ease stepping in and out of bands and relationships. Band members in The Children were actually my friends before we got together, so they were an exception, though not a very powerful one. In Ottawa I watched my peers form attachments, get some girl pregnant, go to work selling shoes. It was happening all around me. This wasn't going to be me.

The Children dissolved shortly after Hawkins's revelation at the

Gardens, and I joined a band called the Esquires for a few months, until the summer of 1967, when their former guitar player told me that an acquaintance of his in Toronto was forming a band and was looking for a songwriting guitarist. He had suggested me. Shortly thereafter I got a call from bass player Neil Lillie (who would later relocate to the United States and reinvent himself as Neil Merryweather). That led to me catching a train to Toronto to try out. He had an organist and a drummer already. The players were good and the band had some potential—I don't think I understood at the time how much potential, really, but it was my ticket out of the hometown, and a step worth taking. I moved to Toronto.

Musically, that city, and particularly the Yorkville district, had become due north in the North American cultural compass for young, and not so young, people. I arrived in time to watch and participate in a revolutionary ascension of human thought, action, and music that, worldwide, would come to define an era.

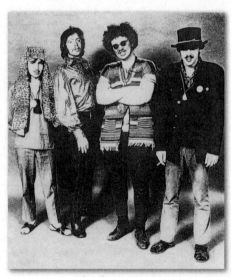

*The Flying Circus*

I suggested we call the band The Flying Circus. Back in the thirties, a travelling "flying circus" would perform in rural communities: stunt flying, wing walking. It seemed like a cool name for a band in the sixties, when people were routinely engaging in nonphysical flight.

All of us wrote songs, though mine made up most of the repertoire. Our music was sort of a hybrid of psychedelia and The Band (among the most important contributors to the Toronto scene, and hugely influential). Marty Fisher, the organist, a fervent Garth Hudson worshipper, brought The Band. I brought

the psych. I wanted a dark, anti-pop, adventurous edge. We practiced a lot, more or less daily. We played very few gigs, but when we did, they were memorable.

In the autumn of 1967 Kitty accompanied The Flying Circus to Detroit for an audition with Motown. Neil Lillie had a contact at the label who had promised us a hearing. We piled into a rented van and rumbled down Highway 401, across the tedious miles of alluvial plain that make up southern Ontario to the twin Canadian-U.S. cities of Windsor and Detroit. Here, where these industrial cankers corrode the southern and western shores of Lake St. Clair, we pulled into the tunnel border crossing. This was just a couple of months after the Detroit riots. The customs agent took a look at Neil's teased-up blond Afro and, past that, a carload of hippies and said icily that he wasn't going to admit us.

As far as riots go, the Detroit conflagration was the real thing. Racial tensions had been extreme for years, so it wasn't altogether surprising that after police broke up a party at a bar in a black community, held to celebrate the return of two Vietnam veterans, the locals pretty much snapped. The riot grew quickly and eventually engulfed vast swaths of the city, tearing it apart. According to Rutgers University, "Looting and fires spread through the northwest side of Detroit, then crossed over to the East Side. Within 48 hours, the National Guard was mobilized, to be followed by the 82nd Airborne on the riot's fourth day. As police and military troops sought to regain control of the city, violence escalated. At the conclusion of 5 days of rioting, 43 people lay dead, 1,189 injured and over 7,000 people had been arrested."

There are two entrances to Detroit from Windsor, one through the tunnel, where we were turned away, and another across a bridge, which is where we went next. There were no computers back then, so we had a good chance of entering the United States on the second attempt. The agent at the bridge was a pleasant older gent. He was a bit skeptical of us but friendly in a paternal way. He said, "All right, I'm going to let you kids through, but make sure you don't. . . ." He

trailed off. Don't what? Do anything bad? Get mugged? Take jobs away from American workers?

Even two months after the drama of July, the Motown neighbourhood looked like a war zone. Block after block of burned-out buildings frowned down upon the few pedestrians, who seemed to skulk from shadow to shadow. The street where Motown was located seemed to

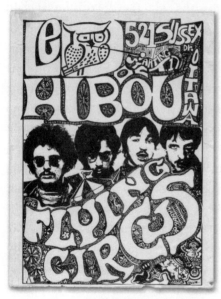

*Fall, 1967*

be the only one that had not been completely trashed. Inside, the place was quiet. Neil's acquaintance greeted us warmly and brought us into a small office. Because I was the main songwriter, the Motown guy had me play guitar and sing some songs, the others joining in for harmonies. I'd play and he'd say, "That was okay—what else have you got?" Next song, same thing. "What else have you got?" After a while of this, I was pretty frustrated.

Subtitles ribboned through my head. *What the fuck do you want from me? Why are you putting me through the wringer like this?*

This went on through the afternoon, my resentment building. In hindsight, the man was being generous with his time. He kept trying to find something that would work with the Motown sound. When we got to the end of the thirty or forty songs I had to offer, he said, "You're more of a Bob Dylan kind of songwriter." That was bitter. I was a pretty big Dylan fan, but to be described in such a way suggested that my songs were derivative. The nerve! He likely intended it as a compliment. He was a nice guy. I was a clueless youth.

Partway through the ordeal, Kitty went out to find a grocery store for some drinks and sandwiches. She indeed found a corner market,

went inside, and worked her way down the shelves to the back of the store, where it dawned on her that she was the only white person in there. Everyone else, about a dozen people, stopped shopping and stood dead still, staring at her. Kitty froze, unsure what to do. A little girl, maybe nine years old, marched up, took her by the hand, and without a word led her out onto the street. The spirit, in the form of that little angel of a girl, was with us, but it wasn't enough to get The Flying Circus a deal with Motown.

Letting the audience know they were loved was not high on the agenda. The notion was to come back later, but for now, in the band context, anger led the charge. Sometime early in 1968 I returned to Le Hibou while we were still The Flying Circus. Our show included a big climactic guitar wank at the end of the set. I'd drop to my knees, flail and gesticulate, and bite the strings. After the show I ran into a guy I knew. "Oh, man," he said, "you used to look so disinterested, and now you look like you're really into it!" It was fake. It was show-biz, and I only did it because Jimi Hendrix did things like that, and I loved Jimi Hendrix. But playing with my teeth didn't last. One night I watched a piece of incisor fly into the audience, landing near, or perhaps in, someone's coffee, and that was the end of that.

We played under the name The Flying Circus for a while, but I wasn't the only one who'd thought of it. A band from Australia calling itself the same thing came to Canada and had a radio hit. We searched for another name and settled on Olivus, the suggestion of Michael Ferry. Michael had recently left a career as a soul singer with a band called Jon and Lee and the Checkmates (he was Lee), and was helping us, having stepped into the organizational gap left when we kicked out Neil, who had founded the band. I don't remember why we did that, but personality differences aggravated by lack of funds had something to do with it. To replace him we enlisted Dennis Pendrith, a top-notch bassist and one of the most likable people I've ever met.

With help from Harvey Glatt, the band landed opening slots for

Wilson Pickett in Toronto, and then as Olivus, for Cream in Ottawa and Jimi Hendrix in Montreal. The Pickett show was at Massey Hall, a venerable and classy downtown concert venue with a great feel and excellent acoustics for quiet music, not as well suited to rock. The Pickett outfit was held up at the border and arrived very late for the setup. Doors eventually opened and the hall quickly filled with a predominantly black crowd, already impatient from having been kept waiting outside. The promoter, an old-school show business type with a chewed-on cigar and a grouchy demeanour named Sid Banks, paced about backstage yelling at people. Eventually he got around to yelling at us. "You guys get out there and play, or you're not getting paid!" Never mind that the tech crew had not even finished setting up the vocal mics. Our own equipment was only partly in place, but on we went. We plugged ourselves in and started to play what we hoped would be a strong opening number. Four bars into the intro, there was a loud cracking sound and a puff of grey smoke rose from the top of the suddenly silent organ. Marty had to perform the whole show on the clavinet he normally used for only a couple of songs. We continued what was now a struggle to put across our material. Before we were done, we had most of the audience on its feet. From a sea of enraged brown faces poured phrases like "Come on, let's hear some music!" Clenched fists waved in our direction. We played the shortest set that would still get us paid and beat a somewhat graceless retreat. Wilson Pickett followed with an excellent, high-energy show.

The other events worked out better. Cream's audience in Ottawa's ornately gilt Capital Theatre at least tolerated us, though nobody seemed to get very excited.

The Hendrix show, in April, was the second occasion in which I found myself on an arena stage. This time it was the cavernous Paul Sauvé Arena in Montreal's east end. We actually had a proper sound check. I was surprised and confused by the sight of the stage techs placing microphones around the drums. "What are you doing that for?" I asked. "The friggin' guy's already too loud!" The tech looked at me like I was an animal he'd never encountered and said, "Well, that's what we do." I had never seen that done before. I had no idea

it had become standard practice to put the drums through the PA in large halls like this.

We went onstage on time, made it through our set without mishap, and got out of the way for the performance by the Soft Machine, a pioneering electronic band that was touring with the Hendrix trio. They were interesting, hypnotic, accompanied by a classically West Coast psychedelic light show, cellular shapes slithering and swelling, projected into air thick with incense and hashish.

Then came the Jimi Hendrix trio. The sound that exploded from Hendrix's stack of overdriven Marshall amps was fluid, shattering, seductive, threatening, and uplifting. The notes seemed to rise high above the thundering rhythm section into the dense air and spontaneously combust. I stood in the darkness of the balcony and marveled. And longed to be a conduit for that kind of power.

One reviewer said that if the main act had been anyone but Hendrix, we would have stolen the show. That may be a measure of how much pot smoke was in the atmosphere. But to me these gigs were monsters under the bed: big shows in big halls stacked with thousands of fans, most of them stoned out of their minds and howling for the headliner. Opening acts were really just meat. "Sure, I'd love to go on first." Freaked me right out. I would be transported to a state of awareness that was glassy, opaque, like an out-of-body experience or the memory of a trauma. I was onstage with my gang, thrashing the strings of my Esquire, cranking out rock and roll like I'd always wanted, and inside I was in survival mode, insulated from the scene.

There was a party for the bands after the show, at a warehouse recording studio in downtown Montreal. Soon after we got there I fell into a conversation with Hendrix's drummer Mitch Mitchell, who told me that the Montreal gig was their thirtieth one-nighter in a row, and they were doing the tour by air. They had no chance to do laundry or sleep. Everything was about arriving in a city, playing a set, getting to the airport, flying to the next city, then playing again. They all smelled bad. Their clothes, fine-looking from an audience perspective, up close were split-seamed and ragged.

When the Hendrix crew had arrived earlier that afternoon, the

major downtown hotel they had booked refused to accommodate them. Management was afraid they would throw the televisions out the window or something. But because Hendrix happened to be African American, *his* management was able to play the race card, and they called the press. The hotel was shamed and eventually gave the band rooms. This kind of thing was common in the sixties. Nonetheless, that night the Jimi Hendrix Experience played what must have been one of the finest sets of rock and roll ever heard in Montreal, which speaks to the professionalism of those guys.

At the party, clusters of wannabes, posers, and industry hucksters clotted dark as platelets in the shadowy corners of the large-ish room. I didn't know any of them, and I didn't want to. They were passing joints and conspicuously assessing to what degree each new arrival warranted their attention. They wasted no time on me. Then Hendrix came in, causing a palpable shift of energy. Ragged and sapped as the trio was, Hendrix was beautiful in half-unbuttoned ruffled shirt, flowing scarf, and blue velvet jacket. He happened to walk up and stand next to me. In front of us was a little stage set up with instruments, but nobody was playing. Jimi lingered awhile and seemed peeved that everyone was gawking at him. He turned to me and said, "I don't know what all these people are staring at, man. I just want to play some music." Then he stepped onstage and stroked some beautiful blues out of an old Stratocaster. It was supposed to be a jam—any guest could get onstage and join in—but I didn't have the nerve to get involved. I left while Hendrix was playing.

Yes: I was at a party with the closest thing I had to a rock-and-roll hero, one of the greatest electric guitar players in rock history. He was playing on an open stage ten feet from me, and I was free to join him, but I didn't. It wasn't just the phony mutterings and poses of sycophants surrounding Hendrix, although I had a definite aversion to being taken for one of those. I wasn't just tired (though I was that). I was held back by the deep inner conviction that I had nothing of value to contribute, and that by getting up and playing, I would demonstrate that to all present.

After a nine-month career that included no more than maybe a

dozen gigs, Olivus disbanded. I was done with psychedelia. All the thrashing and pounding had become boring. My ears were tired. It was time to move on. There was beauty to be coaxed from the guitar that is unique to the instrument. I was only twenty-three years old, but I felt ready to become me, whatever that was. Through this period I had the occasional solo gig, often at Le Hibou, which was the world I wanted to enter full-time. Since early 1966 I had written dozens of songs. Most were easily discarded, but a core body of material stood out, workable songs that sounded better to me when played solo on the Martin 00-18 acoustic I had acquired. I decided to go it alone, as myself.

At the same time I was witnessing a devolution of the Toronto rock scene. There was no question that the "Toronto Sound," a unique conglomeration of R&B styles mostly played by white guys, was becoming an international draw, and the city was alive almost every night with unique and wonderful riffs and rhythms pulsing from dozens of venues. Yorkville, and downtown in general, were packed with an array of clubs large and tiny, funky and fashionable, and the masses swarmed them all: the Riverboat, Club Bluenote, Kiki Rouge, Jacques' Place, Charlie Brown's, the Purple Onion, the Pornographic Onion, the Penny Farthing, the Gas Light, the Mousehole, and the Mynah Bird (whose chef often cooked in the nude). Lucky tavern rats took in the talents of emerging Canadian stars like Ian and Sylvia Tyson, Steppenwolf, Joni Mitchell, Neil Young, the Guess Who, The Band, Gordon Lightfoot, Murray McLauchlan, and Kensington Market. So the devolution might not have been apparent if you'd just arrived and went club-hopping, or if you were a favourite local performer and the stars were aligning in your favour.

But city officials were tiring of accommodating the Beats and hippies, bikers, and drug dealers swarming in the flood of humanity that arrived each night to partake and to gawk. They wanted developers. They wanted Tiffany and Louis Vuitton, Ferrari and Gucci, and they would get them and more. Shortly after protests swept through Yorkville in 1967 (the protesters wanted cars out of the crowded district), Toronto controller and former mayor Allan Lamport said he wanted Yorkville to "become a shopping centre." He got much more than

that. Yorkville is now Toronto's wealthiest district. In 2008 *Fortune* magazine reported that Bloor Street, the main thoroughfare running past Yorkville, was the seventh most expensive shopping street in the world.

*Rain rings trash can bells*
*And what do you know*
*My alley becomes a cathedral*

*Eyes can be archways*
*To enter or leave by*
*Vacuum's replaced by a crystal*

*Jesus don't let Toronto take my song away*

*It's easy to love if*
*You let yourself love it*
*But like a moth's wing it's easily crushed*

*Jesus don't let tomorrow take my love away*

**"THOUGHTS ON A RAINY AFTERNOON," 1969**

Through it all, Toronto remained cold and unwelcoming, musicians ever more aggressively hustling for gigs and desperate. There was some authenticity, some exceptional music, and some promising artists, but as these things often go, the shysters and wannabes, phonies, and petty criminals seemed to take over the scene and make it oppressive. I had a few friends, but mostly I felt detached from humanity in the crazy city. I hovered in my own thoughts and songwriting, and isolation, and stepped further toward a solo career.

My flight from the band scene was delayed by another offer to join an ensemble, one that was difficult to refuse. The invitation was from 3's a Crowd, a Toronto folk-rock band that had relocated from out west. They blazed bright for a few minutes and then collapsed. The

original outfit was an entertaining folk trio consisting of Donna War-
ner, Trevor Veitch, and Brent Titcomb. Those three had performed
together for a few years before getting a record deal and expanding
into a six-piece that included my former bandmates Richard Patterson
and David Wiffen. I knew them from their regular visits to Le Hibou's
stage. Brent's house in Yorkville provided a kind of refuge during my
lonely sojourn in Toronto. He and his then wife Maureen had a mys-
terious tolerance for my silent presence. Sometimes I'd be handed a
guitar and invited to play something.

The band had recorded a couple of my songs (as well as some by
Bill Hawkins) on an album called *Christopher's Movie Matinee*,
produced by Cass Elliot of the Mamas and Papas, whose music I did
not care for. My 3's a Crowd friends weren't happy when I told them
how little I liked their rendition of my stuff, which I thought sounded
mechanistic and passionless. I felt bad about making them feel bad,
but I didn't know how to fake enthusiasm for what they had done.

Just before the founding members decided to disband, they'd landed
a good-paying contract to be the "house" band for a mainly musical
variety show that would run nationwide on Canadian TV. As the
summer of 1968 approached, Richard and David, as the two most
recent members, asked me to join them in a resurrected version of
the group (which would also include Colleen Peterson, Sandy Craw-
ley, and Dennis Pendrith). They had been left in the lurch by the
sudden parting of the original three singers. They hoped to capitalize
on the deal for the show. It was to be called *One More Time*. It would
be taped over the summer at the CTV studios in Montreal.

I was skeptical of the offer for a few reasons, not least of which
was that I had experienced the unhinged side of the show's producer,
Sid Banks, during The Flying Circus's misadventure at the Wilson
Pickett concert. Mostly, though, my hesitation hinged on a desire, a
need, to get out of bands and go it alone. But Patterson and Wiffen
dangled before me the promised $13,000 for a summer of work, which
sounded like decent pay in those days and would provide a stake for
my future solo flight. So I told them, "Okay, I'll do the show, but

that's it, then I'm done." We spent the summer taping twenty-six half-hour episodes, which ranged in quality from laughable to embarrassing to execrable. My $2,166 share, which dribbled in over an eight- or ten-week period, did not constitute much of a grubstake. I agreed to go with them to New York for a meat-market audition to try to score a U.S. college tour, which we got. We spent much of that fall playing through the Carolinas. It actually went well.

The best thing I got out of that tour was meeting Fox Watson. Fox was an accomplished guitar player, a lovely fingerpicker who introduced me to the magic of open tunings. We hung out for a while on tour, and then he came up to Toronto for a couple of months. I was sort of disdainful of open tunings back then because I didn't like most of what people did with them—playing the same four chord formations in different tunings, trying for a specious variety in their sound without going to the trouble of actually learning their instrument—but when Fox played in any of several tunings he used, what came out was fluid as a mountain creek and agile as a gull. My first attempts at instrumental pieces, "Sunwheel Dance" and "Foxglove" (which is named after him), reflect his important and timely influence on my playing. At his suggestion, I replaced the relatively small-bodied 00-18 with a fuller-sounding, dreadnought-shaped Martin D-18.

After the Carolina tour and one or two other gigs with 3's a Crowd, I was done with bands and remained so until the mid-seventies. In early 1969, an excitingly original singer-songwriter named Murray McLauchlan, who had befriended me over the course of several visits to Le Hibou, took me around the Toronto folk music scene that had somehow escaped me, for the most part, while I was a band member there. Most favourably, Murray introduced me to Estelle Klein, who ran the Mariposa Folk Festival. Mariposa was the biggest music festival in Canada, and that year would be the most successful in the event's history, featuring performances by Joni Mitchell, Pete Seeger, Vera Johnson, Bessie Jones, Joan Baez, and others. Estelle booked me for a side stage at the festival, but when Neil Young bowed out of his main stage slot to join Crosby, Stills & Nash at Woodstock

three weeks later (I guess they needed to rehearse), I was moved onto the main stage. I wasn't looking for a "big break," but this was one for sure. Thirty thousand people attended the festival that year, and finally, fitfully, in front of them all, I got to be me, and I sang my songs.

> *Look out the window*
> *Cows hangin' out under spreading trees*
> *Zoom, they're gone behind the sign*
> *White letters pointing to the long white line*
> *And I'm going to the country*
> *O, la la la la la*
> *I'm going to the country*
> *Sunshine smile on me*
>
> *I can smell the grass growing in the field*
> *Wind in my hair tells me how it feels*
> *Farmhouse, silver roof flashing by*
> *Tractor-trailer truck says good-bye with a sigh*
> *And I'm going to the country*
> *O, la la la la la*
> *I'm going to the country*
> *Sunshine smile on me*
>
> *Birds singing, I'm singing in my bones*
> *Doesn't much matter now where I'm goin'*
> *Get it when I get there is what I'll do*
> *If I get enough I'll give some to you*
> *And I'm going to the country*
> *O, la la la la la*
> *I'm going to the country*
> *Sunshine smile on me*

"GOING TO THE COUNTRY," 1969

# 6

In late 1966 I was introduced to two people, in very different circumstances, who would have a profound effect on the shape of my life. Both relationships were codified in 1969, when I married Kitty Macaulay, and when, with somewhat less ceremony, Bernie Finkelstein became my manager.

The nature of these relationships, like all relationships, helps to illuminate an aspect of the human condition—or maybe just *my* condition, though I think I can take a shot at some universal truths. My professional connection with Bernie has lasted nearly four times longer than any of my relationships with women. Business brings the benefit of distance: you don't have to live with or love or even like your business partner to make it work. Relationships of the heart, though, require exposure of the soul. There is risk and, potentially, reward in every utterance, every look, every assumption. You are more vulnerable slipping into bed beside your lover than you are setting up a freelance meth lab in Sinaloa.

It took me decades to become open enough to allow another human beyond the courtyard of my heart. I know it's not just me: most of us, to one degree or another, have difficulty maintaining human bonds. Becoming, and especially remaining, intimately associated with another human being—spouse, child, parent, friend—is challenging. For many of us, the prospect of revealing our inner selves

(if we even know we *have* inner selves) and giving up the autonomy of a solitary life (an autonomy that many people cling to even when living with others, as I can personally attest) can be harrowing. And everyone knows that relationships require work, patience, and trust, and the renunciation of individual freedom in favour of the richness of coalescence.

At the same time, the "freedom" of the individual is an illusion. We need each other. Alone we are not free, but bound by an unnatural state of disconnection. Which is not an argument against *alone time*, something I greatly value, but I recall too well the loneliness of those moments and days with only my own thoughts and spirit. The value of human relationships is inherent; studies of prisoners show that people go mad without human touch. Outside penal walls we, the lucky "free," endure the scrutiny and habits of others in exchange for the benefits of a loving relationship. In the end, successful long-term coevolution allows us to enjoy deeply rooted connections of the heart until our final breath, one of the greatest blessings humans can offer each other.

The caveat in all this is that no matter how much you care and work and try, there's a good chance, in our busy and transient era, that our human connections will be severed—if they are established at all—and that relationships will be short-lived. That's okay. Make it work if you can. The important thing is to pursue these connections no matter the risks. In fact, the risks speak to the importance of mindfulness, and the mindfulness speaks to connection with the Divine. So go there, but don't beat yourself up if it isn't quite happening. You're in good company. We're a tough species.

Another caveat is that all relationships are different. Forging close ties has been particularly hard for me, given the flatlining of emotional content that was the unstated rule in my childhood home. Not everyone feels so constrained. Love was in our house yet rarely expressed. I learned how to bottle up feelings, which would later lead to psychic capitulations and failures to connect, sabotaging deeper relationships with others. Over a lifetime I have had to develop other

ways of being. We don't become different people as we age. We just add on to what we came in with, and hopefully modify it as we go along. For me it was modify or remain trapped forever in a cage of reticence.

Conversely, business is mathematical, it's definable, and—perhaps speaking to a core reason I have never liked this aspect of my career—it is the very nature of the frenetic and often sterile world of business to undermine the contemplation, the open spaces of the heart, that we need to access and to honour artistic creativity. Commerce, in an era when the market has become god, can derail our quest for the Divine. It's easier to sell something than to intimately know something, or someone, but the price we pay for the ensuing derailment can hardly be put into words (though I've tried).

*So we wait beside the desert*
*Nothing left to give away*
*Naked as the Hanged Man's secrets*
*Nothing left to do but pray*

*You don't have to play the horses*
*Life's a gamble all the same*
*It don't take much to make you lose sight*
*Of the object of the game*

*Anyone can be a soldier*
*It's a prevalent disease*
*Oh God I don't know where to step now*
*Help me find the right road please*

"YOU DON'T HAVE TO PLAY THE HORSES," 1972

Our journey is driven by longing. The novelist Robert Olen Butler, a Pulitzer Prize winner, once told me that he teaches his students to incorporate *longing* in what they write, because longing is perhaps

*the* overarching human emotion. Longing has to do with God, because what humans long for the most is a relationship with the Divine. We may not be conscious of it, but we long to know God, in whatever context or guise that might mean to the individual. Which brings us back to projection, to thinking that the missing elements of who we think we are can be supplied by another person, or through the pursuit of esoteric knowledge. Only God can fill that hole.

We often put more thought and energy into establishing business relationships than into creating close relationships with fellow humans, or with God. This is a prevalent pattern. Commerce prospers handily at the expense of human love and spiritual contact. While it has provided some of us with basic needs such as food, shelter, and water, and given a few of us comfort, opulence, and power, the gods of market culture often demand interactions that are stripped of feeling and soul, that devalue the sweetness and openness that are natural attributes of the human heart and invite an allegiance to the material world. At a certain level of immersion this almost guarantees an inability to maintain meaningful relationships with the Divine and with each other.

This is not to say that my business relationships have all been sterile. Far from it. Many of the people I've worked with have become friends, at least while our work together continued. Bernie and I, for instance, remain close. But it may be that our arrangement has outlived all my romantic relationships because we never had to risk creating and maintaining a deep human bond. It was business. I don't like business, and Bernie does. It's worked. Bernie has represented me for forty-four years on a handshake. With one exception, I don't know of any similarly long-lived business relationship in the music industry.

That exception, interestingly, is the one between Neil Young and his manager, Elliot Roberts, which has lasted about as long as ours. Bernie tells a story about discussing the phenomenon with Roberts, who said that he and Neil have enjoyed such longevity because they talk every day, and Neil is deeply involved.

"Well," said Bernie, "I think my relationship with Bruce has lasted as long as it has because he never calls me. I have to call him all the time." For four decades Bernie has had the unenviable job of representing the business to me. I'm not in business. I need and want to know what's afoot, but I don't want to hear about it every day. I don't want to hear about it even when I *have* to hear about it. Bernie tries to do this job, which he does extremely well, and I'm obstreperous about it. *Don't call me all the time.* It got a little better after the first decade, but I still harbour a distaste for the business side of the Business.

Bernie steamed full bore through the early days of True North, the record label he founded in 1969. He took everything very seriously and ran his ship like Captain Bligh, building a record company and a modest music management empire. In those days he was disheveled, like a cat that had left its mother too early. His temper flashed and his attitude careened between quick-witted joviality, serious hard work, and an unstrung rudeness. He wasn't a natural traveller. Early on Bernie and I toured western Canada in my truck. He was always trying to talk to me, and I don't like to talk all the time. For me, long-range driving has a meditative quality. I like to sit in silence and have my thoughts, savor the unfolding landscape. A lot of people aren't comfortable with that. Bernie is more sociable. He needs to talk. He subsequently chose to avoid travelling with me that way.

When it came to band travel, on a tour bus, the issue reappeared in a different guise. Some people are good at travelling in a group. They know how to blend in, when to allow their companions the necessary psychic space. Bernie is not one of them. Maybe I'm projecting here; maybe nobody else cared but me. But, charming and funny as he can be, I found the space too full with Bernie in it. At some point I had to tell him he couldn't come on the road with us. Besides, if I was going to be paying a tour manager, which I would be, I didn't need Bernie there as well in an executive role, hovering over everything and making everyone nervous. We settled into a

routine where he would come out for the first week of a tour, to make sure everything was working, and then follow the rest from his office.

I was averse to business long before I met Bernie, due in part to a lack of aptitude but also on aesthetic grounds. The idea of having someone run interference between the music industry and me had great appeal. I couldn't always keep the "biz" at arm's length, though. Case in point: a fatuous 1970 article in the Canadian newsmagazine *The Province* about my early career. The headline, "How Long Can a Man Dodge $100,000 a Year?," rankles to this day. My first album had been out for a few months, but the writer seemed interested only in the money I *could* be making, not the music I *was* making.

"The talk [between me and Bernie] turned gently to money," the article went, "and to how much Cockburn might earn in the next year. Cockburn was only a little interested, and he mentioned that he had made out quite well on the $10 a week that was his share of the take when he played lead guitar in an obscure Ottawa group called The Children three years ago. But the news that his manager was trying to break to him now was that, at 25, Cockburn is a successful solo artist; that his first album has sold more than 15,000 copies in six months, and that the sales curve is not slackening; that a growing number of other singers are recording Cockburn's songs, and paying him royalties; that the film for which he wrote and sang the sound track, *Goin' Down the Road*, is a hit in New York; and that he, Bernie Finkelstein, is turning down an appearance for Cockburn in January at $1,700 a night 'because the place is a pub.' What it all adds up to, Finkelstein said gently, was that Bruce Cockburn could gross about $100,000 in the next year, if he *wanted* to."

I have nothing against money, but I was raised to regard it as a personal thing. It was rude to ask how much someone spent on something, or how much he made. To see this in print was embarrassing. In 1970, when these numbers were significant, I was opposed to pursuing anything artistic just for the sake of income. Obviously you have to pay some attention to money. The decision to accept a gig is

based in part on the remuneration offered, but it has to honour the muse. To make artistic choices based on money or the anticipation of getting it is not an option. Of course, if you grow up without it, it's likely to mean a lot more to you than if you were reared in comfort, as I was.

The writer of the article was at least insightful. He quoted me saying, "Money is a hard thing to deal with. . . . It's easier for me *not* to have it." Then he somewhat gleefully, if not accurately, recorded my response to the success of my first record, and Bernie's reaction to my response: "Not long after last summer's release of his first album—an event that would see any other singer spending time ingratiating himself with disc jockeys so they would plug the record—Cockburn took his wife, Kitty, and his dog, Aroo, on a *non-working* tour of Western Canada in a camper truck. They made their leisurely way across the Prairies, over the Rockies to the B.C. Coast, then back again, enjoying the delights of the Canadian countryside that loom so large in Cockburn's songs. . . . Bernie Finkelstein is only bewildered. 'Success is happening for Bruce now,' Finkelstein said. But then he added with a touch of professionalism: 'It might have happened *earlier*, if only Bruce hadn't gone out west . . . but, he did, right?' . . . Sadly now, but resigned: 'He's taking December off, too. . . .' " (emphasis in the original)

The notion of "taking" my life partner anywhere also seemed obnoxious. Kitty and I embarked on our adventures together, as a team. We loved the wide-open west. Our explorations of the numinous Canadian landscape *fed* the songs, and our souls. We caught the west in the last of its wild state. Many of the songs I wrote in the seventies reflect our travels through the great expanse of the Canadian prairies, across the Rocky Mountains, to the moisture-rich West Coast. Space was everywhere, and there is *space* in the songs. Everything wasn't a tourist trap yet, clear-cutting was not so evident, and agribusiness hadn't completely killed off the family farm. In the first couple of years that Kitty, Aroo, and I travelled westward from Ontario, we were practically the only road campers out there. Seldom

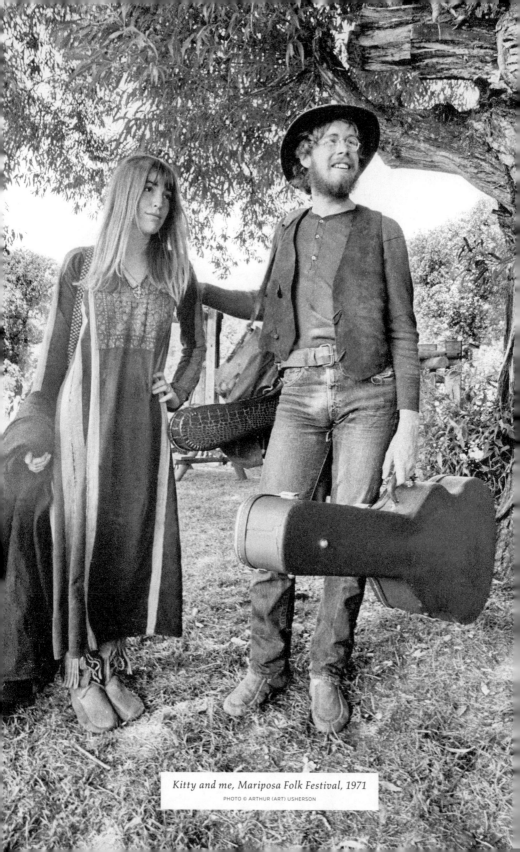

*Kitty and me, Mariposa Folk Festival, 1971*

did we run across anyone else travelling the way we were. The prairies were full of abandoned old farmhouses—no families to be seen—harbingers of the reversion to feudal agricultural economics. All around the land still looked wild. Our journeys offered at least the illusion of freedom, as well as a deep sense of the land as Divine creation. Soon, though, we were seeing the spaces fill up with scabrous industrial sites, hotels, housing developments, shopping opportunities. We'd watch like gawkers at a train wreck as the land was eaten up before our eyes by inevitable human expansion and greed. There were ever more rules about where you could park your camper. It was the tail end of an epoch when the land was open and it, and we, could breathe freely. That will never come again.

*I went up on the mountainside*
*To see what I could see*
*To see what I could be*
*On the shining mountain*

*I watched the day go down in fire*
*And sink in the valley*
*And sink into the sea*
*Drown in golden fire*

*Fireflies danced in the forest night*
*The trees began to sing*
*The crags began to sing*
*Above the black forest*

*I went up on the mountainside*
*To know what I did know*
*To know whence I did know*
*On the crowning mountain*

"SHINING MOUNTAIN," 1970

Bernie was just twenty-two when we first met at Maple Leaf Gardens, but he'd been dabbling in music management since high school and was already a fixture in an expanding Canadian music scene. At the time that scene enjoyed little of the infrastructure (record companies, recording studios, talent agencies, performing rights organizations) that was booming in the United States. So Bernie stepped into the vacuum and built one of Canada's most influential, if modest, music empires, eventually opening an office on Scollard Street in Toronto's Yorkville district.

Bernie held his assets tightly, but he also knew when to let go. Though the band he was managing when we met, the Paupers, sizzled onstage and enjoyed moderate success in Canada and the United States, in 1967 he sold his interest to Albert Grossman, the New York manager of Bob Dylan and Peter, Paul and Mary, among other illuminati. Within two years the Paupers had dissolved.

By 1969 I was performing exclusively solo and was eager to record an album. I had written dozens of songs, and it felt like they were choking me up. I wanted to get rid of these damn things in my head to make room for new ones, and I thought making a record would do that. I didn't know any better. I didn't want a big-time producer who would insist on adding what I saw as superfluous elements: bass and drums, or strings. I wanted the record to be just me singing and playing my songs, nothing else. I wanted a producer who would help me present the songs with the simplicity and purity of albums put out by Mississippi John Hurt and Mance Lipscomb.

One spring day, in the Upper Crust café on Yorkville, I ran into Gene Martynec, a guitar player I knew from the recently disbanded group Kensington Market, which Bernie had managed. "I really want to get into record production," said Gene. I felt the pot being stirred. Here was a colleague who wanted to be a producer, and I wanted to make a record. He said, "And I know this guy who wants to start a record company, Bernie Finkelstein. He's got the funding and he's looking for talent." Gene brought Bernie to hear me play at the Pornographic Onion, a coffeehouse on the campus of Ryerson University.

He liked the music well enough, but what encouraged him to take me on was that I insisted on being the only player on the record. Bernie welcomed the idea. It suited his budget.

Said budget was provided by a Yorkville character named Brazilian George, a shady dude known for dealing the psychotropic chemical MDA. In his 2012 memoir *True North: A Life Inside the Music Business*, Bernie described Brazilian George as "the nicer side of the Tony Montana character played by Al Pacino in the movie *Scarface*." When our trio of neophytes—Gene the producer, Bernie the record label owner, and me the artist—set out to make what for each of us was our first record, Bernie financed it with a $6,000 loan from Brazilian George, who was rumoured to sleep with a loaded rifle under his bed.

Bernie booked recording time at Eastern Sound, in Yorkville, and we knocked out the album in three days. We went through two engineers. The first one made a point of commenting on how pleased he was that there were no drums to record, drums not being to his taste. Bill Seddon took over for this guy, and he would go on to record four of my first five records. The studio had hired Bill because he'd worked at a radio station, so he knew how to thread two-inch tape onto the machines, but that was all he knew about recording. Turned out he had a good ear and a knack for dials. With the exception of an annoying degree of background hiss, the album turned out fine.

*Bruce Cockburn* came out in the spring of 1970. The day of its release was reasonably pleasant for Toronto at that time of year, sunny and mild. As I rambled through Yorkville without a winter coat, I heard something disturbingly familiar oozing out of the open door of a bookstore. It was me. In those days free-form FM radio was new, a rapidly growing phenomenon. The Toronto station CHUM-FM was one of these stations, and it was very popular. They had crazy DJs who would rant and read their stoner poetry and spin all manner of obscure, esoteric, and interesting music. It was not unusual for them to play an entire album. I entered the shop, incredulous that my song was on the radio. It freaked me out. I left in a mild panic and escaped,

or so I thought, into the boutique where I usually bought incense, but the album was on in there too. It was like an episode of *The Twilight Zone*. I realized CHUM was playing the whole record, and it was on in almost every store in Yorkville. Most performers would have been thrilled: *They're playing my album!* I was terrified. I thought, "I'm never going to have privacy again!"

> *Living in the past*
> *Is not living at all*
> *The old fear going fast*
> *Everybody's scared to fall*
> *Turn with the times*
> *Change your mind*
>
> *Sullen and profane*
> *The ancient temple stands*
> *Dissolving in the rain*
> *Its gods long turned to sand*
> *Forgotten childhood rhyme*
> *Change your mind*
>
> *Listen for the ring*
> *Of tomorrow's bell*
> *Be the first to sing*
> *From beyond the wishing well*
> *Know what's behind*
> *But change your mind*

"CHANGE YOUR MIND," 1969

After a few years of Kitty and I being together, coming apart, and getting back together again, I determined that we needed to move our relationship forward somehow. *Move it forward, pin it down.* I asked her to marry me, and she said yes. On the penultimate day of

the decade, we were married at St. George's Anglican Church in downtown Ottawa. Kitty wanted a church wedding. I wasn't concerned with *how* we did it, but I was fascinated with all things medieval, and I thought it would feel good to get married in a place with Gothic arches and stained glass. The bride wore a long antique dress and looked like she could have stepped out of the fifteenth century. I wore my standard outfit of the day: jeans and moccasins and the woolen troubadour's tunic someone had made for Murray McLauchlan, which he had given me. (You can see the look immortalized on the back cover of the first album.) The priest, Father Patrick Playfair, was a man who instantly commanded respect. With his strong Scottish countenance, he looked like God: long robe, big red beard, and longish hair. As usual, I didn't want to make a spectacle of myself, so we kept the wedding small, inviting only immediate family and offending scores of others.

The church setting was mostly an aesthetic choice for me, though more deeply meaningful to Kitty. I took very seriously the idea of making a promise before God, but I didn't care whether we did it in a field or church or somebody's backyard. It was beautiful, but I wasn't attached to the place. I was seeking a deep and mystical bonding with the beautiful woman I loved, which I got, but I also got something else, quite unexpected.

With Father Playfair's guidance we repeated our vows, then exchanged rings. At that moment, when I held Kitty's hand to place her ring, I became aware of a presence standing there with us— invisible to the eye but as solid and obvious as any of the people in the room. I felt bathed in the figure's energy. I shivered and said to myself, "Well, I don't know who or what this is, but we're in a Christian church, so it's got to be Jesus." Who else *would* it be? He spoke no words, but the presence was real, male, and loving. In giving and seeking love, we enter a temple of spirit that we can't see but we can feel, that we can't touch but that nurtures us and makes us whole. The church where Kitty and I were married was a human construct built to accommodate and celebrate the possibility of a relationship

with God. But I don't think it was about the building. It is the opening, the baring of souls to each other and therefore to the Divine, that allows these communications to occur. I will say, though, that we seemed to be in the right place at the right time, doing right by God in his house, and that might have helped.

*He came from the mountain*
*To walk among the wounded*
*They couldn't see him*
*But the snow did melt whenever he passed by*

*He came behind winter*
*His face was like the sun*
*They wouldn't see it*
*But he sang on the bank and made the waters run*

*In his world we wait*
*In his hands our fate*
*Keep on climbing*
*We shall see his gate*
*In good time*

*He came to the lowlands*
*He said we must have faces*
*So we could see like him*
*Before our wings would ever come to fly*

*In his world we wait*
*In his hands our fate*
*Keep on climbing*
*We shall see his gate*
*In good time*

"HE CAME FROM THE MOUNTAIN," 1971

# 7

I never really planned on singing my own songs for a living. My
preference for a covert life, having my thoughts unchallenged,
allowing my imagination to run where it would was a way to make
the best of a slippery world fraught with physical and psychic peril.
Everything was possible, but not in a good way. I could talk. I could
laugh with people, but with an ego and no self-confidence, it was hard
to get very close to anyone without feeling threatened. At times the
loneliness was unbearable, the need to be held unmet, even on the
rare occasions when I *was* held. Yet the ego demanded its due, and
although I couldn't look the feeling in the eye, I really wanted the
approval that might be coaxed from an audience. That was enough
to let me perform onstage, despite the fear and loathing that went
along with it.

I started singing my songs because they were made to be heard,
and it was obvious that no one else was going to sing them. Once away
from the collaborative atmosphere of The Children, I thought I would
write the songs and other artists would sing them. "Here's something
Judy Collins could do," I'd think, or any of the singers I respected who
were not committed to performing only their own material. I had no
means of accessing such people, so of course none of them did.

Sometimes attention is just fine. Shortly after surviving the shock
of hearing my first album playing in all those stores, I was down on

Yonge Street in search of jazz records at Sam the Record Man. (My memory of this event is aided by the December 1996 issue of *Gavin's Woodpile*, a remarkably dedicated monthly zine, now a website, published by one Daniel Keebler.) At Sam's, a young cashier named Barry Wright watched as a teenager approached me for my autograph. I was with my dog, Aroo, and Wright suggested that we give the girl Aroo's autograph too, which we did, using a stamp pad. I enjoyed the fact that Wright, without intending to, implied that the guy she thought so important might not be any more interesting than his dog.

I was in that record store taking a break from recording my second album, *High Winds White Sky*, which came out in 1971, as did my third album, *Sunwheel Dance*. A lot of the songs on my first three records issued straight out of my head—fantasies and visions—rather than arising from what I was seeing in front of me. These records represent one of a couple of album "trilogies" that I've put out, though that's not how I intended them at the time. The early albums were in small part reactionary: I was leaving behind years of questionable rock bands, clearing out the decadent psychedelia that was itself a reaction to institutional decadence, and painting something deeper and more lasting. I was looking for purity in nature, for connections behind things. There is some Christian influence to be found on the records, but just as often the mystic influence was Buddhist or something from occult lore. The Buddhists are great technicians of the sacred, to use Thomas Merton's term. I first encountered this in the Beat writers, then through Alan Watts, Chögyam Trungpa, and the Sutras themselves. There was also a mystic quality to the vast unspoiled landscapes of the Canadian north and west, which I got to watch unravel under the banner of "progress" during the seventies.

Along the way I tried to comport myself in a way implied by 1 Corinthians 13, that lovely and quite clear admonition:

> *And though I have the gift of prophecy, and understand all mysteries and all knowledge, and though I have all faith, so that I could remove mountains, but have not love, I am nothing.*

*Love suffers long and is kind; love does not envy; love does not*
   *parade itself, is not puffed up*
*does not behave rudely, does not seek its own, is not provoked, thinks*
   *no evil*
*does not rejoice in iniquity, but rejoices in the truth*
*Bears all things, believes all things, hopes all things, endures all things.*
*And now abide faith, hope, love, these three; but the greatest of these*
   *is love.*

Who, among believers in any worthy ideal, can disdain these words, can fail to grasp them in their heart? Well, plenty of people, unfortunately, as we know—many of them ideologues professing various faiths, including Christian. An honest reading of this and other beautiful passages in the Bible speaks to a humanity dedicated to serving all creation through active benevolence, through love. Really, *these* are the Bible's juiciest bits.

*Sunwheel Dance* is a snapshot of my mind-set during that decade. Despite my tendency toward a dark view, the songs from that era are full of sunlight. It was a period when I was searching for clues about existence but largely ignorant of my own inner workings. Sunlight was a metaphor. I felt optimistic—at least to the extent that it seemed everything would unfold as it must, within and without—and this optimism was a window that allowed light into the lyrics.

I had few close friends during the seventies, as I'd pretty much abandoned the rock coterie I used to hang with in Toronto and before, and I didn't reach out much after that. Kitty kept a few folks close, but it was really just the two of us most of the time. We spent half the year on the road and the colder half in Ottawa or Toronto, with a scattering of friends in both places. We spent time with Fox Watson when he came to Canada, but eventually he went back south and disappeared off the radar, resurfacing later as a social worker in Appalachia. Murray McLauchlan and his then wife, Patty, who subsequently became known as Marguerite, were frequent companions in Toronto. Murray was also managed by Bernie and recorded for True

North. It was largely Murray who introduced me to the Toronto scene when I reappeared there as myself, the singer-songwriter. Eric and Marty Nagler of the Toronto Folklore Centre were good friends for a while, till they broke up and we drifted apart. Kitty's childhood friend Ann Tenor had married an eccentrically gifted player of ragtime guitar named Mose Scarlett, and we stayed often at their place when visiting Toronto. Mose's rich baritone voice delivers blues or standard tunes with conviction and authenticity. "Musical Friends," on the first album, was written mostly about gatherings at his apartment in the east end. Somewhere near the middle of the decade I became friends with Alan Whatmough in Ottawa. Alan played various instruments, including bass, and made his living as a piano technician. We shared an interest and a faith in non-dogmatic Christianity. It was through Alan that I discovered, in the course of our many conversations about faith, music, and humanity, the pleasure of having a male friend with similar interests.

With albums coming out and word spreading, so did offers for gigs well beyond the small coffeehouse circuit I had known. I'd have a performance in Montreal and then a week later I'd be in Ottawa. A month later it was Winnipeg, and a month after that, Saskatoon. The rigours! Each gig paid for the gas to the next, plus some food. Kitty and I camped in the truck, met locals, walked the mountains and plains, and attempted to merge our lives. It was just Kitty, Aroo and me, and the camper, for most of the first five years we were married—a simple, pleasant life.

*Cloud pillars clinging like vines to the sky*
*Don't cry*
*We'll walk down the meadow with sunrise inside*
*So dry your eyes*
*The winds of all kingdoms meet where we stand*

*The grey forest people cast off their old clothes*
*Good-bye*

*Everything's sleeping as winter draws near*
*So close your eyes*
*The mists of all twilights dance close at hand*

*The rust-coloured river is now slowing down*
*Going dry*
*Harvest has lifted the crown from the ground*
*But don't you cry*
*The song of the seasons brings life to the land*

"FALL," 1971

During these early years my music found its way into the Canadian mainstream. Five songs from the first three albums made the top one hundred on Canadian song charts, four made the top thirty, and album sales kept pace. In 1970 I wrote and performed the title song and soundtrack for the acclaimed Don Shebib film *Goin' Down the Road,* and that music won an award from the Canadian affiliate of the American performing rights organization BMI. Perhaps most unlikely was receiving the Juno Award (the Canadian equivalent of the American Grammy) for Canadian Folksinger of the Year for three consecutive years (1971–73).

I hope my expressions of gratitude for the awards themselves rang louder than the distaste I wore on my sleeve for the contest as a marketing tactic, a way of cashing in on whoever was popular at the time. I recoiled at the notion of competition. (Years later, when I started participating in shooting matches, I would come to understand that I am actually a very competitive person. But I don't believe that applies to art.)

The first Juno Awards ceremony, in 1971, was small. It was very Canadian, not yet a media event. It was just the industry congratulating itself on what it was up to, which seemed legitimate—not very interesting, but okay. The vibe was good. Then in 1975 it became a TV show. I thought, "We don't need to go in this direction as a nation.

Surely we can think of our own way to honour Canadian artists without imitating the Oscars or the Grammys." At that point the Junos became even more competitive. It was ugly enough in the first place to be designated "best" whatever—am I a "better" folksinger than X, Y, or Z, or are they better than I am? (I didn't even consider myself a folksinger.) But the figurative elbowing offstage of my fellow musicians, or their elbowing-off of me, was not a place I wanted to go.

With the passage of time and the acquisition of a facade of maturity, I've mellowed with respect to these things. The "suits" are people

too. The music world is not so sharply divided into *us* and *them*, and the idea of people celebrating their successes in whatever form seems okay. I'm not enthusiastic about the mostly commercial rationale for awards, but the cloud of effrontery is lined with a fuzzy, warm appreciation for the strokes.

At the end of 1972 I embarked on a solo cross-country Canadian tour that differed from my previous outings in one significant way: gone were the clubs and coffeehouses, which I was used to playing but which had become impractical. All

of the shows on this tour would be in midsized theatres and concert halls. In November 1972 I managed to sell out Toronto's twenty-seven-hundred-seat Massey Hall, followed by the prestigious National Arts Centre in Ottawa, with a capacity of twenty-four hundred. Typically there was ample driving time between shows, allowing Kitty and me to hang out, explore the back roads, and develop a feel for the spirit of the places we went.

My increasing notoriety produced another reaction. I began to be

typecast as a "nature singer," with write-ups heralding my position in the "back to the land" movement. I hated the feeling of being pinned down, and in any case the songs coming through me were beginning to change. My response was to cut my hair very short, like a punk, and make an album, *Night Vision*, with a band. It had drums, an electric bass, a Fender Rhodes. I played electric guitar on some songs. By design the overall timbre was urban rather than pastoral. We used the colours of jazz and blues with hints of rock. We played like a band. People seemed to like it.

> *I've been down to parliament, I've been in school*
> *I've been in jail to learn the golden rule*
> *I've been to the workhouse—served my time in those hallowed halls*
> *The only thing I know is the blues got the world by the balls*
>
> *I've been to the tundra and the mountain too*
> *I've been in paris doing what the frenchmen do*
> *I've been in boston where the buildings grow so tall*
> *Everywhere you go the blues got the world by the balls*
>
> *You can catch 'em from the preacher or from the pool shark*
> *You can find 'em in the grammar of the socialite's remark*
> *Or down in the washroom you can read it on the wall*
> *Everywhere you look the blues got the world by the balls*

"THE BLUES GOT THE WORLD," 1972

*Night Vision* came together in a backhanded fashion. I had a number of songs ready for vinyl but no plans to record. Then Harvey Glatt asked me to produce an album for songwriter and Children alumnus David Wiffen. The crew I put together to create a field for David's rich baritone voice consisted of Dennis Pendrith on bass, Pat Godfrey on piano, and a drummer named John Savage. We learned the songs and were ready to go into the studio, but David was chal-

lenged by the recording experience, and not for the first time. (Challenged enough that he had to go into rehab.) So there I was, with this great band looking for a recording session. I talked with Bernie and we decided to make my album instead. What came out was *Night Vision*. (Later on I did produce Wiffen's album *Coast to Coast Fever*, which turned out pretty well, in spite of my lack of expertise behind the console.)

Making *Night Vision* with a band turned out to be a great career move, except I was taken aback at the response. The album, especially the song "Mama Just Wants to Barrelhouse All Night Long," got airplay across Canada. It was my first record to go "gold" in Canada (fifty thousand units sold), which led True North to release a later pressing of the disc on "gold" vinyl. The audience also changed, becoming louder and more exuberant—clapping along, even. I had come up through the coffeehouse scene, where the listening atmosphere was one of quiet reverence no matter who was playing—even if you whispered, someone would shush you—and this carried over into the concert halls when I first started playing bigger places. But because *Night Vision* was such a different album, more urban and rambunctious, audiences responded in kind. They were having a great time. I became alarmed, even offended.

*I was up the road on easy street*
*Watching everybody stand around and cheat*
*Man comes up and says, "Move along*
*Back to the corner where you belong"*
*But mama just wants to barrelhouse all night long*

*Hear the city singing like a siren choir*
*Some fool tried to set this town on fire*
*TV preacher screams "come on along"*
*I feel like Fay Wray face to face with King Kong*
*But mama just wants to barrelhouse all night long*

*Sometimes I wonder what I am*
*I feel like I'm living in a hologram*
*It doesn't seem to matter what's right or wrong*
*Everybody's grabbing and coming on strong*
*But mama just wants to barrelhouse all night long*

"MAMA JUST WANTS TO BARRELHOUSE ALL NIGHT LONG," 1973

I had no idea how to deal with the sudden growth in popularity, this triggering of wanton emotional responses from audiences. I recoiled. *Things are getting out of hand. People want to dance at these shows. Oh my god, that's not me. I can't be responsible for inciting this sort of madness.* It was an issue even before *Night Vision*. One night during a concert in Ottawa I played "Dialogue with the Devil," from *Sunwheel Dance*. I was shocked when the audience applauded wildly at the end, and although I got a huge rush of energy from it, a personal power surge—*I could own this town!*—as soon as I got offstage, I started thinking that the whole experience was very wrong. Kitty and I talked about it. We came to the conclusion that it was wrong to want power over other people. I wasn't supposed to have power; nobody is supposed to have power, at least not the sort of frivolous, selfish power that I could see myself accruing. (Kitty may have been steered partly by guilt in this. In her teens she discovered she could influence people's actions through a kind of telepathy. She swore off that power, feeling it sinful.)

With *Night Vision* the same thing happened, only it was nationwide. I'd play and get whoops and claps and sing-alongs. *Quiet!* After shows, I felt hunted. I started to back off. *Quick! Another reaction, Bruce!*

*Aside: In contrast, there's a pretty good bootleg in circulation of a show I did with my band in Humboldt County, California, in 1984. We were playing an eleven-minute jam version of the originally gentle "Joy Will Find a Way," and I invited the crowd to sing along.*

*How funny to hear myself not only leading a long rock jam but also hollering—indeed, joyfully—"I can't hear you! You have to sing!"*

I was young and idealistic. I hadn't really thought it out. I was not seeing the positive side, or at least the *potential* positive side, of the power afforded popular performers: the power of communication, the ability—the privilege, really—to transmit the energy that humans require to maintain balanced psyches and to direct their lives in ways that benefit each other. (In spite of it all, I remain idealistic.) The artist can and should project *truth*—truth about feelings, truth about the world, truth about love and sex and relationships, and, if it's in them, truth about the Divine. When I'm onstage and I feel the sensation of being a conduit, when I feel the audience receiving whatever it is that might be flowing through me on any given night, it doesn't seem like an exercise in ego. The energy comes from somewhere and feeds me, and therefore the audience, and back again. It's a symbiotic loop, flowing amorphously and in perfect sync, when working right.

The flip side is that you've got to keep your ego on a short leash. Once you become "known," people start treating you with deference: hotel employees, shopkeepers, even your friends. It's easy to get used to that. It can become a trap. I became very aware of this early on.

*Terry Lynn, president of CBS Records, me, Alex Colville—whose painting graced the cover of* Night Vision—*Bill Bannon, CBS marketing director, and Bernie Finkelstein*

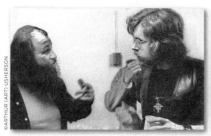

*Thick as thieves*

After *Night Vision* came out, people started addressing me as "Mr. Cockburn," which was embarrassing. I felt like, "Come on, we're all even here, you don't have to do that." But I couldn't stop it, because it's just how people are. I became very conscious of trying to keep that in check, but it wasn't really something a person could forestall. Meanwhile, the strokes are seductive, and I'd be lying if I said there were never times that I liked the attention, or that I don't like it when people do me favours.

My reaction to *Night Vision*'s success was twofold: I took a protracted, virtually work-free trip with Kitty to Europe when I could have (Bernie would say *should* have) been playing summer festivals to support the album; and, once we got home, I recorded an album of new songs, several of them products of those travels. That album, *Salt, Sun and Time,* was the least commercial project I could come up with and still stay within my established style. I didn't want a band, just me and Gene Martynec on guitars, and my voice. In one place Gene added a delicate touch of synthesizer, and we brought in Jack Zaza, a top session player in Toronto's studio scene, for a clarinet duet with me on an instrumental piece. But that was it. I made a conscious about-face. Furthermore, I toured with those songs *before* releasing the album. Gene and I performed as a duo, throwing half an evening's worth of unknown songs at audiences. People liked the guitar work, but few were inspired to dance in the aisles.

I got what I was looking for; everything calmed down. For a long time, *Salt, Sun and Time* was my worst-selling album. Bernie tore out what was left of his hair. But it was my process, my art. I was

growing up, but more so, I was growing into an industry that was looking for human cannonballs rather than shy pointillists. Only later on did I understand that it's a good thing for people to have a good time but, more important, it's a great thing if an artist can produce work without having to consider market forces.

The journey with Kitty to Europe, in the summer of 1973, was a trial of almost constant tension punctuated by a welcome gain in personal insight. Getting there was comic enough. We caught an ocean liner headed for London out of the same Montreal port that had seen me off to Europe nine years before. It was a Russian vessel, sleek and modern for the time. It bore the name *Alexander Pushkin*, after the esteemed Russian poet of the early nineteenth century. Pushkin, son of nobility, was so tempestuous about his honour that he fought a total of twenty-nine duels, losing the last one, and his life, at the age of thirty-seven. It was an apt name for the vessel, given the tribulations to come. Pushkin wrote right at me:

> *Have you not sighed, hearing his quiet voice,*
> *The bard of love, the bard of his own sorrow?*
> *When you looked at that youth in wooded hollow*
> *And met the gaze of his despondent eyes*
> *Have you not sighed?*

For four months Kitty and I sighed across northern Europe. The tone was set early enough, on the voyage across the Atlantic. I was shaving one morning a couple of days out. The heavy steel bathroom door in our cabin kept swinging open with the rolling of the ship and knocking my arm, so I peevishly elbowed it closed just as Kitty made to enter with her head lowered. She went down with a nauseating clang, splayed out on the deck, dazed but not damaged.

The ship was sleek, but the Soviet attempt to provide Western-style "luxury" was a parody. After a few nights in the dining room it became clear that we were going to be fed the same cubes of meat at every dinner, though each evening the name would change on the

menu: "boeuf bourguignon," "filet mignon," and so on. It could have been horse (which is perfectly edible, but they should have said so). There was no maintenance of the pool, so after a few days the water was a shimmering green gloss that gave a gelatinous slosh with each roll of the ship, as if someone were studying the tides using a giant petri dish. There was so little to do on board that a few hardy souls actually swam in it. I believe they were English. I was so bored I opted for Russian lessons. We booked the SS *France* for the return home.

As the British comedic actor Terry-Thomas might have said, Kitty and I were having a rather rough go of it. By the time we arrived at our diminutive Kensington hotel room, we had been together six years. Back in 1967 I was almost wholly ignorant about relationships, about sex, about the means and importance of exploring our issues, fears, and desires. My parents imparted very little of this sort of information to their offspring. Stress, passion, sadness, elation, anger at each other: it didn't matter, they didn't show it in front of us. I'd really had no one else to practice on before Kitty, and Kitty couldn't have had much of a sense of what she was taking on. So here we were six years later, and little had changed. We'd exchanged the sardine can of the truck cab for a Soviet stateroom, then a compact London hotel room.

I knew, because everyone around me talked about this sort of thing, that relationships require communication. But it took a long time for that knowledge to result in anything tangible. I was never able to adequately express myself to Kitty, to open up enough to make progress on the inevitable issues of marriage. It was almost impossible for me to communicate from the heart, especially if the subject— say, sex—required deep openness. With dedication and patience, Kitty drew me out from an often agitated state of desire mixed with doubt of my own capacity and a deep fear of exposure. She coaxed me toward trust, passion, and relative relaxation, but I remained too trapped inside myself to be much of a lover—though I thought about it most of the time.

Our difficulties found a focus in my inability to refrain from notic-

ing other women. It's a guy thing. We, men that is, are wired for a response to visual stimuli. I did not understand that then. Anytime an even minimally attractive female came into view, the imprinting would take hold and I would find myself momentarily fantasizing about her being *mine*. It wasn't that I imagined having sex with them. There was just a kind of smug sense of proprietorship, but I was reluctant to verbalize it, as it seemed rude. I was at least clear about this. Also, I didn't want to encourage Kitty's insecurity about other women making a play for me. I was, quite honestly, usually oblivious to this. *Really? Me?* It wasn't something I was used to. My wife, though, never failed to notice it.

Kitty is a highly intuitive person. Because we were together most of the time, she could read me quite well. She would ask if I was attracted to so-and-so. I would, of course, say no. This caused her to become insecure about her own intuition, which wasn't healthy, because of course she'd been right. Later she would plead with me to be truthful, but my guilt would not let me. I was a Victorian, fear-based moralist with a bohemian overlay. I lived in my head. I knew nothing about my animal nature. She encouraged me to be open, emphasizing that even married people are often attracted to others. So, after a while of this, I confessed. Conflagration. Kitty's insecurity and frustration now raged in a different way. I tried to solve the problem by censoring myself, by willing myself not to feel the attraction, which was even worse. The more I denied speculating about other women, the more I was attracted to them. There were a few issues that plagued us, but this one became a black hole that sucked all else toward its core.

After a few days in England we arrived back to the hotel room at teatime, planning to shower before dinner. Heavy clouds darkened the room. While out exploring we'd gotten lunch in a pub, where I found myself smitten by a waitress. Of course Kitty caught it—it would be like watching the lights change at an intersection—so back in the room she confronted me. It was clear what had happened: I'd become momentarily attracted to a young British woman whom I would never see again. But that was once too often for Kitty. Naked,

she let out a sobbing moan, clambered up on the desk to reach the high window, and fumbled at the latch. The cobblestone courtyard was three floors down. *Fuck! She's going to jump!* I grabbed her around the waist and pulled her down. We both wept. It was surreal. I can still feel the cold mixture of shock, dismay, and shame.

We buried this drama and for a while maintained a pretense of normalcy, enjoying the British summer in a rented station wagon. We circumnavigated the United Kingdom in a rough figure eight, up the west coast of England, across the narrow bit, around the top of Scotland from east to west. We hung towels over the windows to sleep in the back of the car, and stole bottles of milk off someone's front stoop and left money in their place. We walked the wild coast of Cornwall, ate strawberries and clotted cream in Devon, hiked up Cader Idris in North Wales, stood among forty-five-hundred-year-old standing stones on the Isle of Man, and drove the high tide–hidden causeway to call on the twilight ghosts of Lindisfarne. These were conjuring places, and we came to see them as Lewis and Tolkien must have, as their books seemed to embody the feel and shape of this landscape.

In Edinburgh we walked Cockburn Street. I bought a Harris Tweed jacket on the Isle of Harris. It was all terribly adventuresome and romantic, but the tensions never abated. We were our own monster, fighting along the entire shore of Loch Ness. It wasn't merely the attraction issue. There was a general failure to share deeper feelings on my part, which left Kitty feeling isolated. Combined with that was her own lack of a consuming calling around which to hang her exterior life, which put further pressure on our relationship.

After a month and a half of this we caught a boat from Aberdeen to Gothenburg, Sweden, making our way to Stockholm. We found a suite in a flat owned by a genteel older woman of aristocratic stock. It was a large home flush with antiques and an ambiance of faded grandeur. We hooked up with the American folksingers John Prine and Steve Goodman, there to perform on a TV show called *Op O' Poppa*, which John called *Oopoopoopoo*. I did a live show on Swedish national radio. My old friend Per Fagerholm had become a journalist

and was living in Sri Lanka, so we missed seeing him. I didn't try to find Miss Sand.

Then came the fateful shopping trip. Nothing is simple. I was in search of crafts made by the legendary Sami of northern Scandinavia. The Sami, or Laplanders, are the aboriginal people of Scandinavia, nomadic herders of reindeer, and fine crafts workers. Kitty and I were directed to a downtown department store that we were told had a section full of exceptional Lappish artifacts. We each bought a knife made in the traditional style and boots with curled-up toes. I bought a book for my dad called *People of Eight Seasons*, which describes a year in the traditional Sami life.

We were aided by a young, blond, stereotypically pretty Swedish saleswoman. As the transaction progressed, I began to feel an intense longing for this total stranger. I didn't even like how she was dressed, but I wanted her so badly I could hardly speak. I started to sweat, and my face flushed crimson. The most disinterested passerby could have detected the lack of composure pushing through the cracks in my attempt to carry on in a correct manner. The salesgirl must have. Kitty certainly did. She felt humiliated and said so. There was nothing I could say but "Sorry."

I was confused and ashamed at how out of control my desire had been. It wasn't about the woman at all. I'd never have acted on it. Even if I had been single, I wouldn't have had the nerve to approach her. It was an ambush from deep in my psyche. I could not be the person I wanted to be on my own. I needed help.

The next day we were quiet. We took a boat through the Stockholm archipelago, a glorious assemblage of thirty thousand islands dotting the edge of the Baltic. It was late summer, a bright and lovely day, cool. Ripples sparkled and danced along the deep blue waters. Brown tones of reedy shallows were dotted with the darting of tiny fish that flashed as they turned. In them I saw our lives, flaring and fading in the bigness of things. I couldn't shake a feeling of desperate need, of my ultimate helplessness, of the previous day's debacle, of the struggle that our marriage had become.

Back at our suite I entered the bedroom by myself. I ached for the deep and nurturing embrace of the Divine to supplant these cravings for women, whatever they stood for. I wanted a healthy relationship with Kitty. It wasn't long before I was begging on my knees, consciously asking Jesus to help me, to fortify my mind and salve my soul, to make me the person he wanted me to be. I prayed like a child, without reserve. Suddenly it was there, the same presence I had felt during our wedding ceremony, in the room with me, its energy filling the air. I felt my heart forced open. He was there! And it was definitely *he*. A male entity, more fraternal than paternal, radiant with calm power, a *saviour* showing up to save me because I'd asked. I made a commitment to Jesus. From that moment I saw myself as a follower of Christ.

That night the words came, and flowed freely onto the page.

*All the diamonds in this world*
*That mean anything to me*
*Are conjured up by wind and sunlight*
*Sparkling on the sea*

*I ran aground in a harbour town*
*Lost the taste for being free*
*Thank God he sent some gull-chased ship*
*To carry me to sea*

*Two thousand years and half a world away*
*Dying trees still will grow greener when you pray*

*Silver scales flash bright and fade*
*In reeds along the shore*
*Like a pearl in sea of liquid jade*
*His ship comes shining*
*Like a crystal swan in a sky of suns*
*His ship comes shining.*

"ALL THE DIAMONDS IN THE WORLD," 1973

I found some diatonic chords to give it the flavour of a hymn, and in 1974 we placed "All the Diamonds in the World" as the first song on *Salt, Sun and Time*. From that night on, for almost three decades, I told anyone who asked that I was a Christian.

At this point my memory of Bernie becomes two arms stretched heavenward surrounding one big pair of rolling eyes. Clearly, flooding all my new fans not only with toned-down music, but with toned-down *Christian* music, was not his idea of capitalizing on a good thing. And if anyone knows how to capitalize on a good thing, or even a bad thing, it's Bernie Finkelstein. Not to mention whatever inner wrestling he had to do as a Jew saddled with the task of selling this stuff. But he rose to the challenge.

Only two songs on *Salt, Sun and Time* have stood the test of time for me: "All the Diamonds," which is as good as I get, and "Rouler Sa Bosse," a Djangoesque instrumental featuring Zaza's rousing clarinet. People tell me they also like "Seeds on the Wind" and "Never So Free," and I'm glad, but except for "Diamonds" and "Rouler," the songwriting, though earnest, isn't as interesting to me as it is on some of my other albums.

When Kitty and I returned from Europe, my father saw that we needed a real home and gave us twenty-five acres of an eighty-acre farm he and Mom had bought at Burritt's Rapids, forty miles southwest of Ottawa. We built a cedar kit house and attempted to normalize our lives. It sort of worked. Sometimes we attended services at St. George's Anglican Church, where we were married, and Kitty began to talk about children.

> *Don't want to be on no rooftop*
> *Frying in the afternoon sun*
> *Don't want to sit by no fountain*
> *Listening to the man-made stream run*
> *Just want to stand where the sea-spray*
> *Gleams like fire with you*
> *And I don't have to tell you why*

*Don't want to go to no parties*
*Full of fair-weather friends*
*Don't want to be in no "in" crowd*
*Chasing after every trend*
*Just want to stand on some hillside*
*In Wales with you*
*And fly—don't have to tell you why*

*Don't want to live in no mansion*
*Ornate as a crown prince's church*
*Don't want to live on no sidewalk*
*Underneath no pigeon's perch*
*Just want to stand at the rainbow's*
*Real end with you*
*And I don't have to tell you why*

"DON'T HAVE TO TELL YOU WHY," 1973

# 8

Anything that touches me with a sense of meaning is likely to make its way into a song, so it followed that *Joy Will Find a Way*, the album that came after *Salt, Sun and Time*, became the first of a series of more or less explicitly Christian records. It is the only album of mine with songs that mention Satan by name ("Dialogue with the Devil," from Sunwheel Dance, doesn't count), and he's in there twice. It is also the only album with a song on it, "Starwheel," that Kitty and I co-wrote.

We lived in Toronto, across the street from Gene Martynec and his then partner, Catherine, for part of the time the songs were being written, but in late 1974 we moved into our new house at Burritt's Rapids, which is where "Starwheel," "Arrows of Light," and "A Long Time Love Song" came into being. The neurotic plague of 1973 seemed behind us. We still loved each other, and I continued to treasure Kitty's inspiration and insight into the worlds both of spirit and of feeling. In Toronto we had moved on to a state of fatigue, in which I focused on my work and Kitty found validation in social connections, hanging out with a crowd of hipsters based at the Pilot Tavern. I never went there. The move to the country refreshed us both. The novelty of the house, the quiet, the old fields grown up into woods we could walk in—all gave us room to breathe.

*Joy Will Find a Way* reflects exposure to some new musical influences. For the few years leading up to the album, I had made a point

of listening to music other than the popular genres I was familiar with. I missed a few things by doing this (David Bowie, for example), but I soaked in, and absorbed, some magnificent material. I rarely listened to other singer-songwriters. I didn't want to be influenced by anyone who did anything close to what I was doing. I immersed myself in the sounds of other cultures: Swedish fiddling, Gambian kora, the music of Ethiopia, Tibet, medieval and Renaissance Europe. I had an album of indigenous men singing in guttural voices and playing a hollow log on a beach on Guadalcanal. My interest in jazz never entirely waned, but it took a temporary backseat to these other, more exotic forms. I also put a lot of work into the guitar, abandoning attempts to incorporate piano, banjo, and mandolin into my songs. An exception was the dulcimer, which had shown up on *Sunwheel Dance* and still seemed to fit.

Leaving behind the reactionary state of *Salt, Sun and Time*, Gene and I assembled a band to play on *Joy* that included Dennis Pendrith and Pat Godfrey (who had played on *Night Vision*), with Terry Clarke on drums and Dido Morris on percussion. Terry was a "real" jazz drummer.

*Joy Will Find a Way* was an evolutionary step, a chipped groove in the rock wall of my psyche where I found a toehold toward a deeper spiritual understanding, political awareness, and musical achievement—things that would become more fully realized with my next album, *In the Falling Dark*.

We recorded *In the Falling Dark* at Eastern Sound in Toronto in the fall of 1976. It was my seventh studio album in as many years, and I was conscious of the project carrying some degree of import. Obviously, it was important to me. I felt as though my songwriting, and my understanding of people and the world around me, had evolved enough for me to feel okay about my work being important to others. *In the Falling Dark* contained several "firsts" in style and content that would carry over to current times.

One of these firsts came in the form of "witnessing" songs, a hint at the more outward-directed material that would come by the end of the decade. I was angry about the suffering wrought by colonialism upon Native peoples in Canada, assailed for hundreds of years by violence, displacement, disease, and discrimination. I was distressed that this ruin was visited on the continent's original inhabitants primarily by people of my race, and I was appalled that it was so often done in the name of Jesus.

*Went to the museum, red brother*
*Saw your ancient bloom cut, pressed and dried*
*A sign said wasn't it clever what they used to do*
*But it never did say how they died*

*Hey hey hey*
*Hey hey hey*

*Went to Regina, red sister*
*Heard a cab driver say what he'd seen*
*"There's a grand place to eat out on Number One*
*All white ladies if you know what I mean"*

*Hey hey hey*
*Hey hey hey*

*Went to a powwow, red brother*
*Felt the people's love/joy flow around*
*It left me crying just thinking about it*
*How they used my saviour's name to keep you down*

*Hey hey hey*
*Hey hey hey*

"RED BROTHER RED SISTER," 1976

Native peoples remain largely hidden in the Americas, often living in enclaves of poverty on marginal lands called reserves in Canada and reservations in the United States. With a few exceptions, these were usually the least desirable lands at the time Native peoples were sent there—until oil or uranium or trees with newfound value were discovered, at which time another scheme would again remove people from their homes, or simply run them over.

When I was a kid in Ottawa, my peers and I barely knew that Indians existed, outside of Tonto and Chingachgook and all those western movie extras (almost always Anglos smeared with pigment) falling off their horses. Canada's federal government, though, was well aware of aboriginal struggles. Ottawa began regulating Native existence soon after the nation's birth, primarily through eleven treaties signed (often with an "X" by Native leaders, who didn't understand English) between 1871 and 1921. Today the lives of Canada's Native peoples are assigned to the office cubicles of the aptly titled Aboriginal Affairs and Northern Development Canada. Poverty remains critical, along with the diminishing health of the natural environment on which many far-flung communities depend. At the same time, Canada's Native populations have fought, with increasing skill, for their rights, and today continue to achieve incremental gains.

Kitty and I came to know a few Native people during our journeys through the west. Among them was Shingoose (born Curtis Jonnie), an Ojibwe from the Roseau River First Nation who was taken from his birth family and turned over to Mennonite missionaries in Manitoba at the age of four. They were just doing him a favour, of course, lifting him out of the natural inferiority of his race. Shingoose sang in choirs and progressed to a life in professional music and media, but he remained committed to reversing some of the damage done by the wrenching of aboriginal children from their families and entire tribes from their traditional lands. I met Shingoose in the early seventies in Winnipeg. In 1975 I produced a record, an EP, of him performing his songs for a label established by the Native Council of

Canada, Native Country. He also sings on my 1978 album *Further Adventures Of*.

Tom Jackson is a Cree from Saskatchewan who moved to Winnipeg when he was fourteen and soon dropped out of school. He became a highly honoured singer and actor (we are fellow Officers of the Order of Canada), but in his youth he'd run with some rough company in a motorcycle gang. In the mid-seventies he and I played a couple of times, along with other artists, at the medium-security Stony Mountain Institution in Manitoba, conveniently located not far from Winnipeg, the Canadian city with the highest proportion of aboriginal inhabitants (10 percent of the city's population). I met an inmate there who happened to be one of Jackson's acquaintances from the motorcycle days. Daryl was a black man who had killed someone in a bar fight. Jackson, like Shingoose, was, with brains and luck, able to pull himself out of poverty and disaffection to be in the vanguard of a general, gradual movement of his people toward self-respect and self-determination. Daryl and a fellow inmate, a young, skinny long-haired guy who was two years into a five-year sentence for dealing pot, became parts of a composite character that showed up in my song "Gavin's Woodpile," a lament for humanity's failure to honour the freedom of personal space, for the necessity of the natural surroundings, and for the injustice of industrial encroachment on an already oppressed people.

In May 1970, about the same time that Kitty and I left on our "nonworking Canadian vacation," the government of Ontario banned commercial fishing in the English-Wabigoon River system due to massive mercury contamination caused by the Canadian pulp industry. A caustic soda plant on this river system, north of Kenora, Ontario, had dumped tons of ethyl mercury into the once pristine water, disastrously impacting the ecosystem and the health of aboriginal people downstream. (Caustic soda is used to bleach wood pulp in manufacturing paper.)

Pulp was and remains one of the largest industries in Canada. For eight years, beginning in 1962, Dryden Chemicals Ltd. simply

dumped its waste, including ten tons of mercury as well as other contaminants, into the vast river system. One hundred miles downstream the mercury reached the Grassy Narrows Reserve, home of the Asubpeeschoseewagong First Nation; after another hundred miles it hit the White Dog Reserve and the Wabaseemoong people. (And people reached the mercury as well, as they travelled great distances along the river to fish.) The contamination was devastating to these Ojibwe people. They relied on fish such as walleye, pike, large-mouth bass, and whitefish both for sustenance and as a source of income for the many Native fishing guides and commercial fishermen who lived in the region.

Kitty and I developed friendships in Winnipeg, the capital of Manitoba, where I would play. Winnipeg is 150 miles from Kenora, Ontario, the town closest to the contamination. Kitty had an aunt and uncle who had a cottage there, where we stayed on occasion, often enough to feel some relationship to the area. One year, not long after playing a gig in Winnipeg at which I introduced "Gavin's Woodpile" with a discussion of local mercury contamination, I got a letter from a white resident of Kenora who had been at the show. She asked if I had ever been to her town to see the "drunken Indians laying all around." Had I heard about the "disgraceful Indian wife-beaters"? She even used the term "our Indians." Indeed, you couldn't help but notice people staggering, lying in the road, acting oddly, apparently drunk. Many Native communities have a problem with alcohol and other forms of substance abuse, but mercury poisoning produces symptoms similar to drunkenness. So what was really going on here? Did anyone care?

Much is known about the interaction of mercury and human tissue in Ontario, not because the government launched an immediate investigation—it did not—but because a team of Japanese scientists did. In 1975 four researchers from three Japanese universities arrived in Kenora to survey aboriginal health along the English River. The Japanese took an interest because the largest and most devastating case of mercury poisoning in history occurred in the coastal city of

Minamata, Japan, where residents were plagued with similar but inexplicable neurological symptoms, including numbness and pain in limbs and around the mouth, vision and hearing impairment, ataxia (loss of muscular control), and an inability to walk properly, followed by mental impairment, limbs painfully twisting, convulsions and, finally, death. At least a hundred people died in Minamata as the result of mercury poisoning, and hundreds, possibly thousands, were sickened by it.

Like Canada's Ojibwe people, residents of the Japanese town were fish eaters. Mercury was bioaccumulating in the seafood of Minamata Bay because that's where the Chisso Chemical Corporation was manufacturing, among other products, acetaldehyde, which is used as a binder for paints, as a plasticizer for plastics, and in several other applications (including as a flavour enhancer for certain foods). Mercury sulfate was used to catalyze the chemical reaction needed to make acetaldehyde. The researchers who discovered the cause of the deaths estimated that Chisso released a whopping six hundred tons of mercury into Minamata Bay, an amount so copious that it later was found to be cost effective to mine the substance from the outfall and sell it on the open market. Because the mercury poisoning in Japan was a new, human-caused affliction, and endemic, it became known as Minamata disease.

According to Dr. Masazumi Harada, who led the Japanese team investigating mercury contamination in Canada, to this day the Canadian government will not use the term "Minamata disease" to describe what attacked the aboriginal peoples of northwestern Ontario. In 2010 Harada and his team returned to Kenora to follow up on his previous study, and in 2011 he released a new report that said, "[T]he impact [of mercury poisoning] on the health and socioeconomic life of the people throughout the area is immense. . . . Local people still eat a lot of fish." The report also revealed that out of 160 people tested in 2010, 59 percent suffered symptoms of mercury poisoning. By 2010 *all* of the individuals who in 1975 tested above the government's mercury safety guideline of fifty parts per million

were dead. Today, of the ten tons of mercury dumped by Dryden into the English-Wabigoon River system, nearly five tons remain at the bottom of Clay Lake, which is near the former Dryden plant and upriver of the reserves.

*Working out on Gavin's woodpile*
*Safe within the harmony of kin*
*Visions begin to crowd my eyes*
*Like a meteor shower in the autumn skies*
*And the soil beneath me seems to moan*
*With a sound like the wind through a hollow bone*
*And my mind fills with figures like Lappish runes of power. . .*
*And log slams on rough-hewn log*
*And a voice from somewhere scolds a barking dog.*

*I remember a bleak-eyed prisoner*
*In the Stony Mountain life-suspension home*
*You drink and fight and damage someone*
*And they throw you away for some years of boredom*
*One year done and five more to go —*
*No job waiting so no parole*
*And over and over they tell you that you're nothing. . .*
*and I toss another log on Gavin's woodpile*
*and wonder at the lamp-warm window's welcome smile.*

*I remember crackling embers*
*Coloured windows shining through the rain*
*Like the coloured slicks on the English River*
*Death in the marrow and death in the liver*
*And some government gambler with his mouth full of steak*
*Saying, "If you can't eat the fish, fish in some other lake.*
*To watch a people die—it is no new thing."*
*And the stack of wood grows higher and higher*
*And a helpless rage seems to set my brain on fire.*

*And everywhere the free space fills*
*Like a punctured diving suit and I'm*
*Paralyzed in the face of it all*
*Cursed with the curse of these modern times*

*Distant mountains, blue and liquid,*
*Luminous like a thickening of sky*
*Flash in my mind like a stairway to life —*
*A train whistle cuts through the scene like a knife*
*Three hawks wheel in a dazzling sky —*
*A slow-motion jet makes them look like a lie*
*And I'm left to conclude there's no human answer near. . . .*
*But there's a narrow path to a life to come*
*That explodes into sight with the power of the sun*

*A mist rises as the sun goes down*
*And the light that's left forms a kind of crown*
*The earth is bread, the sun is wine*
*It's a sign of a hope that's ours for all time.*

"GAVIN'S WOODPILE," 1975

The laments of "Gavin's Woodpile" were real. The prisoner was real. The mercury poisoning was certainly real. The hawks eclipsed by a jet were real. The rapid transformation of the great Canadian west was real. And my anger was real. I think listeners got that. Writers began claiming that I was now a "protest singer," despite the facts that "Gavin's Woodpile" was the only song of its kind on the album, and that I'd put out a few politically oriented songs in the past (such as "Going Down Slow" and "Burn" and, to a lesser extent, "January in the Halifax Airport Lounge"). Nobody said anything about my being a protest singer when those songs came out. But it's clear I was heading somewhere else on this album and on that song— clear enough for Ottawa journalist Christopher Cobb, in 1977, to note

that "we may be witnessing a metamorphosis: Bruce Cockburn developing into an aggressive, hard-hitting protest singer. . . . He says his latest album, *In the Falling Dark*, is the start of a new direction, but doesn't know where it will lead. It's obvious, though, that 'Gavin's Woodpile,' a song on that album, is a pretty good indication." Interestingly, though, my very politically engaged brother Don found the song "politically offensive" because of the "no human answer near" part.

I'm lavishing ink on Canada's mercury contamination because it's a stark firsthand example of how industrial "progress" often impacts the world's poor and powerless, something that, since the late 1970s and especially throughout the 1980s, I have spent a great deal of my life and artistic output witnessing and recounting. Mercury occupies a keystone position in my evolution as an artist-correspondent.

Over my lifetime economic and military actions by the world's wealthy have come to dominate human life—all life. In Mozambique and Mali, Iraq, Afghanistan and Nepal, Honduras and Spain, Chile and Cambodia, Nicaragua, New Brunswick and South Dakota, I have seen and felt the human and environmental devastation that shortsighted economic structures, created by the world's ruling classes, inflict primarily on the poor (though we are all in the crosshairs) and on the wild, God-given ecosystems of this beautiful blue-green planet. I have spoken with victims (or their next of kin) of the market's march across the globe; I have seen the open pit mines, the gas flares, the endless clear-cuts; I have stepped gingerly through farmlands turned to minefields and hunkered down in an ancient Mesopotamian city transformed to a trillion-dollar free-fire zone. I have found myself facing cagey soldiers and trigger-happy paramilitary cops whose charge (whether or not they realized it) was largely to quash the calling-to-account of the rich by the poor.

As if a twisted message from Ouroboros (the serpent eating its own tail), we have reached a point in human cultural evolution where even the cataclysms wrought by corporations and their government-military proxies—and by nature itself, as it too becomes a sort of

weapon under climate change—are treated as exploitable resources. Author and activist Naomi Klein has dubbed this business model "disaster capitalism." Civil war? Sell guns to both sides. Earthquake in Haiti? Create shell organizations to siphon aid money. Exponential rise in lifestyle-generated diabetes? Develop and market new drugs. Climate change melting the Arctic? Open the Northwest Passage and drill for oil. The examples are legion.

There is plenty in life to protest, but I did not write "Gavin's Woodpile" (or anything else) as a protest song. It was a personal lament, a cry of spiritual anguish that arose from feeling helpless in the face of endless assaults against people and the land. Each of these injustices became a personal affront. I'll be challenged on this, perhaps rightfully so, but I have never intended that my songs "protest" anything. They are attempts to share observations, both of the world around me and of my feelings about what I see.

It has to be art. There's an important line to be drawn between art and propaganda, a line easily blurred. Certainly nothing is blurry about Stalinist-era propaganda posters, with their very effective graphic design, or Leni Riefenstahl's imaginative and technically advanced films celebrating Nazi ideals in thirties Germany. In these cases the Soviets and the Nazis were trying to stimulate support for otherwise insupportable regimes.

My goals are different. I want to paint sonic pictures of what I encounter, feel, and think is true. The songs are not about trying to convince you to rally against the G8 (though I might celebrate it when you do by singing at your protest) or demand a return of land to displaced aboriginal peoples (ditto). I don't like the idea of preaching—although I've been accused of it, usually by critics annoyed at anything that doesn't conform to their brand of cynicism. The injustices that spike my visions are in the songs because they matter, because they have touched me. Sometimes they show up immediately, sometimes later. I learned about the murder of American Indian Movement activist Anna Mae Aquash, a member of the Míkmaq First Nation of Nova Scotia, shortly after it hap-

pened, at the Pine Ridge Reservation in North Dakota, in the aftermath of Wounded Knee in late 1975. In 1986 she found her way into a song.

*From Tierra del Fuego to Ungava Bay*
*The history of betrayal continues to today*
*The spirit of Almighty Voice, the ghost of Anna Mae*
*Call like thunder from the mountains—you can hear them say*
*It's a stolen land*

*Apartheid in Arizona, slaughter in Brazil*
*If bullets don't get good PR there's other ways to kill*
*Kidnap all the children, put 'em in a foreign system*
*Bring them up in no-man's-land where no one really wants them*
*It's a stolen land*

*Stolen land—and it's all we've got*
*Stolen land—and there's no going back*
*Stolen land—and we'll never forget*
*Stolen land—and we're not through yet*

*In my mind I catch a picture—big black raven in the sky*
*Looking at the ocean—sail reflected in black eye —*
*Sail as white as heroin, white like weathered bones —*
*Rum and guns and smallpox gonna change the face of home*
*In this stolen land. . . .*

*If you're like me you'd like to think we've learned from our mistakes*
*Enough to know we can't play god with others' lives at stake*
*So now we've all discovered the world wasn't only made for whites*
*What step are you gonna take to try and set things right*
*In this stolen land*

**"STOLEN LAND," 1986**

Is this propaganda? Admittedly, I do ask listeners what step they might take to "set things right," but this is pretty much the only song of mine that explicitly challenges the listener to do something. "Stolen Land" is a rare instance of a piece that was created deliberately on a chosen theme. I wrote the lyrics (the music is by Hugh Marsh and me) to have something relevant to perform at a benefit concert in Vancouver. The show was in support of the Haida First Nation and their claim to lands in what used to be known as the Queen Charlotte Islands, now renamed Haida Gwaii as part of a settlement deal reached in 2007 between the Haida and the Canadian government. The granting to the Haida Management Authority of much of this rich island ecosystem off the northern British Columbia coast represents a rare victory for Native peoples in North America. Eighteen hundred miles east, on the English River, there has been no such "victory" for the Asubpeescho-seewagong and Wabaseemoong peoples, who remain plagued by mercury contamination and have been vastly undercompensated for their great losses of life, health, and homeland. In "Gavin's Woodpile" I was able

*With Haida artists Bill Reid (seated) and Robert Davidson at a press conference for Haida, 1986. Robert's painting* Raven Brings Light to the World *was the cover art for* Waiting for a Miracle.

to harness my anger and effectively represent it; you can hear it in my voice, certainly in the words, and perhaps even in the guitar's intentionally slicing sound, but I'm not trying to persuade people to act as much as to paint as vivid a picture as I can. Make of it what you will.

Another important, and intentional, element of *In the Falling Dark*

is the prominence of jazz throughout the album. I lacked the guitar chops to provide the jazz myself, but by 1976 I was confident enough in my skills to gather a group of players whose abilities obviously surpassed my own: Michel Donato on bass, Bob DiSalle on drums, and Kathryn Moses on flutes and piccolo. Freddie Stone played brilliant and somewhat crazed flugelhorn and trumpet. On songs that did not call for that flavour we used Jørn Anderson on drums and Dennis Pendrith on bass. Bill Usher provided percussion throughout. Though many of the musicians came from the top echelon of the Toronto session scene, the music is consciously collective in intent. We were going for the sound of a band rather than that of a singer-songwriter with studio backup.

*In the Falling Dark* also offered what might be characterized as a refinement of Christian lyrical content. It is the album that *Joy Will Find a Way* was resolving toward. When I was writing songs for *Salt, Sun and Time* and *Joy Will Find a Way*, my Christianity was somewhat fundamentalist in nature. As a new Christian I wanted to understand what it was I had signed up for, and the voice of fundamentalism—that is, you do and believe what the Bible says you should do and believe—roared loudest in claiming to have the answers. By 1975, when I began writing the songs that make up *In the Falling Dark*, I had shucked most of what I began to see as shackles of fundamentalism in favour of a less tribal and more questioning search for understanding. *Joy Will Find a Way* mentioned Jesus more than *In the Falling Dark*, but on the later album I was clearer about what it meant, for me, to be a practicing Christian. My faith had developed. The songs are perhaps more accessible to a broader spectrum of listeners, which was not necessarily the intent, but was the result, because I'd moved beyond fundamentalism toward mystery. The fundamentalists emphasize a personal relationship with Christ, but they often constrain this possibility with rigid cultural elements that have little to do with the spirit. The "spiritual" songs are about celebrating the Divine and our place in the cosmos, and doing so from a place of seeking, from a desire to know, as best we can, the heart connection with

God, however one might define such an entity. I wrote the opening song, "Lord of the Starfields," as an attempt at a Psalm. It came to me one clear summer night, walking on a gravel road near my friend Eric Nagler's cabin at Killaloe, Ontario. The road was lined with dark walls of dense spruce and cedar. Deep space overhead, far from urban light spill, blazed with millions of distant nuclear furnaces. All the way to the edge of everything, love resounded.

*Lord of the starfields*
*Ancient of Days*
*Universe Maker*
*Here's a song in your praise*

*Wings of the storm cloud*
*Beginning and end*
*You make my heart leap*
*Like a banner in the wind*

*O love that fires the sun*
*Keep me burning*
*Lord of the starfields*
*Sower of life,*
*Heaven and earth are*
*Full of your light*

*Voice of the nova*
*Smile of the dew*
*All of our yearning*
*Only comes home to you*

*O love that fires the sun*
*Keep me burning*

"LORD OF THE STARFIELDS," 1976

My songs are influenced by what I read, where I travel, and what I witness. "Silver Wheels," the sixth song on *In the Falling Dark*, reflects all of these things. At the time I was particularly excited by Allen Ginsberg's latest work, *The Fall of America*, published in 1973. That Ginsberg book in particular resonated with the longer poems of early-twentieth-century Swiss/French poet Blaise Cendrars, an important figure in the Cubist movement. Hawkins had introduced me to his work in the previous decade. Cendrars was so in love with words that he would collect thousands of them—from the dictionary, from ancient edicts—then use them all in a book. He produced marvellous travel poems—*The Prose of the Trans-Siberian*, for example, and *Panama, or the Adventures of My Seven Uncles*—that span the globe and ring with a mythic quality. Ginsberg is less myth, more industrial grit. "Silver Wheels" falls somewhere between the two and represents a documentary style that I still employ. I try to create vivid scenes and then, as a filmmaker would do, juxtapose them in such a way that they add up to something bigger than each is on its own. Readers familiar with *The Fall of America*, a collection of poems that capture Ginsberg's travels through the United States, will see right away the influence that book had on *Silver Wheels*.

*High-speed drift on a prairie road*
*Hot tires sing like a string being bowed*
*Sudden town rears up then explodes*
*Fragments resolve into white line code*
*Whirl on silver wheels*

*Black earth energy receptor fields*
*Undulate under a grey cloud shield*
*We outrun a river colour brick red mud*
*That cleaves apart hills soil rich as blood*

*Highway squeeze in construction steam*
*Stop caution hard hat yellow insect machines*

*Silver steel towers stalk rolling land*
*Toward distant stacks that shout "Feed on demand"*

*A hundred miles later the sky has changed*
*Urban anticipation—we get four lanes*
*Red orange furnace sphere notches down*
*Throws up silhouette skyline in brown*

*Sundogs flare on windshield glass*
*Sudden swoop skyward iron horse overpass*
*Pass a man walking like the man in the moon*
*Walking like his head's full of Irish fiddle tunes*

*The skin around every city looks the same*
*Miles of flat neon spelling well-known names*
*USED TRUCKS DIRTY DONUTS YOU YOU'RE THE ONE*
*Fat-wheeled cars squeal into the sun*
*Radio speakers gargle top-forty trash*
*Muzak soundtrack to slow collapse*
*Planet engines pulsate in sidereal time*
*If you listen close you can hear the whine*

"SILVER WHEELS," 1976

In 1995 the *New York Times* music writer Stephen Holden told Daniel Keebler that *In the Falling Dark* was his favourite of my albums. (Interestingly, the interview came out shortly before the release of my 1996 album, *The Charity of Night,* and the subsequent *Breakfast in New Orleans Dinner in Timbuktu*—which, along with *In the Falling Dark* and whichever CD is newest at the time you ask me, are probably the records of mine with which *I* am most satisfied.) "The lyrics," said Holden, "especially in 'Lord of the Starfields' and 'In the Falling Dark,' have the kind of imagery that makes me see through his eyes in a way no other songs have done quite so well.

That album has a kind of visionary, spiritual/romantic directness that I think eclipses anything else he's done, although this quality is all through his music." Whether or not one agrees with Holden's assessment of the album, he understood what he was hearing.

Keebler asked Holden for his views on why I wasn't as popular in the United States as in Canada. Holden was blunt.

"The kind of moral debates that go on in his songs are, I think, slightly over the head of the mainstream pop audience in the United States. There's something *very* Canadian about his music, too, in its spareness in the pictures of the landscape, that maybe Americans in the 'mall culture' don't really relate to. He's not a self-promoter, not the way American pop stars are, or the way big Canadian pop stars are. He doesn't have that lust for fame, that *obvious* lust for fame, that most stars these days seem to have. There's a remove or detachment about him that prevents him from reaching a mainstream audience."

*In the Falling Dark* coincided with another new direction. On July 14, 1976, Bastille Day, after fifteen hours of labour, Kitty gave birth to our daughter, Jenny. This was something Kitty had been eager for—she wanted a child—and one day she recounted what she felt was an angelically inspired vision of "a being" who was waiting to come into the world. I did not share her enthusiasm for the project, but I believed her and was committed to her, so I went along. We didn't have a great sex life, but we managed to pull it off and get ourselves pregnant. In due course a beautiful baby was born, though it took a day or two for the beauty to shine through. I got in trouble right away for remarking that she looked a bit like Idi Amin. Well, what the hell . . . she did. I thought it was funny. Newborns always have the look of old folks who are very unhappy to be back in the world. It fades over their first few days. I was in love with her even before she was born, and the passing resemblance to the brutal dictator did not shake that.

> *Little seahorse*
> *Swimming in a primal sea*
> *Heartbeat like a*
> *Leaf quaking in the breeze*

*I feel magic as coyote*
*In the middle of the moon-wild night*

*In the forge-fire time*
*Your mother glowed so bright*
*You were like a*
*Voice calling in the night*
*And I'm watching the curtain*
*Rising on a whole new set of dreams*

*The world is waiting*
*Like a Lake Superior gale*
*A locomotive*
*Racing along the rail.*
*It'll sweep you away*
*But you know that you're never alone*

*Little seahorse*
*Floating on a primal tide*
*Quickening like a*
*Spark in a haystack side*
*I already love you*
*And I don't even know who you are*

"LITTLE SEAHORSE," 1975

We were going to need a bigger camper. I traded in the old Dodge pickup, with its 318-cubic-inch engine and makeshift accommodations, for a Chevy three-quarter-ton with a beastly 454 engine and a large, commercially made camper that extended over the cab and weighed a ton. I naively imagined us just travelling along as we always had. We tried it once, on the first leg of a lengthy tour following the release of *In the Falling Dark*. Inevitably Kitty found herself in the back of the truck nursing the baby, changing diapers, wishing she had a warm home and a fire to curl up by and something to do besides sit in the

Styrofoam camper all day tending to Jenny, since I disappeared as soon as we got to the next hall. None of this helped our marriage.

Nor did my travel regimen following release of *In the Falling Dark*. I was so wedded to the road that I wrote "Silver Wheels," a road song, a week after Jenny was born. I definitely spent time at home—in fact,

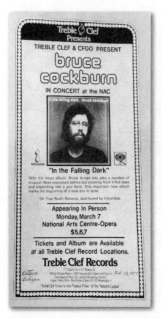

I even put in a short, miserable stint as a "youth leader" at St. George's church—but I was gone, or at least distracted.

I took myself, and my work, very seriously. It's the nature of artists to believe that what they have to say is going to matter to the world at large. I felt a great burden to create more and better and deeper words and music. I had no tolerance for anything that might interfere with this important endeavour. To this day I wince whenever I recall the morning that Jenny, who was two at the time, came smiling into our sunroom where I was practicing, carrying her little plastic Mickey Mouse guitar. It had nylon strings and pictures of Mickey on the white top. She was excited to come in and play along with Daddy. Daddy, however, was caught up in the pressure of having to get a repertoire ready for some occasion or other. I snapped at her to be quiet. Jenny burst into tears, crushed. I was so immersed in my own thing that I didn't recognize the beauty and import of the moment. I saw it immediately afterward, but you can never get back those missed opportunities. Jenny and I have since talked about the incident, but I'm not over it. I'll always regret it.

The memory flooded back twenty years later while I played a duet, filmed for Canadian television, with the great Malian musician Toumani Diabaté, at his house in Bamako. In the middle of the song his two-year-old son toddled into the courtyard where we were playing, clambered onto his dad's lap, and started plucking at the strings of

Toumani's kora. Dad simply beamed. He was proud. I thought, "That's how it should have been. Even if I had been performing on national TV, Jenny should have been able to wander out and play with me." But that wasn't me back in the day.

On the first *Falling Dark* tour, when we finished the shows in British Columbia, Kitty and Jenny flew home and the band went back in their van. I drove the long road solo. It was one of the few times during the next three decades that I would journey alone across Canada, something I would come to miss as we began hiring tour buses and flying. I got a few songs out of the trip, some of which appeared on the next two albums. A visit en route to an uncommercialized hot spring in the Slocan Valley produced a sketch of some verses that didn't get completed for another two decades. Such is the timeline of the poet. The stories evolve forever.

*Here come those silver celestial horses*
*Rays of the moon in the mountain air*
*I'm steeped in the steam of the last wild hot spring*
*Maybe I'm melting but I don't care*
*There's darkness in the canyon*
*But the Light comes pounding through*
*For me and for you*

*Tomorrow may be a hissing blowtorch*
*May be a silken sky shaken by the wind*
*That whirls in the wake of those whispering horses*
*But there's always a pillar of cloud on the valley's rim*
*There's darkness in the canyon*
*But the Light comes pounding through*
*For me and for you*

*Still river full of the depths of candles*
*Burning for the free ones riding on the other shore*
*Even at the heart of these breathing shadows*

*You can feel us gathering at the door*
*There's darkness in the canyon*
*But the Light comes pounding through*
*For me and for you*
*For me and for you*

"CELESTIAL HORSES," 1978/2001

The music on *In the Falling Dark* cried out for a band for its live presentation. Up to this point my appearances had virtually all been solo. I was getting tired of my own company onstage anyway, so I thought, "Let's mix things up." My first road band came to consist of Pat Godfrey on piano, Bill Usher on percussion, and Robert Boucher—who was with the Hamilton, Ontario, symphony—on acoustic bass. It was such a musical and interesting band that we splurged and recorded a live album during a two-night stand in April 1977, at Massey Hall in Toronto. We wanted to capture the sound and feel of the august and vibe-rich venue, so we hired an expensive remote recording outfit out of New York called Fedco. We also hired a piper from one of the Canadian army's Highland regiments, P.M. Doug Mackay, to welcome the audience. He marched from the back of the hall to the foot of the stage as an opening for each show. (Love of the Highland great pipes came with my DNA.) I was nervous and didn't perform very well on the first night, so almost everything on the live album, *Circles in the Stream*, is from the second night.

Around the same time the quickly growing label Island Records picked up *In the Falling Dark* for international distribution, which got the record noticed in Europe, particularly Italy, and Japan, and it circulated in the States as well. It was my first record to chart in the United States, reaching number 191(!) on the *Cash Box* magazine album list. Not long prior I would have shrugged and stayed home, but now I felt ready to stretch outward from Canada. I did some shows in the northeastern U.S., then went to Japan and Italy, finishing off an autumn's worth of performances for non-anglophone audiences

with a two-week tour of Quebec. Who knows what they thought I was saying? In fact, language was less of an issue for me in Quebec, as I had written a couple of songs in French and we had, from the third album on, included translations of the lyrics in the album packaging.

In 1978 we released *Further Adventures Of.* The album was mostly acoustic, with some rocky edges here and there. We made good use of Beverly Glenn-Copeland's stunningly rich vocal timbre on "Rainfall" and "Can I Go with You." "Bright Sky" was a celebration of the wild Yukon set to a brisk guitar part inspired by traditional Swedish fiddling. "A Montreal Song" grew out of an encounter with an elderly stranger one afternoon on the Sparks Street Mall in Ottawa. He picked me out of a crowd in a café and without apology or excuse asked if I would buy him a coffee. I did, and invited him to sit with me. His ruddy, round face encircled lively eyes under pale, bushy brows. He wore a tweed jacket and a red plaid shirt with a green tartan tie and had a lot to say about God and the importance of a spiritual life. That night in a Montreal hotel room, the television screen blazed with rocketry as Beirut blew itself to bits. These things wove themselves together into the song.

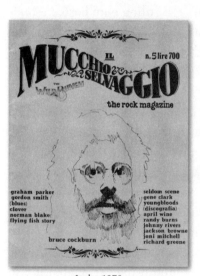

*Italy, 1978*

"Outside a Broken Phone Booth with Money in My Hand" starts with a moment of disaffection in Toronto and goes both inward and outward. The image of the circles in the stream had of course been used as a title for the previous album, but it seemed to belong to this song as well, as a picture of the randomness of ideas. Finally comes "Nanzen Ji," a song I kept sparse in honour of the elegantly simple

Kyoto temple in which it's set. It's the last song on the album, and as its final chord is dying away, Aroo's bark is heard just outside the studio door.

"Feast of Fools" was written on the electric guitar, as was "Phone Booth." Gene Martynec plays a tense guitar lead. Is it a protest song? Perhaps in a way: there is a lament to be found there, something about a species that has always fed upon itself and everything else in its path. The song's conceit comes from the Middle Ages of northern Europe, where for hundreds of years the ruling elite hosted a mid-winter Feast of Fools that upended the social order for a day. The annual event took various forms and was observed throughout medieval and Renaissance Europe, particularly in France and the Low Countries. The village idiot or some other unfortunate would be paraded through town with a mock crown on his head and pelted with rotten food and the occasional turd. It was the only day you could call the king a fink with impunity. The aristocracy tolerated this safety valve because they knew that maintenance of the status quo required that their underlings be able to vent the frustration and rage that went with being so far under. (They didn't yet have TV.) The song was inspired in part by theologian Harvey Cox's book of the same title. It embraces Jesus's declaration, hopeful or ominous, "Blessed are the meek, for they shall inherit the earth," but it also reflects how, in my lifetime, Western nations have devolved from neoconservatism to neoliberalism to neofeudalism. I didn't play the song much after 1980, but twenty years later I brought it back, given how things were going.

*At the feast of fools*
*Humour can sometimes be cruel*
*But under certain conditions*
*You have to forget the rules*

*At the feast of fools*
*Everybody has a voice*

*Nobody goes to the bottom*
*Except by their own choice*

*It's time for the silent criers to be held in love*
*It's time for the ones who dig graves for them to get that final shove*
*It's time for the horizons of the universe to be glimpsed even by the*
*faceless kings of corporations*
*It's time for chaos to win and walk off with the prize which turns out to*
*be nothing*

*At the feast of fools*
*Outlaws can all come home*
*You can wear any disguise you want*
*But you'll be naked past the bone*

*At the feast of fools*
*People's hands weave light*
*There is a diamond wind*
*Flowering in the darkest night*

*It's time for the singers of songs without hope to take a hard look and*
*start from scratch again*
*It's time for these headlights racing against inescapable dark to be just*
*forgotten*
*It's time for Harlequin to leap out of the future into the midst of a world*
*of dancers*
*It's time for us all to stand hushed in the cathedral of silence waiting at*
*the river's end.*

"FEAST OF FOOLS," 1977

My friend Alan Whatmough turned me on to Thomas Merton, the famous Trappist monk, writer, social justice advocate, and jazz lover who wrote more than seventy books. I discovered Teilhard de

Chardin, the Jesuit priest/paleontologist whose writings defied Church doctrine, and behind him I found a trail of Christian mysticism I had not known existed, a strain so powerful that it had been strategically sidelined by mainstream church leaders whose temporal power was anchored in mythic history and rule-making.

As for C. S. Lewis, I read a lot of his books, and though I never completely accepted all of his conclusions, I appreciated his willingness and ability to reason, as a Christian apologist and Oxford professor: to study and philosophize around the Divine and to articulate his careful insights. His little literary group, the Inklings (members included J.R.R. Tolkien, Dorothy L. Sayers, and Charles Williams, among others), produced volumes of inspiring, insightful, and even revolutionary writings—none more so than Williams, who was a terrible writer but had an astounding vision of how Divine/human interaction works. When a fan gave me a copy of *War in Heaven*, I discovered a Christian author whose background in the occult paralleled my own. Williams was able to spin stories that respected the more worthy of those disciplines by giving them a place in the Christian universe. I steamed through all seven of his novels and a volume of very dense poetry in the period between recording *Further Adventures Of* and the album that followed, *Dancing in the Dragon's Jaws*.

Though *Further Adventures Of* contains numerous biblical references, I don't call out to Jesus directly except on "Can I Go with You," which I describe as "joyfully apocalyptic." Beverly is a Buddhist, but after singing her part she told me how much she liked the song. I said, "You're okay with the imagery being so Christian?"

"Oh yeah," she said. "I can picture the bodhisattvas riding out of the heavens to claim their own."

I wrote the song in the dead of winter. Except for a brief period when I was approaching fifty, I have always loved that time of year. I love the energizing drama of winter descending, the season's starkness, its high-contrast visuals. I like the adrenaline that comes with driving in blizzards. The prospect of winter softening into spring, with its sense of renewal and rebirth, carries its own delicious feeling.

*When you ride out of the shining sky*
*To claim the ones who love you*
  *Can I go with you?*
  *Can I go with you?*

*When the angel shouts from the heart of the sun*
*And the living water flows down*
  *Can I go with you?*
  *Can I go with you?*

*When the earth and stars melt like ice in the spring*
*And a million voices sing praise*
  *Can I go with you?*
  *Can I go with you?*

"CAN I GO WITH YOU?," 1976

# 9

*Centred on silence*
*Counting on nothing*
*I saw you standing on the sea*
*And everything was*
*Dark except for*
*Sparks the wind struck from your hair*
*Sparks that turned to*
*Wings around you*
*Angel voices mixed with seabird cries*
*Fields of motion*
*Surging outward*
*Questions that contain their own replies. . .*

*You were dancing*
*I saw you dancing*
*Throwing your arms toward the sky*
*Fingers opening*
*Like flares*
*Stars were shooting everywhere*
*Lines of power*
*Bursting outward*
*Along the channels of your song*
*Mercury waves flashed*
*Under your feet*
*Shots of silver in the shell-pink dawn. . .*

"CREATION DREAM," 1978

I didn't study dreams back in the sixties and seventies, but their impact was expansive. I did not retain many, and the ones that stayed with me were mostly nightmares. Some of those stuck with me a long time, retaining their capacity to get my nervous system rippling. In one of them, a pride of ferocious lions attacked Bill Hawkins's house, where I was living. They prowled around the exterior at first, looking for a way to gain entry. Suddenly they were on the ground floor, then mounting the stairs. I tried to barricade the door of my room, but the lead lioness shouldered through, jaws dripping. I woke up shaking and sweating.

Years later, in early 1979, Kitty and I had dinner with my cousin Doug in a classy little restaurant in Gatineau, then known as Hull, on the Quebec side of the river. He was well into a long career in the world of national security. He was privy to a lot of information he couldn't share, though we knew his work involved the interception and analysis of encoded transmissions, military and otherwise, to and from several countries. At the time there was a lot of sabre rattling going on between Russia and China over their shared border. Shots had been fired. A distinct possibility of war between the two nuclear powers hung in the diplomatic air. Doug was worried, and I was inclined to take his worries seriously. Hearing press reports was one thing, but hearing it from him was the *real* thing. He said that NATO and the Soviet Union had a mutual understanding that neither would surprise the other. Spy technology was such that both were very aware of each other's movements and capabilities. China, however, was not part of the deal. Everybody knew China had nukes, but no one had a clue about what they were willing to do with them. Between bites of filet mignon he said, "For all we know, we could wake up tomorrow to the end of the world."

Into the night I ruminated darkly over my cousin's news. Nuclear annihilation was something that my generation had been fretting about since three months after I was born, with the vaporizing of Hiroshima and Nagasaki. Duck and cover and kiss your ass good-bye.

Next morning I awoke to brilliant sunshine. I breathed the fine

air. The scene outside the bedroom window was devoid of smoke and ruined buildings. Once again I rose from a dream about lions prowling Ottawa. But this time, in contrast to the terrifying nightmare of years before, they were calm, regal, and beautiful, and maintained a greater and more comfortable distance. After breakfast I ran some errands, and while driving west on the Queensway I started chanting to myself, "Sun's up, uh-huh, looks okay, the world survives into another day." Those lions were out there somewhere. Or maybe in *here* somewhere.

Back home I pulled together a set of images from my notebooks, mostly word pictures caught in British Columbia, and strung them on a thread of time driving us inexorably toward death. The lightly rolling guitar part came easily. I had been listening to Bob Marley and the soundtrack from *The Harder They Come*, due to a new infatuation with the rhythms of reggae. I had made a point, for a while, of avoiding pop music, but around mid-decade I spun around and began exploring the waters around me. My "discovery" of reggae owed a lot to the presence of my tour manager Stuart Raven-Hill, an affable, casual but confident Englishman with many contacts in Toronto's large West Indian community and a deep knowledge of its music, which he enthusiastically shared. I liked Stuart, who could often be found in the company of his girlfriend, a stunningly beautiful young blonde named Judy Cade.

I incorporated elements of reggae into the otherwise folkie finger-picking pattern of the new song, but when it came time to record I decided to use real players from the genre. I didn't want to be just another white guy watering down someone else's culture. Stuart contacted Jamaican expat singer Leroy Sibbles, who came to the studio with his drummer, Ben Bow, and bass player, Larry "Sticky Fingers" Silvera. Pat Godfrey played a marimba part that approximated the guitar backbeat typical of the style. (Ben Bow told me that the groove we were playing wasn't really reggae but more like blue beat, a precursor.) Leroy, Pat, and I added background vocals. The result, "Wondering Where the Lions Are," became the lead track on a new

album, *Dancing in the Dragon's Jaws*. I was happy with the song, but not at all prepared for what came next.

"I heard about eight bars of 'Lions' and I said, 'I'll take it,'" Jimmy Ienner, president of the New York label Millennium Records, told *Maclean's*, the national Canadian newsmagazine, in 1981, two years after Millennium began distributing *Dancing in the Dragon's Jaws* in the United States. Jimmy and his brother Donny were the genteel tough guys who ran Millennium. They made a point of listening to a lot of new stuff and taking chances on music they liked, not just on what they thought might become popular. It was a successful formula, and Donny ended up becoming president of Columbia Records, which would distribute a few of my albums in the nineties.

Big brother Jimmy had a long history in the record business. (As a teenager, he sang the bass part on Gene Chandler's 1962 number one hit, "Duke of Earl." He told me he also sang the falsetto part.) Donny liked to play poker, which appealed to Bernie, and during games the brothers freely shared tales of the business, sometimes involving the mob. Jimmy had a story about having been shot, while in his teens, for being impudent to some Mafia don. (In 1990 the Seattle band Nirvana visited Columbia in their search for a new label. Donny Ienner told them, "Listen, men, I'm not going to dick you around. We want to turn you into stars." The band liked the message, but Kurt Cobain balked, saying he found Columbia "too mafiaesque, a little too corporate.") Jimmy Ienner went on to produce the soundtrack album for the film *Dirty Dancing*, one of the bestselling records of all time.

When *Dragon's Jaws* came out Donny worked it hard, making the rounds of radio stations, presumably employing the marketing tactic that was routine in those days: introduce the record and the single, glad-hand the DJs and programmers, then ply them with stimulants to get them to play it.

Donny concocted outlandish promotional schemes. Somewhere in the midwestern United States he showed up at a radio station with a lion on a leash, scaring the shit out of everybody. Another time he

arranged for me to appear outdoors at the Philadelphia Zoo at eight in the morning, in January, to be interviewed in front of the lion cage. "Bring your guitar," he said. "They'll want it for photos." I was already in Philadelphia, having performed the previous night. Donny informed me, as we were getting ready to leave our hotel, that I was also expected to play my "hit" in front of the lions.

"I'm not doing that," I said. "I don't even want to take my guitar out of its case. The cold will crack it. I can't sing this early."

"But the people are already there," said Donny. "You have to. You have to show up at the zoo. You have to play!"

"No, I don't."

"Yes, you do, because we sold tickets."

It was an offer I couldn't refuse. There were bleachers in front of the lion cage, populated by a hundred or so shivering guests bundled against the cold. Little clouds of breath billowed around their heads like thought balloons. A half-dozen lions sporting shaggy winter coats were lounging by the bars, staring at us, licking their lips as if we were breakfast. Everything was frozen, awful. I managed to croak out "Wondering Where the Lions Are," barely able to move my fingers, everything recorded by radio and TV. The vague fear I had about the music industry became diamond sharp in that moment.

The Ienner brothers were masters at the game. I could have lived without the Budweiser sponsorship ("This Bud's for Bruce and You"), but I liked the feeling that something was happening. I enjoyed the novelty of limo rides and dinners with music-business movers. Somewhere in New Jersey we opened for Warren Zevon, who was pretty hot then with a hit of his own, "Werewolves of London." Lions and werewolves, go figure. The year before "Lions" peaked at number twenty-one on the Billboard chart, "Werewolves" also reached number twenty-one. For both of us, these songs would be our biggest U.S. hits.

On May 10, 1980, I played "Wondering Where the Lions Are" on *Saturday Night Live*. At that time the band was a four-piece unit, with Bob DiSalle, Dennis Pendrith, and Hugh Marsh, whom every-

body called Hubie. He was a kinetic and very talented young jazz violinist I had met at a charity telethon in Ottawa and snapped up for the *Dragon's Jaws* tour. He was very excited about *SNL*. He was a fan of the show and wanted to meet the cast, which still included many of the early and iconic members. This show, which I hardly ever watched but which everyone else did, was a Big Deal, and I was scared. Live TV is a stressful medium to work in. You're allowed one chance to get everything right. There's no warm-up. If you screw up, you can't make it all better with a dazzling maneuver later in the show. Some people shine in such circumstances. I do not. Program producers had institutionalized an atmosphere of hurry-up-and-wait. We were treated with respect, but the regulars and crew all seemed tense and angry. (Later in the year, *SNL* went through a major casting shake-up.) When we finally got to play, we pulled it off. It was not the finest rendering of the song, but not the worst either, thank God. After the show there was a party in some restaurant. Hubie asked a visibly stressed Steve Martin for his autograph and was given a snarling brush-off. I drank a lot of Laphroaig. Many people saw us. The thing is still out there, floating like a ghost through cyberspace.

*Sun's up, uh-huh, looks okay*
*The world survives into another day*
*And I'm thinking about eternity*
*Some kind of ecstasy got a hold on me*

*I had another dream about lions at the door*
*They weren't half as frightening as they were before*
*But I'm thinking about eternity*
*Some kind of ecstasy got a hold on me*

*Walls windows trees, waves coming through*
*You be in me and I'll be in you*
*Together in eternity*
*Some kind of ecstasy got a hold on me*

*Up among the firs where it smells so sweet*
*Or down in the valley where the river used to be*
*I got my mind on eternity*
*Some kind of ecstasy got a hold on me*

*And I'm wondering where the lions are. . . .*
*I'm wondering where the lions are. . . .*

*Huge orange flying boat rises off a lake*
*Thousand-year-old petroglyphs doing a double take*
*Pointing a finger at eternity*
*I'm sitting in the middle of this ecstasy*

*Young men marching, helmets shining in the sun,*
*Polished and precise like the brain behind the gun*
*(Should be!) they got me thinking about eternity*
*Some kind of ecstasy got a hold on me*

*And I'm wondering where the lions are. . . .*
*I'm wondering where the lions are. . . .*

*Freighters on the nod on the surface of the bay*
*One of these days we're going to sail away,*
*going to sail into eternity*
*Some kind of ecstasy got a hold on me*

*And I'm wondering where the lions are. . . .*
*I'm wondering where the lions are. . . .*

"WONDERING WHERE THE LIONS ARE," 1979

My music found few outlets outside Canada before 1979 primarily because I didn't want it to, which bemused journalists, among others. "Cockburn still has no immediate plans to extend his performing

beyond Canada," wrote Patricia Holtz in *The Canadian* magazine in 1976, after release of *In the Falling Dark*. "In fact, he parted company with his first record distributor, Epic, because he wasn't interested in lengthy tours to promote his songs elsewhere." There's always more to the story: that parting had as much to do with the label's ineptitude as anything else. They put out the first album believing that "True North" was its title, and promoted it that way.

Touring in the United States picked up after "Wondering Where the Lions Are" hit the charts, but even then the schedule was less packed than it might normally be on the heels of a top-forty hit. I grew up with the typically Canadian attitude toward the United States: superiority mixed with admiration, fear, and envy, as if we were the younger of rival siblings born of Mother England (which is more or less the case). My eighteen months in Boston had left me with a slightly jaundiced view of American culture, a distaste heavily tempered by a love of the music, some of the people, the cavalcade of cars and guitars, the movies, the spirit of daring—but these things weren't enough to lure me down there. (Another visitor, Alexis de Tocqueville, said, "Although the desire of acquiring the good things of this world is the prevailing passion of the American people, certain momentary outbreaks occur when their souls seem suddenly to burst the bonds of matter by which they are restrained and to soar impetuously toward heaven." He added, "Religious insanity is very common in the United States.") For a decade I had held to the notion that I should try to build an audience in Canada before I looked elsewhere, and furthermore, I had no interest in being part of the hit machine. Bernie and I would sometimes argue about what, if anything, should be pushed to radio as a single. I didn't really care for the concept.

Once a song becomes a "single" it gets tortured to death, played over and over until everyone's sick of it. The music gets ground in with inane crap and commercials, like audio sausage. I had more love for my songs than that. I don't feel so strongly about it now, but I think these arguments still apply. Have a listen to today's top-forty stations. Every now and then a phenomenon such as Feist breaks

through the miasma, and what a relief that is; otherwise, it's almost wholly unlistenable. An incredible amount of talent (see: Justin Bieber) is sacrificed to the mediocrity of what Paul Klein, who was the "executive of audience measurement" at NBC TV during the 1960s, called the "least objectionable programming" theory: that is (and this is my translation), you overproduce your song or show into a homogenized, white-bread state, until all the edge and experimentation are bled out of it, and then it becomes more palatable—or, conversely, less objectionable—to more people, so audience numbers remain high. That is, people won't change the channel, which means the commercials will reach their target.

It also bothered me that for Canadians to get accepted as legitimate artists—and this is part of our national pathology—we had to first sell ourselves to New York or Los Angeles or London for a stamp of approval before being accepted by our public. So I went in the other direction and set out to build an audience in my own country before I looked elsewhere.

I remember getting into an argument with somebody on an Ottawa street one day about whether Joni Mitchell was Canadian. "She couldn't be; she's too good," he said. That dreary cluelessness typified Canadians' self-perception in those days.

The quirky Canadian comic Jeremy Hotz, who lives in L.A. and is one of our nation's covert stormers of the entertainment beachhead, voiced this analysis of our culture: "You know what Canadians want? We want to wake up in the morning and stand there. Because if we move, we might cause some trouble. The best thing is you just don't fucking move, stand there, let the world move around us. And then, when nobody's looking, sneak away." We also frequently display a sort of false modesty by putting ourselves down.

*I sneaked across the border—it was threatening rain —*
*So I could stand in this tunnel, waiting for the roaring train*
*And watch those black kids working out kung fu moves*
*If you don't want to be the horses' hoofprints you got to be the hooves*

*Hear that lonesome violin play*
*See the notes float up into the overcast*
*and change to white birds as they sail on through*
*and soar away free into incandescent blue*

*People getting ready behind all those rectangles of light*
*"Put on your grin mask, babe, you know we're steppin' out tonight"*
*You hear that sound, like hammers only small?*
*It's what the people's heads say when they beat them against the wall*

*Hear that lonesome violin play*
*See the notes float up into the overcast*
*and change to white birds as they sail on through*
*and soar away free into incandescent blue*

*Concrete vortex sucks down the wind*
*It's howling like a blinded violin.*
*Oh—tongues of fire, come and kiss my brow*
*if I ever needed you, well I need you now*

*Hear that lonesome violin play*
*See the notes float up into the overcast*
*and change to white birds as they sail on through*
*and soar away free into incandescent blue*

"INCANDESCENT BLUE," 1979

I toured a lot after the release of *Dragon's Jaws*, though I commit-
ted to no more than three weeks in a row without a break, to give me
some time at home. Home, however, was coming apart at the seams.
Not much was said, but the air between Kitty and me was darkening
by the day. Both of us felt a sort of suffocation setting in. The pres-
ence of a small child will inevitably expose the weaknesses in a rela-
tionship, and ours were beginning to creep out from under the rug

faster than we could weave it back over them. We were going to church. We were praying for guidance. We were doing our best to be good parents. Only Jenny was happy.

*Underneath the mask of the sulphur sky*
*A bunch of us were busy waiting,*
*Watching the people looking ill at ease,*
*Watching the fraying rope get closer to breaking*

*Women and men moved back and forth*
*In between effect and cause*
*And just beyond the range of normal sight*
*This glittering joker was dancing in the dragon's jaws*

*Let me be a little of your breath*
*Moving over the face of the deep —*
*I want to be a particle of your light*
*Flowing over the hills of morning*

*The only sign you gave of who you were*
*When you first came walking down the road,*
*Was the way the dust motes danced around*
*Your feet in a cloud of gold*

*But everything you see's not the way it seems —*
*Tears can sing and joy shed tears.*
*You can take the wisdom of this world*
*And give it to the ones who think it all ends here*

"HILLS OF MORNING," 1979

In the fall of 1979 I played solo up and down Japan, took a break, embarked on a band tour through northern Italy, took another break, and then went on an extended run through the province of Quebec.

Operating in non-English-speaking environments carried with it a sense of dislocation. In Japan I was even illiterate, no matter how lovely the symbols. Italy was wonderfully surreal but slightly baffling. In the course of all that I developed a dependency on strangers, an uncomfortable reality that melded neatly with the psychic toil at home. The ensuing confluence of emotions forced me open, and I found myself more sensitive to the feelings swirling through me. I also found that I liked it.

Even in 1979 Italians still carried visceral memories of Mussolini. Factions of the current generation were just as volatile, particularly the Brigate Rosse, or Red Brigades, which were at war with the Italian government, the police, and a very strong underground fascist movement. The Red Brigades formed in 1970 ostensibly to get Italy out of the North Atlantic Treaty Organization. They were a violent and well-organized revolutionary gang that by 1979 had carried out dozens of high-profile attacks against public figures and others, including the assassination of two members of the official neo-Fascist party in Padua, Italy. In 1978 the Red Brigades pulled off their most infamous attack, stopping the car of former Italian prime minister Aldo Moro, killing five of his bodyguards with machine-gun fire, then holding Moro hostage for fifty-four days while unsuccessfully attempting to negotiate a prisoner exchange. When it was clear that the Red Brigades would not get their comrades out of prison, they stuffed Moro in a large basket, shot him eleven times, and left his body in the trunk of a Renault 4 in the old centre of Rome.

My bias against mixing the aesthetic and the political began to crumble when I was confronted with this charged atmosphere. Everybody talked politics. "Politics," as I would later come to understand the word, is simply humans trying to get along in a group. It's an external expression of something that we all carry around in our hearts. The average Italian, though, was more likely than his or her Canadian counterpart to be active in, or at least cognizant of and vocal about, political life. Many Italian artists were polarized, at least the serious ones, and several of our concerts were produced by local

chapters of the Communist Party. The political turmoil affecting the country was evident in the streets. Fringe leftists were shooting policemen. Fascist extremists bombed Bologna's central station. The police were occasionally shooting passersby they thought were members of the Red Brigades. The fractiousness carried over into the world of entertainment. Chicago singer and guitarist David Bromberg, an excellent player whose Italian tour was organized by the same people who did ours, had to dodge paving stones hurled at the stage because he happened to be performing on the anniversary of the death of a martyred student protester. There was little room to stand back from all this.

Our tour, like the earlier one in 1978, was promoted nationally by a company called Barley Arts, run by Claudio Trotta and Ivano Amati. They were lovers of acoustic music, traditional and modern. Ivano was certain he had some Celtic blood in him. He had been active politically as a student and paid a price for it. In one demonstration he caught a cop's rifle butt in the face, which smashed one side of his jaw and cost him a number of teeth. Though his jaw had been wired back together and his teeth fixed, he still had scars. He was wary and nervous whenever he saw uniforms.

My team consisted of band members Bob DiSalle and Dennis Pendrith plus crew members Stuart Raven-Hill, Glen MacLaren on sound, and a spunky, attractive young woman named Sue Cook on lights.

Dennis recalls that when we arrived in Italy, it was not long after the government had lifted a ban on people gathering in large groups. We caught the resulting wave of revelry. Furthermore, so many touring acts, including the Rolling Stones, had been ripped off by Italian promoters that artists had simply stopped going there. We were the first foreign band to play in Genoa in ten years. I enjoyed a rather delicious sense of teetering on the brink of chaos.

Heavily armed police lurked everywhere. The ones to fear were the Carabinieri, who were paramilitary cops somewhat analogous to the Royal Canadian Mounted Police, but far more military in terms

of equipment and attitude. Driving out of Genoa the morning after our show, we were flagged down by a man in a well-tailored grey-green uniform. Claudio was at the wheel. He turned and in an urgent tone said, "This is very dangerous. Say nothing!" We sat in the back of the rented van, a large Fiat painted dog-vomit yellow, while our promoters got out and explained, to the four or five officers who appeared out of the bushes, the function of every piece of equipment we were carrying. All of it was laid out on the side of the road for their perusal. They got worked up over an electronic guitar tuner, which they seemed to think might be a bomb trigger. Eventually they were persuaded that our gear was what we said it was, and waved us onward. As we finally pulled onto the road I asked, "What if we had just kept driving and not stopped?" Ivano replied, "That," and pointed to the shoulder fifty metres on. Over a low pile of sandbags, an additional crew of Carabinieri eyed us from behind a tripod-mounted heavy machine gun.

That episode was a strange anticlimax to the goings-on during the previous night's dinner, which wrapped up around two in the morning. The local presenters of the concert took us to a nightclub/restaurant, the only place still open by the time we were packed up and ready to roll. We were seated at a long table down one side of a dance floor. A band played sixties Italian pop tunes, sounding like the score for a Fellini film. Three or four couples wove about the floor in various stages of inebriation. One of them consisted of a mournful-looking young man in a sailor's uniform and an elderly woman in conservative clothing with orange-tinted curly hair. Though unsteady, they held each other with obvious passion. The tune ended, the band took a break, and the old lady led the sailor off the floor and past our table. She stopped to ask who we were. I told her, and right away she switched to English and, looking down with a wistful expression at my plate of profiteroles, said, "If only I could find a man with three . . ." *Huh? What? Oh. Ah hah.* Apparently quantity, not size, was what she was missing. A short while later, back on the dance floor, I watched her snatch a banana off the buffet as the two of them swept

past. She hiked up her skirt and eased the banana into herself. The sailor was in for a strange night.

Many of the Italian concerts were in basketball arenas with questionable sound systems, packed with crowds of excitable patrons. We played Turin the night before a captured higher-up in the Red Brigades was due to go on trial in that city. The atmosphere was very tense. A dense fog shrouded the town, reducing visibility to a couple of yards. Soldiers in full combat gear were positioned twenty feet apart on the topmost tier of the oval indoor arena where we played. In midperformance, a half-dozen armed men appeared on the stage and started moving our equipment around. We kept playing. They focused on the drum kit. One of them shook a leather cymbal case next to Bob's head and started shouting, but we couldn't hear him for the racket we were making. Later we learned that someone had phoned in a bomb threat. In the end, there was no bomb, the show ended, and we packed ourselves and our gear back into the yellow diesel van and trundled off into the fog.

The next morning, heading west out of Turin on the autostrada, we passed a long line of upended and burned-out cars and trucks, some still smoldering. In murk of the night, as we played, a collision had triggered a 150-car pileup.

The tour ran up and down the Po Valley in the northern part of the country. A damp November cold clung to us like lichen. Compared to a Canadian winter it was nothing, but there was no respite, as there was no central heating. It got warm only when the stage lights came on. The fog we encountered in Turin was endemic.

Showtime was usually nine o'clock, but we never started on time. Those were the days when I would eat before shows, and we were always told not to hurry, as it was customary for concertgoers to leave home about the time a show was scheduled to begin. This was the case on the wet night we played in Vicenza, near the northeastern town of Padua, famous for its eight-hundred-year-old university where Galileo taught, and for being a hotbed of student protest.

As usual, our hosts were very casual, not at all worried about time.

We did a sound check and went to dinner, stayed until nine, then ambled back to the small indoor arena that was the venue. But something had changed. We stepped out of the yellow van onto a crunching layer of broken glass that frosted the entire back parking lot, glinting in the glow of the overhead lights. There was mayhem in front of the building. We heard shouting and popping sounds. An acrid odor filled the air. We found Massimo, the beefy biker type who was assisting with the lights, guarding the stage door with a microphone stand clutched, clublike, in his fist. He hustled us in and quickly slammed and barred the door behind us. A lot of angry people were trying to get into the show. Some of them had guns. The windows had been shot out on the street side of the hall. Uniformed security guards were defending the front doors. One of them had been badly beaten. No one had been shot—yet. Our Massimo, who thought little of clambering one-handed like King Kong up the lighting towers with a spotlight dangling from his free hand, was quaking with fear. A couple of years earlier he had suffered a broken back in just this kind of situation.

My first thought was "Geez, we're not *that* late!" But that wasn't the problem. A mob of university students from Padua had begun the evening by shooting up the home of a local judge, then ambled on over to the show. In Italy security guards were accustomed to large contingents of confrontational young people demanding unpaid entry to concerts, as the music "should be free." Promoters were faced with a choice of resisting the crowd and thereby almost certainly risking violence, or waiting until ticket holders had gone in before opening the doors to anyone. Our situation was somewhat different. By the time we took the stage, the real cops had arrived. A number of them were visible in the hall, in plainclothes (turtlenecks and blazers), recognizable by the compact Beretta submachine guns slung at the ready on their shoulders.

The lights came up and we went on. People packed the floor, and more snaked up the sloping tiers of seats. The area closer to the main doors was a continuous swirl of motion, as some people came in and

others ran out to check on events outside. From all around us came the *pssht* sound of breaking glass as paving stones sailed through the high windows. Every now and then a whiff of that acrid smell would blow our way, tear gas from the battle scene. At one point Stuart passed by the foot of the stage, his dark shoulder-length hair bejeweled with glittering bits of windowpane. In between songs, I caught the eye of Sue, at the lighting desk, below stage left. She flashed a broad grin, shot both thumbs aloft, and shouted "Rock 'n' roll!" Action at last! This was probably the best night of the tour for her. I think overall she found my shows somewhat sedate.

We were getting ready to end the set with "Lord of the Starfields" when Glen's voice came back through the monitors: "The head cop says if you don't stop playing, he's going to order his men to start shooting." Pause. "Don't believe him. I went out and checked. It's almost over out there. I'd keep playing." Good enough for me! I launched into the guitar intro, which elicited a scowl on the jowls of the man in charge, but no gunfire. The response from the crowd was immediate and enthusiastic. That song was showing up on radio around the country. It was, and still is, the track of mine that has garnered the most attention in Italy.

The tour ended in a circus tent in Rome, and I was sick. Something I had eaten was wrecking my guts. At the end of the sound check, I shit myself running for the backstage portable toilet. I was weak and shaky, and told Ivano and Claudio I'd have to cancel the show. They grew visibly panicked, which I understood, having tasted the volatility of Italian audiences. If we didn't play, they would probably riot. But I didn't see how I could go on in the condition I was in. If you think diarrhea sucks, try having it onstage while pumping your abdominal muscles to force air past your vocal cords. Someone showed up with pills, which were supposed to help but did not. Our two promoters begged me to go on "even for a half an hour," which seemed ludicrous to me. A short show would enrage the audience as much as no show, maybe more. As the appointed hour neared, I said, "Okay, I'll try and do something, but be prepared for a sudden stop."

We went on. Somehow I managed to survive ninety minutes onstage. Every time I strained for a high vocal note I felt like my innards would erupt, but my system was so drained by then that we were all spared that. I thought the performance had to have been, well, crap, but everyone seemed pleased.

After the show, as was the custom, we were hauled off to a restaurant with the local promoter and his friends, then said our good nights. Our little group—me, Claudio and Ivano, Stuart, Dennis, Bob, Glen and Sue—set out over the cobblestones. The full moon seemed to overpower the yellow streetlight glow, casting sharp shadows in the faintly misted air. We turned a corner and proceeded across a small plaza, Glen and I at the head of the pack. Under a street lamp on the opposite corner was the caped figure of a lone Carabinieri officer. "Do not go near to him," Ivano admonished in a low voice, but he was standing pretty much where we had to go. Giving him as wide a berth as possible, Glen and I approached. The cop cradled his little Beretta machine pistol. His eyes followed our hands while the muzzle followed our progress. He made only one other move.

"He took the safety off," observed Glen. "I saw that," I said. The guy looked like a teenager. His hands shook visibly. I felt sorry for him. What if we'd been the Red Brigades? We looked the part, the right age group, Glen with his David Crosby hair and mustache, and me looking faintly punky with a motorcycle jacket and a tie, black jeans, and sneakers. We all survived the encounter, and I found myself wishing long life for that young lad.

*Sun went down looking like the eye of God*
*Behind icy mist and stark bare trees*
*Inside the dim empty cinema two guys in leather jackets*
*Glance at each other and shiver*
*"They never built these places with winter in mind"*
*Out the window down the grey road*
*You can see old walled monastery*
*Now become a barracks for the paramilitary police*

*I saw an old lady's face once on a Japanese train*
*Half-lit, rich with soft luminosity*
*She was dozing straight upright, head bobbing almost imperceptibly*
*The wheels were playing fast in 9/8 time*
*Her husband's friendly face suddenly folded up in a sneeze*
*Across the strait a volcano flew a white smoke flag of surrender*

*In a Roman street on a full moon night*
*I was sick and there was a young cop in a circle of yellow light*
*As we drew near he snapped the safety off his machine pistol*
*And slid a trembling finger to the trigger*
*I wanted to say something calming but couldn't catch his eye*
*He didn't want contact—he was trained to see movement*
*"Well don't shoot me, man, I'm a graceful slow dancer*
*I'm just a dream to you not real at all"*

*I wonder if I'll end up like Bernie in his dream*
*A displaced person in some foreign border town*
*Waiting for a train part hope part myth*
*While the station changes hands*
*Or just sitting at home growing tenser with the times*
*Or like that guy in "The Seventh Seal"*
*Watching the newly dead dance across the hills*
*Or wearing this leather jacket shivering with a friend*
*While the eye of God blazes at us like the sun*

"HOW I SPENT MY FALL VACATION," 1979

As *Dragon's Jaws* went gold, my marriage took an inversely proportional nosedive. Kitty and I found ourselves adrift in an interpersonal wormhole. The reasons were many, but a long history of failing to communicate our deepest fears, resentments, and longings was at the core of our unraveling. We couldn't sew things back up, and we couldn't figure out how to move forward. Kitty was a pretty good

communicator, but like most of us at that age she didn't have a complete grasp of her own inner workings. I was like a chain-saw rendering of Rodin's *The Thinker* done in ice, a frozen simulacrum of anger, avoidance, and angst in the posture of a man taking a dump. Neither of us would entertain for a moment the notion of going for counseling. To share our deepest thoughts and feelings with a total stranger called for more trust than either of us was capable of at the time. Something would come up and we couldn't talk about it, then something else would surface that also couldn't be discussed. Together we were a mess. Then I'd leave on tour. My wife would be left in a stew of frustration and loneliness.

Kitty made the move, announcing she was leaving the marriage, catching me by surprise. To my mind we had made a promise before God, and that promise had to be kept at any price. There was no way out of it. How much heavier can it be than making a promise before *God*? I can't be sure, with hindsight, that I would never have made the call, but I hadn't reached the point of imagining us splitting up. I'm not sure what my threshold would have been, but Kitty was smarter than I was and recognized that the marriage was going nowhere. I think I was in the bathroom, shaving, when she informed me that she wanted a divorce. Suddenly, on the inside at least, I was a hurricane blowing through a keyhole.

"Okay," I snapped, "take the money and the kid and just go."

"No way," said Kitty. "You're Jenny's father. You're going to be in her life no matter what you think about it."

She was right, of course, and in the end being a father, even every second weekend, was a blessing. Yet at that moment all I wanted was to amputate the broken limb and move on. When you get spun off the tracks like I was, anger can take over and attempt to crush the cause. This isn't how things are supposed to go! We're supposed to be a couple! God doesn't want us to split up!

Deep beneath the surface, though, I was relieved. We had all this biogas built up from suppressing our issues and emotions, our endless well of *stuff*, and when it finally blew I could feel, far below the pain,

a welcome sense of freedom, of floating into a sea of new possibilities.

During the thirteen years Kitty and I were together, our quest for a relationship with the Divine, with Christ, was fruitful, often beautiful and mysterious. In all senses of the word, we *travelled*. I encountered places within myself, and within the cosmos, across a spirit world occupied and offered to us by God, that I would not have reached without her. Kitty is one of several women who have helped guide me into and through critical realms of self-exploration, who helped blaze paths toward understanding the Divine and the human condition. In large part our marriage broke down because I could not open up. I remained mired in my childhood psyche, unable to adequately express feeling, to demonstrate or even appreciate the love that simmered in my soul, both for Kitty and, eventually, for our daughter Jenny.

*Disharmony gives way*
*To mute helplessness*
*Not enough communication*
*Too much not expressed*

*It's all too easy*
*To let go of hope*
*To think there's nothing worth saving*
*And let it all go up in smoke*

*What about the bond?*
*What about the mystical unity?*
*What about the bond*
*Sealed in the loving presence of the Father?*

*Dysfunction*
*Of the institutions*
*That should give a frame to work in*
*Got to find our own solutions*

*Confusion*
*Pressure from all sides*
*Got to head right down the centre*
*In the love that will abide*

*What about the bond?*
*What about the mystical unity?*
*What about the bond*
*Sealed in the loving presence of the Father?*

*Man and woman*
*Made to be one flesh*
*Nobody said it would be easy*
*But can we let go now and fail the test?*

*Now you could say*
*Life is full of moving on*
*But do you want the pain that's*
*Already been spent*
*To all be wasted—c'mon*

*What about the bond?*
*What about the mystical unity?*
*What about the bond*
*Sealed in the loving presence of the Father?*

"WHAT ABOUT THE BOND?," 1980

How droll now to look back at my assumption that I knew what God did or did not want. I have a T-shirt I picked up in Buenos Aires that says, "*Si quieres hacer reir a Dios, cuentale tus planes*" ("If you want to make God laugh, tell him your plans"). The breakup brought me an inch or two closer to an understanding of what it means to live in relationship with the Divine. God makes the plans. In the day to

day we carry on, intending this and that, hoping for whatever, but it's best to maintain a very light attachment to those intentions and hopes. You will be given what you need, but you might not appreciate that at the time.

After Kitty's announcement I recalled an experience I'd had in Italy. Part of the legacy Il Duce left behind is a style of construction he championed, commonly known as "fascist architecture." The buildings are larger than life, the stated intention being to celebrate the glories of human achievement. In fact, they dwarf the human spirit, rendering people tiny and helpless and the state omnipotent. It's a reflection of the state as god, propped up by a cadre of corporate devotees. Fascist architecture became a suitable metaphor for the structures I had created in myself—defensive constructs whose function was to shore up a psyche stuck in an insecure and frightened child's view of the world, but that impeded forward motion into the larger expanse of human existence. Kitty's action had cracked the foundations more deeply than her love had been able to.

I remembered the Stadio dei Marmi, its giant sculptures of naked athletes whispering an echo of Mussolini, who forty years before had stood outside the stadium praising "the new fascist man." The stadium is still there; its walls have not fallen.

*Fascist architecture of my own design*
*Too long been keeping my love confined*
*You tore me out of myself alive*

*Those fingers drawing out blood like sweat*
*While the magnificent facades crumble and burn*
*The billion facets of brilliant love*
*The billion facets of freedom turning in the light*

*Bloody nose and burning eyes*
*Raised in laughter to the skies*
*I've been in trouble but I'm ok*

*Been through the wringer but I'm ok*
*Walls are falling and I'm ok*
*Under the mercy and I'm ok*

*Gonna tell my old lady*
*Gonna tell my little girl*
*There isn't anything in the world*
*That can lock up my love again*

"FASCIST ARCHITECTURE," 1980

# 10

Though I never could quote chapter and verse, over time I familiarized myself with the Bible. I read it cover to cover. For a while I used it the way some people use the *I Ching*: just open it up on a given day and apply whatever jumps out. I paid a lot of attention to the letters of Paul. He was the authority on what it means to be Christian. Various TV evangelists claim to be that also, but they are, at best, interpreters of Paul, who is interpreting Jesus, whom he never met. Not in the flesh, at any rate. I found Paul quite hard to like. I was struck, though, by how much personality vibrated in those pages. In reading his letters I felt touched by his presence, not in a mystical way, but in the way of one human being reaching out to another. The fact that I was annoyed by much of what he had to say did not diminish my understanding that he was trying to communicate truth to me, as he knew it. It remains difficult to see why Jesus needed that guy to translate for him. It seemed to me that Paul was struggling with how to apply his faith in the risen Christ to the day-to-day world of men and women. He talks to them about love, but he also lays down rules, imposing his experience on theirs. Maybe they wanted that. Subsequent apologists cite differences in customs between that time and our own, but the attempts to reconcile the codes of behaviour ring somewhat hollow for me. God is not a social phenomenon.

When a group of humans try to make him that, their faith slides into superstition, often pathological.

When I got married I did not yet think of myself as a Christian. I was very interested in God, though I had outgrown the imagery presented to me as a child: the bearded Caucasian in the white robe . . . who *was* that? Some druid perhaps, lured in from the sidelines of history. Then there were the rays of sunlight passing through clouds. That at least had a celestial aspect. But overall I had abandoned the idea that the Christian imagery represented the Divine in any meaningful way, except for the meaning each of us might, in our hearts, invest in it. I found the myriad visions of God interesting. The Father was a bit too familiar, and too loaded a concept. Odin was cooler: the "all-father" who, with his ravens and his one eye, curiously, had returned home from having been hung on a tree and stabbed with a spear. Then there was Zeus, with his fondness for forcing himself on earthly women, and his fellow Olympians, with their petty jealousies and intrigues. The many Trickster figures made for great storytelling, though none of it was to be taken literally. All of it represented our species' hunger for relationship with, and understanding of, the Divine, as well as our deep psychological processes.

When I first became a Christian, I wanted to know what it was I had signed up for. I had never paid much attention to the church, the bride of Christ, with which I had now identified myself. The first time I took communion—in response to a nudge from within during a service at St. George's, where Kitty and I were married—I felt a wondrous shiver of contact, of connection. Afterward I went and asked Father Playfair what I had done. He graciously explained the teaching around the act, starting with Jesus's exhortation to celebrate his memory by consuming bread and wine. This was a directive I could readily picture myself following.

I looked to the people who proclaimed most loudly that they knew what the faith was all about. These tended to be conservative evangelists, some of the television variety. That crowd is fond of translating the word of God for us, into whatever cultural context suits them.

They love regulations and the passing of judgment. "God hates homosexuals!" screams one, and lo! It is revealed that he always travels with a male prostitute as a companion. Another shouts, "Don't allow performances of a sexual nature in public!" (referring to rock and roll or rhythmic body movements), and somebody discovers him getting head from a hooker in the back of a car. The hollowness of these figures soon became apparent, as did the hollowness of their unrelenting literalism with respect to the Bible. I wasn't cut out to be a fundamentalist. Still, a promise is a promise, and I figured the promise Kitty and I made before God to remain together, to maintain a bond unto death, was not negotiable.

I was wrong about that, too. Kitty and I went through our separate anguish over the split. We tried to make it as smooth as possible for Jenny's sake, and for our own, but it was still traumatic, as these things usually are. My anger and bitterness were somewhat softened by the gratitude I carried for the time we had had together. And whereas I enjoyed the freedom to spend my time however I wanted, I was lonely and forlorn. I lost two pant sizes. I prayed a lot. I asked for forgiveness for having screwed up, and for guidance in making sense of what was happening. What I got back was "Don't worry about it. The flow is moving. Move with it."

I moved to Toronto, feeling, in the midst of all this, that I should be seeking community of some kind. I tended to put all my emotional eggs in one mixing bowl, allowing only Kitty and Jenny close to my heart. It occurred to me that if I accepted the notion that I was supposed to love my neighbour, I ought to know who that neighbour is. Step one would be to embrace the city. God seemed to be more interested in the next step than in where we had been, mired in place and needing relief. Kitty went through a similar process. She felt terribly guilty, but she would pray about it and get a response like "Child, it's okay. The love in your heart is what's important, and it's far more complex than the promise you made in the church."

Occasionally I'd tune in to religious television, catching Jerry Falwell or Jim and Tammy Faye Bakker, or *100 Huntley Street,* a

talk show produced in Canada—partly to put myself in touch with some version of the Christian community, but also to see what peculiar exhortations might be offered a searching soul. One night, on the black-and-white TV I'd brought to Toronto, a John Q. Public sort of guy testified that he had lost his job, fallen into depression, and taken to drink. He smoked too much. His marriage started breaking apart. Then he found Jesus. Now he had quit smoking, found a new job, had a solid marriage again, and drank only coffee. Good for him, but I'd had an opposite experience. After I found Jesus, my marriage fell apart and I started drinking Bell's whiskey and smoking Gauloises.

Because I came to believe that God had permitted this breakup, some of my other religious understandings changed as well. God is good. God is on your side, and if you believe and pray, or maybe even if you don't, then God will help you. But what constitutes *help* may not be what you expect, and the same goes for *believe, pray,* and even *good*. Relationship with God is not rigid. It's elastic. The relationship changes as you change, as your understandings deepen and expand, as new mistakes ask for new kinds of patience from him. A relationship with God is not about who lives and dies. It's not about who suffers what. Those may be circumstantial parts of the picture, but really it's about connection, correlation, association: with the Divine, with each other, with the planet. This is my understanding of what it *may* mean to have a relationship with God. It may not be your truth, and at some point it may not even be mine. I do not *know,* but *seek* spiritual truths, and in the seeking I trust that whatever is put in front of me is at least permitted by God, if not placed there by him. The challenge is to remain open, to be still and listen.

After the breakup I remained vitally interested in maintaining a spiritual life, as I still do, though it has become less specifically Christian. I attended various churches, in Toronto and on the road. Some were welcoming; some viewed me, the outsider, with suspicion. The act of taking communion, when I could do it, always felt meaningful. I never found a church, though, that had the same feeling of com-

munity, of being filled with spirit, as St. George's. That church, with its healing services and its congregation half made up of ex-cons, was more special than I had realized. Gradually the habit of attending worship services faded away.

The world of human beings became the landscape of a continually unfolding adventure. I absorbed a wealth of stories from the street people who accosted me and the hipsters in the all-night speakeasies, from the bouncers at the bar next door and the men and women of diverse ethnic backgrounds who populated the shops in Kensington Market. Everybody had a story. Previously, when I was holed up in Toronto for a season, I made it a point to avoid contact beyond the one or two people I needed in order to not feel completely isolated. People had been there for me in the past, but I never appreciated them as much as I did now. I didn't suddenly emerge as Mr. Gregarious; it was a slow and uneven process, a psychic surfing of the crowd. I decided to feel comfortable embracing strangers.

*Above the dark town*
*After the sun's gone down*
*Two vapor trails cross the sky*
*Catching the day's last slow good-bye*
*Black skyline looks rich as velvet*
*Something is shining*
*Like gold but better*
*Rumours of glory*

*Smiles mixed with curses*
*The crowd disperses*
*About whom no details are known*
*Each one alone yet not alone*
*Behind the pain/fear etched on the faces*
*Something is shining*
*Like gold but better*
*Rumours of glory*

*You see the extremes*
*Of what humans can be*
*In that distance some tension's born*
*Energy surging like a storm*
*You plunge your hand in—you draw it back scorched*
*Beneath it's shining*
*Like gold but better*
*Rumours of glory*

"RUMOURS OF GLORY," 1979

Bernie helped me land in Toronto by offering me a room in his house. The timing was good. He had just split with his girlfriend, so he was there by himself. He lived uptown in the Yonge-Eglinton area. (In Toronto, uptown is actually *up*.) I bought a big Dutch one-speed bicycle and rode it downtown and back every day, which put me in pretty good shape. After a while I found a place of my own: a small flat on Spadina Avenue next door to a chicken slaughterhouse and around the corner from Kensington Market. I walked the city, watching, learning, discerning, wondering, wandering, open to incoming information, swapping the bonds of isolation for the infinitely elastic bag of human absurdity. It was a conscious flipping of a switch. What I found wasn't so surprising. People were basically the stumblers I had thought they were, but so was I. There was solidarity. And there was something to love there because we're all in the same boat.

*Woman cry—chase man down street crying,*
*"No Chuckie, no, please don't"*
*Another girl comes they run along St. Andrew,*
*turn south on Kensington*
*Meanwhile Chuckie beats it down the alley by the chicken packer's*
*By the time I reach the corner they've all vanished*
*Just a deaf kid talking like Popeye to a large fleshy*
*laughing man in a blue shirt*

*You pay your money and you take your chance*
*When you're dealing with love and romance*

*Down the alley past the fire escape a woman is talking on the telephone*
*Kitchen light spills out, laughter riding on its beam*
*In the maze of Moebius streets we're trying to amuse ourselves to death*
*Under the deep sky that's squatting so close over us tonight*
*You'd think it was trying to hatch us*
*The numb and confused*
*The battered and bruised*
*The counters of cost*
*And the star-crossed*
*You pay your money and you take your chance*
*When you're dealing with love and romance*

*Confused and solo in the spawning ground*
*I watch the confusion of friends all numb with love*
*Moving like stray dogs to the anthem of night-long conversations,*
*of pulsing rhythms and random-voltage voices*
*In spite of themselves, graceful as these raindrops creeping spermlike*
*across the car window*
*Stay or leave, give or withhold, hesitate or leap*
*Each step splashing sparks of red pain in every direction*
*And through it all, somehow, this willingness that asks no questions*
*You pay your money and you take your chance*
*When you're dealing with love and romance*

"YOU PAY YOUR MONEY AND YOU TAKE YOUR CHANCE," 1981

By chance, I reconnected in Toronto with the former operators of a folk club that had been part of my little gigging circuit ten years earlier. John and Joanne Smale had run Smale's Pace in London, Ontario. John was now running a restaurant, and Joanne seemed to be involved in just about everything that was going on in town. They

welcomed me in, and I became a frequent visitor at their third-floor flat next to the El Mocambo, at the time the premier rock club in the city. It was Joanne who, for Christmas of 1980, gave me a gift certificate for an ear piercing. Two in the right ear, it said, so that's what I got. I thought about the symbolism. An earring in the right ear was supposed to indicate a homosexual leaning. Maybe two in that lobe would cancel each other out. I didn't much care if I was taken for gay or not. Why would I? I just liked the earrings.

I also became a frequent visitor at the topmost apartment, immediately above the Smales, the home of Judy Cade. Judy and Stuart Raven-Hill were on the outs. I didn't really know her, but as we became acquainted I experienced a growing attraction to a woman whose physical beauty was matched by her warmth and humanity. We started dating and eventually moved in together. I wrote "Inner City Front" on the rooftop deck behind Judy's place. Her presence looms large in the songs on the album of the same name.

I wanted to be accepted into the society of hip, arty folks I was meeting in Toronto, at the Smales' parties and elsewhere, but they weren't very receptive at first. The ones who interested me were operating in the outer orbits of the arts scene, challenging the boundaries of what was considered acceptable in visual arts, in songwriting, in style . . . perhaps also in good taste. They were generally disdainful of this folksinger in a tweed jacket. After the earrings, I began wearing leather and mascara and they started talking to me. Which doesn't say much for the depth of people, but that kind of tribalism shows up everywhere. A door opened. I changed my way of living, as they say. More important, my music changed.

*Blue billboard on the roof next door*
*Makes a square of light on the kitchen floor*
*Smoke rises from a cigarette*
*There's a dull glisten where the table's wet*
*Soft breath rises from the bed*
*A thousand question marks over my head*

*Turn on the tube but there's nothing new*
*The usual panic in red, white, and blue*
*"Military advisors" marching in the square*
*Knife-sharp trouser creases slicing air*
*Private armies on suburban lawns*
*Shoulders braced against the tidal dawn*
*All's quiet on the inner city front*
*I don't know why I should but I feel content*

*Bell in the fire station tower*
*Rings out the measure of the racing hours*
*I slip through the door to the roof outside*
*To gaze at the sign hanging in the sky*
*That sailor on the billboard looks so self-possessed*
*Doesn't have a thing to forgive or forget*
*All's quiet on the inner city front*

"ALL'S QUIET ON THE INNER CITY FRONT," 1980

The direction of my work shifts from album to album, but the changes between *Dancing in the Dragon's Jaws* and the next album, *Humans*, were radical. *Humans* had more instruments, more of a rock sensibility, more drums, more electric guitar. In the lyrics, the prevalent nature imagery of the previous decade gave way to cityscapes, mercenaries, skylines, car crashes, barbed wire, the architecture of suffering, the buzzing anguish of men and women desperate for love. It was *reportage*, the documentary approach to poetics I'd absorbed from Ginsberg et al., taken further than I had before. Literary influences were as likely to come from the leftist *bandes dessinées* of Christin and Bilal as from Doris Lessing and Edward Whittemore. And Christ? He didn't go entirely missing, but he showed up as his cosmic self, or in the faces of strangers. As always, I rummaged for answers through alleys of the spirit, but now humans—lots of them—and their habitat became central to the

explorations. Unlike my *Salt, Sun and Time* response to the success of *Night Vision*, with *Humans* and the next album, *Inner City Front*, I wasn't running away from the success of *Dragon's Jaws* but continuing to move toward the next thing, allowing scene and circumstance to flow into and through the music. I never wanted to do the same thing over again, no matter how successful it was. If you repeat something simply because it sells, it stops being art and becomes *product*, like hair gel or Rubik's Cubes.

Some of my listeners weren't pleased. Just as I lost a few fans when Jesus came into the songs, some of the Christian fans fled when he stopped looking like the man with the robe and the halo. Then a few more fans fell away as the songs began to express political positions and occasionally employ less dignified language. But even more came on board: win some, lose some.

I did care. It felt good to know the audience was growing, but it hurt to think some people were being alienated. The songs have to be true, though—true to the heart and vision of the writer. Take that away, and they have no value at all. After a show in the early eighties, a young Christian fan scolded me for smoking a cigarette and thereby polluting God's temple. He was pretty taken aback when I retorted that it was none of his business. My temple, my smoke. I quit smoking for the last time nearly twenty years ago, but I don't think that had much to do with salvation.

It may seem pat to analyze my life in terms of decades, but my life and the songs that come out of it have worked that way. If the seventies were marked by a deep introspection, the eighties were largely characterized by a more exterior orientation. While retaining the necessary inward gaze, I began looking outward with intention, trying to turn my mind's eye like an owl's head, completely around, pulling in the uncharted view and reporting it in songs. This redirection reflected the teachings of Jesus—reach out to your fellow humans, love your brothers and sisters and serve them—but ironically, it also led to a weakening of my attachment to the language and imagery of mainstream Christianity.

I began to discover in my secular friends approaches to spirituality that were unlike the Christian one but very real, very appealing. Prayer became a way of breathing and seeing, and of caring, a means of giving thanks and opening the mind and soul. Rather than isolating me from humans, my prayers now connected us. Prayer may be offered in a church, a synagogue or a mosque, in a temple, a pagoda or a stupa, or in an alley or a public toilet. The place is less important than the sincere intent. The Divine infiltrates our being and manifests, as it must, through the electrochemical processes in our brains.

These days I'm inclined to think of Jesus as a collective animus figure, an archetypal image God has used to make real the possibility of being in a personal relationship with him. Jesus the revolutionary leader of the poor, Jesus the Son of God—both or neither. The point is not who or what Jesus *exactly* was, or *whether* he even was, but how we embrace what is offered. Three thousand years before Jesus entered history the Egyptians worshipped Horus, a son of the god Osiris, who was miraculously conceived and performed healing miracles. If we clutter up our line to God with cultural concerns and the stories we tell ourselves, we miss the point.

Christianity is based on the Divine touching a human. So is Islam, so is Taoism or Shinto, and so are the animist beliefs that are all over Africa. But the Divine is there in any case, no matter the ism or structure that goes with it. It's as if God is the matrix in which we move, if we were only aware of it. The Divine touches us. We feel it as a species. We hunger for it. Sometimes we run from it. A distortion occurs when the gifts of God are translated by cultural gatekeepers who don't always include the notion of authentic access to the Divine in their schemes, no matter their claims. The problem is intensified when the Talibans of the world, the Sunnis or Southern Baptists or Jim Joneses, seek to usurp divine power, make it their instrument, and crown themselves God's regents. They murder homosexuals, throw acid in women's faces, stone adulterers to death, and bomb clinics that perform abortions, then demand your tithes. Brutal deeds are done under the banner of God, fueled by men's ego, greed, and

fear. If we truly believe in a Supreme Being who is omnipotent and all-seeing, how is it he needs *us* to protect his interests? Could it be that what we worship is so much a product of our shame-covering pride that its face is no more than the face of our own pathology?

*What's been done in the name of Jesus?*
*What's been done in the name of Buddha?*
*What's been done in the name of Islam?*
*What's been done in the name of man?*
*What's been done in the name of liberation?*
*And in the name of civilization?*
*And in the name of race?*
*And in the name of peace?*
*Everybody*
*Loves to see*
*Justice done*
*On somebody else*

*Can you tell me how much bleeding*
*It takes to fill a word with meaning?*
*And how much, how much death*
*It takes to give a slogan breath?*
*And how much, how much, how much flame*
*Gives light to a name*
*For the hollow darkness*
*In which nations dress?*
*Everybody*
*Loves to see*
*Justice done*
*On somebody else*

*Everybody's seen the things they've seen*
*We all have to live with what we've been*
*When they say charity begins at home*

*They're not just talking about a toilet and a telephone*
*Got to search the silence of the soul's wild places*
*For a voice that can cross the spaces*
*These definitions that we love create —*
*These names for heaven, hero, tribe and state*
*Everybody*
*Loves to see*
*Justice done*
*On somebody else*

"JUSTICE," 1981

In the face of so much evil done on God's behalf, it's no surprise that many thinking and sensitive people proclaim themselves agnostic. I share something with this crowd, coming to the faith as I did from a similarly skeptical place. My own experience taught me that there was a reality behind the overlay of distortion. Without claiming any special understanding, I could stand up and say, "I'm a Christian. You might give it a glance yourself, because it might not be as dumb as you think it is." That was the message I hoped to impart to a community of people seeking a relationship with God but not necessarily inclined to accept somebody else's dogma because they've been told to. I assumed people might be interested in my own explorations and discoveries, such as they were, just as I was interested in theirs.

I also began to understand that if earth and all of its creatures were indeed God's creation, then a lot of what I was seeing in my outward explorations amounted to blasphemy.

*Way out on the rim of the galaxy*
*The gifts of the Lord lie torn*
*Into whose charge the gifts were given*
*Have made it a curse for so many to be born*
*This is my trouble —*

*These were my fathers*
*So how am I supposed to feel?*
*Way out on the rim of the broken wheel*

*Water of life is going to flow again*
*Changed from the blood of heroes and knaves*
*The word mercy's going to have a new meaning*
*When we are judged by the children of our slaves*
*No adult of sound mind*
*Can be an innocent bystander*
*Trial comes before truth's revealed*
*Out here on the rim of the broken wheel*

*You and me—we are the break in the broken wheel*
*Bleeding wound that will not heal*
*Lord, spit on our eyes so we can see*
*How to wake up from this tragedy*

*Way out on the rim of the broken wheel*
*Bleeding wound that will not heal*
*Trial comes before truth's revealed*
*So how am I supposed to feel?*
*This is my trouble —*
*Can't be an innocent bystander*
*In a world of pain and fire and steel*
*Way out on the rim of the broken wheel*

"BROKEN WHEEL," 1981

While I waded in the waters of my urban baptism, my erstwhile family was having an adventure of their own. Kitty had hooked up with a new boyfriend who had an interest in the Yukon Territory. They were spending half the year placer mining for gold near Dawson, where the Klondike gold rush of the 1890s had taken place. A

couple of times a summer, my status as part-time dad took me there too. Around the time I wrote "Broken Wheel," I found myself way out on the rim of the North American continent visiting my daughter. It was a long way to go but I loved the wild north, and I would have gone anywhere to see Jenny. Partly for her own reasons, and partly by way of making things easier for at least part of the year, Kitty wintered in Toronto, so I got more of Jenny then, though it was a long time before those visits were free of the large quantity of emotional baggage that Kitty and I, in spite of our best efforts, laid on each other.

Dawson is a tiny place. In the early eighties the year-round population numbered only about two thousand souls. That could swell six to ten times with the arrival of tourists and prospectors in the summer. These provided fodder for the region's legendarily large mosquito population. You could get there by road if you had the time and a hardy vehicle, but it took a *lot* of time. The practical way was to fly: Toronto to Vancouver to Whitehorse to Dawson, the aircraft ever diminishing in size. The last leg took you over green rolling mountains, smooth from never having been glaciated. The plane would descend until it bumped along a dirt airstrip, propellers strobing in the portholes. The engines would shut down, and you'd step out the door into an immense quiet, no sound but wind, moving air so free of extraneous matter that it tasted sweet on the tongue.

Kitty and Jenny and John lived in a trailer near their mining site. Occasionally the location would change. Mining was done with a bulldozer and a sluice with a series of increasingly fine screens, the fossil fuel–driven update of the old gold rush placer method. They would scour hillsides overlooking one of the creek beds feeding the Klondike River, then move on when there was no more of the glittering grit.

I'd get a motel room for a few nights, and Jenny would come and stay with me. Usually I travelled there alone, though Judy came once. We'd go out on adventures, savor the twenty-four-hour daylight, fight off the mosquitoes, dine at Diamond Tooth Gertie's Saloon. One

time a helicopter pilot took us for a ride. He had a regular route, carrying supplies to several prospectors' camps in the area. He carried us the equivalent of a three days' walk from town and dropped us off near a fast-flowing salmon stream, with the assurance that he'd pick us up as he returned from his run. Before landing, we flew a circuit just above the treetops to scout for grizzlies. There were none, but we passed directly over two big young black bears up on their hind legs, engaged in a wrestling match. They both stopped to stare up at us in surprise. The quicker one took advantage of the moment to slap the other across the jaw, knocking him flat. We spent several hours steeped in the music of the rushing water before hearing the throb of the chopper's return. We encountered neither grizzlies nor fish.

Jenny was sweet, and as cute as all children are in their parents' eyes, but she was sad. She took the breakup on herself, the way kids do. The whole universe revolves around them, so the bad parts of it also must. That was one of the hardest parts of the separation. One night in a hotel room, early in the breakup, the first summer—Jenny had just turned four—we were talking about the day we had just had when she suddenly said, "Daddy, I think my tears are going to come." And they did, just like that, and so did mine.

Judy and I also did a lot of travelling. She's a fan of beaches. I'm not especially, but if the beaches were in interesting enough places, I was happy to go to them. Through the seven years we were together, we spent time in Tobago, Jamaica, Guadeloupe, the Grenadines, the Canary Islands, and Sardinia, all fascinating places. The islands provided song material, or at least the opportunity to reflect and allow songs to flow.

In the fall of 1982 I began recording my twelfth studio album, *The Trouble with Normal*, which came out early the following year. In addition to a strong world-beat influence, the album had a political tone that would last through the eighties. If *Humans* and *Inner City Front* set the bar, then *The Trouble with Normal* leapt it. The song

"Candy Man's Gone" lamented our misplaced faith in the gods of the consumer culture, who sell the expectation that there will always be more, and mislead the disadvantaged into believing that the entitlement will extend to them. Satan in a business suit, "pimping dreams of riches for everybody," taking from all and giving to a tiny elite— Robin Hood in reverse. The title cut, "The Trouble with Normal," was a rant with a shouted chorus.

> *Strikes across the frontier and strikes for higher wage*
> *Planet lurches to the right as ideologies engage*
> *Suddenly it's repression, moratorium on rights*
> *What did they think the politics of panic would invite?*
> *Person in the street shrugs—"Security comes first"*
> *But the trouble with normal is it always gets worse*
>
> *Callous men in business costume speak computerese*
> *Play pinball with the Third World trying to keep it on its knees*
> *Their single-crop starvation plans put sugar in your tea*
> *And the local Third World's kept on reservations you don't see*
> *"It'll all go back to normal if we put our nation first"*
> *But the trouble with normal is it always gets worse*
>
> *Fashionable fascism dominates the scene*
> *When ends don't meet it's easier to justify the means*
> *Tenants get the dregs and landlords get the cream*
> *As the grinding devolution of the democratic dream*
> *Brings us men in gas masks dancing while the shells burst*
> *The trouble with normal is it always gets worse*

"THE TROUBLE WITH NORMAL," 1981

Though I didn't plan it that way, *The Trouble with Normal* initiated a trilogy of albums focusing in large part on North-South issues, especially the ongoing attacks against life itself—humans, rivers,

mountains, oceans, air—for the benefit of an already wealthy few. These songs decry the abandonment by the powerful of a sense of *humanness* as they inflict widespread suffering, apparently without a second thought.

I, of course, as much as anyone, benefit from this through the lifestyle I am able to maintain, but in all the travels of the period I kept meeting people who were at the other end of the global economic equation. It was easy to feel for them. My take on their voices shows up throughout the albums. The rage in those voices was real, but it was not simply a flail. I tried to tell real stories with real information, and I wanted to make it clear how I felt about it. I didn't set out to foment anger, but I did want to stir the pot. Somebody had to.

The scum, as they say, had risen quite effectively to the top. Today corporate crime has reached epidemic proportions, and even people in the developed world are finding themselves falling victim to it, though there is still plenty of willful blindness around. The gap between rich and poor is becoming almost medieval in scale, as the ranks of the latter swell and the middle class shrinks. Ecological devastation has become routine to the point of waning media interest, while very rational scholars and scientists are uttering the once fantastic notion that in my young daughter's lifetime, the planet she depends on may become uninhabitable. Each sliding step down this road brings cries of warning and expressions of dismay. Each new skid downward leaves the previous one seeming acceptable after all. That, indeed, is the trouble with "normal."

The album title set the tone, but it differed from the other two albums in the trilogy because the information and imagery for the Third World–related songs came more from remote observation: TV, books, and magazine articles, including those passed along by my brother Don.

Perhaps more than anyone else, Don was pleased about my newfound appreciation for politics. Whenever I saw him in the late seventies I could count on him to share political tracts and push issues close to his heart, mostly the need to support revolutionary movements in

Central America. In particular, Don was a supporter of a coalition of five populist groups in El Salvador that, in 1980, merged into the Farabundo Martí National Liberation Front (FMLN) and launched a guerrilla war against the right-wing government that would continue for a dozen years.

While the brutality of the military was a fact of life during the 1970s in El Salvador, it escalated dramatically in the early 1980s when Ronald Reagan became the fortieth president of the United States. It was no coincidence that the FMLN launched its first major military offensive (with troops made up almost entirely of poor, landless peasants, including women and the elderly) against the Salvadoran government in January 1981, two months after Reagan's election.

The pattern of atrocity was already in force by the time Reagan took office. A pivotal event occurred on March 24, 1980, when the military, at the instigation of Major Roberto D'Aubuisson, assassinated Catholic archbishop Óscar Romero. According to the United Nations, "After speaking out against U.S. military support for the government of El Salvador, and calling for soldiers to disobey orders to fire on innocent civilians, Archbishop Romero was shot dead while celebrating Mass at the small chapel of the cancer hospital where he lived. It is believed that those who organised his assassination were members of Salvadoran death squads, including two graduates of the School of the Americas." During the popular cleric's funeral, death squads opened fire on mourners, killing up to fifty people.

Don also kept me aware of a successful revolution against another U.S.-backed dictatorship, this one in Nicaragua, El Salvador's southern neighbour, where the United States was carrying on a campaign of "low-intensity" warfare against the new, populist Sandinista government. America was simply protecting its investment, of course. In 1937, after decades of attempting to gain total control of Nicaragua, the United States installed Anastasio Somoza García as dictator of the country. By World War II Somoza, a sociopath, was the largest landowner in Nicaragua. (In 1939, U.S. president Franklin D. Roosevelt famously said, "Somoza may be a son of a bitch, but he's our

son of a bitch.") The Somozas ruled Nicaragua with utter brutality until the summer of 1979, when the Sandinistas finally routed the regime of Anastasio Somoza Debayle, the son and heir to his namesake.

*Aside: The Sandinista movement was founded in 1962 by Carlos Fonseca, a teacher and librarian, along with Tomás Borge and Silvio Mayorga. It was named after Augusto Sandino, who led a campaign of resistance against the U.S. military occupation of Nicaragua in the twenties and thirties. (Interestingly, Don discovered that one of Sandino's generals bore the name Adolfo Cockburn. He was the son of a Scottish immigrant and a Miskito Indian woman.) Fonseca and Mayorga were killed in the mid-seventies.*

The administration of U.S. president Jimmy Carter, which was in office at the time of the revolution, initially supported the Sandinistas—or at least chose not to promote an active resistance to them—but when Reagan took office, he funded and trained a counterrevolutionary force of terrorists that became known as the Contras. Reagan claimed that revolutions in Central America would establish a "Communist foothold" in America's "backyard." In truth, the administration was concerned that a successful people's revolution would inspire similar uprisings throughout Latin America and elsewhere, thereby diminishing Northerners' access to cheap labour and natural resources. Fundraising for the Contras, who were doing their best to drown the revolution in its own blood, was partly accomplished through the clandestine sale of arms to Iran, in violation of an arms embargo that the United States had facilitated.

Not long after the Sandinistas took power, Don gave me a small volume of poetry by the eminent Nicaraguan writer Ernesto Cardenal, a Jesuit priest who served as minister of culture in the new government. Despite pressure from the Catholic hierarchy, Cardenal continued to be both a priest and a Sandinista. His passionate and sharply drawn poetics portray the history of U.S. imperialism in Central America since the Monroe Doctrine of 1823, and since American physician-attorney William Walker and his mercenary gang of

"filibusters" seized control of Nicaragua in 1856. (The government of Honduras executed Walker in 1860 after he was captured and turned over to them by British troops. The British wanted Central America for themselves.)

Cardenal's poetry is beautiful and painterly, done in a "documentary" style that piqued my interest in the region and its struggles, and contributed to my songwriting in both form and content. To read him is to be transported in much the way a film takes you out of your seat and into the life force on screen—only better, because you get to fill in the pictures yourself. With vivid strokes the poet recounts events of the moment, and of history, holding forth the creative heart of his people's aspirations for a life of meaning and self-determination.

Through his simple but vivid and shattering lines, Fr. Cardenal transports us to his homeland and the realities of imperial cruelty. He couldn't have done it if he hadn't been there, in Nicaragua, participating in a unique and powerful societal transformation. His writing, among other things, helped me grasp the importance of witnessing. I sucked the stuff up like a thirsty quarter horse.

In addition to Cardenal's poetry, Don gave me a report by Pax Christi, a Catholic human rights organization, which refuted the Church hierarchy's claims to have been persecuted by the Sandinistas. Pax Christi determined that not only were the Sandinistas not persecuting the Church, but that many Church people, such as Cardenal, were directly involved in making Sandinista policy. The report concluded that the hierarchy should just shut up (my translation) and get out of the way. I found it compelling that a Catholic group would produce such a report.

Alongside Cardenal I read the poetry of American Carolyn Forché, whose book *The Country Between Us* is infused with grim communiqués from El Salvador. In one entry she recounts meeting a Salvadoran colonel in his fortressed home. He drank fine wine and kept a pistol on the pillow beside him. His wife brought tea while their daughter filed her nails. At one point in the conversation he

tired of probing from the *norteamericana* and disappeared into another room, then "returned with a sack used to bring groceries home. He spilled many human ears on the table . . . took one of them in his hands, shook it in our faces, dropped it into a water glass. It came alive there. I am tired of fooling around he said. As for the rights of anyone, tell your people they can go fuck themselves. He swept the ears to the floor with his arm and held the last of his wine in the air."

Here was a merciless slice, if you will, of life in a "banana republic" that was propped up, some might say owned, by the United States, an old but largely hidden relationship that emerged in sinister relief during the early Reagan years. Conversely, it appeared that the new Sandinista government of Nicaragua might actually have the interests of its people at heart. This became something I wanted to see up close. What I was reading did not match my mental picture of a banana-republic revolution: literacy, health care, no bloodbath, and at least some tolerance for democratic opposition. The voice inside told me I should go there, but I didn't want to just buy a ticket and show up cold, without a guide. I didn't speak the language. I feared I wouldn't have any understanding of what I was seeing, or any sense of perspective. For some months I cast about, seeking the right way to get to Nicaragua, without success.

In early 1983, just after the release of *The Trouble with Normal*, the "rhythm of Circumstance" generated a call to Bernie from Oxfam Canada asking if I would join a team they were sending to Central America to witness and report on the situation in the region, specifically their development work and the conditions that made it necessary. Here was the opening I'd sought, a chance to witness rather than be a mere tourist. When I said yes I knew, in the deep place where we know such things, that this would shift the course of my life. The spirit was still coming through.

*Away from the river*
*Away from the smoke of the burning*

*Fearful survivors*
*Subject of government directives*
*One sad guitar note*
*Echoes off the wall of the jungle*
*Seen from the air they're just targets with nowhere to run to*

*Children of rape*
*Raised on malnutrition*
*Men in camouflage*
*Filled with a sense of mission*
*Light through the wire mesh*
*Plays on the president's pistol*
*Like the gleam of a bead of sweat in the glow of a candle*

*Hear the cry in the tropic night*
*Should be the cry of love but it's a cry of fright*
*Some people never see the light*
*Till it shines through bullet holes*

*The tropic moon*
*Bathing a beach fringed with palms*
*Glitters on shells*
*And beach tar and coke cans*
*And on the night-coloured boat*
*And on the barrels of guns*
*In the rage in the hearts of these men is the seed of a wind they call*
*Kingdom Come*

*Hear the cry in the tropic night*
*Should be the cry of love but it's a cry of fright*
*Some people never see the light*
*Till it shines through bullet holes*

"TROPIC MOON," 1982

# II

In June 2011 the Guatemalan forensic scientist Fredy Peccerelli swabbed a DNA sample from the cheek of a young man named Óscar Ramirez, a Guatemalan national living in Framingham, Massachusetts, a Boston suburb. Óscar had illegally moved to the States in 1999, so when a Guatemalan human rights investigator contacted him in connection with a crime in his homeland, Óscar at first balked. Once he learned the severity of the crime, however, and his intimate if bizarre connection to it, he agreed to cooperate.

Óscar was the son of Óscar Ramirez Ramos, a lieutenant in the Guatemalan military—or so he had always believed. It turned out that on December 6, 1982, when Óscar was three years old, Ramirez Ramos had kidnapped the boy from a small Guatemalan village in the northern highlands called Dos Erres. "Kidnapped" is a euphemism in this case, however: Ramirez Ramos was an architect of the Guatemalan government's massacre of virtually everyone in Dos Erres— more than two hundred people who, one by one, were blindfolded, led to a community well, hit on the head with a sledgehammer, and then dumped into the well, whether or not they were dead. The killing began with a baby who was torn from her mother's arms and dropped, alive, into the well. Most of the women and girls were raped, often in front of their families, before being dumped down the hole.

Only three people who were in Dos Erres that day survived: an

eleven-year-old boy who escaped into the bush, and two toddlers who were taken and raised by the killers. Ramirez Ramos kept Óscar for himself and gave the boy to his mother, who had always wanted her son to have children. It wasn't until the late nineties that Guatemalan human rights activists learned from soldiers who had been in Dos Erres that day that two toddlers were taken. More than a decade later, an investigator located Óscar in the United States.

As recounted in 2012 by the nonprofit ProPublica news site and the radio show *This American Life,* the DNA swab proved that Óscar was the son not of Ramos but of Tranquilino Castañeda Valenzuela, a man from the village who, incredibly, survived the massacre because he happened to be away. (Castaneda's pregnant wife and eight other children died in Dos Erres.) In 2012, after thirty years, father and son were reunited.

The Dos Erres massacre occurred around the same time we were mixing *The Trouble with Normal,* and just before the call from Oxfam Canada. Although at the time we couldn't have known specifically about Dos Erres, it was clear to anyone paying attention that Guatemala had become a killing field. Between 1978 and 1983 the Guatemalan military, using weapons, money, and training from the United States and Israel, destroyed 626 Guatemalan villages and murdered more than two hundred thousand villagers, most of them Mayan farmers—campesinos scratching out a meager living on marginal lands that had somehow escaped acquisition by the country's major landowning families. (According to the Land Tenure Center at the University of Wisconsin–Madison, in 1979 Guatemala had the highest concentration of farmland ownership in Central America, with 2.6 percent of the farms controlling 60 percent of the arable land. Those estates mostly produced coffee, sugarcane, and other export crops. In 1984, fully 84 percent of Guatemala's rural population was "landless or near landless.")

One of the most obvious indications of atrocity was the more than one hundred thousand Guatemalans crowded into a number of refugee camps in southern Mexico, along the Río Lacantún, which con-

stitutes about one hundred miles of the border between Mexico and Guatemala. (By 1983 there were more than one million internally displaced Guatemalans as well.) Oxfam proposed sending me and another Canadian songwriter, Nancy White, along with interpreter Rick Arnold, a Canadian who'd grown up in Venezuela, to southern Mexico to visit a couple of the refugee camps, then on to Nicaragua to witness the revolution. The point was to observe, attempt to understand, and then share our findings and impressions with the Canadian public.

In several sessions over a few days the Latin American Working Group, a Toronto-based nonprofit information centre, briefed Nancy, Rick, and me on the history and recent politics of Latin America in general and Central America in particular. From the Monroe Doctrine to the CIA-Contra connection, from the Argentine Dirty War to the selling of Guatemalan children for their body parts, we heard the sorry stories of Latin Americans suffering the lash of wealthy nations seeking cheap labour and natural resources. In February 1983 we departed for Mexico.

Mexico City is shockingly large. Today megacities dot the globe, having metastasized furiously over the past three decades as impoverished rural regions empty out into urban commerce zones. But in the early eighties Mexico City stood out as an anomaly, a single megalopolis containing some twenty million souls, nearly the population of Canada at the time. It was one thing to know a number, quite another to see what it meant on the physical plane. In a commercial jet soaring at whatever rapid rate those things go on approach to airports, we flew over mile after mile of suburbs, single-story buildings the colour of the surrounding dust giving way to larger and more substantial ones and eventually to high-rises, for half an hour before landing.

Modernity surprised me throughout Mexico City. I didn't have any particular expectations, but my mind turned out to be awash in

unexamined stereotypes. I was expecting a backwater of sombreros and serapes, which speaks loudly to the educational benefits of travel. When my guitar failed to turn up on the baggage carousel, I shrugged to myself and said, "Of course," but it was delivered to our hotel in the art deco Zona Rosa neighbourhood in a most efficient fashion. Here was a modern, throbbing metropolis of unexpected beauty and concentrated wealth contrasting sharply with limitless poverty. Mexico City is the world's eighth-richest city, with a gross domestic product of around $400 billion. More important to me, then and now, the place is home to diverse and spirited communities of artists, musicians, intellectuals, and dissidents, some of whom I would meet during our brief stay.

One night we attended a party at the apartment of a film director, which featured a screening of his newly completed documentary on the tango. I knew virtually nothing about the music other than cheesy stereotypes, but in the film the tango came alive, rich and sophisticated. Like the earliest jazz, it was an outgrowth of the underclass traditions of the African diaspora, in this case as manifested in Argentina.

I had made it clear to Oxfam, and stressed to people we met along the way, that I wanted to understand what was going on and not be propagandized to. We arranged meetings with Central American political activists who were exiles from various countries, including Guatemala. At one of these, a spokeswoman for the main element of Guatemala's anti-government guerrilla movement provided accounts of government troops committing atrocities against unarmed peasants.

"Forgive my ignorance," I said, "but how do you know it was the army doing this? How do people know it wasn't some guerrilla faction?"

She looked at me blankly for a moment and then answered, without condescension, "They came in helicopters."

It was embarrassing, but it wasn't a totally misplaced question. It's just that the answer was so glaringly obvious, at least to the victims.

Later, in 1999, the Guatemalan Report of the Commission for Historical Clarification found that 93 percent of human rights abuses in
Guatemala during the seventies and eighties were committed by the
Guatemalan military. The report also disclosed that 83 percent of
those killed were Mayan, and that the United States' funding, training, and directing of the Guatemalan military and intelligence units
"had significant bearing on human rights violations during the armed
confrontation." The units in question did the hands-on work. For the
United States, it was just another Indian war.

I made a lot of notes during our three weeks in Mexico and Nicaragua, and they help paint the scene.

---

*The Kinks on the radio driving along Avenue of the Insurgents—
"You really got me now." Climb up two flights of stairs in a bare
art deco building. Knock, looking for X. X is a Baptist pastor who
used to share an office in San Salvador with a Jesuit priest on an
ecumenical education project. X was sent to Puerto Rico for a World
Council of Churches meeting. On arrival, he called home to tell
his wife he was okay. She told him not to come back. Soldiers had
taken the priest away. No, they were not in uniform but as they left,
one said to the other, "OK, major." So the pastor came to Mexico,
eventually to be joined by his family. Three years later they have a
life here. But he wants to go back to El Salvador, and I ask him how
he can think of going back, meaning where does the courage come
from? He misunderstands and talks about planes, false papers, and
the underground. I lamely wish him good luck and ask, "By the way,
what happened to the priest?" "After some days his body appeared in
the dump, burn marks on his eyelids, the mark of the beast."*

---

During our couple of days in Mexico City, Nancy and Rick went
out and bought six suitcases, which they filled with medical supplies,
including much-needed penicillin and painkillers—you can buy
anything over the counter in Mexico—to be distributed at the

refugee camps on behalf of Oxfam Canada. We then flew to Oaxaca and rented a car, making our way through the rugged terrain of what would later be the Zapatista stronghold of Chiapas to the old colonial city of San Cristóbal de las Casas. The Catholic archdiocese there had quietly arranged for a pilot to meet us in the nearby hamlet of Las Margaritas, just thirty miles from the Guatemalan border. (The government of Mexico had, for reasons known only to them, chosen to deny that there were any refugees. No outsiders were permitted into the camps, not even representatives of the United Nations. The Church provided the only source of support for the Guatemalans, and even that had to be covert. It wasn't nearly enough.)

Las Margaritas is at the eastern edge of a vast tropical wilderness spread across much of southern Mexico and northern Guatemala. Although logging, ranching, road building, and oil exploration have made a deep impact on this critical island of biodiversity, it remains one of the wildest and most beautiful places in the Western Hemisphere. Surrounding cloud forests still nurture endangered species such as the horned guan and the resplendent quetzal, Guatemala's national bird. It was in the middle of this wilderness, on the western, Mexican side of the Río Lacantún, where we would find the Guatemalan refugees, impressive in their own way for being alive against the odds. They were eager to connect.

The Mexican government's denial of the existence of a refugee problem was odd, as if the longest-running war in the Americas and tens of thousands of desperate camp dwellers sprawled along a major river could be ignored. The Guatemalan civil war had begun in 1960 and would not end until 1996. The genesis of the war was the 1954 coup that ousted the democratically elected president, Jacobo Árbenz Guzmán. The CIA, acting on behalf of the United Fruit Company, armed, funded, and trained coup leaders to reestablish Guatemala as a feudal state in fealty to foreign businesses. At the time United Fruit owned 42 percent of the arable land in Guatemala—the largest single land holding in the country—but the company was slated to lose 40

percent of it to Árbenz's Decree 900, which sought to redistribute farmlands to allow campesinos to grow food and become self-sufficient.

United Fruit had a couple of key allies in the U.S. government—the Dulles brothers, Allen and John Foster, who designed and implemented the coup. At the time, Allen was director of the CIA and also on the board of United Fruit; John Foster was secretary of state and his law firm, Sullivan and Cromwell, represented United Fruit. These guys were, and their modern-day protégés remain, startlingly brazen in their self-serving wars—their greed knowing no bounds, their shame never acknowledged. That a democratically elected government could be overthrown and an entire nation brutalized in the service of just one corporation reveals more about Western economics (and about the mechanics of "democracy") than anything you're likely to find in *The Wall Street Journal*.

In Las Margaritas, Rick located the man who would fly us to the refugee camps. The pilot was a slightly paunchy but fit-looking man of middle age, with longish hair framing a face lined and stubbled, mouth permanently set in a sneer. When he noticed the gold loops in my ear, he started addressing me disdainfully as "Alice Cooper." He flew a battered single-engine Cessna with no passenger seats. Where the seats would have been, he'd piled a number of fifty-pound bags of rice. Our man's livelihood came mainly from supplying the large farms in the area, the *fincas*, with food, fuel, furniture, whatever—if it would fit in his plane, he would fly it in.

Nancy was invited to sit in the copilot's seat. Rick and I climbed onto the rice and piled the medical supplies and our personal things at our feet. I did a double take and chuckled at the dashboard: where you would expect to see navigational gear, there was just a fuel gauge, an altimeter, and a battery-powered transistor radio jangling out ranchero music. Otherwise, the panel was an array of variously shaped holes. The pilot cranked the engine over and taxied us, roaring and bouncing, down the grassy field. As we picked up speed, he looked over his shoulder with a grin and shouted in a perfect Pancho

Villa accent, "You know, I never took a flying lesson. Now I own my own airline. How do you like that, Alice Cooper?"

I asked where he learned to fly. He said, "Well, I used to hang around the pilots and they showed me what to do. Eventually I managed to get hold of an airplane." He learned by apprenticing, the way people in traditional societies do. It was novel to see that applied to a job we think of as so high-tech, but, lessons or not, he got us where we wanted to go. Soon enough, we landed on a dusty, rutted strip at a camp called Puerto Rico, a few miles from the border. Our man would come back and pick us up to fly us to our other destination, a camp called Chanjul, in a couple of days.

---

*We carry medical supplies to the Guatemalan refugee camps. Remote. Sad, tired faces. Pathetic smiles of welcome. The airplane the only contact with civilization and its casual gifts of aid on which they almost survive. The little boys along the dirt runway hold toy planes made of scraps of wood. Our medicine is all that they have—six full suitcases for 8,000 people. They feel that we, and those like us, are their only hope. Someone to tell their story to the outside world.*

---

I had seen refugee camps on TV—Sally Struthers, eyes tearing up like a kind of anti–Tammy Faye Bakker, in front of rows of tents in the sun and babies with flies on their eyes—but face to face it was different. TV has no smell, no feel. This kind of poverty stinks. It smells like too much sweat and not enough soap. It smells like human shit baking in the sun. That said, the camp was laid out in an orderly fashion. There were numerous dwellings and several communal buildings constructed from what the jungle had to offer: rough-hewn lumber, bamboo, palm leaves for thatch. The three thousand inhabitants, mostly women, children, and the elderly, carried themselves with grace and dignity, though they were clearly desperate. That was the most moving part of being there, to see the suffering, and to see

the strength in the face of that suffering, of the constant threats, of the immense and brutal theft of life and security. Their response to chaos was organized and cohesive, though they had absolutely nothing, no prospects whatsoever. They were even building a school, never mind that they had nothing to put in it, no books, no teachers. At Chanjul, we would later see, they had constructed a little infirmary, which was staffed by a couple of nuns. There was no medicine, but they would be ready when supplies came. They never did, of course, not in any significant way. Later the Mexican army went in and burned it all down anyway. When I saw the strength and clarity of the people in those camps, combined with the threat of violence and starvation, I experienced intense waves of emotion, alternately dark and light. There was no way for a greenhorn like me to find balance in such conditions. I was in awe, appalled, incensed.

People greeted us warmly and took us to meet the elders of the community. There was some head scratching about us. Why three Canadians? Why musicians? We explained that we had come to bear witness and to bring to the outside world what we saw and heard. They seemed pleased that someone was paying attention. The people we met had survived demonic counterinsurgency tactics, and now they gathered in relative safety but on the brink of starvation and still suffering sporadic acts of violence by the Guatemalan military, even on Mexican soil. Food was rationed: three tortillas a day per person. Parents boiled leaves from trees to feed their hungry children. But it was better than where they had come from.

The Guatemalan military wasn't content to simply torture and slaughter and destroy villages where they were. They continued to harass the survivors, crossing the border into Mexico and attacking the refugee camps, strafing from helicopters, now and then dragging people off into the jungle and hacking them to pieces with machetes. A helicopter assault had occurred at Chanjul, which was only a few hundred metres from the border, the week before our visit. The week after there was another. We were lucky it didn't happen to us, because no one knew we were there.

The first night in camp we stayed in a little guesthouse, sleeping in hammocks. It had a tin roof and cement-block walls with large, paneless windows, and had been on this remote farm before it was a refugee camp. Some young men came in. They were refugees but weren't living in the camp. Some of the young men who had not joined the guerrillas were sneaking back to their farms to keep the crops alive, hoping to save the harvest. It was hard to imagine how they could carry any of their produce back to the camp over thirty miles of mountains, but it was clear that if anyone could do so, it was they. Farming had to be carried on clandestinely because the army was constantly surveilling the villages, and former villages, for activity.

Rick asked them in Spanish, Why did you guys flee? One of them described what happened to his neighbour. The army came and took this man. They tortured him, then cut all the flesh off his forearms from his elbows to his wrists and hung him up on his own gatepost to die slowly. There was another episode: The army went to a house. The wife was pregnant. They beheaded the husband, then slit open the woman, ripped out the fetus, and stuck the husband's head where the fetus would have been. This was a message to the neighbours. These acts were aimed to shock, to prove their dominance. These sorts of atrocities were being committed every day throughout the countryside by the U.S. client state of Guatemala, along with the annihilation of whole villages, using U.S. weapons and training. The strategy was to create what during the Vietnam conflict were called "strategic hamlets," by forcing the people to abandon their traditional villages and cluster in artificially created population centres that could be closely watched.

Mayan people feel a sacred connection to the place where they are born. Few would willingly leave land they understood themselves to be a part of. To this end, the army, not content with massacring the people, also destroyed everything they valued. That's why our hosts were refugees, and why so many others had taken up arms.

*I understand now why people want to kill.*

According to the venerable British Peace Pledge Union, the stories we heard were commonplace:

Working methodically across the Mayan region, the army and its paramilitary teams, including "civil patrols" of forcibly conscripted local men, attacked 626 villages. Each community was rounded up, or seized when gathered already for a celebration or a market day. The villagers, if they didn't escape to become hunted refugees, were then brutally murdered; others were forced to watch, and sometimes to take part. Buildings were vandalized and demolished, and a "scorched earth" policy applied: the killers destroyed crops, slaughtered livestock, fouled water supplies, and violated sacred places and cultural symbols. Children were often beaten against walls, or thrown alive into pits where the bodies of adults were later thrown; they were also tortured and raped. Victims of all ages often had their limbs amputated, or were impaled and left to die slowly. Others were doused in petrol and set alight, or disemboweled while still alive. Yet others were shot repeatedly, or tortured and shut up alone to die in pain. The wombs of pregnant women were cut open. Women were routinely raped while being tortured.

In due course our macho pilot appeared and we moved on to Chanjul. Our approach to the camp took us low over the silty brown flow of the Lacantún, between walls of jungle rising from sheer gravel banks. A sudden, steeply banked left turn had us aimed at the runway. This was a strip of cleared land, free of stumps and rocks. The only obstacle was a little gang of half a dozen dogs milling about, wagging their tails and sniffing each other's hindquarters, right where we'd be touching down. Despite the danger I felt a twinge of perverse pleasure as the pilot blanched and started muttering, *"Los perros!*

Get the dogs out of there!" Alice Cooper's (pyrrhic) revenge. At the last possible moment someone in the mob of refugees, which had lined the airstrip when they heard us coming, realized the problem. A small boy ran out and chased them off. It was a bumpy but fair landing.

People went out of their way to be hospitable. They apologized for having so little to offer. They had suffered in the worst of ways, but they were serious, and they wanted us to hear their stories. Those stories were delivered in a near deadpan tone, which made them all the more horrifying. It was as if they were recounting ancient myths, but they weren't. It was what they had very recently lived through. These calm voices. Maybe it was shock. Maybe it was how an oral culture does things. Maybe their sense of connection to that culture gave them unexpected strength.

Strength enough that Chanjul camp threw us a party. We were musicians, so there should be music. A full-sized marimba appeared, as if by magic, in front of one of the houses near the centre of the camp. Some of the refugees had managed to haul it with them in flight from their village, each person carrying a piece of it. They rebuilt it when they reached what passed for safety.

In the Guatemalan folk tradition, the marimba is handled by three players. One stands at the low end and plays bass, another stands in the middle and plays chords, and the third plays the melody in the upper register. Each man donned his one good shirt for the occasion. The rich sound of the instrument brought people flocking around. I was invited to jam with them. Easy enough: the harmonies were simple and the beat was strong. People started to dance, especially the little girls, dolled up in their brightly woven "best" clothes, many with tiny siblings slung on their backs. The party didn't last long, but it was real. The smiles and laughter in that setting were heart-breaking.

As a backdrop to all this was the intermittent throbbing drone of the Guatemalan choppers, hunting wasplike along the border. The *so-nearby* border. After a couple of days in each camp, we returned

to San Cristóbal. I was overwhelmed. To intellectually understand, or at least consider (because who can understand it?), the evil that humans inflict upon one another is one thing; to feel the results through the faces and stories of the survivors was something other. I was intellectually prepared but emotionally wrenched. What makes a government do this to its own people? What allows a human to do this to another person? What could possibly convince the world's most powerful nation, our neighbour the United States, not only to accept but to support, even *design*, such slaughter?

It seems possible to view the genocide against Mayan people as an extension of the historic U.S. policies of extermination at home against Native Americans. The atrocities were not unique. They were part of a pattern of depravity that surfaces again and again all over the globe. In southern Mexico we found raw evidence of the banality of evil. Not only was it horrible, but for the most part it wasn't even creative. Not much has changed in the realm of mass murder since biblical times. Though the tools of the trade have become more sophisticated, when we get down to it, it's somebody bashing someone's head with a hammer or a shovel, or herding folks into a church and setting it ablaze. Same old shit. The difference for me was that this aspect of us had leapt off the page and become flesh and blood.

Asking God how he could allow such brutality seemed like an irrelevant question. Here, splayed before me in ways I had previously only imagined, were the "juicy bits" from the Bible. Here was the horror, Conrad's heart of darkness, Thanatos projected, all too real. I felt the violence pulsing through our DNA. These actions are embedded in our social, religious, and political traditions. A decade later, surveying the mine-strewn beauty of a Mozambican landscape ravaged by the same evils, it struck me that war is the default position of mankind, peace an aberration.

In San Cristóbal I bought a bottle of cheap whiskey and holed up in my bare hotel room. I needed the simple whitewashed walls. I didn't want to see anyone. I kept reliving the terrible stories, trying to breathe them into some comprehensible order. The quiet courage,

the fierce determination and dignity of the refugees, the children still being children after all they'd seen—all of it hit me like an ice pick to the heart. When I thought about the perpetrators of those deeds, especially the anonymous airborne ones, I felt all-consuming outrage, a conviction that whoever would do such things had forfeited any claim to humanity. I envisioned myself with an RPG, blowing them out of the sky. In the hotel room, through tears and under dim light driven back from night's rippled windows, I began writing.

*Here comes the helicopter—second time today*
*Everybody scatters and hopes it goes away*
*How many kids they've murdered only God can say*
*If I had a rocket launcher*
*I'd make somebody pay*

*I don't believe in guarded borders and I don't believe in hate*
*I don't believe in generals or their stinking torture states*
*And when I talk with the survivors of things too sickening to relate*
*If I had a rocket launcher*
*I would retaliate*

*On the Río Lacantún, one hundred thousand wait*
*To fall down from starvation—or some less humane fate*
*Cry for Guatemala, with a corpse in every gate*
*If I had a rocket launcher*
*I would not hesitate*

*I want to raise every voice—at least I've got to try*
*Every time I think about it, water rises to my eyes.*
*Situation desperate, echoes of the victim's cry*
*If I had a rocket launcher*
*Some son of a bitch would die*

"IF I HAD A ROCKET LAUNCHER," 1983

# 12

During the tour that followed the release of my 1984 album *Stealing Fire*, after a gig in L.A., an acquaintance—a man of good intentions who belonged to one of those California hipster churches—challenged my take on Guatemala. He spouted a surprisingly conservative line: How did I know Ríos Montt was so bad? How did I know there were massacres?

"I met the survivors," I said.

He went silent for a moment, then mumbled: "Oh . . . well, we have to stop Communism."

All you had to do in those Cold War days was cry "Communism," and some members of North American society would fall all over themselves to support, at least ideologically, a U.S. policy—so demonstrably insupportable—that was resulting in the murder of thousands of peaceful people in a tiny country fifteen hundred miles away. I suggested to my friend and others like him that they take some time to dig below the surface of the scam, to learn what was really happening to real people with real dollars that came from people like them. Now, of course, the buzzword is "terrorism," but the same dynamic is at work.

On May 10, 2013, a Guatemalan court convicted former dictator Efraín Ríos Montt of the murder of at least 1,771 Mayan people dur-

ing his scorched-earth reign as a general in the Guatemalan army, and as de facto president after he seized power in a CIA-backed coup in 1982. (He was deposed a year and a half later in another coup, by officers who presumably seemed more "reasonable" to the vested interests they represented.)

Ríos Montt's conviction was extraordinary in Latin American politics—particularly in Guatemala, which, despite some reforms, remains under the control of wealthy oligarchs heavily in thrall to the United States. But in the politico-legal saga that starred the former strongman, the charges were first quashed and then reinstated; Ríos Montt was sentenced to eighty years in prison; and finally—as of this writing, anyway—his conviction was overturned and the charges thrown out again. One waits with bated breath to see what will happen next.

The general's relationship with the United States is typical of the way an imperial power maintains control of smaller nations through local proxies. In 1951 Ríos Montt attended the notorious School of the Americas in Fort Benning, Georgia, which specialized in training military types from all over the southern continent in "counterinsurgency" (read: anti-left) strategies, including coups, assassinations, and the use of terror. By 1970 he was an army general active in Guatemalan politics.

In 1978, shifting his approach, he became an ordained minister with the California-based Church of the Word, then forged close relationships with an Augean stable of right-wing U.S. evangelists, including Jerry Falwell and Pat Robertson. After the Carter administration denied U.S. military support to Guatemala, Ríos Montt drummed up money from conservative Christians committed to defending the Western world against the alleged threat of Communism. (Illicit funding and arms for Central American regimes were often facilitated by Israel.) At the same time, Falwell's Moral Majority was a major contributor to the election of Ronald Reagan as U.S. president in 1980.

The Reagan administration then cozied up to Ríos Montt and

began funneling weapons and money to the Guatemalan military for its war against Mayan villagers before his installation, by the CIA, as dictator in 1982. Later that year, Reagan bypassed congressional objections and sent additional millions of dollars' worth of military hardware to Guatemala, even after receiving reports of atrocities, and declared, "President Ríos Montt is a man of great personal integrity and commitment. . . . I know he wants to improve the quality of life for all Guatemalans and to promote social justice." (At nearly the same time, the United States Conference of Catholic Bishops charged that the Guatemalan military was committing "genocide" against the Mayan people.)

The general was not called to account for his reign of terror against tens of thousands of campesinos until 2012, when he was indicted. By that time, he was a wealthy and well-fed eighty-five-year-old.

Ríos Montt's Christian connections are particularly galling, though not surprising. Acquiring and violently wielding a religious power base is a time-tested way of ensuring popular obedience. "I'm doing God's work," sing the false prophets.

In 1999 U.S. president Bill Clinton offered a remarkable apology for the U.S. role in the Guatemalan genocide. Clinton said his country's "support for [Guatemalan] military forces and intelligence units which engaged in violence and widespread repression was wrong and the United States must not repeat that mistake."

Clearly his successor, George W. Bush, wasn't listening. In fact, several of the players in the theatre of misery created by U.S. wars in Central America in the 1980s would resurface in Iraq and Afghanistan in the 2000s. These include U.S. colonel James Steele, who was instrumental in the unleashing of a counterinsurgency program in El Salvador that killed seventy-five thousand civilians, and who went on to oversee similar operations in Iraq that resulted in major sectarian violence. (The counterinsurgency campaign in Iraq became known as the Salvador Option.)

Steele was also one of the six known operatives, along with the infamous colonel Oliver North, who orchestrated the Iran-Contra

deal. North went on to become a correspondent for that mighty bastion of journalistic veracity, Fox News, even reporting from Iraq during the American war. At this writing he is a consultant for violent video games and hosts *War Stories with Oliver North* on the Fox network. He also contributes a regular opinion column to *Soldier of Fortune* magazine.

Another sinister figure who pops up in both Central America and Iraq is John Negroponte. In 2004 President Bush appointed Negroponte ambassador to Iraq, just in time to usher in a plan, devised by Steele and others, to divide and conquer rival factions among the population in order to benefit the U.S. occupation. From 2004 to 2006 that civil war resulted in the sowing of death on Iraqi streets to the tune of three thousand bodies a month. As ambassador to Honduras from 1981 to 1985, Negroponte was similarly charged with establishing U.S. training bases where the Contra army, aiming to overthrow the Sandinistas, learned the fine arts of destabilization: terror, murder, and otherwise making life difficult for the civilian population. Most Nicaraguans wanted only peace and enough land to grow food so they wouldn't starve, and they had successfully shucked the bonds of a succession of U.S.-backed dictators. For that, they paid dearly.

Honduras suffered the pains of intervention as well, with U.S. military aid increasing from $3.9 million in 1980 to $77 million by 1984. Negroponte oversaw the vastly increased militarization of Honduras, including the notorious government death squad Battalion 3-16, "a secret army unit trained and supported by the Central Intelligence Agency," according to an extraordinary 1995 investigative report by *The Baltimore Sun*. "Battalion 3-16 used shock and suffocation devices in interrogations," the *Sun* reported. "Prisoners often were kept naked and, when no longer useful, killed and buried in unmarked graves." Negroponte was well aware of the Honduran military's death squad activities yet continued to orchestrate shipments of U.S. weapons and cash.

Elliott Abrams was another Reagan hack who reappeared during the second Bush administration. In 1982 Abrams, as assistant secre-

tary of state for human rights and humanitarian affairs under Reagan, was quick to discount as "not credible" reports from Central America that in December 1981 the Salvadoran army had executed five thousand civilians in the village of El Mozote. Abrams's denial came despite well-documented reports of the massacre from human rights groups, and articles in the *New York Times* and *The Washington Post.* (In 1993 the Salvadoran Truth Commission confirmed the deaths, and in 2011 the government of El Salvador apologized for them.) Human Rights Watch and Amnesty International accused Abrams of covering up atrocities committed in Nicaragua, Guatemala, El Salvador, and Honduras. In due course Abrams pled guilty to two counts of withholding information from Congress in the Iran-Contra scandal. In 2001 president George W. Bush appointed him to the post of special assistant at the National Security Council, where he allegedly played a role in the failed coup attempt against democratically elected Venezuelan president Hugo Chavez in 2002.

Then there's Dick Cheney, who as a U.S. congressman in the 1980s supported the viciously repressive Salvadoran government. Cheney even served as an observer of the 1984 Salvadoran elections, which were widely condemned as a farce but which he touted as a success. Of course, Cheney's role, when he was vice president, as an architect of the conflicts in Iraq and Afghanistan is well known. The wars he fomented enriched several major U.S. arms, energy, and service companies, particularly his own Halliburton.

Perhaps one more parallel: I, too, was, at moments, in Central America, Iraq, and Afghanistan as the wars raged, the difference being that the successes I saw involved poor and embattled communities struggling to rise above the worst forms of external pressure to survive and attempt to create more equitable societies. This was particularly true in Nicaragua, where the Sandinista revolution ousted the Somoza dictatorship in 1979, and where Nancy White, Rick Arnold, and I went after we left southern Mexico.

Our first sight of Managua, the capital, seemed post-apocalyptic. Most of the city centre had been leveled in the disastrous earthquake of 1972 and never rebuilt. Streets remained rutted and potholed, weaving through a landscape of rubble. Here and there a small strip of two-story buildings still showed signs of life, but in between, an infant wilderness had arisen. In some places, you could spot little tent communities where people were squatting.

The nations of the world poured buckets of relief money into Nicaragua after the quake, but instead of using the funds to rebuild homes for the 120,000 people who had been displaced, Somoza, the classic banana-republic dictator, salted it away in his own bank account. Even many of his upper-crust cronies were disgusted. The ranks of the revolution swelled. In 1979 he was forced to make use of his ill-gotten gains to flee the country. Justice caught up with Somoza in the streets of Bogotá, where his limousine, with him in it, was blown to bits in a rocket attack. No one claimed credit, but a Sandinista official told me it was thought that "a few of the boys" had done the job.

The Nicaraguan people were alive with revolution. They believed themselves charged with the task of building a better life for every- one after centuries of serfdom—understanding that "for everyone" might be a utopian goal, but a worthy one nonetheless. Not every Nicaraguan we spoke with was a Sandinista supporter, of course; some were critical of the new leadership. These people were usually relatively well off and had enjoyed a certain level of comfort during Somoza's reign. But the majority of the population, most of whom were poor, clearly felt the Sandinistas spoke for them. How much that was true was evidenced by, among other things, the total absence of anti-Sandinista graffiti and the fact that, in contrast to virtually every other country I have visited south of Texas, people in uniform were not seen as a presence to be feared.

After several visits to Nicaragua between 1983 and 1988, it was obvious to me that regardless of the ideology, background, qualifica- tions, or even honesty of the men and women who were running the

place, they were at that moment the absolute best option for the Nicaraguan people. At the time the country was the poorest in the Western Hemisphere after Haiti (and today remains so), yet under the Sandinistas life improved dramatically for most people, even in the face of a war waged against them by the most powerful nation on earth.

*Look at them working in the hot sun*
*The pilloried saints and the fallen ones*
*Working and waiting for the night to come*
*And waiting for a miracle*

*Somewhere out there is a place that's cool*
*Where peace and balance are the rule*
*Working toward a future like some kind of mystic jewel*
*And waiting for a miracle*

*You rub your palm*
*On the grimy pane*
*In the hope that you can see*
*You stand up proud*
*You pretend you're strong*
*In the hope that you can be*
*Like the ones who've cried*
*Like the ones who've died*
*Trying to set the angel in us free*
*While they're waiting for a miracle*

*Struggle for a dollar, scuffle for a dime*
*Step out from the past and try to hold the line*
*So how come history takes such a long, long time*
*When you're waiting for a miracle*

**"WAITING FOR A MIRACLE," 1986**

Every time I visited Nicaragua, the Sandinistas were fighting for survival. They were attempting to rescue a nation under siege. After a bloody war against the oppressive Somoza regime, the movement gained control of the country, only to suffer constant attacks by mercenaries trained and armed by the United States. Some Sandinista leaders were taking advantage of the situation to improve their own lives, giving themselves nice houses to live in, reliable transportation, better schools. But for that price the country was getting vastly increased life expectancy and sharply curtailed child mortality, even while at war. Everyone who wanted to learn to read was able to, including an old farmer I met. He was very proud. He told me, "Thanks to the Sandinistas, nobody's ever going to fuck me on a contract again." Naive, but nice to see.

Cooperative farms sprouted everywhere, hunger diminished, coffee pickers were allowed to organize and share profits. Foreign plantation owners could no longer rely on bleeding the country dry to pay corporate shareholders. There was fairness, an uncommon element in Central America at that time.

*Battered buses jammed up to the roof*
*Dust and diesel the prevailing themes*
*Farmer sleeping on the truck in front*
*Feet trailing over like he's trolling for dreams*
*Smiling girl directing traffic flow*
*.45 strapped over cotton print dress*
*Marimba-brown and graceful limbs*
*Give me a moment of loneliness*

*Dust and diesel*
*Rise like incense from the road*
*Smoke of offering*
*For the revolution morning*

*Headlights pick out fallen sack of corn*
*One lone tarantula standing guard*

*We pull up and stop and she ambles off*
*Discretion much the better part of cars*
*Rodrigo the government driver jumps out*
*He's got chickens who can use the feed*
*We sweep the asphalt on our hands and knees*
*Fill up his trunk with dusty yellow seeds*

*Dust and diesel*
*Rise like incense from the road*
*Smoke of offering*
*For the revolution morning*

*Guitars and rifles in blue moonlight*
*Soldiers stretched out on sparkling grass*
*Engine broke down—they took us in*
*Now we make music for the time to pass*
*Tired men and women raise their voice to the night*
*Hope the fragile bloom they've grown will last*
*Pride and passion and love and fear*
*Burning hearts burning the boats of the past*

*Dust and diesel*
*Rise like incense from the road*
*Smoke of offering*
*For the revolution morning*

"DUST AND DIESEL," 1983

As the feminist American poet Margaret Randall wrote in the 1995 preface to her 1981 book, *Sandino's Daughters*, "In a word, the [Sandinista] revolution meant dignity. The wealthiest class lost out, of course, and therein lay the problem for the 'free' world." Randall spent the years 1980–84 living in Nicaragua, working in support of the revolution. When she returned to the United States, in 1984, the government, citing the 1952 McCarran-Walter Immigration and

Nationality Act, revoked her citizenship and attempted to deport her, claiming that her books went "against the good order and happiness of the United States." The Center for Constitutional Rights defended her in federal court, which in 1989 ordered her citizenship reinstated.

The Sandinistas also instituted environmental cleanup programs because the Somozas' corporate allies left the country a toxic and deforested mess. Pesticide use on export crops was suspected of causing cancer and environmental degradation. Investigators also discovered one of the largest cases of mercury poisoning outside Minamata, Japan, in Lake Managua. For years a company 40 percent owned by the Philadelphia-based Pennwalt Corporation dumped waste from a chlorine and caustic soda plant in Managua, into the lake, which is a principal source of fish for the Nicaraguan diet. For more than a decade Somoza's government knew about the mercury and other contaminants, which were sickening inhabitants of the area, and did nothing about it. In 1991 the government ordered the plant closed. Neighbors celebrated.

---

*The day we go up to the Honduran border is the day they commemorate Sandino's death. Racing through Managua streets in Sandino Day dawn. Fireworks at 5 a.m. Hope and hard work. Reconstruction. New houses mushroom slowly out of blasted ground. Fonseca's tomb is guarded by a kid in sneakers with a Czech machine gun. Fields of fresh rice. Girl driving a donkey cart. Small boy on horseback driving a cow across the highway. Siren river, onion fields, tobacco coops. Flowering leafless fruit trees. We're following the army to the Honduran border. Crowded ancient buses. A car with Salvadoran plates. Tobacco fields are raided, therefore constantly guarded. Ironically, Nicaragua reminds me of Israel in a certain sense—being surrounded by enemies. Everything is militarized and everyone is aware of the need for self-defense.*

---

Nancy, Rick, and I arrived in Nicaragua as guests of the Asociación Sandinista de Trabajadores de la Cultura (ASTC), the Artists Union.

Many Sandinista leaders were artists. The ASTC had a headquarters in Managua, a villa with a pleasant backyard that contained a small stage. We performed there a couple of times, and that's where I met writer Rosario Murillo, wife of President Daniel Ortega, who headed up the Artists Union. She was well spoken and engaging, and we chatted a few times. I thought with some envy, "There is no other country in the world with a government like this—a government of artists and intellectuals."

I remember in the mid-eighties, after I'd made a couple of trips to Central America, my dad asked me, "What's so special about Nicaragua? It's so tiny and it has no influence. Why should anybody care?" Well, the United States cared enough to spend vast sums of money, for more than a century, to squash it. Nicaragua was special because the Sandinistas had cut the reins of imperialism to create a greater good for a majority of people, a very rare occurrence and an example that would have shone like a beacon to the rest of the post-colonial world, had it been allowed to prosper.

We played music in sundry odd venues across the country: a 5 P.M. concert at the main intersection of a Managua suburb; a lunchtime performance in the police station in León; a somewhat more formal appearance in the pleasant garden of the ASTC headquarters. We also played at the military base of an elite commando unit of the Sandinista army. While waiting to play, we sat in a small office in the company of a soldier, our assigned bodyguard. He didn't speak any English. He carried a Russian AK-47 assault rifle. I had seen them only in pictures.

"Interesting rifle," I said.

"*Ah-kah*," said the soldier. Then he popped the magazine out and, from across the room, tossed me the gun. I caught it, held it, liked it. It felt as though it belonged in my hands. All the childhood fascination with weapons came back. Before the decade was up I would own one, or at least its Hungarian equivalent.

A highlight of that first trip to Nicaragua was meeting the Sandinistas' minister of culture, Ernesto Cardenal, whose poetry had helped pique my interest in the region. The Sandinista government

was nominally Marxist, but Cardenal continued to serve as a Catholic priest, which he felt was no contradiction. Like most progressives, Cardenal saw no conflict in a mostly Christian society, as Nicaragua is, also believing in an egalitarian distribution of wealth and political power. He carried his minister's portfolio with none of the trappings of a politician. He was a man with a vision of how things should go, and the Sandinistas let him do it his way. Everyone in Nicaragua was encouraged to write and to create art through several programs: *Let's do pictures of your life. Or let's write about your life. Write a short story.* There was a fantastic flowering of the arts, conjoined in a revolutionary context.

We also met the Sandinistas' interior minister, Tomás Borge, who had been in prison with Ortega under Somoza, and there wrote a book, *Carlos, The Dawn Is No Longer Beyond Our Reach: The Prison Journals of Tomás Borge Remembering Carlos Fonseca.* Many of the movement's leaders had written books, and the books were good: little books, fairly quick reading, but philosophical and movingly real.

---

*We pass an army barracks that looks like a farm. A shot-down Somoza aircraft is planted on a hilltop, flying the FSLN flag on its tail. A banner in a rural village says, "As long as Nicaragua has children who love her she will always be free." Women carry firewood on shoulders up the hill. Palms and pines on denuded hills. Battered buses with fantastic paint jobs, jammed with people. People cling to the roof racks, hang from the doors and the windows hoping they won't have to get off and push. Hot roads, diesel clouds—the whole Third World perfumed with diesel. A fat man sleeps in the back of a pickup, feet dangling over the bumper. Rugged bushy hills full of the smell of coffee. Occasional pause for the crossing of beautiful milky-white half-Brahma cattle. Around the bend and there it is—a chain across the road, a customs house, and a garrison of half a dozen militia. Thirty metres away a few Hondurans watch with suspicion and strut around like John Wayne. Their lookouts hiding on the*

*hilltop watch us through field glasses while I watch them with mine.*
*The main spokesman for the Nicaraguan garrison at the border is a*
*short plump pleasant guy with a bad leg. I ask him, "What happens*
*when you have to fight?" For he walked with a severe limp and had*
*trouble getting around. He says, "Sandinistas don't run anyway."*

One of the things that had intrigued me about the Sandinista revolution, when I read about it in advance, was that it was not accompanied by bloody reprisals. They didn't take power and then go around massacring all of their enemies. They attempted to reconcile with their opponents, or at least ignore them. But many of the privileged enemies they had made went to Miami, and with U.S. backing and guidance formed a counterrevolutionary movement: the *contrarrevolución*, or Contras. I mentioned the apparent absence of a campaign of payback to a Sandinista official, who said, "We learn as we go. You look at the previous revolutions, and we don't want to make those mistakes. The French revolutionaries killed all the people they didn't like, but that was bad, it was unproductive. The Russian revolution made similar mistakes. The Cuban revolution, of course, was not so inhumane; it was a little better, though there were executions and repression and killings that probably were unnecessary, and we're trying to be better than that."

I was able to travel freely through the Nicaraguan countryside, where one sometimes encountered oddly placed foreigners: hippie backpackers with no idea they were in a war zone; a troupe of itinerant American clowns on a mission to bolster morale among the people. One day during my third or fourth trip, I was hitchhiking in the blistering heat with a Swiss woman I'd met at my hotel. We were going swimming at a nearby lake. An olive-drab vehicle stopped for us. In it rode two blonds: a big, beefy, hard-faced male and a big, beefy, hard-faced female. They were glowing with sunburn and sweat. They spoke English, but with heavy German accents. When my Swiss friend addressed them in German, they pretended not to understand.

"Where are you guys from?" I asked.

*"Vee ahh frum Tex-aahs."*

Texas? The accents and the Russian vehicle made them East Germans. Maybe they were "private contractors" from that side of the game. But it was funny. Their attempt to pass themselves off as Americans was ridiculous. They were reminiscent of Arnold Schwarzenegger in *Predator,* right down to the man's biceps bulging from cutoff sleeves. Maybe they *were* from Texas, as Arnold is from California.

*Yanqui wake up*
*You know it's time to go*
*The sun is almost up and we want to be alone*

*Yanqui head spin*
*Better get some rest*
*Tomorrow we can talk about the way you insulted the guests*

*Ivan's outside*
*Sulking in the yard*
*Everyone got bad communication when the time gets hard*

*Not a nice guy*
*But he's got troubles of his own*
*Anyway it's best if you both just leave the rest of us alone*

*Yanqui go home*
*You had too much*
*Better go sleep it off*
*Party's over —*
*Time to meditate on it*
*Time to tally up the cost*

*Yanqui wake up*
*Don't you see what you're doing*
*Trying to be the Pharaoh of the West bringing nothing but ruin*

*Better start swimming*
*Before you begin to drown*
*All those petty tyrants in your pocket gonna weigh you down*

*You're my friend but I say*
*Yanqui go home*
*You had too much*
*Better go sleep it off*
*Party's over*
*Time to meditate on it*
*Time to tally up the cost*

"YANQUI GO HOME," 1983

During my last trip to Nicaragua, in late 1988, I looked up Susan Johnson, the point person for the Canadian organization Tools for Peace, which was shipping construction equipment, tractors, and other supplies to the country after an embargo was imposed by the Reagan administration on May 1, 1985. We had met on the first trip, in 1983. Susan was headed to the northeastern coastal town of Puerto Cabezas to track down some missing zinc roofing that had never arrived at its destination. It was supposed to have gone to Miskito Indians, the indigenous people of that side of the country, living near the Honduran border. She invited me to go with her. We flew in a rickety DC3 to the Atlantic coast. The aircraft was so old that the rivets holding the fuselage together rattled. From my seat, which was a metal bench, I could see daylight around the edges of the rivet heads. The engines sounded in tune, though, and it got us where we wanted to go.

Puerto Cabezas is the principal seaport at the north end of the Caribbean side of Nicaragua. The Sandinista mayor was a tall, thirtysomething black man with a bushy Afro. He put Susan and me in the front of a big blue Toyota pickup with his driver, then jumped in the back, and off we went up the highway through largely deforested

terrain toward the Río Coco, which defines the border with Hondu-
ras. Security was less of a problem than it would have been even a
couple of weeks previously. The majority of the Miskito element of
the Contras had signed a truce agreement with the government, so
there was a reduced risk of coming under attack. We were told that
there were, however, a couple of splinter groups that had not signed
on. It was thought that one of them was operating somewhere in the
area. About halfway to the border, we found Susan's zinc roofing.

The road ended abruptly at the edge of a brown and brimming
river. A hundred yards away it started up again on the opposite bank.
If there had been a bridge, it was not in evidence. Either it had been
sabotaged or it had never existed. Any traffic had to be ferried across
on a flat barge. All around where the boat landed on the far shore
were makeshift shanties with grey corrugated roofs. This was as far
as the shipment had gotten before being appropriated by the locals.

The mystery solved, there was no need to go farther. We sat near
the river and consumed the sandwiches and a couple of the beers we
had brought, contemplating the roofing, watching the comings and
goings of a few vehicles and a surprising number of pedestrians. After
a while the atmosphere turned weird. People around us seemed ner-
vous, as they muttered together.

The drive had taken about four hours, and on the way we had
passed a large group of people trudging back south toward town with
what looked like pillowcases filled with their belongings, as if they
were refugees. These people, it turned out, were a sign. As we sat
eating, the mayor came over and said, "We've got to go right away.
Now." We scrambled into the truck, and he told us that the people
we had seen walking on the roadside had been passengers on a bus
that was attacked by the rogue Contras, who killed the driver and
sent the passengers packing before torching the vehicle.

The mayor, as an official of the Sandinista government, was clearly
vulnerable, and he knew it. He drank practically all that was left of
our case of beer in the rear of the truck on the drive back to Puerto
Cabezas. He almost started to convulse when we got to the spot where

the ambush had taken place. We didn't see the bus—it was gone—but we knew that it had been at this crossroads and that close by, there was a whole platoon of Contras out looking for trouble.

I was nervous myself. I began to strategize. What's the best card I can play if they capture us? *Wanna hear a song? I'm a good hostage! I'm worth something to you guys! Don't torture me and drown me in shit. Just ask people for money for me.* Then I thought maybe I could pose as a Moravian missionary. They were the only non-Hispanic- or non-native-looking people likely to show up in that area. I didn't have a beard. I had earrings and a nontraditional haircut. I mentioned this ploy to Susan. She gave me a brief look and said drily, "I don't think you'll pass."

---

*Women of the town laundry. Warm night blanket floats down. Dim silhouette of trees in friendly dark. Headlights pick out smashed sack of corn strewn over asphalt. A single tarantula stands guard. Rodrigo, the driver, keeps chickens, so we jump out and spend ten minutes filling the trunk with dusty kernels. Later we have car trouble—limp into military truck depot. Barbed-wire gates glint in the moonlight. A hundred tired soldiers stretched out on the grass. Tired from a month in the cotton fields. We sing. They sing. Men and women, all young. Guitars and guns. Ballistic music blows open every heart. Passion bursts like rockets. Cotton bales bursting at the seams. Dignity and poems erupting out of parched poverty trance— broken forever. Brilliant green birds over the lava hole. Volcanoes stand around like the gods of old, pumping incense of the earth into the tropical sky. Down on the beach, horses canter through surf as warm as bath water. Emerald birds against flaming hills. Dry thunder and hot sky. Dust hangs in the air behind the feet of a passerby. Too much heat. This northern body can't sleep.*

---

Toward the end of this trip, we went to a party in the capital with a bunch of Canadians and some other internationals. On the way

Susan delivered a message she had received earlier in the day as though she were a Graham Greene character:

"To be confirmed later: President Ortega would like to meet Mr. Cockburn. Tonight."

She told the president's people where to look for us. We had been at the party an hour when the call came. Susan was invited to interpret, and we drove to Daniel Ortega's headquarters. He was in one of Managua's few central office buildings left standing after the 1972 earthquake. We pulled into the back parking lot because the front was all rubble. There was a little guardhouse, and the sentry asked Susan what we were doing. He said, "Just go to the loading dock. Security will meet you there."

A half-dozen of the toughest-looking guys I could ever remember meeting lounged around the loading bay. They were scarred and wiry, scruffy as a pack of feral dogs. They didn't seem particularly tense or wary. We pulled up and told them we were expected. They were friendly and hospitable, though they remained vigilant. Later we learned that before the fall of Somoza, they had all been in prison with Ortega. They had a unique bond. He knew he could trust them.

The president's office was small and modestly furnished. We talked with Ortega for half an hour. He said he preferred to work when it was cooler, when nobody would bother him, typically arriving at 10 P.M. and staying until dawn.

Ortega wanted to say thank you to Canada. He said, "You know, when we started we were so focused on the U.S. that we didn't even think about Canada. We wanted the support of people in the U.S. We worked at that because we knew the administration wasn't going to support us." He paused and looked at something, or maybe nothing, on his desk. "We were very surprised when all this support came from Canada, and I just wanted to say thank you."

Of course, being typically Canadian, I said, "Canada will do whatever the U.S. tells it to do. Don't count on anything from us. But it's great we've been able to do what we're doing." It was a somewhat awkward exchange.

Ortega appeared vulnerable. There were times during the conversation when it seemed as if he would cry. He had the vibe of an ex-con, of having been robbed of personal sovereignty. It wasn't weakness, just vulnerability.

And he *was* vulnerable. Less than two years later, on February 25, 1990, a decade after the Sandinistas took power, Ortega lost the Nicaraguan presidential election to Violeta Chamorro, who had received

$9 million in campaign money from the United States. Chamorro won by a wide margin, 54 percent to 40 percent. People were worn down by endless low-intensity warfare. They didn't have the heart to keep going. Besides, the Sandinistas

*In the lair of the Communist threat, Daniel Ortega, 1988*

had been in power long enough for their inevitable human failings to show.

Throughout the 1980s it was clear, from even a cursory glance at the evidence, that the United States was striving to maintain control over Central America for the benefit of American business, as it had since the days of the Monroe Doctrine. After 1990, though, deeper, more somber truths escaped into the public realm, one of which was the bombshell that the CIA had been complicit in the trafficking of drugs to pay for the illegal Contra war. The website of the National Security Archive, an independent research institution located at George Washington University, contains a trove of declassified documents that demonstrate the "dark alliance" between U.S. officials, mercenary leaders seeking to unseat the Sandinistas on behalf of the United States and their own interests, and drug traffickers. ("The Dark Alliance" was the title of a series of investigative reports filed in August 1996 by *San Jose Mercury News* reporter Gary Webb, which incontrovertibly documented the

Contra-CIA-cocaine connection, linking it even to the flooding of American inner cities with crack cocaine, which was epidemic during the Reagan administration. Government officials and the mainstream press pilloried Webb for his courageous and well-researched series. He was said to have killed himself in 2004, though that interpretation came under question, as he suffered *two* gunshot wounds to the head.)

At the same time, the administration launched the now familiar "war on drugs" that has continued to be waged by its successors. In thirty years it has been largely responsible for quintupling the U.S. prison population, from 500,000 to 2.5 million; a win-win both for drug dealers and for the prison-industrial complex.

*Breakfast woodsmoke on the breeze —*
*On the cliff the U.S. Embassy*
*Frowns out over Managua like Dracula's tower.*
*The kid who guards Fonseca's tomb*
*Cradles a beat-up submachine gun —*
*At age fifteen he's a veteran of four years of war*
*Proud to pay his dues*
*He knows who turns the screws*
*Baby face and old man's eyes*

*Blue lagoon and flowering trees —*
*Bullet-pocked Masaya streets*
*Full of the ghosts of the heroes of Monimbo*
*Women of the town laundry*
*Work and gossip and laugh at me —*
*They don't believe I'll ever send them the pictures I took.*
*For every scar on a wall*
*There's a hole in someone's heart*
*Where a loved one's memory lives*

*In the flash of this moment*
*You're the best of what we are —*
*Don't let them stop you now*
*Nicaragua*

*Sandino in his Tom Mix hat*
*Gazes from billboards and coins*
"Sandino vive en la lucha por la paz"
*Sandino of the shining dream*
*Who stood up to the U.S. Marines —*
*Now Washington panics at U-2 shots of "Cuban-style" latrines*
*They peek from planes, eavesdrop from ships*
*Voyeurs licking moistened lips, 'cause. . .*

*In the flash of this moment*
*You're the best of what we are —*
*Don't let them stop you now*
*Nicaragua*

"NICARAGUA," 1983

# 13

When I returned to Toronto from the first trip to Central America, I fell flat on my face. Judy's father had died while I was away. I had never met him. He abandoned the family long before I came on the scene, fleeing his life as a Toronto musician to become the proprietor of a bar in Tokyo. Not a good business for a heavy drinker, though it may have worked for him to some degree in Japan, where drunkenness is considered a semisacred state. No one in the family had a single good thing to say about him. His daughters, especially Judy, mentioned him only with bitterness.

Judy contacted me about his passing while I was in Managua. She wanted me to cut the trip short and come home. I couldn't make sense of that—couldn't see leaving my companions in the lurch, and ending the adventure I was having, because this guy had finally left the planet. I didn't get why she would care. The man had given her next to nothing. I failed to appreciate how much of an impact his death had on Judy. I was neither experienced nor alert enough to understand, among other things, that now she could never have the real relationship with her father that had been taken from her, that now the rent in the weave of her life could never be repaired.

No one in my family had died while I was still close to them. My grandparents, certainly, but I had had relatively little contact with them from my midteens on. Our family's disinclination to share

emotions carried over into the area of death. I was raised to have a kind of hard-ass, unsentimental attitude toward the subject. When my father's mother passed away in Ottawa in 1970, I was living in Toronto. Nobody got around to letting me know. A month after the fact I happened to answer the phone when my mother-in-law called. "Sorry to hear about your grandmother," she said. "What do you mean?" I asked.

The one or two acquaintances among my peers who died had taken their own lives. That was tragic enough, but a step removed from my heart. I was baffled by Judy's pain and had no idea how to address it. I did my best to offer what support I could, but I didn't have the tools. We eventually moved on, but it was an issue that never completely faded.

Judy had more family than anybody I'd been involved with up to that time. She was one of three daughters of a single mother, Peggy, from Liverpool, England. And sometime after her divorce, Peggy hooked up with a man named Harry and they had another girl.

With Judy and her family, I enjoyed an immediate and unexpected support group for the going-out-and-loving-my-neighbour project. Not long after Judy and I got together, her sister Kelly started dating Jonathan Goldsmith, a brilliant pianist and composer. Jon became very important to my music in the eighties and onward. He and Kelly, Judy and I, and Hugh Marsh made up a little tribe of friends who often shared food and music.

*Judy and my mom, mid-eighties*

In 1981 Judy and I moved into an eccentric two-floor apartment above a fish store at the corner of College and Clinton Streets, the intersection that subsequently became the epicentre of the College Street Strip. Upon enter-

ing, you had to ascend a flight of stairs past the shop's storeroom. The funk of generations of dead seafood formed a sensory surf you had to fight through. Anything left too long in the stairwell—clothing, potted plants, and so on—acquired the aroma. But once upstairs, the place had a faded charm. There was a high-walled third-floor deck at the back. On the College Street side you could get out onto the fishmonger's roof, which gave a fine view of the goings-on below. This was especially good on religious holidays, when there was always a parade coming from the Portuguese church a couple of blocks away: the scourging of Christ reenacted in less-than-realistic costumes, accompanied by a brass band emanating music of wondrous mournfulness.

Neither of us was inclined toward marriage. I had had enough of that, and in my newly politically aware state, I felt that authority in the form of church and state had no business involving itself in my personal life. We were committed to each other, and that was sufficient.

During the preceding few years I had become acquainted with a group called Jesus People USA (JPUSA). Based in Chicago, they constituted a church whose congregation was the lost youth of the urban mean streets. Charismatic and outwardly hip, they saved a lot of young people from a lot of sordid things. I attended a couple of their services when I played the city. I liked the folks, but was uncomfortable with the theatricality of raising my hands skyward in praise as they did, and I found myself being stared at disapprovingly by my scruffy fellow worshippers. Under the rock-and-roll hair and heavy metal music, the group's ideology was decidedly conservative, though they seemed to regard me as at least a fellow traveller.

Until, that is, Glenn Kaiser, the lead singer of the church's heavy metal band and one of its main pastors, came by our College Street apartment while in Toronto on church business. We had a pleasantly friendly visit, but as he prepared to go on his way, Glenn said something about being glad to meet my wife. Judy was quick to correct him. "Oh, we're not married," she said. A look of surprise appeared

on his face, immediately followed by a darkening expression. He bade us a polite but somewhat curt farewell. I never saw him again.

Members of JPUSA were noticeable by their absence from my subsequent shows in Chicago. A couple of years later a disaffected former member wrote to me, saying that while he'd been a resident at their communal hostel, word had come down that I was persona non grata, and that all members should divest themselves of my albums as soon as possible. I was sorry things had gone that way, and it rankled to be so judged by someone who was no better than I.

A year or so later Judy and I bought a house together, around the time that Peggy and Harry experienced an "adventure" more typical of urban centres farther south. They were sound asleep in their third-floor walk-up at 5 A.M. one summer Saturday when a loud crash woke them. Peggy stumbled groggily into the kitchen to discover that the sink was full of glass. The window above it had been shot out, and there was a corresponding hole in the opposite wall. Had it been a weekday, Harry might well have found the hole in himself, as he would have been standing in front of the window making his morning tea. Police investigated—canvassing, among others, the Jamaicans downstairs, who were still partying from the night before—but turned up nothing.

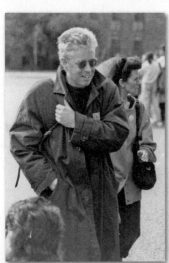

*With Peggy Cade of "Peggy's Kitchen Wall" during a demonstration at Queens Park in Toronto, late eighties*

The bullet had to have come from the neighbouring apartment, whose kitchen window faced Peggy's, but when the cops stormed in and searched the place, they found no trace of a gun. Peggy and Harry got a good tale to tell, and I got a song out of it. The episode would have made a better story had it remained a mystery. As life would have it, the resolution was sadder and messier. Several years later,

the woman next door decided that her husband had beaten her up one time too many. She went to the authorities and told them where they might find the pistol. The shooting had apparently been an accidental discharge: her guy was threatening her with his loaded .38 and oops, it went off. He went to jail. Hopefully she got on with her life.

> *Crashing in the kitchen, noises in the hall*
> *Roll over and go back to sleep—it's just a dream, that's all*
> *So how come the window's broken?*
> *What caused the glass to fall?*
> *And who put that bullet hole in Peggy's kitchen wall?*
>
> *Police arrive—muddy up the floor*
> *Dig out half the plaster—it's a .38 for sure*
> *Kick the neighbour's door in*
> *Saying, "Better tell it all."*
> *Who put that bullet hole in Peggy's kitchen wall?*
>
> *Blaster on the back porch shaking up the lane*
> *They're drinking gin and joking, laughter falling down like rain*
> *Everybody wears a halo*
> *Never saw nothin' at all*
> *So who put that bullet hole in Peggy's kitchen wall?*
> *Tell me who put that bullet hole in Peggy's kitchen wall?*

"PEGGY'S KITCHEN WALL," 1983

Judy did her best to crank me open emotionally and to be an every-second-weekend mother to Jenny, whom she loved. Our relationship had its fire, and real love, but it also suffered from my being gone half the time and not totally present when I was around. The house we shared, as with all the places I've lived, never felt like more than base camp. *Home* was the road. I carried my alienation wherever I went, but it was of less immediate consequence while in motion

among people who didn't know me so well. This might be why, in early 1987, just after the recording of *Big Circumstance*, Judy decided to end the relationship. She was searching for something. I was not it. We remain close friends, though.

*Me and Judy, Prince Edward County, mid-eighties*

I was a reasonably competent parttime father to Jenny, but I didn't relate to children very well. Kids no longer frightened me, but I never felt like I had been one, so I didn't have much of a sense of how it felt to be her. Jenny was lucky to have Kitty as an engaged and demonstrably loving mother. She was cautious with Judy because she didn't understand how this new partner of mine fit into things.

Jenny was a smart and selfpossessed kid. The seas would get rough for her in the years ahead, but she would come through with courage and clarity. Later, after she had a child of her own and then split up with the father, she understood what Judy had been compelled to deal with.

Meanwhile, 1983 continued to be a year filled with travel. After the trip to Central America I toured Australia and New Zealand for the first time, returned to Toronto, and then, in December, flew back to the Southern Hemisphere and the troubled land of Chile.

At that time, Chile was under siege. Ten years earlier the country had succumbed to the dictatorship of General Augusto Pinochet, who seized power in a U.S.-backed military coup. A concentration of displaced Chileans now lived in Toronto, mostly interwoven with the expatriate Greek community around Danforth Avenue. They included artists, union leaders, government officials, teachers, and other sur-

vivors of Pinochet's *Gleichschaltung.* The Danforth had become the scene of an exciting, fertile cultural cross-pollination between Latin American and Greek dissidents who had suffered under their own military dictatorship. (Toronto was, in fact, the seat of Greece's government in exile.)

There was a lot of sympathy among Canadians for the Chileans. One supporter, a woman named Terri Jackman, contacted Bernie to see if I might join a delegation to their first (and, it would turn out, only) Congress of Artists and Cultural Workers of Chile. I was quick to sign on.

It was a courageous undertaking on their part. They were the survivors of a campaign of repression carried on by the regime against all who opposed them or even seemed to be the type who *might* oppose them. In addition to facing interrogation, consignment to concentration camps, internal exile to the country's harsh northern desert or frozen far south, and assassination, artists disapproved of by the regime were locked out of media outlets, including radio, television, recording studios, concert halls, galleries, and museums. Nobody could make a living, and the country's cultural communities had shriveled. Pinochet had banned performances, publication, broadcast, and installation of all but the most politically inoffensive arts. Our job, coming from the outside, was to attend the congress as witnesses and "human shields." The assumption was that even the general's security hounds would be held in check if there were sufficient international scrutiny.

We were all aware of the 1973 coup in which Pinochet, with assistance from American military and intelligence operatives and their associated business allies, violently overthrew a democratically elected leader to save Chile from the cancer of equitable distribution of wealth. It was a terrible and, one might say, familiar story in the region. But historically, Chile had been the most stable democracy in Latin America, so the Chileans had nothing to compare it with.

Pinochet led an assault by all branches of the national military against the presidency of Salvador Allende, who in 1970 had become the first democratically elected socialist in the Western Hemisphere. Emboldened despite winning by a margin of only thirty-nine thousand votes over the far-right National Party, Allende's administration began nationalizing industries and redistributing land to meet the growing needs of Chile's poor, a class rapidly expanding under stifling inflation and foreign ownership of land and industry. It was a brave but ultimately disastrous course.

Total foreign investment at the time was $788 million, a significant sum in 1970, of which 75 percent was American. Allende's government nationalized the major copper holdings of Anaconda and Kennecott, as well as First National City Bank, the General Motors factory, and the Ford Motor Company.

The government also had the temerity to nationalize the holdings of ITT, the U.S.-based international communications conglomerate. John McCone, an ITT bigwig, had been director of the CIA from 1961 to 1965. Thousands of pages of documents released since the coup, including a 2000 internal report by the CIA itself, have revealed how McCone and other business leaders conspired with the administration of U.S. president Richard M. Nixon—particularly national security advisor (and later secretary of state) Henry Kissinger and CIA head Richard Helms—to direct Allende's removal from office.

While there is no evidence that the Canadian government assisted with the coup, Canadian industry, especially the mining sector, was happy to benefit from the reversal of Allende's socialist policies. According to a 2005 report by Mining Watch Canada and the Latin American Observatory of Environmental Conflicts, "Canadian mining companies have led the increase of mining investment in Chile since the '90s." The Chilean business elite has many friends in Canada, including Toronto businessman Peter Munk, the eighty-six-year-old chairman of Barrick Gold Corporation, the world's largest gold mining company. According to the Canadian activist group Protest-Barrick, at the company's 1996 shareholder meeting Munk praised

Pinochet for "transforming Chile from a wealth-destroying socialist state to a capital-friendly model that is being copied around the world." Munk said with sickening cynicism, conscious or otherwise, that Pinochet "can put people in jail, I have no comment on that, I think that may be true," but that the incarcerations were worth it "because it brought wealth to an enormous number of people. If you ask somebody who is in jail, he'll say no. But that's the wonderful thing about our world; we can have the freedom to disagree."

In 1996 Chile signed its first-ever Free Trade Agreement, and it was with Canada. (It was the era of such things. That same year we also signed a similar deal with Israel.) Today Canada is Chile's largest outside investor, pumping over $13 billion into the country in 2010.

Prior to Allende's election, Henry Kissinger had famously said, "I don't see why we need to stand by and watch a country go Communist due to the irresponsibility of its own people. The issues are much too important for the Chilean voters to be left to decide for themselves." (And they call it democracy.) After Allende took office, it was Kissinger who devised what he called a "two-track" program designed to unseat him—a successful enterprise, as we have seen.

The aftermath of the coup included the assassination of high-ranking Allende supporters. Most infamously, on September 21, 1976, operatives from Pinochet's secret police, the DINA, led by American Michael Townley, bombed the car of Chilean economist Orlando Letelier, who had served under Allende as ambassador and minister of defense. The killing was shocking enough, but the location—in Sheridan Circle on Embassy Row in Washington, D.C., directly in front of the Chilean embassy—brought Pinochet's war on human rights to the doorstep of his most powerful ally. Letelier was working at the Institute for Policy Studies (IPS), a progressive Washington think tank, and was driving to the office with his colleague Ronnie Moffitt and her newlywed husband, Michael. Ronnie died. Michael survived. (In 2000 I had the honour of singing at IPS's annual Letelier-Moffitt Human Rights Awards ceremony, which commem-

orates the two by recognizing heroes of the human rights movement.)

The Letelier killing was one of many implemented under Operation Condor, an organized effort by several U.S.-backed South American regimes to assassinate their populist opponents. Henry Kissinger was, at the very least, well aware of the program but took no diplomatic measures to stop it. At least sixty thousand people died as a result of Operation Condor.

Inside Chile during the first days after the coup, the situation was desperate. Pinochet's military had thrown so many people in jail that they had to use a Santiago boxing stadium as a makeshift prison. Thousands were incarcerated there: artists, leftists, military personnel believed to be "disloyal" to the new regime, students and professors and grade-school teachers, janitors and traffic cops, shantytown dwellers—the gamut of Chilean society, excepting in large part the upper tiers of the Chilean business class, many of whom supported Pinochet.

Among the victims was Alberto Bachelet, an Air Force official arrested and then tortured every day for months before he died on March 12, 1974. Soon thereafter Chilean security forces arrested Bachelet's wife, Ángela Jeria Gómez, and their daughter, Michelle Bachelet. Both were repeatedly tortured and eventually released to exile in Australia. Incredibly, Michelle Bachelet returned to Chile in 1979, became a physician, and, in 2006, displaying the courage and resilience that was the lasting hallmark of the Allende period, was elected Chile's first female president.

Another victim was the beloved Chilean singer-songwriter Victor Jara. On September 12, 1973—less than twenty-four hours after the coup—the military seized Jara and threw him, with the multitude of others, into Chile Stadium. Jara was a close ally of Allende's and had played at many of his campaign rallies, including some at that same arena. In the stadium a soldier recognized Jara, kicked him to the ground, and dragged him to a basement. There his captors broke

his fingers and wrists so he couldn't play guitar to cheer his fellow prisoners, then tortured him for five days before murdering him with machine-gun fire. His body was dumped with five others on a street in Santiago. An autopsy revealed that Jara was shot forty-four times.

The coup destroyed more than a century of independence and democratic rule in Chile, on a continent where such things were fleeting at best, and installed a seventeen-year dictatorship that became a worldwide symbol of flagrant and widespread human rights abuse. Pinochet was finally ousted in an election in 1991, but he continued to control the Chilean military until 1998, when he was indicted in Spain in connection with the deaths of Spanish nationals at the hands of his forces. Chilean government investigators later reported that in the first months after the coup, the DINA rounded up more than seven thousand suspected political opponents. Virtually all of them were tortured, and more than two thousand were killed. (In 1999 *The Progressive* magazine reported that the Pinochet regime eventually "detained 40,000 people, tortured large numbers of them, exiled 9,000, and murdered 4,000.")

All of this was done with the full knowledge and support of many U.S. intelligence and military officials and operatives, including top officials at the CIA and the Pentagon, as well as members of Congress and certainly members of the Nixon administration, especially Henry Kissinger but also Nixon himself. A 2000 CIA report states that the "CIA actively supported the military junta after the overthrow of Allende. . . . Many of Pinochet's officers were involved in systematic and widespread human rights abuses. . . . Some of these were contacts or agents of the CIA or U.S. military."

*Aside: Mr. Kissinger and I share a birthday. While I was writing this book, in 2013, Kissinger enjoyed a ninetieth-birthday bash at what the* Daily Beast *characterized as "New York's most glamorous dining room in Manhattan's St. Regis Hotel." The event "drew an astonishing lineup of luminaries, including former secretaries of state Hillary Clinton and Condoleezza Rice, former French president Valéry Giscard D'Estaing, former chief of staff James Baker, former*

*secretary of state Colin Powell, Gen. David Petraeus, and former defense secretary Donald Rumsfeld. . . . Former president Bill Clinton, former secretary of state George Shultz, and current secretary of state John Kerry all came to the podium to toast what Kerry called America's 'indispensable statesman.' " That a man who was apparently indispensable to the design of policies that killed millions of unarmed, innocent peasants in Southeast Asia, and destroyed the lives of countless others around the world, was feted so lavishly instead of being consigned to a bare cell is evidence of the power of the "principalities and powers" that run the world.*

We arrived in Santiago three months after Pinochet held national celebrations marking the tenth anniversary of his accession to power. Public enthusiasm for the event was dampened by a devastating collapse of the economy the previous year, which, though we did not know it then, signaled the beginning of the end of Pinochet's regime. He would not go down easily, or quickly, but down he would go, mostly under the pressure of an ever-swelling number of newly impoverished citizens who had previously known little of the privation an authoritarian regime could create. Santiago is a beautiful and sophisticated capital city, yet shantytowns encircled the metropolis like a funeral wreath, and they were swelling with the ranks of what was once, by South American standards, a relatively strong middle class. Chile was crashing, and it was clear who was in the driver's seat.

Though the term would not be coined for many years yet, here was Naomi Klein's "disaster capitalism," as the Pinochet junta and its elite supporters, after creating a sense of disaster around the election of a socialist president, and the "need" to respond by ousting him, proceeded to loot the nation's treasury and resources at the expense of the rest of the citizenry. It's an old yet very current story.

In addition to Terri Jackman and me, our delegation included Arlene Mantle, a singer-songwriter who worked closely with labour

unions; Dr. Meyer Brownstone, chairman of the board of Oxfam Canada and director of the University of Toronto's Center for Urban and Community Studies; and Terri's brother Joe, whose job was to document the goings-on photographically. There were two other small delegations, from Norway and Switzerland, and that was it—a much smaller international presence than organizers had hoped for.

We flew in as tourists, acting as if we didn't know each other: "Beautiful country you've got here." As we disembarked onto the tarmac, we were greeted by an intelligence agent who was photographing every face that came off the plane. Inside the terminal, we proceeded down a long, narrow corridor with unmarked doorways on either side. Meyer and I found ourselves walking alone, which is when he said, "If they were going to disappear us, it would happen here. They'd drag us through one of those doors and we'd be gone." I felt as if I had stepped into Nazi Germany, with heavily armed military everywhere and control of all aspects of life by a band of ideological thugs whose main domestic-policy directive was violence. They even staged public book burnings.

The congress was held in a monastery on the outskirts of Santiago. We attended meetings, which were translated, and offered what moral support we could. Our three-nation group devised a statement to be delivered to our artist brethren in Chile, a draft of which said:

> We face, instead of an all-too-visible military dictatorship, an invisible and all-pervasive enemy in the form of the institutionalized economic repression on which our society is based, and the complacency that results from it. We don't mean to make light of the horrors you have faced for the past ten years. While you carry on a process that is so auspiciously beginning here, we hope we can work from the other end to alter our own system and lighten the burden it places on you. Tell us how we can help you. Be patient with us, for we are not a heartless people. The reality of your lives, or the effects of our way of life on them, are perceived and understood by only a few of us. This is why we're here. The world

needs the example of the social experiments precariously taking place in Nicaragua. It needs your example of the power of artists and workers of all kinds.

There was music every night, from us and from the Chileans. At that time "If I Had a Rocket Launcher" was still a new song for me—we hadn't recorded it yet—but I figured it might have some meaning for these folks, and for the DINA spies who undoubtedly attended every gathering. The way the song is structured, there is ample room between lines for translation. A Chilean singer performed the song with me, reciting the lyrics in Spanish line by line. In this fashion we delivered the song to six hundred people seated on folding chairs in a large room in the monastery. The atmosphere was charged. When we got to "some son of a bitch would die," the translator thrust his fist in the air and shouted the line, and the crowd erupted. They could relate. It was a standout moment, a once-in-a-lifetime rush of human coalescence and expanded meaning.

The next day we visited one of the hundreds of squatter communities that surrounded Santiago. The structures there were technically illegal but obviously were not going anywhere. People in the shanties were far better off than the Guatemalan refugees I'd visited earlier in the year, but there was a similar feeling of desperation because the Chileans too faced daily hunger, and there was a feeling of permanence to the poverty and privation as well. In Mexico many of the refugees believed that someday they would return home. The Chileans *were* home.

In these communities, thousands of people lived in makeshift shelters of all sorts. They accessed water by digging up and breaking into municipal water mains, and they stole electricity by hijacking it off the power lines. When visiting people in their tents, I'd duck nervously away from insecure webs of wire filament. Lightbulbs hung here and there. The residents had built a small stage, where I sang "The Blues Got the World by the Balls." I could offer only one line in Spanish, the title, *"El Blues Tiene el Mundo por los Cojones,"*

which got a laugh. They knew exactly what that song was about.

The squatter communities, or *poblaciónes*, were estimated to house a million souls in total and were an embarrassment to the government. They were also places of anti-establishment ferment, which the authorities feared. The community we visited had recently been raided by the army, a periodic occurrence designed to keep the oppressed population in its place. This time, though, the inhabitants had been ready. By night they prepared stacks of tires that could be quickly moved into place. When the military began its dawn house-to-house sweep, the residents used the tires to barricade the streets, then torched them and trapped the invaders in a fuselage of rocks that were also stockpiled in advance. The soldiers, seriously outnumbered and soon bloodied, were forced to withdraw in disarray. The people had in effect defeated the army, and they were very proud of that. That they had gotten away with it seemed to suggest that after ten years, the dictatorship was beginning to weaken. Certainly, many members of the middle class who had supported the coup out of fear of Communism had seen the error of their ways, as they watched their well-being slip away.

> *Something moves in the still dark hours*
> *Sunday in a shantytown*
> *Eyelids open two by two*
> *But not a single light goes on*
>
> *Tension builds as the only sound*
> *Is the quiet clash of metal and boots*
> *And now and then an order barked*
> *At the bullies in the drab green suits*
>
> *Military thugs with their dogs and clubs*
> *Spreading through the* población
> *Hunting whoever still has a voice*
> *Sure that everyone will run*

*They come in strong but it's not that long*
*Before they know it's not so easy to leave*
*To keep a million homeless down takes more*
*Than a strong arm up your sleeve*

*At the crack of dawn the first door goes down*
*Snapped off a makeshift frame*
*In a matter of minutes the first rock flies*
*Barricades burst into flame*

*First mass rings through smoke and gas*
*Day flowers out of the night*
*Creatures of the dark in disarray*
*Fall before the morning light*

*Bells of rage—bells of hope*
*As the ten-year night wears down*
*Sisters and brothers are coming home*
*To see the Santiago dawn*

*Santiago sunrise*
*See them marching home*
*See them rising like grass through cement*
*In the Santiago dawn*

*I got a dream and I'm not alone*
*Darkness dead and gone*
*All the people marching home*
*Kissing the rush of dawn*

*Santiago sunrise*
*See them marching home*
*See them rising like grass through cement*
*In the Santiago dawn*

"SANTIAGO DAWN," 1983

By the time we got to Chile, hundreds or even thousands of Chileans were gathering downtown every day to protest what was being done to them, to their country. And it wasn't just the poor. Teenage boys in ratty Coca-Cola shirts stood alongside schoolteachers and people in business attire, all hurling stones. An armoured bus loaded with riot cops sat on every second corner in the downtown area, so there was always a quick response. Police had helmets, truncheons, and gas grenades; protesters wielded rocks and bottles. Soon came the taunting chant: *"Ay! Ay! Que calor! El guanaco por favor!"* ("Hey, hey, it's so hot, the water cannon please!") The *guanaco* is an Andean relative of the alpaca and llama known for spitting at the unwary, an apt nickname for the lumbering machine. Sure enough, out would come the armoured vehicle shooting high-powered jets of water, and there would go protesters rolling like melons down the street.

As a songwriter newly attuned to political subject matter, I came away from Chile with altered assumptions about the relationship between creative expression and politics. The unexamined notion that art must remain "pure," untainted by the political, had already been shaken by my experiences in Italy, and of course in Central America. In the sophisticated Latin American setting of Chile I understood that the distinction was specious, that politics actually demanded art. In Chile I found popular acceptance of songwriting that focused on social and political issues. I began to understand that if an artist's job is to distill the human experience into something that can be shared, then the political, as much a part of that experience as God or sex or alienation, deserved to be seen as raw material. The arts contribute significantly to social movements and cultural cohesion. This wasn't something I encountered much in Canada, though I could see that even Canadians might someday require singers and painters and street theatre to help define and translate current events as a means of resisting authority—a premise that may seem absurd, given Canada's humble stability, but then few people anticipated a military coup in Chile, a nation that had run on democratic principles since achieving independence from Spain in 1844. Artists can help clarify confusing events and herald the vanguard's solutions.

Artists inspire and inform. A song can be a rallying point around which popular feeling can galvanize. Pinochet's people had put serious thought into whom to round up once they took over, and artists were at the top of the list.

On December 27, 2012, Chilean judge Miguel Vásquez charged eight former Chilean soldiers, including two officers, with the murder of Victor Jara. Naturally one of those charged, Pedro Barrientos, was living in comfort in Florida, and at this writing the Chilean authorities were attempting to have him extradited. (Pinochet died in Chile in 2006 without ever being prosecuted for his crimes.)

Legendary Chilean poet and diplomat Pablo Neruda, who had supported socialist platforms and candidates since the 1940s, upon receiving the Nobel Prize for Literature, said in his acceptance speech, "A poet is at the same time a force for solidarity and for solitude." When Pinochet's secret police raided Neruda's home a few days after the coup, he said to them, "Look around—there's only one thing of danger for you here—poetry."

*Maybe the poet is gay*
*But he'll be heard anyway*

*Maybe the poet is drugged*
*But he won't stay under the rug*

*Maybe the voice of the spirit*
*In which case you'd better hear it*

*Maybe he's a woman*
*Who can touch you where you're human*

*Male female slave or free*
*Peaceful or disorderly*
*Maybe you and he will not agree*
*But you need him to show you new ways to see*

*Don't let the system fool you*
*All it wants to do is rule you*
*Pay attention to the poet*
*You need him and you know it*

*Put him up against the wall*
*Shoot him up with Pentothal*

*Shoot him up with lead*
*You won't call back what's been said*

*Put him in the ground*
*But one day you'll look around*

*There'll be a face you don't know*
*Voicing thoughts you've heard before*

"MAYBE THE POET," 1982

Where was God in all of this? That nagging question came up in Chile, as it has in many times and places since the 1970s, as I've hovered around the bizarre cruelties of man.

# 14

In the ancient Greek myth of Prometheus, the heroic Titan steals fire from the gods and shares it with humanity, thereby weakening the Olympians' hold over us. The tale seemed a workable metaphor for the way some struggles, like that of Nicaragua, can become beacons for oppressed people everywhere. The Powers That Be always exact a terrible price for noncompliance. Prometheus was condemned to spend eternity chained spread-eagled to a rock. Daily, an eagle would swoop down and rip out his liver, which grew back each night, just as every day Nicaraguans were met with harassment and war for having pried loose the grip of the gods of commerce.

*Aside: Once the Sandinista revolution and social programs were halted by the 1990 election, the gods could get back to their important work, which at this writing includes plans for an alternate waterway connecting the Atlantic and Pacific Oceans. In June 2013 the Nicaraguan government approved a fifty-year concession for a Hong Kong company to build and run this new canal, which would be three times longer than the Panama Canal and accommodate Triple-E ships, which hold four times as much cargo as the biggest vessels that can fit through the Panama Canal. It's the old Cornelius Vanderbilt dream of a Nicaraguan canal, writ large. The ripples of stones in that water will be felt for generations.*

We recorded my thirteenth studio album, *Stealing Fire*, at Manta Sound in Toronto in March and April 1984, where we made all of my

eighties records as well as *Dancing in the Dragon's Jaws*. For this record I put together a new band. I wanted less subtlety and more rock and roll from the drums, but a feel for Third World rhythms was also important. Ottawa drummer Miche Pouliot played beautifully and injected tasty blues and reggae rhythms, though more than once I've regretted replacing jazz drummer Bob DiSalle, who was such a great and loyal performer on the previous six albums and on tour. Chi Sharpe added West African percussion, and Hugh's brother Fergus Jemison Marsh took over on bass.

Fergus also played the Chapman Stick, an exotic ten-stringed instrument invented by musician Emmett Chapman. Its range combines that of the bass and the guitar. It is played by tapping the strings against the fretboard with the fingers of both hands. I wanted to explore the sonic possibilities the stick and the guitar might produce together. It is very difficult to play, requiring a frightening level of independence between the left and right hands, but Fergus plunged in with great fervor and came up with interwoven parts that brought the music to life. As we dug deeper into the songs, he became a true master. Our guitar-stick rapport formed the basis of four albums and hundreds of concerts during the eighties. (The virtuosity of Ferg's stick work is particularly noticeable on the 1990 album *Live*.)

I enlisted Jonathan Goldsmith and Kerry Crawford to produce *Stealing Fire* (Jon also played keyboards), a change from Gene Martynec, who produced twelve of my first thirteen records. By the early eighties Gene was shifting his focus to electronic music and film scores, which he still does, and I was ready for something new. There was a certain irony in the fact that Jon and Kerry had become successful producing . . . TV jingles! Let *Stealing Fire*, then, be the anti-jingle. As a team, Jon and Kerry were highly skilled elicitors and weavers of sound.

Now and then my dad used to accuse me of being "anti-American." He thought it unseemly to be critical of a friend and neighbour. My response was that the only place anyone ever calls me anti-American

is in Canada. What I get from most Americans is tolerance, sometimes empathy, often a good debate. It's true that some radio personality once refused to play "Call It Democracy," calling the song "un-American," and certainly there's more where that came from. Overall, though, Americans have a capacity for self-criticism that may not be obvious when viewed from the outside, but is clear when you're in country. It's one of the nation's great strengths. A lot of societies don't have such open discourse. That's what makes it particularly tragic to see the Tea Party or its ilk polarizing things the way they do. They nurture discord and divisiveness, those well-broken-in tools so useful for controlling people and for getting money out of them. It's disaster capitalism with a big banner and bombast. But the potential for genuine dissent and critical dialogue was built into the birth of the country and still runs strong.

I hadn't thought much about this capacity for healthy disputation until the release of *Stealing Fire*, my most "political" record up to that time and the one that initiated an affair with the United States that continues to this day. "If I Had a Rocket Launcher" reached the top ten of album-oriented rock FM playlists in the States, and number eighty-eight on the Billboard Hot 100 chart. Once that happened I toured all over the States, where a world of friends and music quickly revealed itself.

The Germans, too, particularly liked that song, which is one of three on the album about Central America, along with "Dust and Diesel" and "Nicaragua." All of a sudden I found myself touring Europe regularly, especially Germany, which had the added benefit of producing fodder for the next few albums as well. I had a German fan base before *Stealing Fire*, mostly Christians, people who liked "Lord of the Starfields," but it was small and I wasn't much aware of it. *Stealing Fire* quickly sold seventy thousand copies in Germany—not an avalanche compared with superstar numbers, but significant for me.

More so, though, it was Americans who were drawn to these songs. Under the Reagan administration, arms and "advisors" were being shipped to Central America and cocaine was being shipped back to the United States. U.S.-promoted wars against the poor of the region

were well understood. The Vietnam generation watched a familiar scenario unfolding, and a college-age crowd suddenly understood what their parents had been talking about. That late in the Cold War game, and on turf so close to home, the fact that U.S. involvement was all about business was transparently clear. The significant minority of Americans who recoiled from what they saw their government doing were almost completely without representation in public media. In a small way *Stealing Fire* told listeners that their outrage was justified, that they were not alone.

In Canada, "Rocket Launcher" reached just forty-nine on the RPM chart, the equivalent of the Billboard Hot 100, whereas the album's leadoff song, "Lovers in a Dangerous Time," hit number twenty-four (and number eight on the Adult Contemporary chart). "Lovers" also ranked number eleven on the Canadian Broadcasting Corporation's 2005 compilation of the "fifty most essential songs in Canadian pop music history." It was actually slated to be the single from the album, the one we would push in America, but that song didn't get nearly the same attention from U.S. radio. (It did get some notice, though. Bono quoted it in the U2 song "God Part II": "Heard a singer on the radio late last night / Says he's gonna kick the darkness til it bleeds daylight.")

*Don't the hours grow shorter as the days go by*
*You never get to stop and open your eyes*
*One day you're waiting for the sky to fall*
*The next you're dazzled by the beauty of it all*
*When you're lovers in a dangerous time*
*Lovers in a dangerous time*

*These fragile bodies of touch and taste*
*This vibrant skin—this hair like lace*
*Spirits open to the thrust of grace*
*Never a breath you can afford to waste*
*When you're lovers in a dangerous time*
*Lovers in a dangerous time*

*When you're lovers in a dangerous time*
*Sometimes you're made to feel as if your love's a crime —*
*But nothing worth having comes without some kind of fight —*
*Got to kick at the darkness til it bleeds daylight*

*When you're lovers in a dangerous time*
*Lovers in a dangerous time*
*And we're lovers in a dangerous time*
*Lovers in a dangerous time*

"LOVERS IN A DANGEROUS TIME," 1983

All these chart numbers, like awards, mean little to me. I include them here for perspective. I wasn't sure that the listening public would accept "Rocket Launcher." I was afraid that if it did, I would be promoting a violent response to the violence the song deplores. During the 1983 tour of Australia, I played it backstage for Bernie before a gig in Melbourne. It was the first time I had let anyone besides Judy hear it. As Bernie remembers it in his book, "I was blown away. Hearing the line 'Some son of a bitch would die' took my breath away. Bruce was quite torn about whether he should even record the song and was deeply concerned about the real possibility of it being misunderstood as some kind of rallying cry, urging people to incite violence." Common sense won out, of course. The song was honest, something the times were demanding, and self-censorship did not seem to be the right choice. Later Bernie suggested releasing "Rocket Launcher" as a single.

"You feeling all right? No radio station is going to program that song," I said.

"We're getting signals that they will."

Touring with *Stealing Fire* was exciting. Sold-out crowds radiated enthusiasm and love. The game was on, and I got to play in a lot of new places. "Wondering Where the Lions Are" had opened doors in the United States, but now the opportunities were worldwide. It was

especially gratifying to witness the effect of playing songs about Central America for our southern neighbours. U.S. alternative press outlets were small and overshadowed by the mainstream media, whose coverage of the region was shallow and misleading. There was no coverage at all of the public opposition to Reagan's policies, which was visible everywhere, and there was no Internet. If you wanted information about American skullduggery in Central America, you had to hunt for it in such publications as *Covert Action Quarterly* or *Soldier of Fortune*. You sure couldn't go looking in the nation's capital: it seemed like no one in Washington was either interested in or effective at opposing the Reagan wars. We'd take the stage and crank out these songs, and you could see a developing recognition of common concern spread through the room. People who had thought they were alone in their dismay realized that they in fact had a lot of company. It was fantastic to see the muse spreading, a roomful of people literally turning to each other with a mutual understanding. These were powerful moments.

I went to considerable lengths to make sure listeners knew that the songs were not merely the product of reading and speculation. During the "Central America" part of the set, I talked almost as much as I played; I was especially concerned that audiences understand where "Rocket Launcher" was coming from. Sometimes the introduction was longer than the song. Not everyone appreciated that. Once, during a lunchtime show at a club in St. Louis, I was on a verbal jag when a young man near the stage, his table festooned with empty beer glasses, took issue. I was describing the Guatemalan refugee camps when he bellowed, "Yeah, yeah. Life's a bitch and then you die." I may have responded rudely.

Still, at the time I was skeptical about the ability of music to accomplish anything in a direct way. Music can have emotional impact, and it maintains an important place in the nurturing of culture and of dissent. Pinochet's shock troops understood that when they killed Victor Jara. But a song by itself does not foment change; it is a harbinger or chronicler, a spark. Often journalists ask me, "Do you think

music really changes anything, changes the world?" I'd answer, "No, I don't. People do."

When there is a body of popular feeling around an issue, a song can be a focusing agent, a rallying point. If it gets enough exposure, it can help spread public awareness of the issue. That's the power music has, no more. We made a pretty good video for "Rocket Launcher." It combined musical performance with dramatized scenes of a Central American family in flight, intercut with news footage of the war in El Salvador. The medium was new at that point, and the TV world was still trying to figure out how to profit from it. MTV gave us quite a bit of airtime, as did its Canadian counterpart, Much Music. Being on television meant I was recognized a lot more on the street, though the visibility did not imply that people were paying attention to the content. On one occasion a young guy rushed up to me, declaring how much he liked my song and the video. "Things must be really bad there in Africa!" he said.

Some people seemed mystified that such a song would even be written. More than once, in the course of an interview for radio or television, the question would be posed: "Tell me, would you say you're a *happy* person?"

My little howl of outrage was noticed in Washington—by no less than Vernon Walters, then the U.S. ambassador to the United Nations. Walters was, according to the British paper *The Telegraph*, "thought by some to have cultivated unhealthily close ties with certain Latin American military dictatorships" and suspected of "being involved in the overthrow of Salvador Allende in Chile in 1973." In June 1984, when things were starting to spin out of control in El Salvador—with ARENA Party presidential candidate and death squad leader Roberto D'Aubuisson (who had ordered the killing of Archbishop Óscar Romero) threatening to assassinate U.S. ambassador Thomas Pickering—President Reagan tapped Walters to fly to San Salvador and point out to the army major that killing Pickering would "unquestionably terminate U.S. assistance programs." In the course of an interview with CBC Radio during the late eighties, Walters lamented

that many American artists, actors, and writers had become "dupes" of the Sandinistas. "In fact," he said, "you've got one of your own right there in Canada: that singer Bruce COCKburn." I happened to be listening. Oh, the rush of pride I felt!

With the exception of "To Raise the Morning Star" and "Making Contact," God is more implicit than explicit on *Stealing Fire*. Many of the songs reflect the vestigial divinity I kept finding in other people, whether in everyday encounters at home or in the drama of war zones. I had God very much in mind when I wrote "To Raise the Morning Star." During that first Australian tour I was told about an Aboriginal custom of singing to raise the morning star. This was a literal application. Early, before dawn, people would gather and sing until the morning star lifted off the horizon. They believed that if they didn't sing, it wouldn't come. Back in Toronto, I stood on the roof of my Little Italy apartment and started thinking about all the people who were sleeping and dreaming, and I visualized the energy of those dreams rising skyward, sending light back at me from the cloud cover made by that energy. The light was God's creation, just as much as the light of the morning star. The imagery and creative spark for the song came from worlds away and from right in front of me, all of it one, each part connected to the others by that unfathomable mystery that we seek, even as it fills and surrounds us.

*Rising like lightspill from this sleeping town*
*Like the light in a lover's eyes*
*Rising from the hearts of the sleepers all around*
*All those dreamers trying to light the sky*

*Burning—all night long*
*Burning—at the gates of dawn*
*Singing—near and far*
*Singing—to raise the morning star*

*Rising like lightning in the pregnant air*
*It's electric—I can feel its might*

*I can feel it crackling in my nails and hair —*
*Makes me feel like I'm dancing on feet of light*

*Burning—all night long*
*Burning—at the gates of dawn*
*Singing—near and far*
*Singing—to raise the morning star*

*Singing for the yellow and the brown and the black*
*For the red and the white people, too*
*Dovetailing strong points with the things we lack*
*Singing for the people like me and you*

*Burning—all night long*
*Burning—at the gates of dawn*
*Singing—near and far*
*Singing—to raise the morning star*

"TO RAISE THE MORNING STAR," 1983

During breaks in recording I'd scan the news for tumult, of which there was plenty. It was early 1984, when the Islamic Jihad Organization kidnapped William Francis Buckley, the CIA station chief in Beirut, eventually killing him. Canadian prime minister Pierre Trudeau announced his retirement. Nokia launched what was essentially the world's first commercially available cell phone. And Iran accused Iraq of using chemical weapons three years into their devastating eight-year war, and almost exactly twenty years before the United States invaded Iraq in 2003.

The Iranian charge was true: the Iraqis had used mustard gas and nerve agents against Iranian soldiers and civilians, and against Iraqi Kurds. At least one million Iraqis and Iranians eventually died in the war, which raged from 1980 to 1988 and settled nothing. Where did the Iraqis get chemical weapons? The Iranian accusation came just four months after Donald Rumsfeld, President Ronald Reagan's spe-

cial envoy to the Middle East (and at the time a hired shill for the pharmaceutical industry), met with longtime Iraqi president Saddam Hussein, newly anointed as a U.S. ally, on December 20, 1983. (Like a dark comet, Rumsfeld would return to visit another wave of ill fortune on Iraq during the reign of President George W. Bush.) In 1982 the Reagan State Department removed Iraq from its highly selective list of "states supporting international terrorism" in order to send arms and money to Saddam for his fight against Iran. The United States had had it in for Iran since 1979, when a revolution deposed Shah Mohammad Reza Pahlavi, who took power in a CIA-led coup in 1953 (another production of the Dulles brothers). In 1983, the United States apparently decided to give the Iraqis whatever they wanted. According to a 2009 report by *The Washington Post* and *CBS News*, "[T]he administrations of President Reagan and the first President Bush both authorized providing Iraq with intelligence and logistical support, and okayed the sale of dual use items—those with military and civilian applications—that included chemicals and germs, even anthrax and bubonic plague."

This is the real Ronald Reagan: an international gunslinger wearing a bandolier of crack vials, taking territory and scalps, trading in chemical and biological weapons with the likes of Saddam Hussein. Fifteen years before Rumsfeld first went to Iraq, the Reverend Dr. Martin Luther King called the United States "the greatest purveyor of violence in the world today." The echoes continue to resound.

In 1985, shortly after Reagan was reelected, I gave him his own song, which appears on my 1986 album *World of Wonders*. "People See Through You" reached number four on the Canadian Adult Contemporary chart, which may or may not say something about Canadians. Reagan inspired the song with his sinister crackdown on the U.S. Sanctuary movement, a peaceful Christian effort involving more than five hundred churches that provided safe haven and a modern underground railroad to Canada for Central American refugees, one million of whom crossed into the United States during the 1980s to escape death in their homeland. (Canada, at the time, offered asylum

to the refugees, while the United States refused on the basis that there was no war in Central America; therefore, there could be no refugees. The million just wanted to come and clean floors and bus tables. Reagan went to Canada's new prime minister, Brian Mulroney, asking that he do something to end the embarrassing imbalance in policy between the two countries. Canada was dishearteningly quick to oblige, requiring that asylum seekers apply for refuge at the Canadian embassy in their own country instead of at the border.)

Within the United States, government agents, by way of intimidation, staged break-ins at houses of worship. Many Sanctuary leaders were arrested.

*You've got covert action*
*Prejudice to extremes*
*You've got primitive cunning*
*And high-tech means*
*You've got eyes everywhere*
*But people see through you*

*You've got good manipulators*
*Got your store of dupes*
*You've got the idiot clamor*
*Of your lobby groups*
*You like to play on fears*
*But people see through you*

*You've got instant communication*
*Instant data tabulation*
*You got the forces of occupation*
*But you don't get capitulation*
*'Cause people see through you*

*You've got the sounding brass*
*You've got the triumph of the will*

*You do what you want to*
*And we pay the bills*
*You hype the need for sacrifice*
*But people see through you*

*You've got anti-matter language*
*Contrived to conceal*
*You've been lying so long*
*You don't know what's real*
*You're a figment of your own imagination*
*And people see through you*

*You've got lip service tributaries*
*You've got death fetish mercenaries*
*You hold the tickets to the cemeteries*
*You're big and bad and scary*
*But people see through you*

"PEOPLE SEE THROUGH YOU," 1985

My travels have immeasurably informed my understanding of world events, of peoples, of the ways that rivers move through landscapes. The songs are made of these things. Without travel I could only marginally understand geopolitics, reflect on deforestation only as a concept rather than as a mountainside bleeding soil, see only in photographs the eyes of an old woman who has lived her entire life at thirteen thousand feet of elevation, who has seen ten of her thirteen children die before reaching adulthood.

Which is not to downplay the importance of reading. Like travel, writings of all stripes have fired my imagination. Reading and travel are joined at the hip. News accounts, political tracts, and even the charitable solicitations that show up in the mailbox have been crucial, as have all the poetry and prose with which I've seasoned my less-than-

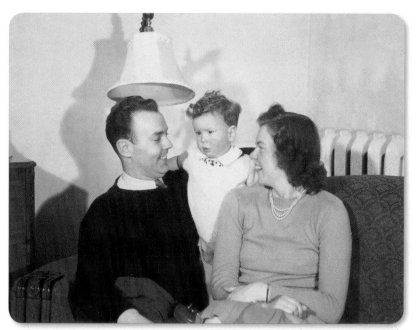

*Kingston, 1947*

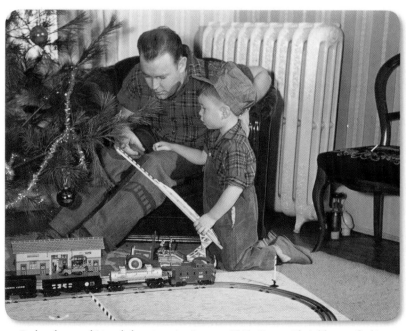

*Dad and me and Lionel electric train, Ottawa, 1948. Got to ride it like you find it.*

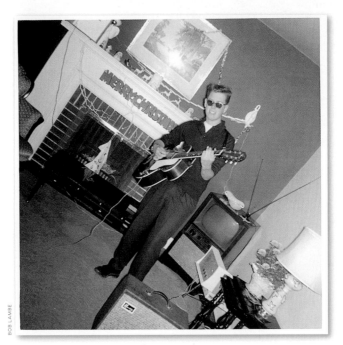

*Christmas, 1960*

*Just before leaving for Europe, 1964*

*Aroo and Me,*
*Toronto, 1975*

*Japan, 1978*

*Genoa, 1980*

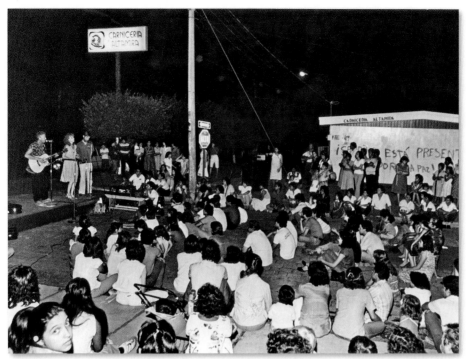

*Street corner concert, Managua, 1983*

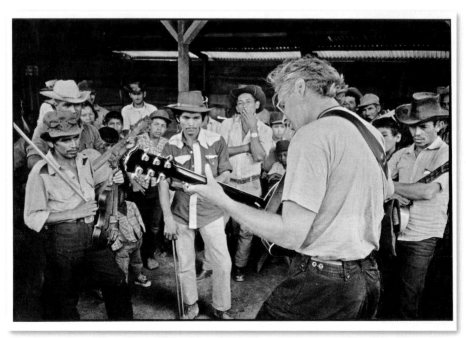

*Colomoncagua, Honduras, 1985*

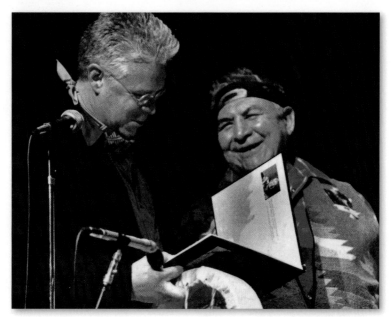

*Elder Napoleon Kruger presenting me with an autographed copy of*
Our Elders Speak *on stage before my concert in Vancouver, 1992*

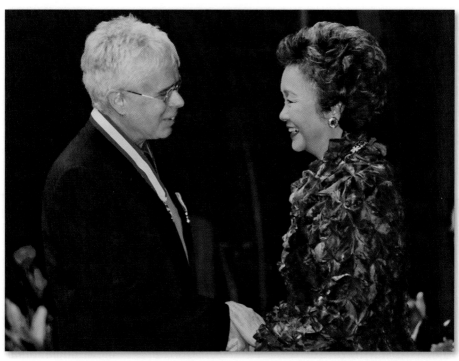

*Receiving promotion to the rank of Officer in the Order of Canada*
*from Governor General Adrienne Clarkson*

*Me and Jackson Browne (far right), Verde Valley Festival, Sedona, Arizona,*
*with Salvador and Katia Cardenal of the Nicaraguan Duo Guardabarranco*

*Rosanne Cash, me, Lou Reed, and Rob Wasserman; the second Christmas with Cockburn, 1992*

*With Usama the oud player, Baghdad, 2004*

*Movie theatre, University of Baghdad.*
*They were aiming at the police station next door.*

*The streets of Amman*

systematic mind. A fine example is Doris Lessing's strongly allegorical sci-fi classic *Shikasta*, which profoundly influenced my perspective on the flow of human history. ("Of all the planets we have colonized totally or in part this is the richest," Lessing wrote of her not-so-fictional world. "More than once the inhabitants of Shikasta have included creatures so large that one of them could consume the food and living space of hundreds of their co-inhabitants in a single meal.") The book was a forceful read on the Playa del Inglés, on Lanzarote in the Canary Islands, facing the Moroccan coast fifty salty miles east. Standing at night on the edges of the sea and star-shot space, filled with vertigo at the *bigness of things,* I felt the words wash in.

> *Stare into the moonlight*
> *Silver fingers press my eyes*
> *Probing in my heart with longing*

> *These footprints by the sea's edge*
> *Disappearing grain by grain*
> *Lose their form but keep their substance*

> *And the waves roar on the beach like a squadron of F-16s*
> *Ebb and flow like the better days they say this world has seen*

> *Government by outrage*
> *Hunger camps and shantytowns*
> *Dignity and love still holding*

> *This blue-green ball in black space*
> *Filled with beauty even now*
> *battered and abused and lovely*

> *And the waves roar on the beach like a squadron of F-16s*
> *Ebb and flow like the better days they say this world has seen*

*Each one in our own heart*
*Desperate to know where we stand*
*Planet of the clowns in wet shoes*

"PLANET OF THE CLOWNS," 1981

My songs tend to be triggered by whatever is in front of me, filtered through feeling and imagination. I went looking for humanity in all its guises. I wrote about what I found: the love, the meanness, the artists, the farmers, the juntas; the books, the slums, the palaces; the conflicts, the peace, the music. That's why I don't think of the things I write as "protest" songs. They reflect what I see and how I feel about it. The songs are not ideologically driven. They are meant not as calls to action—though if someone heard one of my songs and was inspired to help the poor or save an ecosystem, all the better— but as an attempt to share my personal response to experience with anyone who feels a resonance, or even someone who doesn't, because life is one long conversation.

"Berlin Tonight," the fourth track on my fifteenth album, *World of Wonders*, is a case in point. *Stealing Fire* brought me to Germany three times in nine months, and many times thereafter. Apprehension hued my first journey there. I had hitchhiked across a corner of the country in the sixties, and Bernie and I had flown to Munich once in the late seventies for a meeting with Manfred Eicher of ECM Records, but the bulk of what I "knew" about Germany derived from World War II movies and John le Carré novels. Like all of Europe, Germany is fascinating, rich in culture and history, yet it remains imbued with the shadow of the Holocaust. One afternoon during that first tour, we were sitting in a sidewalk café in Cologne when Bernie remarked, "All that stuff, you know, it happened on days like this. It happened in colour."

The Berlin Wall was a scowling, twelve-foot-high, ninety-mile division and encirclement from the city, a dam designed to hold back the allure of Western influence from the Soviet-dominated East. In

1961 the East German government built the wall to "protect" its population from latent "fascist" elements that they said still existed in the West. In fact, people were fleeing totalitarian and impoverished East Germany in droves, so the authorities simply cut them off with a symbol so base it would be invoked for decades as a metaphor for human division.

The wall was a bleak and ugly ploy in a loser's game. NATO poured vast sums of money into the post–World War II Allied zones of control and beamed TV imagery of Western opulence unceasingly into the surrounding society, including parts of Prussia under Communist rule. Although West Berlin had a municipal government of sorts, each zone remained under official control of the occupying force to which it had been assigned after the war: French, English, and American. East Berlin was the designated Russian zone. The western section was an island of chaotic liberalism in a sea of repression and economic privation. An estimated one-third of East German citizens informed on the others for the Stasi secret police. None of them could get out.

The city was connected to West Germany by a four-lane umbilical cord, part of Hitler's autobahn system, which passed through Prussian fields said to be mined. Access to this corridor was through a carefully watched but not-so-unusual border station. The agreement among the Allies that created the postwar city gave each occupying power right of access to the other zones. Every day, wall or no wall, a truckload of U.S. Marines in full battle gear passed through Checkpoint Charlie and travelled the streets of the East German capital, because they could. The East Germans, of course, guarded the wall with rigour. You could cross in either direction only at designated checkpoints. Any attempt to cross elsewhere would most commonly result in death, either from the rifle fire of the guards or from the land mines sown in the "death strip" between the wall's two parallel halves.

After a couple of visits to West Germany, we were invited, as part of the next tour, to perform in the East, in Leipzig, Dresden, and

Karlmarxstadt (now on maps under its original name, Chemnitz), and at the International Festival of Political Song in East Berlin. There was no system in place for the exchange of money between the West and the Soviet bloc, so the East Germans compensated us by covering our transatlantic travel. This meant that we had to come and go through their Schönefeld Airport. We were met by a wiry blond kid from Frankfurt, Gery, who was to be our driver for the tour. Bags and gear were loaded into his van, and we proceeded to Checkpoint Charlie, the main crossing point for non-Germans. Things were complicated by the fact that Gery had to drop us off and then cross at a different checkpoint. In the middle of the night, in the middle of winter, over wet cobblestones shining dark and deserted beneath overhead lamps, our little aggregation walked a block down the street and into a twisting sheep corridor of razor wire, and presented ourselves to the surprised guards. Our papers were in order, but foreigners didn't usually appear at such an hour, without baggage and on the "wrong" side of the wall. We went through a few layers of scrutiny, each one less unfriendly than the one before. By the time we got to the last guard post, a smiling soldier told us he was going to hear us at the festival and asked for our autographs. Deep drifts of absurd irony gathered around us as we ambled out of a vale of tears that by then had been in total lock-down for more than twenty years.

*Dull twilight spits hesitant sulphur rain*
*Sky been down around our ears for weeks*
*Only once—gap-glimpsed moon over that anal-retentive border wall*
*As we laughed through some midnight checkpoint under yellow urban cloud*

*Weeks of frantic motion—petrol veins of Europe pumping*
*Through scratchy acid-bitten transparent winter trees*
*Through brownish haze that makes a ghost of the horizon*
*I'm rushing after some ever-receding destination*

*Berlin tonight*
*Table-dancing in black tights*
*Waving a silver crutch in the blue lights*
*Shape-changing over glass*
*On the front line of the last gasp*

*Green shoots of winter wheat and patches of snow*
*Russian walks dog in Saxon field*
*From the top of a solitary tree like the one on the flag of Lebanon*
*Unblinking eye of hawk follows traffic on the autobahn*

*Tank convoy winds down smokestack valley*
*Proud chemical pennants wave against the sky*
*Turret gunner laughs when I throw up my hands*
*I'm all glasses and grin to him under my "commie" fur hat*

"BERLIN TONIGHT," 1985

Shortly after returning from Germany I attended a briefing in
Toronto by a group of Canadian church delegates, for the press and
interested parties, about recent events in Honduras. By then I had
been to Central America twice, but never to Honduras, which at the
time was relatively stable, at least compared with Nicaragua, Guate-
mala, and El Salvador. At the briefing I learned that the Honduran
army had attacked a U.N. refugee camp full of Salvadoran civilians,
inside Honduras near the border with El Salvador. U.N. camps had
been attacked before, but this was the first time in the organization's
history that the act had been carried out by the army of a host coun-
try. A lot of rounds had been fired, but loss of life was confined to an
old man who was shot and a baby who was kicked to death. The
Honduran army had stayed around, though, instilling a fear of fur-
ther violence. The church team happened to end up at the camp a day
or two later, then travelled directly back to Canada with the news, so
it was very fresh. No one else from the outside world yet had knowl-

edge of this. I happened to be sitting next to Meyer Brownstone, the head of Oxfam Canada and my travelling companion in Chile. Meyer looked at me and said, "There needs to be an international presence on the ground right away. By the time the U.N. can get moving, it might be too late. We should get down there. What are you doing next week?" This was on a Wednesday. The following Tuesday, we were in Honduras.

Like the Yanks in Berlin, we went because we could. We had neither the bureaucratic nor the diplomatic encumbrances that would likely slow a U.N. response. Getting outside witnesses into the camp could make a critical difference to the survival of the refugees. There wasn't time to waste on protocol.

Our group consisted of Meyer, a Toronto immigration lawyer named Jeff House, and me. In the Honduran capital, Tegucigalpa, Meyer contacted the Canadian honourary consul, who turned out to be the former head of one of the country's major banks and very well connected. He received us with smooth warmth, and we told him what we wanted to do.

"Well," said the banker, turning a snifter of cognac between finely manicured fingers, "the army has cut off Colomoncagua, where the camp is located. They'll never allow you through their lines. I have a friend who happens to be the general in charge of the armed forces. He is kind of on the outs. A group of younger officers is campaigning to get rid of him. They don't feel he shows enough zeal when it comes to counterinsurgency matters. He's still in charge, though, and might be persuaded to give you a letter of passage, just to spite his rivals."

He made a call, and we went to see the general. He was an older man, sitting behind an untidy desk in his shirtsleeves. His eyes were yellowish and watery. He was a bit drunk and expressed no great concern for our mission, but he seemed pleased at the chance to assert his authority and screw the younger officers, who would surely have objected. If we'd gone through the prescribed channels, up the line, we would have been waiting in Tegucigalpa for a week for our papers, if we were granted access at all.

"Sure, you can do this," he said, smiling, and wrote a letter granting us authority to visit the refugee camp, which he then stamped with his official seal.

That night there was a party at the home of an older American couple, friends of Meyer's who were deeply involved in covert support work with the Salvadoran FMLN. It was an intimate and congenial gathering of mostly U.S. expats and visitors, and I played a couple of songs. Among the guests was an attractive young couple named Bob and Gracie Ekblad, who were engaged in agricultural development work, with a side of Bible study, among the poorest campesinos in the mountainous interior of Honduras.

The next morning the driver Meyer had found showed up with a battered white Land Cruiser, which subsequently splashed and smeared its way over rutted red dirt roads, reduced to muck by recent rains, westerly, toward the border with El Salvador. Hours jostled by before we arrived at the tiny village of Colomoncagua. The hamlet is situated on top of a mountain. From the main street you can look west over the border at the green and rugged terrain of El Salvador, and right across that to the Pacific Ocean, stretching blue into the hazy horizon. Below, to the south and down a steep hill, lay the refugee camp, set out in tidy streets lined with canvas-roofed wooden structures.

Reaching the town meant penetrating a ring of troops. The soldiers at the checkpoint had doubtless heard the laboring low-range gears of the 4x4 from a long way off. A dozen or so slouched around a makeshift hut, M16s in hand. The hard young faces wore expressions of curiosity mixed with malice—uniformed gangbangers whose turf we had stumbled onto. A lift gate made of a stripped tree trunk blocked our path. In Spanish our driver explained the situation to the corporal who confronted us, handing him the letter from the general. The soldier made a great show of studying its contents, then said, "Well, yeah, okay," and handed it back. He slung his rifle on his shoulder and raised the gate. I thought, "Let's get out of here before someone who can read shows up." He'd been holding the letter upside down.

It was late afternoon by the time we pressed uphill into Colomon-cagua. We stayed in a guesthouse slung with hammocks, the only occupants. The house stood on the main street, beside the police sta-

*Colomoncagua refugee camp,*
*me and Don Fergus*

tion. We were warned to shake out our shoes in the morning before putting them on, as scorpions found them cozy. Such proximity to the police in a place like this made me more nervous than the possibility of arachnids in my boots. That and the hammock made sleep difficult. Deep into the night, sounds of laughter wafted

in from next door. I finally drifted off, only to be jolted awake in the small hours by a blood-curdling scream. It was so close I felt as if it were in the room with me. I thought they must be torturing someone in the police post. I lay tense in the dark, barely breathing, waiting for more. It never came. In the morning I found out it had been a pig in the street outside. The sun was barely above the horizon, not yet hot, the morning air crisp and clear. Somebody said, "Look, they're bombing over there!"

From our mountaintop vantage we watched a Cessna A-37 Drag-onfly jet, developed by the U.S. military for the tight corners of Vietnam, make run after run at a small town mostly obscured by trees on the far side of the border, in the killing fields of El Salvador—"The Saviour," a country named for Jesus Christ. The town's church steeple stood gleaming in low yellow rays as the plane bellied above the rooftops and then blasted upward. In its wake, plumes of blacken-ing smoke shot skyward, followed by a distant boom. The warplane climbed and banked steeply to swing back for another pass. From the time lag between the detonation of the bombs and the sound reach-ing us, we estimated the town to be ten or twelve kilometres away. Later, one of the Salvadorans we spoke with suggested that the town probably had no guerrillas in it, possibly even no people in it, and the

pilots were just getting rid of their bombs where they wouldn't get shot at. Apparently that was characteristic of the war in El Salvador.

Nonetheless, from 1980 to 1992, an estimated seventy-five thousand people died in this so-called civil war, which was more an imperial pogrom against the people of a chattel state. Most of the dead were civilians, whom Salvadoran army officers sneeringly referred to as "the masses." During the early eighties the armed forces employed their U.S.-supplied weapons to slaughter up to ten thousand civilians a year.

The bombing raid made it into the second verse of "The Charity of Night," the song whose first verse described my teenage encounter with the predator on the Stockholm bridge. I chose to make the witness a woman so I could frame the whole piece as a slowly unfolding love story. The word "she" is the only piece of fiction in the song, other than having the attack aircraft be plural. In the third verse there's a coming together of the two characters—anima and animus, yin and yang—in the heat of this short span we call a life.

*Slow revolution—1985—crosswise in a hammock in the*
*hot volcanic hills*
*It's 3 A.M. the night after the air raid*
*From the ridge she watched A-37s, like ugly gulls,*
*Make a dozen swooping passes over some luckless town*
*Maybe ten klicks beyond the border*
*In the distance the Pacific glimmered silver*

*Now lascivious laughter floats on the darkness from the*
*police post next door —*
*Male voices—and a woman's —*
*Little clouds of desire painted around the edges with rum*
*In the muddy street a pig suddenly screams*

*Wave on wave of life*
*Like the great wide ocean's roll*

*Haunting hands of memory*
*Pluck silver strands of soul*
*The damage and the dying done*
*The clarity of light*
*Gentle bows and glasses raised*
*To the charity of night*

"THE CHARITY OF NIGHT," 1994

Heavily armed soldiers surrounded the refugee camp. There would be no sneaking into this place, as we did in Mexico, even had we wanted to, which we did not. The whole point of being there was to be visible, so that the higher-ups literally calling the shots would know the world was watching them.

On our arrival a small swirl of guns, boots, and olive drab eddied around our vehicle. Nobody looked happy to see us. The officer in charge could not read the letter either, but he recognized the general's signature and seal, so he ordered an opening in the cordon of troops and in we went.

Bullet holes laced the rough-sawn walls of the flimsy houses. Honduran troops had swept through the camp, not targeting people directly but firing into houses to intimidate. The troops claimed they were looking for FMLN rebel fighters in the camp, but it was clear they were also trying to discourage further migration, which was in fact happening, as thousands of Salvadorans were desperate to get anywhere outside their own borders. The old man and baby were killed and others beaten up, but it could have been worse, and may have been had we not arrived when we did.

I wondered if the Hondurans were afraid that the large influx of refugees would lead to a confrontation with the Salvadoran military, which had easily beaten Honduras during the so-called Soccer War of 1969. No doubt FMLN guerrillas were inclined to move through this remote area. The military imposed a 5 P.M. curfew on the entire region outside town. The penalty for violating the curfew was death.

Paramilitary squads hunted the countryside, looking for anyone outside between dinner and dawn. Even in your house, if a lantern burned too late, they might come after you.

The camp was similar to those I'd seen in Chiapas, only better supplied. The dwellings were more substantial, constructed with lumber and nails and tentlike canvas roofs. The refugees themselves were cautiously relieved at our arrival. They insisted on feeding us. They were doing everything they could to create some semblance of normalcy, though they faced difficult conditions, including an inadequate flow of food. They had a band—when you show up with a guitar, there always seems to be a band—and had made their own instruments: a string bass, several homemade fiddles, a cigar box guitar. Word went round and in a short time half a dozen players had shown up, and we jammed on a low, canvas-roofed stage. A tall, wiry old man whom everyone addressed as Don Fergus was both luthier and the main musician. He'd start a fiddle tune and everyone would jump in to play along, including me. People gathered around, enjoying the diversion.

We stayed two nights at the refugee camp and then left for the capital. There we ran into a U.N. inspection team, which had arrived in Tegucigalpa just after we left, and was attempting to make the same trek. They were visibly upset. Actually, furious. The army had been stonewalling them, and they blamed our unauthorized intervention for that. We were called irresponsible, meddlesome, and some other things. I doubt we had added to their difficulties. Had it not been for our fortuitous contact we would have been faced with the same situation, so we sent them to the Canadian honourary consul. Meyer felt, and Jeff and I agreed, that there had been no time to lose. We were the first to find out, the ones who could arrive the quickest, and it seemed to me like Big Circumstance at work.

Back in Toronto, media response to the tale of our Honduran adventure was disappointingly sluggish. I was invited to appear for an interview on a midday news show on CBC television. As the conversation progressed with no mention of the trip, I happened to catch a glimpse of the anchorwoman's production notes, which read: "We

have this commie fag sympathizer who wants to talk about Central American refugees and what a rough time they're having. Nix on that. . . ." She waxed pretty embarrassed when she realized I had seen the cue sheet. I was quite put out.

I maintained some correspondence with the Ekblads. The following January I returned to Honduras to visit them. They had landed in Central America some years earlier as young, gung-ho Christian missionaries with a mind for spreading the Presbyterian Word and helping the poor in whatever ways they could. They quickly came to understand that food security was a major issue for the campesinos among whom they worked, as Honduras runs largely on a plantation economy. The massive sugar and banana farms, which occupy most of the good land, require the availability of seasonal labour. That availability is maintained by ensuring that the majority of small farmers must work land that can't produce enough food for sur-vival—if they have land to work at all. The only way they can feed their families is to join the cheap seasonal labour pool, earning just enough money to buy the food they can't grow. "This shall be the System," sayeth the colonizers. And so it remains.

The Ekblads began hosting Bible study classes, and that became an important element of a courageous and creative program of working alongside peasant farmers, developing agricultural tech-niques that would help them gain independence from the planta-tion treadmill. It was courageous because such work is considered subversive. Government thugs threatened, among other things, to torch their house in Minas de Oro, but they never quit.

With the campesinos, the Ekblads examined the surrounding media: What does that billboard mean to you, what's that ad really trying to sell you? Their efforts bore fruit, and not just the fruit of the land. We visited the tiny village of Guachipilin (named for a local tree that provides a fine-grained yellow wood and yellow dye), where people were gleaning impressive amounts of produce from steeply

sloping hillside plots that would challenge a mountain sheep. The work allowed a spirit of healing to descend on the place, which even manifested in the resolution of old feuds among neighbours. The sensation of balance seemed pretty fragile to me, but it was certainly there. Whether it has withstood the general slide into entropy that has infected so much of the world since then, I don't know.

The Ekblads were involved in an ongoing moral struggle against the U.S. Agency for International Development (USAID), whose policies appeared designed to preserve the status quo, and whose agents were forever attempting to subvert the Ekblads' work with

promises of food handouts and chemical fertilizers. At a high point in their organizing, the Ekblads facilitated the operations of twenty-five hundred people who had gained independence in food production and community organization. Today Bob has a prison

*Honduras, 1986.*
*I plow a better furrow with a guitar.*

ministry in northern Washington state, but returns to Honduras semiregularly to offer continued support and guidance. Recently he told me that within a decade the work of USAID had reduced that number to five hundred, and that today many of the people in the region who were doing well two decades ago had been reduced once again to a life of privation and struggle.

Although Honduras's leftist insurgency and accompanying death squad activity didn't get as much attention as those in other Central American countries, they were present. Most notorious was Battalion 3-16 (see chapter 12). Today several former members of Battalion 3-16 hold high positions in the federal government of Honduras, a regime openly supported by the administration of U.S. president Barack Obama despite knowledge of its current, ongoing death squad activities.

The dark miracle of the Internet now allows anyone to watch Honduran death squads in action. The November 21, 2012, assassination of two young brothers in Tegucigalpa, for example, was recorded on fixed security cameras and posted on the website of the Honduran newspaper *El Heraldo*. Eight heavily armed men pull up in two newer SUVs and corner five people who are on foot. They shoot at the three who run, wounding one of them, but they get away. The other two are made to lie facedown on the pavement and are shot several times with automatic rifle fire. Despite the excellent quality of the security video, the government has not identified the attackers, who were highly militarized and obviously well funded. Tegucigalpa, which annually suffers 91 homicides per 100,000 residents, is now, by the U.N.'s reckoning, the capital of the world's most violent country. Death squads roam with impunity. All the spaghetti western clichés I had found absent in Mexico are writ large on the land of Honduras.

> *Goons in blackface creeping in the road —*
> *Farm family waiting for the night to explode —*
> *Working the land in an age of terror*
> *You come to see the moon as the bad-news bearer*
> *Down where the death squad lives*
>
> *They cut down people like they cut down trees —*
> *Chop off its head so it will stay on its knees —*
> *The forest shrinks but the earth remains*
> *Slash and burn and it grows again*
> *Down where the death squad lives.*
>
> *I've got friends trying to batter the system down*
> *Fighting the past till the future comes round.*
> *It'll never be a perfect world till God declares it that way*
> *But that don't mean there's nothing we can do or say*
> *Down where the death squad lives*

*Like some kind of never-ending Easter passion,*
*From every agony a hero's fashioned.*
*Around every evil there gathers love —*
*Bombs aren't the only things that fall from above*
*Down where the death squad lives*
*Down where the death squad lives*

*Sometimes I feel like there's a padlock on my soul.*
*If you opened up my heart you'd find a big black hole*
*But when the feeling comes through, it comes through strong —*
*If you think there's no difference between right and wrong*
*Just go down where the death squad lives*

*This world can be better than it is today*
*You can say I'm a dreamer but that's okay*
*Without the could-be and the might-have-been*
*All you've got left is your fragile skin*
*And that ain't worth much down where the death squad lives*

"WHERE THE DEATH SQUAD LIVES," 1986

I don't go to war zones in search of song material. To go to a place steeped in suffering just to get something interesting to write about seems to me exploitative and obscene. I try to write what touches me. Sometimes a song comes out of exposure to conflict, sometimes not. War zones are by definition chaotic places, and they attract all sorts of characters: saints and killers, charmers and charlatans.

For an outsider who does not live in a state of war, however, there can also be a selfish component to visiting war zones. The adrenaline is literally intoxicating. In his book *War Is a Force That Gives Us Meaning*, fabled Pulitzer Prize–winning war correspondent Chris Hedges describes being in El Salvador in 1982, where he got caught in a firefight between government troops and rebel forces. As he faced "several full bursts of automatic fire," bullets bouncing off the road

and buildings around him, Hedges—who holds a master's degree in divinity from Harvard—prayed: "God, if you get me out of here I will never do this again." Of course he did get out, retreating to San Salvador, where he "drank away the fear and excitement in a seedy bar. . . . I was hooked."

It's also a matter of (perhaps morbid) curiosity: this is an interesting thing for *me* to do for *me*. That's a major factor, but "for me" has to also include some positive action to try to alleviate people's pain. Otherwise you're just engaging in voyeurism.

Travels of this sort have always been about something bigger than I that justifies going: something about stepping through doorways God has opened for me, something about serving humanity in some small way. Anybody can buy a ticket to anywhere in this world. If you want to go to Grozny to see what's going on in Chechnya, you can buy a ticket and go there. But it may not mean much. As a selfish exercise it's fine, and there's nothing really wrong with that, if that's where your interests take you; but it seems more worthwhile, if you're headed to a war zone, to be affiliated with a group that's trying to fix it, and in this way to potentially be useful in the world. Being under organizational auspices can provide connections and insights not necessarily available if you just buy a ticket and go, which is what some journalists do. They find out what's going on from the taxi driver, or from the bartender, or from each other. I don't mean people like Hedges or the courageous journalist Janine di Giovanni, but those correspondents who hole up in the Holiday Inn, or stay in another country, and get the story from afar.

There is ample reason for this, as wars become increasingly dangerous for journalists. The recent Iraq war was the most deadly in history for reporters, according to the Committee to Protect Journalists, which reported that more than half of the 204 media workers killed in Iraq from 2003 to 2011 died in "targeted killings." That would include Tareq Ayoub, who perished on April 8, 2003, when a U.S. warplane bombed Al Jazeera's Baghdad headquarters shortly after the news agency provided the American military with the build-

ing's coordinates. The United States also bombed Al Jazeera's Kabul headquarters during the 2001 invasion of Afghanistan.

In his book Hedges describes how he became a war junkie, though it didn't take him long to sour on the rush. I very quickly acquired an understanding of the attraction. It's like being in a shipboard romance with everyone you meet. Fear and an awareness of one's fragility trigger an openness and vulnerability, an affection that people share with an unstated understanding that it could all be over in the next instant. Which of course is true anywhere at any time, but can't be ignored in a war zone. There is no future to be assumed.

*You could have gone off the Bloor Street viaduct*
*I could have been run down in the street*
*You could have got botulism anytime*
*I could have gone overboard into the sea*

*Anything can happen*
*To put out the light,*
*Is it any wonder*
*I don't want to say good night?*

*I could have been hit by a falling pane of glass*
*You could have had shark teeth write "fini"*
*We could have been nailed by some vigilante type*
*In a case of mistaken identity—obviously*

*Anything can happen*
*To put out the light*
*Is it any wonder*
*I don't want to say good night?*

*We could have been lynched and tarred and feathered*
*Been on a plane that crashed in flames*

*Could have done the neutron melt together*
*But here we are just the same!*

*You could have been daggered in the dead of night*
*You could have been gassed inside your car*
*I could have been walking in the open fields*
*And been drilled through the head by a shooting star*

*Anything can happen*
*To put out the light*
*Is it any wonder*
*I don't want to say good night?*

"ANYTHING CAN HAPPEN," 1980

# 15

A funny thing happened on the way to releasing *World of Wonders* in the United States. Just as I was beginning to enjoy the American capacity for healthy disputation, Bernie and I found ourselves embroiled in one of those quintessentially American flare-ups over content. As the *Houston Press* put it, "*World of Wonders* quickly became one of the first albums subjected to the wrist slap of censorship, not for dissing the U.S. government's exploitation of underdeveloped countries, but for using the F-word."

In 1986 the Powers That Be declared that one must not say "fuck" on an album without having a warning label affixed to the front of the packaging. (My mother also didn't care for my intentional use of the vernacular. She said, "Did you have to use *that* word?") "Fuck" appears in the opening song, "Call It Democracy," about that spawn of transnational finance, the International Monetary Fund (IMF). Maybe it was the F-word that brought *World of Wonders* to the attention of American censors, or maybe it was the surprise of seeing their sacred monetary system called out in a popular song. I believe "Call It Democracy" remains the only song about the IMF, and certainly the only one containing the phrase "insupportable debt," ever to get exposure on radio. Which is sort of amazing, given that the IMF and World Bank have interfered in the lives of millions of people around the world, including some

great songwriters and, you'd have to think, at least a few radio program directors.

The planet's poor suffer in service, and in inverse proportion, to the ongoing accumulation of wealth by the embarrassingly rich, who collectively control world finance, as well as entire nations, through institutions such as the IMF and associated bodies, banks, and agreements: GATT, NAFTA, WTO, G8, BCCI, HSBC, the alphabet soup of world domination. Over the last century the world's financial elite have arguably impacted people and the environment in ways more devastating than any other human construct, with the possible exceptions of religion and war. In terms of environmental degradation the financiers actually weigh in at the top of the triad, though the U.S. military is the world's single largest emitter of greenhouse gasses. But with all of this going on, some people felt it was my choice of language to describe it that was the problem.

We had a deal for U.S. release of the album with the independent American record label Gold Mountain, owned by legendary rock manager Danny Goldberg. His label was, in turn, distributed by MCA. One day Danny called Bernie with some bizarre news: lawyers at MCA had decided that, because of "fuck," the record would require a "Parental Advisory Explicit Content" label for distribution in the States.

It was not a total surprise. We had been aware of an ongoing fuss inside the Beltway over the pernicious effects of rock music on youth. Bernie remembers it in his book: "We released this record in 1986, one year after the Parents Music Resource Center—a group dedicated to giving parents more control over music that they felt was violent or sexually suggestive—was formed. The founders, known as the 'Washington Wives,' included Tipper Gore, Senator Al Gore's wife; Susan Baker, married to then–treasury secretary James Baker; and two other women whose husbands had senior government jobs in Washington." Out of the bizarre biochemistry of Reagan's D.C., the Washington Wives had evolved from hosting polo club luncheons to "protecting" American children—who in that era would have witnessed tens of

thousands of murders on television (if not a few in their neighbour-hoods) before they were eighteen—from a mere word. Would that they had addressed poverty and injustice with the same fervor.

The warning label became known as the "Tipper Sticker." We didn't make PMRC's Filthy Fifteen list—songs that they deemed "rock porn" (categories included "the occult")—but it was still galling to be targeted for censorship by this cult of unelected busybodies.

As if the folks in Washington didn't have anything more pressing to think about, in 1985 the Senate Commerce, Science, and Transportation Committee actually held hearings on PMRC's proposed labeling idea. One of the best things to come out of the hearings was testimony by musicians, particularly Frank Zappa, who called the labeling scheme "somebody's hobby project. . . . The establishment of a rating system, voluntary or otherwise, opens the door to an endless parade of moral quality control programs based on things certain Christians don't like. . . . The PMRC proposal is an ill-conceived piece of nonsense which fails to deliver any real benefits to children [and] infringes the civil liberties of people who are not children. . . ."

The hearing did not result in a new law because the Recording Industry Association of America agreed to voluntarily develop a generic sticker that labels could apply to records on a subjective basis. (How history repeats, like acid reflux, from Hollywood blacklists and the Comics Code Authority on down!) This immediately included Zappa's 1986 Grammy-winning release *Jazz from Hell*, an entirely instrumental album (which admittedly included the youth-warping title, "G-Spot Tornado"). And the warnings did result in censorship in that many major chains, including Walmart and Sears, refused to sell stickered albums. We didn't know this at the time, so we agreed to be stickered to keep things easy between us and MCA, also eyeing the potential benefit of more attention for the album.

Things got wacky after that. MCA told Bernie it was abandoning the sticker idea for a better one: print the lyrics on the back cover of the album, and this would serve as the warning to the public. Okay, we said, what the fuck. Go for it. Then the MCA lawyers said that

the word "fuck" had to stand out, so they decided to highlight it in yellow, which they did without our consent, shipping several thousand copies of the album before we could put a stop to it. Probably the only people who really benefitted from this misery are people who bought *World of Wonders* with the word "fuck" highlighted; it is now a collector's item.

*Padded with power here they come*
*International loan sharks backed by the guns*
*Of market-hungry military profiteers*
*Whose word is a swamp and whose brow is smeared*
*With the blood of the poor*

*Who rob life of its quality*
*Who render rage a necessity*
*By turning countries into labour camps*
*Modern slavers in drag as champions of freedom*

*Sinister cynical instrument*
*Who makes the gun into a sacrament —*
*The only response to the deification*
*Of tyranny by so-called "developed" nations'*
*Idolatry of ideology*

*North South East West*
*Kill the best and buy the rest*
*It's just spend a buck to make a buck*
*You don't really give a flying fuck*
*About the people in misery*

*IMF dirty MF*
*Takes away everything it can get*
*Always making certain that there's one thing left*
*Keep them on the hook with insupportable debt*

*See the paid-off local bottom feeders*
*Passing themselves off as leaders*
*Kiss the ladies shake hands with the fellows*
*And it's open for business like a cheap bordello*

*And they call it democracy*
*And they call it democracy*
*And they call it democracy*
*And they call it democracy*

*See the loaded eyes of the children too*
*Trying to make the best of it the way kids do*
*One day you're going to rise from your habitual feast*
*To find yourself staring down the throat of the beast*
*They call the revolution*

*IMF dirty MF*
*Takes away everything it can get*
*Always making certain that there's one thing left*
*Keep them on the hook with insupportable debt*
*And they call it democracy. . . .*

"CALL IT DEMOCRACY," 1985

I still consider "Call It Democracy" one of the more pertinent songs I've written. Sadly, the subject matter has not passed its "sell-by" date. The video turned out pretty well too, with delightful images such as a map of Latin America being fed into a meat grinder and coming out a Coke bottle. It got a lot of play in Canada, and in fact won an award, but MTV refused to show it because it included the logos of certain offending corporate entities. No doubt altruistically and in the interests of media integrity, they had a policy of not displaying companies' symbols except as advertising. After that, MTV got into "lifestyles" and seemed to stop showing videos that had no sexual content.

I think the song does a decent job of poeticizing the highly complex and extremely destructive connivance of international finance, governments, and militaries. In the few years preceding, I had seen up close the infuriating offspring of such unions in the Americas—grinding poverty, widespread landlessness and the metastasizing of urban slums, environmental degradation, the rich getting richer, the slaughter of the innocents with scorched-earth counterinsurgency strategies—and there would be much more of it to come. Then and now, wherever you look you find the same financial interests at work. When the complaints of the exploited rise above a certain volume, out come the troops, and then the arms companies get rich too. This is a long-recognized phenomenon. On May 28, 1816, former U.S. president Thomas Jefferson wrote to friend and colleague John Taylor: "I sincerely believe . . . that banking establishments are more dangerous than standing armies; and that the principle of spending money to be paid by posterity, under the name of funding, is but swindling futurity on a large scale."

In its 1999 "Jubilee Call for Debt Forgiveness," the United States Conference of Catholic Bishops reported, "[T]he impact of debt on the world's poorest countries is especially crushing. . . . In contrast to the 1980s, when the debt crisis was focused in Latin America and private banks held much of the debt, today's most heavily indebted poor countries are primarily in Africa and their loans come mostly from the U.S. and other governments and from multilateral institutions such as the World Bank, the International Monetary Fund (IMF), and the Asian, African, and Inter-American development banks."

One of the African nations that the bishops singled out in their report was Mozambique, where I found myself in 1988, shortly after recording my next album, *Big Circumstance*. It was the first of two journeys I would make to this beautiful but battered African nation. At that time the country was still suffering from four centuries of Portuguese

colonialism, associated bad finance, and more than twenty years of civil war. Starvation and preventable disease were at crisis levels, but more critically the war, an experiment in the violence by proxy known as "low-intensity conflict," was crushing the very fabric of Mozambican society. This war was analogous to the Contra war in Nicaragua, only the impetus behind the anti-government forces came first from white-ruled Rhodesia (now Zimbabwe) and then from apartheid South Africa. It stands out in modern history as being the first war to feature the pervasive and organized use of child soldiers.

Mozambique is about twice the size of California, nearly eight hundred thousand square kilometres of mostly rolling bush, broken dramatically in places by inselbergs, solitary mountains rising distinctly out of the tropical lowland. The country is situated on the southeastern African coast, facing the Indian Ocean opposite Madagascar. A group of charitable organizations, operating under the umbrella Cooperation Canada Mozambique (COCAMO), invited me to carry out what was becoming a familiar mission: witness, and then come back and report to the public about my findings. They wanted to generate support for a hunger relief program intended to help some of the estimated half-million people displaced internally by the war.

It was in Rhodesia and South Africa's interest to see a neighbouring indigenous, and Marxist, government fail. Their paid-off proxy forces operated under the name Mozambican National Resistance, or RENAMO. Rhodesia, fighting its own war to preserve white supremacy, rightly feared a radical, black-run state on its eastern border. RENAMO was the creation of Rhodesian agents, in cahoots with a few disgruntled Mozambicans. The Marxist government, FRELIMO, had imposed Soviet-style economic plans, which did not translate well in an African context. The results were sufficiently disastrous that it was relatively easy to establish a legitimate opposition, but that was not RENAMO's agenda. They had no plans for a structure to replace the Marxists if they succeeded in driving them from power; their aim was destabilization. They sought to destroy the entire infra-

*Locomotive disabled by RPG round
that failed to explode*

*The rest of the train.
A narrow escape for the engineer.*

*FRELIMO soldiers, Mozambique, 1988*

structure of the country, rendering it ungovernable. This they did quite well.

The war began in 1977, just two years after Mozambique won independence from Portugal in a brutal ten-year conflict. RENAMO's bandit army spread out through the countryside, maiming and slaughtering the civilian population and destroying beyond repair roads, schools, and communications— everything that represented the government. Land mines were used to great effect as the terror weapon they became after World War II, when most warfare worldwide came to be carried on inside national borders rather than between countries. Rural people, virtually all of them farmers, were forced to flee their homes. Poor to begin with, they headed, with nothing, toward any refuge available. Those near the borders crossed them. Those lacking that escape option gathered in rough, precarious camps or around the defended perimeters of cities. Nobody was growing any food, so the urban population was faced with privation as well.

Cooperation Canada Mozambique was operating out of the north-

ern provincial capital, Nampula, which was surrounded by a ring of squatter camps. The aim of the project was to support the development of an agricultural base in the camps, where it could be protected from attack, to enable the displaced squatters to feed themselves as well as residents of the city.

In 1988, the war was raging and you couldn't travel through the countryside. To the outsider, Mozambique was simply a chain of urban islands surrounded by a sea of conflict. In the company of a remarkable Mozambican of Portuguese descent, one of the few who had stayed after independence, named Antonio Carvalho-Neves, I travelled from island to island—Maputo, Inhambane, Beira, a massive refugee camp somewhere up the Zambezi River, Quelimane, Nampula—meeting people from a wide range of backgrounds and conditions, among them a long-haul trucker whose left foot had been nearly severed when his rig ran over a mine. On a subsequent foray he took an AK bullet in the shoulder. He was still driving, to the extent the shattered roads allowed. I thought of the Little Feat song "Willin'," wondering what kind of truck-driving song I could make out of this man's story.

I was accompanied as well, for a while, by a three-man film crew from Montreal that was shooting a documentary on the war as seen through the eyes of Zena Bacar, a Mozambican singer. She was a highly animated, warm, intense woman in her late thirties. She had toured in Europe and become famous nationally with her band, Eyuphuro, but that was before the economy had collapsed to the point where nobody could buy anything, music especially. Zena was orig- inally from Ilha de Mozambique, an *actual* island that was the land- ing site of Vasco da Gama, the first European explorer to set eyes on that shore of Africa. The film people would follow her home to see how the war had affected her family. We flew in a small plane from Nampula eastward to the coast. Her uncle lent us a beat-up car to get around in locally. As we drove slowly through the streets of Ilha, Zena unexpectedly assumed a kind of regal air, as if she were in a limousine. Sitting next to the window in the backseat, she was visible

to the many pedestrians. People stopped and stared as we passed. We were almost the only motor vehicle, and the only whites. Their expressions suggested nothing but subdued curiosity to me. Zena's chin tilted proudly upward, basking in adulation only she could see. "My people love me!" she said.

The northern coast around Ilha de Mozambique had seen less action than other parts of the country, but while we were there a nearby village was attacked. Word spread quickly. The following morning we interviewed survivors, who were very nervous. Some houses had been burnt, but we were unable to find out how many people, if any, had been killed or injured. It seemed as if there was a general fear of reprisal should the "bandits" return. They may not have been far away.

We returned to the small mainland town in the back of a large dump truck jammed with local travellers, mostly people going to the market. There were a few soldiers. As one of the last to climb aboard, I was pressed against the tailgate—a fine vantage point, despite the rough ride, from which to watch the countryside roll away in our wake. From time to time I felt something rigid bump the back of my head. Turning to see what it was, I found myself eye to eye with the business end of an RPG-7. The anti-tank rocket launcher, missile in place, was slung casually over the shoulder of a soldier standing next to me. I tapped him on the arm and with gestures asked him if he'd mind moving the thing to his other side. He grinned apologetically and complied. The rocket itself is detonated by means of impact on a button mounted in its nose. It was that I'd been feeling, banging against my head with the lurching of the truck.

According to former Canadian senator Roméo Dallaire, who as a general in the Canadian army was in command of U.N. forces in Rwanda during the 1994 genocide (and is credited with saving at least thirty thousand people), it was RENAMO that first employed, in a systematic way, the strategy of abducting children and compelling them to fight. Dallaire has gone on to campaign vigourously against the use of child soldiers.

*Marcelino Dos Santos, poet and speaker of Mozambican Parliament, Maputo, 1988*

Children make an especially pernicious force. If you're a poor government or a rebel warlord and you lack the funds for equipment, bombs, and technology, you turn to your people as weapons. Those who will best do your bidding are kids, kidnapped from captured villages, sometimes as young as six or seven. They'll do whatever you say, especially if you scare the wits out of them, force them to commit a couple of horrible acts themselves, then ply them with amphetamines and marijuana and ammunition and send them out to destroy. They become an affordable weapons system: boys typically the fighters, girls the pack animals, cooks, and sex slaves. The Mozambican experiment proved the effectiveness of this approach, and it has become an all-too-popular strategy throughout Africa and worldwide.

When the civil war finally ended in 1992, with more than one million people killed, the bankers—those modern slavers and champions of freedom—moved back in to continue the plunder. As the United States Conference of Catholic Bishops reported, "[I]n 1998, Mozambique's annual debt service obligation was more than half of its public revenue. In a country still emerging from a sixteen-year civil war, half the rural population does not have access to safe drinking water; 200,000 children die annually from preventable diseases such as malaria, measles, and respiratory infections."

Holding the other hand of Mozambique's child soldiers was the American Christian right. As with Guatemala, it was felt in those circles that rolling back the Satanic tide of Marxism in Mozambique was worth any cost in foreign lives and well-being. In public and to the press, I frequently had to explain that these self-professed "Christians" did not represent me or any number of folks of all denominations who are trying to follow the way of love. There's an inherent

dishonesty in the messaging and actions of some leaders of the Christian right.

TV personality Pat Robertson was a leading supporter of Mozambique's bastard resistance movement. It was no secret at the time that RENAMO was a vicious mercenary army working for outside interests to recapture control of Mozambique's resources and labour pool. In her 1989 book *The Politics of the Christian Right*, Sara Diamond, a noted critic of lunatic conservatism, reported that on April 25, 1986, Robertson's *700 Club* TV show aired a program, of which I actually saw a portion, called "The Bush War." (Robertson was fond of prophecies, including a 1976 prediction that the world would come to an end in 1982. While "The Bush War" was not an actual prophecy, as a double entendre it would seem to rate as one of his most accurate.) "The Bush War" was a production of Robertson's Christian Broadcasting Network, whose reporter, Scott Hatch, claimed to have accompanied RENAMO mercenaries inside their territory.

"The segment featured film footage of a guerrilla exercise in the use of explosives," writes Diamond. " 'A guerrilla war is fought with the mind as much as with bullets,' said Hatch as the camera focused on land mines which RENAMO placed on roads travelled by Mozambican civilians and soldiers. The mines, Hatch noted, were 'designed not to kill, only to maim,' thereby creating a long-term hardship of wounded people for the government to care for." Indeed, the people's wounds are long term. The mines left in the red soil at war's end would continue to strike down the unlucky for decades.

Unsurprisingly, RENAMO also received significant support from within the Reagan administration, whose alliance with the racist government of South Africa was well known.

To revisit this stuff now rekindles the anger I carry toward public figures like Robertson, who use their visibility to sow hatred, who bless the worst sort of butchers, who enthuse over the cruelty of such weapons as anti-personnel land mines. (In 2005, Robertson would pad his Christian rep by advocating the assassination of Venezuela's democratically elected president, Hugo Chavez.)

Both sides in the Mozambique civil war used mines. There is no excusing it. But there is also no lauding it, as Robertson's crew did— filming and presenting the placing of the mines as if they were a kinder, gentler instrument of human destruction because they "only maim." In reality, the presence of land mines, especially in a country like Mozambique, where 90 percent of residents are farmers, renders vast reaches of countryside unusable and unlivable, and creates a pervasive terror that won't go away. Though Mozambique is by no means the worst-afflicted nation, parts of the country remain littered with mines; demining operations are ongoing but painfully slow.

In supporting RENAMO, Robertson and others were also support- ing the use of child soldiers. According to a 2004 investigation by *U.S. News & World Report*, "The Renamo leaders began recruiting from rural villages, and if they couldn't recruit able-bodied young boys, they simply kidnapped them. Most of the recruits were 12, 13, 14 years old, but some were as young as 6. The youngest boys often served as por- ters and servants to Renamo officers, or as spies, but most were sys- tematically trained to be soldiers. They were exposed to the noise of rifle blasts, to desensitize them. They were ordered to kill cattle; then, when they got used to that, to kill other humans, often those who ignored orders or tried to escape. The perimeters of the rebels' camps were often littered with the skulls of those who had tried to escape but failed." Coming from a somewhat conservative newsmagazine, this is likely a sanitized version; survivors of RENAMO attacks would have more terrible tales to tell. The article makes the point, though.

Legions of honourable and compassionate men and women of faith hold conservative views, but ignoring information like this—which was available to anyone in real time, especially someone who has an investigative news crew hanging out with the rebels—exposes the hypocrisy of the institutional Christian right. The suffering promoted or supported by its Bible-quoting leadership is hard for a mere human to forgive. Falwell, Robertson, and their ilk embody a weakness of human spirit, a back door left open to darkness, a deep insecurity salved by acquiring and wielding power.

At a performance in 1988 I introduced "Gospel of Bondage," a new song that decried the abuse of Jesus's message, by saying, "They scare the hell out of me and also irritate me, because I've gotten tired of saying, 'Yes, I'm a Christian, but I'm not one of them.' So here's my way of saying 'fuck you' to them." The language is divisive and disrespectful, and some have chastised me for it, but I don't think salvation depends on whether or not you use four-letter words. Crude language is a cultural issue, not a spiritual one. If I'm in a room with someone from the Christian right, I'm not going to talk to them like that. It would kill the opportunity for dialogue. But if I need to succinctly introduce a song, then a lyrical broadside works. Anyway, the assholes had it coming.

> *Tabloids, bellowing raw delight*
> *Hail the return of the Teutonic Knights*
> *Inbred for purity and spoiling for a fight,*
> *Another little puppet of the New Right*

> *See-through dollars and mystery plagues*
> *Varied detritus of Aquarian Age*
> *Shutters on storefronts and shutters in the mind —*
> *We kill ourselves to keep ourselves safe from crime.*
> *That's the gospel of bondage. . . .*

> *We're so afraid of disorder we make it into a god*
> *We can only placate with state security laws*
> *Whose church consists of secret courts and wiretaps and shocks*
> *Whose priests hold smoking guns, and whose sign is the double cross*

> *But God must be on the side of the side that's right*
> *And not the right that justifies itself in terms of might —*
> *Least of all a bunch of neo-Nazis running hooded through the night*
> *Which may be why He's so conspicuously out of sight*
> *Of the gospel of bondage. . . .*

*You read the Bible in your special ways*
*You're fond of quoting certain things it says —*
*Mouth full of righteousness and wrath from above*
*But when do we hear about forgiveness and love?*

*Sometimes you can hear the spirit whispering to you,*
*But if God stays silent, what else can you do*
*Except listen to the silence? If you ever did you'd surely see*
*That God won't be reduced to an ideology*
*Such as the gospel of bondage. . . .*

"GOSPEL OF BONDAGE," 1987

"Gospel of Bondage" comes third on *Big Circumstance*, my six-teenth album in eighteen years. It was, as they say, a helluva run, and I may have gotten a little fried from it. The eighties were par-ticularly intense, with hit songs and bigger crowds and busier tours; a swan dive into contentious politics; Reagan and Mulroney elected and then, incredibly, reelected; and the endless . . . motion. . . .

Of course there was balance. The decade began with a dynamic and romantic relationship between Judy and me that provided seven good years and a lot of songs. Our breakup was not of my choosing, but it would likely have been inevitable, given my walls and my travels. It was a gentle parting, though accompanied by some dis-comfort during the *World of Wonders* tour, when Judy was in the band. Though its dissolution hinged to a great extent on my absences, physical and spiritual, the relationship brought both of us greater understanding of the world and of ourselves. We remain close friends. During the eighties, my love for people grew and became more authentic. I learned to embrace my neighbour, which has been a gift all these years.

On the other hand, often feeling battered by the phenomenon of humans maligning and hurting each other and the planet, I struck back in song. Once the songs were in circulation, the media provided

plenty of opportunities for speaking out—more than I wanted. My privacy meant a lot to me. There I was ranting in public but feeling burdened by the attention I got back. So by the end of the eighties, even with my heart opening more fully, I grew a thicker skin— perhaps reptilian, or maybe like a tree.

*Big Circumstance* begins with "If a Tree Falls," a cry against clear-cutting that remains pertinent after twenty-five years, as the decima-tion of the world's forests rages on unabated. A lot of people seemed to like it—the song reached number eight on the Canadian RPM chart, did very well on U.S. radio, and became a hit in Australia—but there was an opposite response as well. Shortly after the song came out, an organization of Alberta beef growers took out ads declaring that I, along with Canadian singer k.d. lang (an outspoken vegetarian), were *anti-beef*. Critics complained that the song was "too pedantic." I was being too "literal," was "stretching my metaphors too far." As I said to an interviewer in 1989, "I have a two-word response for those people." Who knew "parasitic greedhead scam" would offend so?

*Rain forest*
*Mist and mystery*
*Teeming green*
*Green brain facing lobotomy*
*Climate-control centre for the world*
*Ancient cord of coexistence*
*Hacked by parasitic greedhead scam —*
*From Sarawak to Amazonas*
*Costa Rica to mangy B.C. hills —*
*Cortege rhythm of falling timber.*
*What kind of currency grows in these new deserts,*
*These brand-new floodplains?*

*If a tree falls in the forest does anybody hear?*
*If a tree falls in the forest does anybody hear?*
*Anybody hear the forest fall?*

*Cut and move on*
*Cut and move on*
*Take out trees*
*Take out wildlife at a rate of species every single day*
*Take out people who've lived with this for a hundred thousand years —*
*Inject a billion burgers worth of beef —*
*Grain eaters—methane dispensers.*

*Through thinning ozone,*
*Waves fall on wrinkled earth —*
*Gravity, light, ancient refuse of stars,*
*Speak of a drowning —*
*But this, this is something other.*
*Busy monster eats dark holes in the spirit world*
*Where wild things have to go*
*To disappear*
*Forever*

*If a tree falls in the forest, etc.*

"IF A TREE FALLS," 1988

The eighties for me were also a time of struggle over what it meant to be a Christian. I never found a church in Toronto at which I felt the collective spirit the way I had at St. George's in Ottawa. In my travels I would attend Sunday services of any denomination wherever I could, but the experiences were mixed. Occasionally I experienced a real spark. Other times I'd be sadly aware of being viewed with suspicion as an interloper. Gradually I stopped going.

The Catholic writer Brennan Manning once said that embracing the true God of Christianity "has meant repudiating the god of fear and wrath handed on to me by preachers, teachers and church authorities in my youth, repudiating the strange god who sees all non-Christians as good-for-nothings, who consigns all heathens to

hell." If only leaders of the Christian right could be so converted. As Manning points out, theirs is not a true Christian path. A true Christian path would lead them into the untidy stables of the poor and oppressed, to shovel shit with the Messiah. Instead they remain spiritually shipwrecked, foundering on shoals of their own ambition and indifference, slick and ridiculous in their genuflections to greed. I got tired of answering for them, for there really isn't much of an answer except an ancient one, something about human hubris. And when you get down to that, I have a sense that deep in my limbic brain, in my own fashion, I'm not so different. We remain in this wave-tossed ship together, and it's for each of us to try to grasp where we are led, and by what.

> *The man who twirled with rose in teeth*
> *Has his tongue tied up in thorns*
> *His once-expanded sense of time and*
> *Space all shot and torn*
> *See him wander hat in hand —*
> *"Look at me, I'm so forlorn —*
> *Ask anyone who can recall*
> *It's horrible to be born!"*

> *Big Circumstance comes looming*
> *Like a darkly roaring train —*
> *Rushes like a sucking wound*
> *Across a winter plain*
> *Recognizing neither polished shine*
> *Nor spot nor stain —*
> *And wherever you are on the compass rose*
> *You'll never be again*

> *Left like a shadow on the step*
> *Where the body was before —*
> *Shipwrecked at the stable door*

*Big Circumstance has brought me here —*
*Wish it would send me home*
*Never was clear where home is*
*But it's nothing you can own*
*It can't be bought with cigarettes*
*Or nylons or perfume*
*And all the highest bidder gets*
*Is a voucher for a tomb*

*Blessed are the poor in spirit —*
*Blessed are the meek*
*For theirs shall be the kingdom*
*That the power mongers seek*
*Blessed are the dead for love*
*And those who cry for peace*
*And those who love the gift of earth —*
*May their gene pool increase*

*Left like a shadow on the step*
*Where the body was before —*
*Shipwrecked at the stable door*

"SHIPWRECKED AT THE STABLE DOOR," 1988

By the time we wrapped up *Big Circumstance*, I had felt the psy-chic terra firma somewhat shift from under me. I would emerge from that decade not apolitical, but certainly less willing to dive right in. I became choosy about issues and the proffered opportunities to speak out about them, although at the same time, in the nineties, I began doing more actual *speaking* about issues, at colleges and other public fora.

One song on the album reflects the way in which politics finds you, whether or not you pay attention. We were scheduled to begin a German tour in early May 1986. I was to go over a few days early

to do media interviews in advance of the first gig. On April 26, the world was treated to the spectacle of a nuclear meltdown in Ukraine. On April 29, I landed in Cologne.

The cities of what was then West Germany are barely a two-day drive from Chernobyl, a stone's throw for airborne radioactive isotopes. I didn't have to go. I could have cancelled the tour, or at least the PR exercise, but it struck me that all the cesium-laced crap that the nuclear plant was spewing into the atmosphere would be carried on the jet stream to Ontario in a matter of weeks anyway, so why not go? I've always hated the idea of cancelling things. I was raised on the premise that the show must go on. "What the hell, anything can happen anytime, might as well check it out," I thought. "It's a once in a lifetime experience," I believe was the hope.

The scenes in West Germany were sci-fi surreal: workers in hazmat suits hosing down transport trucks coming in from the east; people vying with each other in the corner stores to grab the oldest, pre-meltdown milk products; pedestrians ducking into doorways to escape intermittent rains; absurd government admonishments to avoid consuming milk and leafy greens, and to hold your breath to avoid the dust kicked up by passing cars. Here was horror and intrigue, even grotesque humour. I listened to an extended interview on a car radio with a man who claimed to have a radiation-proof hotel. The guy went on and on about how safe it was. He would not divulge its location. When the interviewer asked him how one would go about getting a room, he replied, "Oh, it is fully booked!"

Adding to the overall farcical sense of doom were the headlines—because in spite of a very vocal opposition, Europeans use lots and lots of nuclear power—proclaiming that the nukes in the West were safer than those in the East. (The same thing happened after the reactor failure at Fukushima, Japan, in 2011: "It can't happen here." Bullshit. Anyway, it doesn't have to happen *here*. With nukes, everything is everywhere.)

The "safe nuke" argument is far more prevalent today than it was after Chernobyl. It's doubly disturbing that the fantasy of "safe, new-

generation" nuclear power plants, reminiscent of "unsinkable ships" and energy "too cheap to meter" (and we know how that went), is championed by many "green" leaders—*Whole Earth Catalog* creator Stewart Brand and Canadian ecologist Patrick Moore, to name a couple—as a path away from climate change. Even James Hansen, the otherwise heroic former head of NASA's Goddard Institute—who was arrested, while still working at NASA, for protesting government inaction on climate change, particularly coal power generation—has publicly advocated building the whiter, brighter nukes. In 2010 Hansen told *Newsweek*, "I think that next-generation, safe nuclear power is an option which we need to develop" to cut carbon emissions. Incredibly, Hansen also said, "In fact there's the possibility for the technology which would burn nuclear waste, which would solve the biggest problem with nuclear energy."

Nuclear is the end. Maybe it will cut into dirty coal generation and provide a temporary respite from our mad dash toward a comprehensive undoing of earth's life support systems, but are we really willing to settle for a temporary respite? I understand the emergency, and even how thinking gets muddled at high strategic levels. But pimping for nuclear is giving up the game. And it's not just the fifty-thousand-year half-life that's worrisome, nor Hansen's fantasy of safely burning nuclear waste. Imagine what would have happened if warring nations had possessed nuclear power plants during World War II. The perfect target. No one would be reading this, that's for sure.

*They're hosing down trucks at the border under a rainbow sign —*
*The raindrops falling on my head burn into my mind*
*On a hillside in the distance there's a patch of green sunshine*
*Ain't it a shame*
*Ain't it a shame*
*About the radium rain*

*Every day in the paper you can watch the numbers rise*
*No such event can overtake us here, we're much too wise*

*In the meantime don't eat anything that grows and don't breathe*
*when the cars go by*
*Ain't it a shame*
*Ain't it a shame*
*About the radium rain*

*Big motorcycle rumbles out of the rain like some creation of mist*
*There's a man on a roof with a blindfold on and a*
*hand grenade in his fist*
*I walk stiff, with teeth clenched tight, filled with nostalgia*
*for a clean wind's kiss*
*Ain't it a shame*
*Ain't it a shame*
*About the radium rain*

*A flock of birds writes something on the sky in a language*
*I can't understand*
*God's graffiti—but it don't say why so much evil seems to land on man*
*When everyone I meet just wants to live and love,*
*and get along as best they can*
*Ain't it a shame*
*Ain't it a shame*
*About the radium rain*

"RADIUM RAIN," 1986

(It was cesium in the Chernobyl rain, not radium, but "cesium" just didn't roll off the tongue as well.)

Rounding out *Big Circumstance* were four songs that came out of a 1987 journey to Nepal: "Tibetan Side of Town," "Understanding Nothing," "Don't Feel Your Touch," and "Pangs of Love," the latter two lamenting my breakup with Judy.

I went to Nepal at the invitation of USC Canada (founded as the Unitarian Service Committee of Canada), an organization I have

supported since 1970. They asked if I would visit one of the various countries in which they were supporting development projects, to witness and help generate interest in their work among the public at home. I chose Nepal because it wasn't a war zone. I wanted to visit a place where people weren't hurting each other.

My brother Don had been in Nepal during his three-year trek around the world in the early seventies. He travelled by car, bicycle, riverboat, tramp steamer, and foot across Europe, Africa, and Asia. Nepal, he said, was the most beautiful place he'd seen in all his travels. I was there for five weeks, and from the first day it was clear that Don was right. Even though at the time I thought Kathmandu must be the most polluted city on earth, the glorious scale of the rugged landscape seeped into my soul through every breath and visual. Towns whose ancient architecture spoke of the mystery of time had their message echoed by hamlets carved into the mountainsides, overlooking terraces where the plows of spring were drawn by water buffalo. The colourfully attired residents were cautious, maybe a little shy, but gracious and hospitable despite privation. Humans have lived in Nepal for the past eleven thousand years. It's the world's most mountainous nation, and these are the most imposing mountains anywhere. Eight of the world's ten highest peaks crown the wall of stone and ice that runs east–west to the north of the capital, Kathmandu.

Travelling in the company of Susie Walsh, USC's project officer for the region, I was excited and grateful to step onto this planet of stupas and prayer flags and public cremation rituals, to be embraced by an atmosphere exotic yet accessible, where the plowing and life in general were carried on at a buffalo's pace. I marveled yet again at grace blooming amid chaos.

We spent a few days in the capital before travelling out to the villages where we would find the USC-supported projects. We connected with an expat American photographer named Tom Kelly, a tall, rangy blond-haired Buddhist who had been living in Kathmandu for nine years with his partner, Carroll. They spoke Nepali. Tom had a port-

folio of beautiful shots of landscapes and people, and a knack for putting potential subjects at ease. The USC had engaged his services to document our encounters with its Nepali associates. On our return to Canada his work was made into a slide show, which I narrated and USC used for fund-raising. In spite of the inherent stiffness of the medium, it came out well. Tom's photos have appeared in *National Geographic* and other publications. He now leads treks into the Himalayas and spends a chunk of each year in Mongolia.

USC Nepal was headed by an impressive, highly educated, and dedicated woman named Nirmala Pokharel. Running the field operations was a shrewd young Nepali by the name of Sri Ram Shresta, who travelled with Susie, Tom, and me much of the time. Sri Ram had strong political views that he was extremely cautious about voicing. His favourite song of mine was "Call It Democracy."

"Tibetan Side of Town" is a little grittier than the other three songs from that trip. In 1950 China invaded and took control of Tibet, rending the heart of a peaceful, spiritual population and sending thousands fleeing into neighbouring countries such as India and Nepal. A large community of refugees had put down roots in Kathmandu. Among other things, the Tibetans had brought *tungba*, a beverage made by pouring boiling water over a baseball-sized wad of fermented millet and a bit of yeast. After a wait of only a few minutes, you had a large wooden mug of moderately strong, flat ale. It is drunk hot through a bamboo tube. The fermented mass is good for two or three fillings. After that you have to send out for a new batch of millet. It's an acquired taste, but not that hard to acquire. The search for *tungba* came to occupy a fair amount of what leisure time I had in Kathmandu. Fortunately, I had a guide in this enterprise in the form of Tom, who had the largest motorcycle I saw in Nepal, an Indian-made Enfield.

In a way, the quest for *tungba* was a symbolic replacement for politics on this journey. I was seeking connection, culture, history, communion. Not that the politics of poverty went unnoticed. Nepali society was a revolution waiting to happen. Political parties were illegal. The reigning monarch, King Birendra, and his family con-

trolled everything, raking in money from tourism and shadier things. A brother of the king was widely believed to be selling off the country's antiquities and was suspected of being involved in the heroin trade. Meanwhile, the welfare of the citizenry was left entirely to the community of foreign nongovernmental organizations (NGOs). The government had built health posts here and there, but had not gotten around to providing nurses or doctors or medicines. There were many things people would not say when they could be overheard, but you could feel the slow simmer.

On the surface Nepal evinced an air of mellow tranquillity. I thought the lid would take much longer to blow than it did. Only a couple of years later, public protests erupted and were met with violent repression. In February 1996 a Maoist insurgency exploded, quickly becoming a full-blown civil war characterized by extreme nastiness on both sides.

*Through rutted winding streets of Kathmandu*
*Dodging crowded humans cows dogs rickshaws —*
*Storefronts constellated pools of blue-white*
*Bright against darkening walls*

*The butterfly sparkle in my lasered eye still seems*
*To hold that last shot of red sun through haze over jumbled roofs*
*Everything moves like slow fluid in this atmosphere*
*Thick as dreams*
*With sewage, incense, dust, and fever and the smoke of brick kilns and*
*cremations —*
*Tom Kelly's bike rumbles down —*
*We're going drinking on the Tibetan side of town.*
*Beggar with withered legs sits sideways on a skateboard, grinning*
*There's a joke going on somewhere but we'll never know*
*Those laughing kids with hungry eyes must be in on it too*
*With their clinging memories of a culture crushed*
*By Chinese greed*

*Pretty young mother by the temple gate*
*Covers her baby's face against diesel fumes*
*That look of concern—you can see it still —*
*Not yet masked by the hard lines of a woman's*
*Struggle to survive*

*Hard bargains going down*
*When you're living on the Tibetan side of town.*

*Big red Enfield Bullet lurches to a halt in the dust*
*Last blast of engine leaves a ringing in the ears*
*That fades into the rustle of bare feet and slapping sandals*
*And the baritone moan of long bronze trumpets*
*Muffled by monastery walls.*

*Prayer flags crack like whips in the breeze*
*Sending to the world—tonight the message blows east*
*Dark door opens to warm yellow room and there*
*Are these steaming jugs of hot millet beer*
*And I'm sucked into the scene like this liquor up*
*This bamboo straw*

*Sweet tungba sliding down —*
*drinking on the Tibetan side of town*

"TIBETAN SIDE OF TOWN," 1987

In pursuit of the USC work Susie, Tom, Sri Ram, and I—along with Tom's sister Pam, who joined us for much of the trip—would drive to the end of one of the few roads and then hike most of a day, sometimes longer, to reach a village. It was worth the sweat and the altitude-shortened wind to visit ancient communities with little con-nection to the modern world.

Little connection, but not *zero* connection. In one town they threw

a party for us. They built a huge bonfire, which must have consumed a month's supply of precious fuel for cooking. The town musicians performed: a wildly atonal skirl of oboe-like instruments and drums played at a breakneck tempo in a completely incomprehensible time signature. The young men sprang about in vigorous dance: dark silhouettes against the leaping blaze, like the figures I had imagined while listening to de Falla's "Ritual Fire Dance" as a child. Then a couple of them began to break-dance, busting all sorts of moves, spinning on their necks in the dewy grass.

For our last week in Nepal we headed to the region of Mount Everest, home of the Sherpa people, who practice a form of Tibetan Buddhism. Our "excuse" was that we wanted to inspect the charitable projects undertaken by Sir Edmund Hillary's Himalayan Trust, with the support of Canada's Sir Edmund Hillary Foundation. (On May 29, 1953, the New Zealander Hillary and Sherpa Tenzing Norgay became the first humans to summit Mount Everest. Hillary bonded with the Sherpas and subsequently set up his trust to benefit them.) These undertakings were not extensive, but were important and mostly practical: a hospital, a new bridge across some impossible chasm, an improved water system, a rather modest reforestation project. Really, we were there to just knock around.

The town of Lukla, a forty-minute flight from Kathmandu, is the most popular starting point for trekkers headed toward Everest. Arriving by air might sound straightforward enough, but consider that in 2010 the History Channel rated Lukla the most dangerous airport in the world, and that was *after* the runway had been paved. When we got there it was a grassy strip on an expansive ledge nine thousand feet above sea level. To reach Lukla, planes soar between massive mountains that seem to loom just off the wingtips, then hit a narrow runway that runs upward at a twelve-degree pitch and is only fifteen hundred feet long. The runway is bordered with brush and houses and begins (or ends, depending on your direction) at the brink of a cliff overlooking the Dudh Kosi River valley two thousand feet below. Lining the runway were the overgrown, decaying car-

casses of crashed aircraft, including the one in which Hillary's wife was killed. You deplane and you're in town, which I'm told has grown since we were there, now sporting a Starbucks alongside the Karma Inn Restaurant and Irish Pub.

From Lukla we trekked to Namche, the region's main market town, on the slope above which Sir Edmund's reforestation project sat, forlorn. The locals apparently cared so little about it that they had let their goats consume all the million seedlings planted by the foundation. We spent the night there. The next day we marched on over a very big hill into the next valley, finding a town, whose name I no longer recall, virtually empty of human life. It was a Saturday, and everyone had gone to the market in Namche. The sky was a brilliant sapphire. The stone and timber houses sat orderly and quaint. The only sound was the rising and falling wind. The only things moving were the prayer flags fluttering and snapping by every house, the wind carrying their message of devotion to the ends of the earth.

As we entered town, the trail became the main street. A dog appeared fifty metres ahead, looked our way, trotted silently across the road, and vanished. A moment later, a particularly strong gust seemed to carry with it another sound: a deep and somber moan broken by an intermittent percussive pounding. We followed it down a side street and around some corners. The sound grew ever clearer until it resolved into something like trombones and drums and cymbal clashes, around the edges of which were human voices.

It was a funeral. In one house, the inhabitants were giving the dead a send-off. While her relatives kept watch, a small group of monks and nuns, robed in a dark red the colour of dried blood, alternately played several six-foot-long bronze trumpets whose long tones rolled over and around each other like eddies in a river, punctuated by percussion sounds, and chanted instructions for the departed, helping her to move on and avoid rebirth into the world.

Farther up the trail we encountered Sir Edmund himself, old but very fit and cheerful. He happened to be there on his charitable business. He made us welcome, introducing us to the Sherpa who was his

right-hand man and his wife, as well as their son, an apparently autistic man in his thirties, I'd say, who was a gifted painter of *tanka* (Buddhist religious scrolls). The son was one of three children born

SUSAN WALSH

*Me and Sir Edmund Hillary with the wife of Sir Edmund's head Sherpa, Nepal, 1987*

to the couple who survived to adulthood. Three out of a total of thirteen. *Tungba* was found, and we sat in the Sherpa's house talking and drinking while Caucasian faces grew redder and everyone became a notch more animated.

We carried on our ascent through a magical landscape of frightening heights, heart-stretching vistas, and torrents rushing down deep canyons, walking for hours under a canopy of scarlet-flowered rhododendron trees. At every crossroads stood a stone cairn built by pilgrims over the centuries, each rock carved with prayers and carried to the spot from wherever they came. The whole landscape seemed charged with the energy of the spirit.

As we rounded a bend, we chanced to meet a small party of travellers coming down—an elderly couple who turned out to be Americans, along with some Sherpas. We stopped to chat. The old man told me he had left his teaching job at a seminary in the Midwest to come to Nepal twenty-five years earlier and bring the gospel to its people. He was about to leave to return to the United States and was taking one last opportunity to appreciate the glory of the surroundings.

He proudly told me that he had taught Robert Schuller, of Crystal Cathedral fame, but he was bitter and seemed diminished. In twenty-five years, he said, he had not made a single convert. His words were "These people don't want to know about God!"

I felt sad for him, as he appeared to be so oblivious to the spirituality built into the surroundings. He had spent a quarter of a century wearing cultural blinkers, not seeing, not learning what he might have about the Divine. If it's true that the attribute of God that is

supposed to have the greatest effect on us is love, how can it flower in a soil of censure, tribalism, false pride . . . fear of the other? But for Big Circumstance, that could have been me.

As often happens in the sway of travel, Nepal altered my life in at least one very significant and unexpected way. Back in Lukla, we learned that all of Nepal Airlines planes small enough to land there—around four—were grounded in other parts of the country because of bad weather. So we sat, waiting for a lift out. During that time trekkers came streaming into town, quickly filling hotels and guest-houses. People were scattered everywhere, even camping on the run-way. We had a hotel room, but Susie got sick with something like the flu. It didn't seem like the usual travel bug, and I was anxious to get us out of there. No one knew how long our wait might be. Then I got a bright idea: let's rent horses and ride out! The Sherpas had them—rugged ponies. I thought it was a good idea at the time. It was a six-day walk to the nearest road, but we could sit on animals while they did the work, all sure-footed and obedient! I had no idea what I was talk-ing about. We would have gone over a cliff. Fortunately, everyone else just looked at me like I was an idiot and said, "I don't think you should do that."

After three days the Nepali government figured out that they had a situation at Lukla—there were now hundreds of people stranded at the edge of the earth—so they responded, using any aircraft they had to get people out. We ended up on King Birendra's personal helicopter, a French Puma SA 330 military chopper painted white, not gussied up at all. It was very Spartan for a royal ride. We strapped in on a bench along the starboard side, and as we took off with that special lurch that choppers have, Susie vomited, which amused us both. It seemed an appropriate gesture, given what we thought of the king.

Susie recovered quickly, and we landed back in Canada a few days later. Nepal sent me home with a wealth of promptings. Among the most significant, though I couldn't have known it at the time, was that I should take riding lessons. I thought that if I were going to be travelling in places where people use horses for transportation, then

I ought to know how to operate one. Sometimes you form simple intentions that can take you where you never imagined you would go, profoundly shaping your life. Leaving Berklee was like that, going to Central America was like that, and learning to ride horses was like that. In hindsight it's clear that the pursuit unlocked a succession of doors—doors of the mind, doors of the body and the spirit, and doors to people and places—that eventually led me into a dimension where nearly five decades of interior walls, having been cracked and cracked again, began to fall, and I found myself, for the first time, throwing my heart fully at the feet of another person. Unfortunately, that person was married to someone else.

There may be a metaphor here—something stereotypical about being lost in a wilderness, but the horse knows the way home. But there was nothing stereotypical about what was to unfold.

*High above valley,*
*Above deep shade coloured with the calls of cuckoos,*
*The ring of coppersmith's hammer*
*high in the hiss of the wind*
*Wind filled with spirits and bright with the jangle of horse bells*
*It's morning*

*Over the scratched-up soil, scorched-earth wasted,*
*Long shadows lead women bearing water*
*I watch the sway of skirts,*
*Think of moist spice forests —*
*Still, midnight whispers in my ear*

*Weavers' fingers flying on the loom*
*Patterns shift too fast to be discerned*
*All these years of thinking*
*Ended up like this*
*In front of all this beauty*
*Understanding nothing*

*Rhododendrons in bloom, sharp against*
*Spring snow*
*Remind me of another time*
*In Japanese temple —*
*There was a single orange blossom*
*At the wrong time of year —*
*Seemed like a sign —*
*When I looked again*
*It was gone*

*Weavers' fingers flying on the loom*
*Patterns shift too fast to be discerned*
*All these years of thinking*
*Ended up like this*
*In front of all this beauty*
*Understanding nothing*

"UNDERSTANDING NOTHING," 1987

# 16

Around June 1986 I started seeing things. That is, when I looked at a line, like a guitar string, it would be straight, then there would be a little notch in it, and then it would be straight again. Every straight line that I looked at, door frame or anything, was like that. Over a summer filled with gigs, the notch grew until it was clear that this was something I'd better look into. An ophthalmologist informed me that I had a fungal infection in my left eye called ocular histoplasmosis. Tiny spores had sprung forth from the droppings of some passing bird to colonize my retina. They were eating a hole in it, which eventually grew to the point that doctors felt there was nothing to lose by cauterizing the edges with a laser beam. The intense ruby flashes, though mildly painful, were a truly beautiful shade. The fungus died, along with all but the peripheral vision, and for the past twenty-five years I have been legally blind in my left eye.

Adversity being the mother of opportunity, the eye problem sent me spinning into new experiences. I'm left-handed, so I had always assumed that I was also left-eyed, and had thrown that way and sighted that way. When that eye went, I had to become right-handed for anything requiring aiming. Not long after the surgery, I was at Jon Goldsmith's farmhouse. He and his partner, Kelly, had a dartboard, and I was pressed into a game. I was always useless at throwing darts. Put a projectile in my hand and it would be inadvisable to

remain in the room. At Jon's I aimed with the right eye and threw with my right hand. Bingo. Right on target. Suddenly I was an unembarrassing, if unimpressive, dart player. After forty-two years on this planet, I learned something very basic about myself: my right eye is the dominant one. Good thing I wasn't born into a hunter-gatherer society!

Shortly after that, I was talking with a friend who owns a music store in Toronto. He asked me how my eye was doing. I told him about the dart game. "Ah," he said, "you should come out to the range with me sometime and see how you do with a handgun." That was a surprise. I hadn't known it, but he was involved in competitive target shooting. I had never fired anything one-handed but an air pistol. I had a nice German piece that I would occasionally use for amusement, shooting out of hotel room windows at passing garbage trucks.

Back in 1970, when Kitty and I first started road camping, I bought a 20-gauge over-and-under shotgun. I was unreasonably afraid of bears, rabies, and biker packs. That gun travelled around with us but rarely left its case. When we moved to our country house, in 1974, I used to blast tin cans in a little gravel pit at the back of the property. I achieved a very low kill ratio. Wrong eye. Who knew?

But now, at a pistol club in Toronto, festooned with earmuffs and safety glasses, I was able to put holes in the appropriate parts of a torso-shaped target with my friend's .38 Smith & Wesson and 9mm Browning. Exciting! I went shooting a few more times, then went deep. I applied for, and received, a government permit to own a firearm. I joined a gun club north of the city that had a lot of space and numerous well-maintained ranges, then enrolled in a training course under the auspices of the International Practical Shooting Confederation (IPSC).

Practical shooting, as a sport, grew out of a perceived need to provide civilian shooters with defensive handgun skills. It's target shooting, but it's also playing out half of a gunfight—that is, you run through a course of fire, engaging targets as if in a real confrontation, but nobody is shooting at *you*.

Over the years since it began, practical shooting has become some-what less practical, with less emphasis on realistic training and more on refinements of equipment (holsters you could never wear on the street, for instance) and excelling at the *game*. But I still found it a lot of fun, and quite democratic. I was on the line next to people from all walks of life, all sectors of society, all genders and demographics. What we had in common was a love of running around making loud noises and a sense of friendly competition. What we did not share, for the most part, were political views. Most of the shooters I met, many of whom I came to think of as friends, were more conservative than I was, though a few of them were so libertarian it seemed like they'd come full circle to where they merged with the anarchist left.

My involvement in shooting peaked in the early nineties, when I took a long break from performing and could spend many hours working out with my Colt 1911 .45, or the Glock .40 I picked up as a second pistol, or my Remington pump-action 12-gauge, or sometimes with my Hungarian AK.

The AK was semiautomatic. In the United States there are certain people who can legally own full-auto weapons. In Canada there's no such option, though I would have exercised it if there were. Some-times I'd fire hundreds of rounds in a practice session, so I learned to make my own ammunition by reloading spent shells.

I did get to shoot a machine gun once. In the late nineties I was dating a woman named Sally Sweetland, who lived in Vermont. She expressed curiosity about my admittedly controversial pastime. Dur-ing one of her visits to Toronto, I took her to the club. No one was there. It was midwinter, snow everywhere, crisp and beautiful.

I started Sally out on an old Russian SKS, a rifle used extensively by the Soviets during World War II and largely replaced during the early fifties by Kalashnikovs—AK-47s. We were cranking off rounds when four SUVs with police markings streamed into the parking lot, kicking up loose gravel and snow. A dozen large, dark-uniformed, and conspicuously armed men got out and began to approach. The breath that hung in little cloudy puffs around their

334 ⊛ *Bruce Cockburn*

heads gleamed in the low winter sun. My heart jumped for a moment—no matter how innocent you are, standing there with a gun when the cops show up somehow brings out guilt—until I realized that this was the local tactical squad. I recognized the leader, Casey, who was a board member of the club and was bringing his officers in to train. We were in their way—they wanted to use the range that Sally and I were on.

Very politely, Casey asked us if we wouldn't mind shooting on a different range so they could practice with their short-barreled MP5s, little 9mm submachine guns preferred by many Special Ops units and SWAT teams. The MP5 is one of the most widely used machine guns in the world. (The logo of the infamous West German terrorist Red Army Faction featured an MP5 superimposed over a red star.)

"If you're still here in an hour," Casey said, "come on back and you can try our stuff." We did. They demonstrated some techniques and ran us through their training routine. It was, as we used to say, a gas. There was virtually no recoil, but the muzzle climb took some getting used to. When any gun goes off, the muzzle wants to go up. When you shoot one shot at a time, the muzzle rises and then gravity brings it down. When the rounds are coming out at a rate of nine hundred per minute, the muzzle wants to keep climbing. You have to be aware and forcibly hold it on target.

I appreciated sharing the range with Casey and his crew because, in a small way, it made me feel we were comrades. Coming of age in the sixties inevitably meant harbouring a deep (and, I think, well-founded) mistrust of authority in all its manifestations, including law enforcement. Later I "mellowed" and told myself that cops are just humans with a particular job to do, though I didn't find myself hanging out socially in their company. When I took up shooting I met a lot of them at matches, which was new, but we didn't often travel in the same circles (except at security checkpoints).

At the range, though, we were equals, and we treated each other with respect despite our disparate sociopolitical backgrounds. In this way shooting became an important part of my education. I was the

leftie "rock star" with earrings and punkish hair, seen on the news supporting gay-marriage rights and Central American refugees. They, and much of the shooting community in general, were inclined toward law and order, crew cuts, and valorously manly self-images. We'd razz each other about whatever might have been in the news that day, but we ended up genuinely liking each other, which was a welcome novelty for me. The bridge was guns, but it wouldn't have had to be. In most cases, all it takes to engage in open-minded interaction is willingness combined with an opportunity. Previously, I'd scan the political scene and wonder, "Where are all the honourable conservatives? There must be some, right? Holding conservative views doesn't make you a rat." But all I saw on TV were rats in suits. So where are they? I found them at the gun club.

The most significant match I participated in was IPSC's North American Practical Shooting Championships, in 1995, when I finished more or less in the middle of some three hundred shooters. That may not sound like much, but I was up against U.S. Border Patrol agents and people of that calibre. One shooter on my squad was a policeman from Brazil whose job was to chase down and kill kidnappers. I felt pretty good about my performance.

People who don't like the idea of using guns for sport should still want their police forces to take up practical shooting. The Border Patrol officers regularly train in pistol combat because they often confront virtual armies that are well equipped and well funded with drug money. But few municipal cops train this way, though it's the repetitive training that allows an officer to employ a fast and accurate response to armed attackers and, more important, to avoid mistakes.

Policemen and -women have a hard and largely thankless job to do. Most of them try their damnedest to do it well. Their frequent lack of practical shooting experience, though, is evident on the streets. In the early nineties, while I was in Los Angeles recording, a woman commandeered a city bus and took its passengers hostage. She stopped the bus in the middle of a major intersection and released the passengers after killing one of them, then sat there for hours with a .357

revolver and plenty of time. Local TV covered it as if it were a golf tournament, with "live on the scene" reporters appearing periodically to update us on the rather static event, voices lowered as if they were afraid of being overheard. The LAPD tried to wait her out for a while, but as rush hour neared they wanted their intersection back, so they boarded the bus and blasted away with their MP5s. (A cynic might say they were waiting until they could appear live on the five o'clock news.) They fired at least thirty-five rounds, *three* of which were recovered from the woman, now deceased. No one else was hit, but where did all those other bullets go?

In August 2012, passersby in Manhattan didn't fare as well. A man named Jeffrey Johnson killed a former colleague, Steven Ercolino, in front of the Empire State Building, shooting him five times. Two of New York's finest confronted Johnson, and when he pointed a gun at them from just a few feet away, the cops unleashed a fusillade, killing Johnson and wounding *nine bystanders*. (The *New York Times* website offers a sixteen-second security-camera video of the shooting, preceded by a thirty-second ad for Mercedes Benz or fancy watches. What's interesting is that Johnson had the drop on the officers and could have easily killed them both, but he never fired a shot. Suicide by cop, one assumes.) Examples of police ineptitude, even malfeasance, when it comes to guns are not hard to find.

As a kid I was fascinated with weapons, but as a young adult I bore the same knee-jerk disdain for firearms that all my friends and peers did. I was against handguns. Whatever the fashionable political rhetoric was, I just bought it, because I didn't think about it. In a way I had ignored my own instincts, my curiosity. It sparked back to life in Nicaragua when the soldier tossed me his Kalashnikov, but histoplasmosis is really what put the gun in my hand.

My newfound enjoyment of firearms caused some consternation among my friends. *Guns are inherently evil. What about the carnage? What about your leftist cred?* I'm no fan of so-called special-interest lobby groups such as the National Rifle Association, which seems to me to be little more than a shill for gun manufacturers, but

I do believe that responsible citizens of a democracy should enjoy the right to bear arms.

It's important to examine the context in which guns appear. Some countries, such as the United States, have both high rates of gun ownership and high rates of gun killings. And let's bear in mind that most of the statistics on this issue include deaths by suicide, which I think distort the numbers and are a different issue, tragic as they are. At this writing the United States leads all nations with a gun owner-ship rate of 88.8 firearms per 100 residents: almost one per person. The United States also suffers a high rate of annual gun deaths, 10.20 per 100,000 residents, according to U.N. statistics. In contrast, Canada has 30.8 guns per 100 residents (the thirteenth-highest rate in the world), and we annually lose 2.13 people per 100,000 to gun violence. Whereas that's 2.13 per 100,000 too many, Canada has a lot of guns but a much lower rate of gun deaths than the States.

The analogy deepens. Look at poor Jamaica: 47.44 firearm-related deaths per 100,000, but only 8.1 firearms per 100 people. Conversely, Germany has 30.3 guns per 100 people, much like Canada, but an annual gun death rate of 1.10.

Guns are inherently dangerous, and the consequences of their misuse are devastating. Like many inventions (the TV remote, the Internet, the shovel), guns were invented to do a certain job, in this case to take life from a distance. Should we regulate guns because they are dangerous? Absolutely. Should guns be banned because they are dangerous? I don't think so. By that line of thinking we should ban the internal combustion engine, which kills far more people in developed countries than guns do (though the United States is trying hard to close the gap), and that's just from automobile collisions. Deaths from cars' environmental effects are much higher, as illus-trated by a 2010 *Lancet* study showing that more than two million people die from car pollution every year in China. Coal-fired power plants kill millions of people worldwide every year and saturate the globe with heavy metals such as mercury. (Shooting a gun also puts mercury into the air, but in insignificant quantities, unless you're

spending a lot of time in a poorly ventilated indoor range.)

In his 2002 film *Bowling for Columbine,* Michael Moore may have provided a partial explanation for the otherwise inexplicable gun violence in the United States: a nation saturated in officially sanctioned violence is likely to see the unofficial violence trickle down proportionally into the general population. He argues that the United States was established through violence: the genocidal treatment of Native Americans and the theft of their lands, the importation and brutalizing of slaves (including many Native Americans), and two wars with the British. Next came Manifest Destiny and the Monroe Doctrine, militarily backed legal fictions intended to justify stealing land and riches. The American Civil War appears to have stimulated the invention of the repeating rifle, among other weapons (although the Austrian army was using repeating air rifles as early as 1795), and established a milestone for carnage in modern warfare. Since then the United States has pursued a pattern of seemingly ceaseless wars around the globe, which continues to this day and has chalked up a death toll into the tens of millions.

The United States is hardly alone in finding warfare expedient, even attractive. Pretty much every country in the Western Hemisphere except Canada has a similar history. The capacity for war appears to have been with us bipeds since our poorly remembered inception.

There was good reason for the founders of the United States to create the Second Amendment to their Constitution. They understood that a complacent, poorly prepared population is an invitation to tyranny. In the context of the time in which it was written, the Second Amendment was appropriate as a defense against totalitarianism and the threat of foreign takeover. The founders could not have foreseen the coming pressure-cooker society that regularly defecates enraged and chewed-up bits of itself, bitter and embattled souls who feel they have to vent their spleen on the rest of us.

These days you can't outgun the authorities; they will always possess more and heavier weapons. Now it's about information. An armed response to government oppression is not effective, except as an

attention-getter. The thing that scares totalitarians most is people knowing the truth; otherwise, they wouldn't go to such lengths to keep it from us. Even so, in a democracy, the police and military should not be the only ones who are allowed to bear arms. A best-case scenario might be if nobody were armed. But if one sector of society can have guns, then all should be able to.

In large part, however, the gun-control debate, as fraught with urgency and passion as it is, is a distraction from broader issues such as social justice or its absence, exploitation, and the degradation of the environment. These problems are complicated by the presence of weapons, and that needs to be addressed, but gun control is hardly the biggest challenge we face.

For me, taking up shooting was timely, and it circumstantially filled a void: I got into the sport around the same time that I fell into a writing dry spell. The way I have always produced songs is to write down lyric ideas as they come to me. But in mid-1988 I noticed that I was waiting fruitlessly for words to arrive. I found myself in a creative limbo that lasted until the end of 1989. For eighteen months, from the time we recorded *Big Circumstance* in July and August 1988, no good ideas went down on paper—my longest hiatus since I started writing songs in 1965. I wrote in my notebook from time to time, but nothing useful came to me. A year went by. No songs appeared.

I started to wonder: Is it all over? Is this the end of my life in music? Some things simply run their course and peter out, and maybe the muse had just up and left. My notes from that time say, "Tired of music biz. What do I want? Outdoors: kayak, horses, open space, mountain, prairie, simplicity. I want time. Too stressed out." I wondered: Should I report for reeducation, learn to do something else? I thought about art school. I always liked the idea of creating graphic novels. I decided that before I did anything too drastic, I would declare myself on sabbatical, "take a little time for myself." On the grounds

that I might just be suffering from burnout, I thought I should step away from things for a bit and see what happened. For me, 1990 would be the year of detachment.

With the turning dial of the year beginning to creep toward Christmas, and the creative dry spell remaining solidly in place, I began to feel that, for the first time, I should spend the holiday season away from extended family. For most of my life, especially as a kid, Christmas was a point in the year that I always looked forward to, a pivotal event around which the rest of the year moved. But from the early eighties on, with the divorce, the joy of the season was eroded by the annual need to negotiate where, with whom, and for how long Jenny would spend the holiday. The stress of that grind put a damper on the season. This feeling decreased with time, and as she grew older Jenny had her own ideas on the issue, but Christmas never quite recovered.

Earlier in 1989 I had started dating a woman named Jennifer Morton. I was already well into riding lessons, and it turned out that Jennifer had some experience with horses. Something put it in my head that she and Jenny and I should escape to Arizona, to a dude ranch, and see what Christmas in the desert was like.

My two Jenns and I spent a week and a half at Tanque Verde Ranch near Tucson, at the edge of Saguaro National Park—a dramatic setting comprising nearly a hundred thousand acres of wild, rugged, spiky upper Sonoran desert. The quality of the air, the light, the almost ceaseless wind, the towering saguaro cacti, and the quiet were spectacular. It was the perfect linchpin on which to hang a year of regrouping. Every day we rode horses into the ranch's adjacent wildlands. Here was a landscape that asked nothing of me but to appreciate it, which I did, soaking it in. The broad sky, the vistas rendered razor sharp by the dryness of the air, the smell of horse sweat, and the creak of saddle leather were a balm to the soul. I went out after dark with a handheld night vision scope. Didn't see a damn thing— only the pale greenish shapes of Jenn and Jenn, out among the ghosts of looming saguaros, mesquite, creosote bush, coachwhip, soaptree

yucca, and jumping cholla, vegetation all heavily defended with spikes, thorns, bristles, and hooks of every size and shape. This is why cowboys wear chaps.

I was thankful to be there, and I found myself mentioning that to God. In that moment my perspective on the world and how I fit in it began to recover from the battering I'd given it over the preceding few years. Be in it but not of it, or, as it says in Romans, "Do not be conformed to this world, but be transformed by the renewing of your mind, that you may prove what *is* that good and acceptable and perfect will of God." These are tall orders, for we *are* of it. We were made that way, devised and constructed to be in it *and* of it. If you're not in your body, how are you going to hear the whisper of the Divine, the visceral nudge we call a hunch? How else but through the deepest feelings can we convince our literal and fashion-bound minds to receive these boundless truths?

To get a bit of relief from the harsh beauty, we forayed into Tucson. Daughter Jenn got her ears pierced, and I had a new hole punched in my left ear, to go with the two in the right. In the afternoon glare a man approached us out of the black shade of an alley. He had an old army musette bag over one shoulder, from which he produced a .357 Magnum revolver.

"Want to buy it?"

"No thanks," I said. "I don't know where it's been."

That night, elbows braced, we stomped around the mosh pit while a punk band performed in a club whose stage was an open loading dock. Freight trains passed, groaning and roaring, five feet behind the drummer. If it had been any other music it would have been a disaster, but the sounds and imagery went together well. The single song I can recall now had only one line, repeated over and over: "fuck you fuck you fuck you fuck you."

A few days after arriving in Arizona, on Christmas Eve 1989, in the driest place I had ever been, my dry spell came to an end. I wrote a song. Somehow just knowing there was nowhere I had to be had cleared the psychic landscape sufficiently for words to return. "Child

of the Wind" is the song of a nomad, a magpie spirit enamored of shiny simple things, inclined, and fated, to keep moving: toward discovery, toward understanding, toward God, and definitely toward the next gig. The song celebrates landscape and power, nature and human connections, but most of all it honours the mystery.

The next morning, Christmas, I awoke to a beautiful surprise: snow. Big, fat flakes the size of silver dollars floated downward across the landscape, settling on bushes and rocks for just a moment before vanishing into nothing, not even forming drops of moisture. I woke up my gals. We walked to breakfast with snow coating our hats. For an hour or two the snow kept coming. Here was a gift, a White Light—of human connection, of the earth, of God—arcing at us from every frozen facet.

In the year that followed, I wrote more than a dozen songs, most of them showing up on my 1991 album *Nothing but a Burning Light*, the first of two records I made with legendary producer T Bone Burnett. Again, in a weirdly decadal fashion, my life was about to drastically change, driven by a singular constant: heavenly interference with my poor judgment.

*I love the pounding of hooves*
*I love engines that roar*
*I love the wild music of waves on the shore*
*And the spiral perfection of a hawk when it soars*
*Love my sweet woman down to the core*

*There's roads and there's roads*
*And they call, can't you hear it?*
*Roads of the earth*
*And roads of the spirit*
*The best roads of all*
*Are the ones that aren't certain*
*One of those is where you'll find me*
*Till they drop the big curtain*

*Hear the wind moan*
*In the bright diamond sky*
*These mountains are waiting*
*Brown-green and dry*
*I'm too old for the term*
*But I'll use it anyway*
*I'll be a child of the wind*
*Till the end of my days*

*Little round planet*
*In a big universe*
*Sometimes it looks blessed*
*Sometimes it looks cursed*
*Depends on what you look at obviously*
*But even more it depends on the way that you see*

*Hear the wind moan*
*In the bright diamond sky*
*These mountains are waiting*
*Brown-green and dry*
*I'm too old for the term*
*But I'll use it anyway*
*I'll be a child of the wind*
*Till the end of my days*

"CHILD OF THE WIND," 1989

# 17

Early in 1990, with Jenny approaching the age of fourteen, I got a phone call from Kitty. She was worried. The two of them were in a pattern of dispute that, a few times, Jenn had punctuated by running away from home—not for long periods, just a day or two at a time, but long enough to allow the imagination to go where you'd rather it didn't. Jenny would vanish into the downtown street scene, sleeping in squats, hanging out with an assortment of homeless young people. Some of them, like her, were kids with homes whose teen frustration and sense of adventure drove them to try out life on the street. Others were escapees from disastrous, abusive backgrounds that left them little choice but to be where they were. It was a dangerous, violent milieu.

In a weird way, I was proud of Jenny. That did not diminish the worry, or make Kitty's life any easier, but I admired her willingness to take risks, and I prayed that she would know when to back off. Her panhandler friends were tough, or aspired to be. Some played in punk bands; others were self-professed Nazi skinheads whom Jenny was convinced she could convert from their racist delusions. She liked hanging out with this crowd. Collectively, they were nearly as covered with spikes as the Arizona desert. Sometimes I'd run into her on Queen Street, panhandling in front of the Much Music building. I think I was supposed to be embarrassed by that, but I enjoyed the

cheekiness of it. The running away, though, was disturbing.

The disagreements, as far as I know, were mostly the typical teen apron string–cutting kind, albeit atypically expressed. The intensity of emotion between Jenny and her mother was wonderful when they were on the same side. Otherwise, volatility reigned. The stories that Jenny brought home were full of anarchic violence, actual or pending: kids getting their heads kicked in when squabbling over PCP or a lover, creeps harassing panhandling girls. One time she said, "Hey, Dad, you interested in buying grenades? There's a biker in Kensington Market selling them for fifty bucks each." The more we learned about some of her friends, the more frightening it was when she would disappear.

Kitty's call sent me searching for my daughter through the night streets of Toronto as if I were *Taxi Driver*'s Travis Bickle, garish Chinatown neon reflections slithering over the windshield of the battleship grey Suburban I was driving at the time. I had no idea what I would be up against if I found her in a tight spot. I prepared for any eventuality, but on the two or three occasions this happened, I never found her. I prayed she would turn up alive and well, and she always did.

In the midst of this teenage chaos, I had parted ways with Jennifer Morton. Our respective outlooks and intentions were markedly different. She wanted us to buy a house together, start a family. She had a fully developed vision, notwithstanding the short duration of the time we'd been together, of a future in which I couldn't recognize myself. I didn't relate to babies. I had survived the breakup of two long-term relationships. I dated little as a youth. I was looking for more casual companionship. Between Judy and Jennifer, I had kept company with a few different women for short periods. They were smart and attractive, fun in the moment. I was not thinking of settling down with anyone but was exploring, learning. A few things I learned: There is no such thing as casual sex. One partner is likely to want something more or different than the other, or to fall in love when the other doesn't. There are always tears. With Jennifer, I

learned what it felt like to be the one who pulled the plug. That experience gave me empathy with my two former long-term partners.

One day in the course of a riding lesson, my instructor at the time, Sue Franklin, asked me what was wrong. She could see my sadness, and I told her what had happened with Jennifer. We went to dinner and found common interests beyond horses, and in common a desire to replace lost partners. Mutual loneliness and mutual opportunism pushed us together. On my part, it was clearly time to reestablish contact with the land. Before the date with Sue, I'd begun looking for a house to rent in the country. I was not interested in taking on the burdens of a landowner. I wanted privacy and breathing space. I wanted to be surrounded by sounds other than those of the cityscape. Sue, as it turned out, wanted to establish a horse farm. That wasn't the direction I had seen myself going in, but it seemed a close enough fit with my aspirations that soon we became unlikely partners, both in intimacy and in attempting to raise and train show horses.

Sue was a top-level competitor in the jumper ring, but she didn't have the horse to match her skills. Her idea was to find a place with a barn, buy young horses, and train them. Once she had a shining example of equestrian prowess, she would sell it for a tidy profit, basically financing her expensive horse habit.

We found a forty-eight-acre farm in Halton Hills, north of Milton, Ontario, an hour west of Toronto. The frame house was old, painted white, and separated from a busy two-lane highway by a wide lawn on which stood a single weeping willow tree. Twenty yards behind the lawn, the land sloped sharply to form a large open field with a hedgerow of wild vegetation and a small island of brush surrounding a tall pine in the centre. That made up most of the acreage. A skyline of Godzilla-scale hydroelectric towers marched across the property immediately to the south.

A gravel laneway led from the road, past the house, and down the hill to a grey steel building that housed stalls for a dozen horses. We leased the property from a pair of brothers from what was then still Yugoslavia, who had bought the land for investment to sell it down

the line and make serious money. (Which I guess they did. The place is now a housing development.) They were the sort of hands-off landlords that I've always preferred.

We started off with five animals of our own. The remaining stalls we filled with boarders (horses, that is). Before long we had a boarder of a different sort. By summer, Jenny had become anxious to free herself from the street-kid scene. She had witnessed too many beatings and saw her number coming up anytime. She needed out of the city. The rural setting would offer a healthy distance from the enticements of downtown. She moved in not long after we did.

This created a certain pressure. Sue did not see herself as a mother. On her scale of enthusiasm, housing a troubled teenager—especially one who would compete for my attention—ranked somewhere between a neighbour's vacation slide show and a root canal. She understood the urgency of the situation, though, and my responsibility as a father. She gave it her best shot. Up to a point she could communicate well with Jenny, who enjoyed the horses and showed a modest enthusiasm for the sport.

Sue was a tense and highly competitive person. Toughness and fragility commingled in the mindscape of a nearly perfect misanthrope. She was a top-notch trainer and rider who, with the right horse, could have competed in show jumping at the World Cup level. Of course, we never had the half-million dollars or the extreme good luck to get a horse that could win at such a level. Our horses were far less costly, but a not-so-expensive horse—say, a one-year-old with the bloodlines to make it a good prospect—still might run ten grand. We went through many of these lesser steeds, but none had talent enough to compete at high levels. One that might have been a winner slipped and broke its ankle while training at another facility.

We put in a sand ring across the laneway from the house, which ate up some money, but far less than would have gone into building an indoor arena. The trade-off was that we couldn't use it during the winter. Sue gave riding lessons on the side. We took in boarders (horses, that is), which slightly mitigated the cost of feed, veterinary

services, blacksmithing, show entry fees, and transportation. The horses that sold barely fetched a price equal to the cost of getting them ready. The tap was open, and the money flowed freely into the muck behind the barn. As the months, and years, wore on, and the cash drained unrestrained into our equine affliction, this particular tension became grave. Sue had seen me as the rock star with Scrooge McDuck's money bath to draw from. I was doing all right, but I couldn't sustain the outlay needed to maintain a horse habit at the level she would have liked.

Like most relationships, ours began in hope. Though I was closer to Toronto than I had wanted to be, I was getting at least a semblance of the proximity to nature I had sought. Sue was getting an opportunity to build her horse business. It seemed we were pushing in the same direction. There *were* some strong threads of compatibility, as well as a rush of newness in the horse shows and shooting competitions, my sabbatical, and our joint assumption that all this added up to love. Predictably (or at least it should have been), these thin threads became frayed as the years passed. Until then, though, it was easy to miss the deeper differences that actually defined our relationship. Early on I found our life together enjoyable, and there were times when I even felt—to use a word that rarely shows up in my lexicon—happy.

*Evening sun slants across the road*
*Painting everything with gold*
*I'm headed for home, got a woman there*
*I can barely wait to hold*
*Got wind in my hair, got the heat inside*
*Heart jumping up and down*
*An empty head and a messed-up bed*
*I'll be floating just above the ground*

*Great big love*
*Sweeping across the sky*

*Seen a lot of things in the world outside*
*Some bad but some good stuff too*
*Felt the touch of love in the works of God*
*And now and then in what people do*
*Never had a lot of faith in human beings*
*But sometimes we manage to shine*
*Like a light on a hill beaming out to space*
*From somewhere hard to find*

*Great big love*
*Sweeping across the sky*

*I ride and I shoot and I play guitar*
*And I like my life just fine*
*If you try to take one of these things from me*
*Then you're no friend of mine*
*Got a woman I love and she loves me*
*And we live on a piece of land*
*I never know quite how to measure these things*
*But I guess I'm a happy man*

"GREAT BIG LOVE," 1990

Ironically, our compatibility did not extend to music. I'd walk into the house and Sue would have Journey or Bon Jovi blaring from the stereo. Or "Stairway to Heaven," played continually to meet her obsessive need for immersive stimuli. She'd spin the same song over and over, ten or a dozen times, sometimes for days, until she got from it whatever was needed. On the other side of things, after waking at five in the morning to work for several hours with the horses, Sue would come in and find me in the living room on the hand-me-down exercise bike my dad had given me, drowning out its roar with Eric Dolphy or Nine Inch Nails. The mutual accommodation carried within it a mutual attrition.

There was a genuine curiosity on my part about the world of

horses, and on Sue's part to live the dream of owning a horse farm and a champion steed. We held a genuine affection for each other, but we never could reach that deeper love that might have bound us.

Now and again, perhaps subliminally aware of that missing element, Sue would wonder out loud when I was going to produce the impassioned, romantic piece that songwriters necessarily pen for their sweethearts. I don't write on command. Not well. Nor was I, the emotionally cloistered chameleon, feeling the charge necessary to come up with such a song. Being the gifted trainer she was, though, Sue knew how to cajole. And I wanted to please her. I gave it a lot of thought, and eventually wrote "One of the Best Ones." It's a song about God's many gifts, a loving relationship being one of the best ones. I was pretty satisfied with the way it turned out.

The song was not well received. Sue said, "*One* of the best ones? What kind of shit is that, '*one* of the best ones'?" She wasn't thinking about God; in her mind, I was depicting her as some sort of favourite in my stable of women. Of course, there was no stable. Eventually she came to understand the universality of the lyrics, just as she understood that the song did not express what she hoped to hear. Every now and then, she'd bring it up as a dig: "Oh yeah, that must be one of the best ones."

*Guess I'd get along without you*
*If I had no choice*
*It's taken me this long to find you*

*Done a lot of getting ready for this*
*Some things we learn so slow*
*But look at you, you've got plenty behind you*

*There's lots of ways to hit the ground*
*Not many answers to be found*
*We're faced with mysteries profound*
*And this is one of the best ones*

*There are eight million mysteries*
*In the naked body*
*Can't even sight on some distant horizon*

*Like the nine billion names of God*
*Don't bring you any closer*
*To anyone you can simply set eyes on*

*But in the same way it's as real*
*Don't always recognize what I feel*
*But of the dancing scenes that life reveals*
*This is one of the best ones*

*Say what you will*
*There's no snake oil or pill*
*Can make love less painful or fine*
*There's no theatre*
*Even of the absurd*
*Can express what goes on in this meeting of hearts and minds*

*Guess I'd get along without you*
*If I had no choice*
*But please never make it so I have to*

*Paid a lot of dues to get here*
*And after all this life*
*I'm a loser if I don't live with you*

*There's lots of ways to hit the ground*
*Not many answers to be found*
*We're faced with mysteries profound*
*And this is one of the best ones*

**"ONE OF THE BEST ONES," 1990**

I worked hard at the farm and sweated out some stress. Learning to relate to the giant beasts, riding, jumping, competing, mucking out stalls and saddle-soaping leather, blasting holes in targets at the shooting range—it was a pretty good life, and the taut-line of tensions I'd accrued through the eighties began to slacken. Once Jenny arrived, the interpersonal angst escalated—not due to anything Jenny did or didn't do, though I found I had a very limited tolerance for adolescent sass. The three of us simply weren't a good fit, especially since Sue and I weren't such a good fit in the first place.

Jenny went to school in nearby Milton. She was the only punk at the school and quickly acquired as a boyfriend the only skinhead in town. The boy had come by his bigotry honestly, directly from his parents. In other respects, he was a decent kid. Jenny actually succeeded in weaning him away from his racist views, and he became as reasonable a person as a teenage male is likely to be. They lasted a year. By then, Jenny had had enough of Sue and me and the farm. She moved back to Toronto and in due course got her own apartment, sharing it with a twentysomething man who was the subject of a Canada-wide arrest warrant. He had walked away from his halfway house with six months left to serve of a five-year sentence for armed robbery. Though not well endowed with judgment, he wasn't a bad guy. He was very protective of Jenny, except when crazed on PCP. He was imposingly large and muscular, so I didn't worry about my daughter's physical safety when they were hanging around the street. Nobody would mess with him.

One day I suggested to Jenny that she might like practical shooting. We went to the gun club. I put up some targets, gave her the safety demonstration, and set her up with a Yaqui Slide holster and my Colt 1911 .45. She gave me a look that said, "Well, what do I do with this?" She had just seen *Reservoir Dogs*, so I said, "Just do what you've seen them do in the Quentin Tarantino movies." She did. Jenny was surprisingly fast and accurate with the pistol *and* my short-barreled Remington 870 shotgun. She was a natural shooter who could have been competitive had she pursued it. She enjoyed

herself, but for some reason we never again went out shooting.

Not long after returning to Toronto, Jenny landed provincial funding and enrolled in an alternative school. She told me she was going to graduate. I made encouraging noises, but I didn't let myself count on it, given what I'd seen. Not only did she dedicate herself to a radically independent program of study—meeting with a teacher once a week in a café—but she applied to and was accepted at Concordia University in Montreal to study anthropology. I remained skeptical—needlessly, as it turned out, because after she graduated from Concordia, Jenny earned a master's degree, at the same time building a life for herself in Montreal with a new man and having a baby. In 2013 she completed a Ph.D. program, little more than a year after giving birth to her third child. Today she's a woman of great energy with a deep capacity for compassion and love. She is still edgy, and wise. I'm very proud of her.

That first year at the horse farm was also my first, and only, extended break from the music scene since I had started performing in the sixties. Before leaving for the Arizona dude ranch, I had announced to Bernie, and everybody else who might be affected by it, that I was going on sabbatical beginning in the New Year. As 1990 rolled along, I declined dozens of performing opportunities as well as invitations from various NGOs to travel, including a trip to survey the destruction of the Borneo rain forest and another to Russia, just after the Soviet Union crumbled, to meet Russian artists and travel along the Volga River on some sort of music barge. I said no to all this, no matter how tempting, because I needed my year off. It worked. Beginning with "Child of the Wind," the creative current swelled to its original strength. I wrote a lot of songs that year.

I made a particular choice in approaching the new compositions. I still started with the lyrics, at least partly developed, moving to the guitar to create an atmospheric field for the words to exist in. The melody came out of that. With the exception of a few eighties songs in which the guitar parts were kept small to allow room for keyboards and other sounds, my instrumental elements have been fairly com-

plex. This time, I made a point of trying to create songs that would still sound intact and musical without depending on the intricacies of the guitar parts written into the songs. The idea was to make the tunes accessible to hobby guitar players who might want to play them. That became a guiding principle through the next two albums: simpler song structures that were not contingent on my not-so-simple way with the guitar.

Somewhere in the fray, our old friend Donnie Ienner ascended to the presidency of Columbia Records. In late 1990 Bernie, through his acquaintance with Donnie (and possibly his ability to beat him at poker), landed me a distribution agreement with Columbia Records for the world outside Canada. It was a pretty good deal. Columbia insisted that the next record be recorded in the United States with a high-profile American producer. I had never recorded outside Toronto. It was time for my horizons to expand.

After some kibitzing between me, Bernie and Ienner, and Columbia A&R man Steve Berkowitz, I met with two candidates who had expressed interest in the project. The first was Scott Litt, producer for the band R.E.M., who liked my music. Scott was a good candidate and probably would have worked out well, but I wanted to meet the other prospect before making a choice; some intuition whispered that I ought to keep looking.

The other producer whose name had been on everyone's list was T Bone Burnett. Even at that time, before the massive success of the 2000 soundtrack album *O Brother Where Art Thou* and his music direction for the 2012 box-office blockbuster *The Hunger Games*, T Bone was an industry icon. Prior to our meeting, he had produced pioneering albums by Elvis Costello, Los Lobos, Roy Orbison, and Sam Phillips, his wife at the time. Earlier in his career, T Bone had excelled as a talented session player and touring guitarist, with standout performances as a sideman in Bob Dylan's Rolling Thunder Revue. I had known of him in the seventies as a member of the quirky, writing-heavy Rolling Thunder spin-off called the Alpha Band.

We first met in a somewhat sterile conference room in the looming

black Manhattan office building that houses Columbia Records. A finely tailored black suit draped his imposingly tall frame. T Bone spoke with Texan courtliness but projected a clear assumption that he was in command of his environment. He had about him an intriguing intensity and a penetrating intelligence, along with the faintest whiff of a cruel streak held in check by moral resolve. He'd listened closely to the demo we had sent him, and his comments reflected the wisdom of a seasoned professional, someone with an ear for detail and a deep knowledge of how music is made, especially in the studio.

T Bone Burnett comes with a large pool of highly skilled players from which he can draw, especially in the roots idiom. As we talked, I got the feeling that I was standing on the shore of a new country waiting to be explored. We had found our producer.

Our second meeting was a brainstorming session at a hotel in Los Angeles in advance of heading into the studio to begin making what would become my sixteenth studio album, *Nothing but a Burning Light*. T Bone suggested a possible cast of players. The list of names set me to laughing with delight and a slight sense of disbelief. T. Bone said, "We could get Ringo to play drums."

"Ringo *Starr*?"

"Sure."

Ringo turned out to be unavailable, but the next suggestion was even better: Jim Keltner, "the leading session drummer in America," in the words of Bob Dylan biographer Howard Sounes. Keltner had recorded with three of the former Beatles: John, George, and, interestingly, Ringo. (Among their collaborations: Ringo and Keltner were the drummers at the 1971 Concert for Bangladesh.) An idiosyncratic and very musical player, Keltner had contributed to many of the best records made in the preceding couple of decades. We asked him and he said yes, but T Bone felt that we would want something different for a couple of the songs, which called for a more rigid, metronomic style than Keltner's. After some searching, he came up with a dynamic young rock drummer by the name of Denny Fongheiser.

Bassist Michael Been, fresh from his notable success with his band

the Call, rounded out the rhythm section. (Been died of a massive heart attack in 2010. He was sixty years old.) In addition to Michael's electric bass, we got Edgar Meyer on upright acoustic. He is a supremely talented classical bassist from Nashville who appears as a soloist with major symphonies all over the world. He has played with Béla Fleck, Yo-Yo Ma, James Taylor, Alison Krauss, and T Bone himself. Edgar's chunky rhythm part moves under "A Dream Like Mine" like a shifting tectonic plate, pushing the whole track before it. He's a perfectionist. Once we spent most of a day fixing one of his bass parts. It sounded good to me the first time, but he kept hearing flaws in the rhythmic placement of some notes: "Oh no, that note's out of sync." So he'd return to the studio, where the engineer would ask him to play along so he could punch in the replacement note. This was before the sleight of hand of Pro Tools. It was all tape, so it took time. The result: an uplifted and unstoppable groove.

When T Bone produces an album, he likes to pair the artist with a "foil," someone to play off, a presence whose sound complements and also creates a dynamic tension with that of the main player. So that was our next question: Who would be the foil? What other instrument would it be on the album? We decided on organ, and T Bone said, "Let's get Booker T." I was seventeen years old when Booker T. & the M.G.'s released their 1962 hit "Green Onions." That record sent shock waves through the tiny community of teen guitar players I knew. The groove was as deep as Lake Superior, as unstoppable as a train. Steve Cropper's guitar sound had a visceral quality that had never been heard on Ottawa's airwaves.

When we met, Booker told me that he had also been seventeen when that song came out. We were the same age. His ethereally melodic and sensitive playing provided the perfect foil for my sound. Like all the players, he was professional and warm. The respect they showed for my songs touched and honoured me, and in turn pushed me to a new standard, especially with respect to rhythm.

Rounding out the album were appearances by Mark O'Connor on violin; Michael Blair and Ralph Forbes on percussion; a bass part by

Larry Klein on "Mighty Trucks of Midnight"; backing vocals and some guitar work by the legendary singer-songwriter Jackson Browne; and vocals by Sam Phillips, whose music I knew through our mutual friend Dan Russell. It was Sam and T Bone who picked me up at LAX when I dropped into that blue-grey town on a lovely spring day in 1991. Sam was a charming and delightful presence, in and out of the studio.

I had met Jackson in 1986, when the Christic Institute was pursuing a lawsuit against Oliver North and others involved in the Iran-Contra scandal. Iran-Contra is one of those typically massive but little appreciated American scandals that was itself connected to another scandal, the suitcase-bombing of a 1984 press conference hosted by Nicaraguan Contra leader Edén Pastora at his hideout on the Nicaragua–Costa Rica border. Four people, including journalists, were killed, and a number of others were wounded.

Jackson and his then girlfriend, the actress Daryl Hannah, were hosting a benefit party at their house in Santa Monica to raise money for the lawsuit, and I was invited because of the Central American content on *Stealing Fire*. The actor Ed Asner was present, along with Jane Fonda and maybe a dozen other left-leaning Hollywood luminaries. Christic Institute lawyer Danny Sheehan spoke passionately about the cause, as did plaintiffs Tony Avirgan, a reporter who had been badly injured in the bombing, and his wife, fellow journalist Martha Honey.

When Bernie and I rang at the big wooden door, Daryl answered, every bit as attractive as she appeared on screen. I said, "It's great to meet you; I've enjoyed you in so many movies." Then Jackson popped up behind her shoulder. I couldn't give him equivalent praise because I really didn't know his music, but he'd heard me compliment Daryl. It was an awkward moment, which they both graciously ignored. Later I got to know more of Jackson and his music, and developed a deep appreciation for his talent and his heart. During the 1970s he was a leading anti-nuclear activist. In 1979 he cofounded (along with Bonnie Raitt, John Hall, Graham Nash, and Harvey Wasserman) the

anti-nuclear group Musicians United for Safe Energy, which remains active today. Later he became a vocal opponent of the U.S.-backed wars in Central America and expanded his ongoing support for Native American rights.

The next time I met Jackson was in July 1989 at the Pahá Sápa Festival in Rapid City, South Dakota. Jackson co-organized the event, along with the Lakota people of the area, as a fund-raiser for a Native-run radio station and an alcohol treatment program on the Pine Ridge reservation. They also wanted to spotlight Native attempts to regain legal control of sacred lands in the Black Hills, which was originally ceded to the Indians in two government treaties that the United States violated once gold was found in the region. (Pahá Sápa is Lakota for "Black Hills.")

The Pahá Sápa Festival featured an outstanding lineup of artists: Neil Young, Willie Nelson, John Trudell, John Denver, Kris Kristofferson, Floyd Westerman, Buddy Red Bow, Timbuk3, and a number of traditional Native performers. Of course Jackson himself played, along with multi-instrumentalist David Lindley. One of the MCs was Wavy Gravy, who filled the dressing room he and I shared with so much smoldering sage I could hardly breathe. The other MC was Catherine Bach, who happens to be Native American and who was famous for playing the hot babe on *The Dukes of Hazzard* television program. It was at this concert that, for the first and only time, I asked for someone's autograph. My mother was a fan of Willie Nelson, so I lined up with the folks and asked him to sign one of his albums for her. He wrote: "To Lois, Love Willie."

Jackson Browne made that festival happen, and he put on a very strong performance, but he did more than that. The day after the gig, I went to the Native radio station, KILI, for an on-air performance. The studio was crammed with crates of CDs. The manager told me that Jackson had turned up a couple of days earlier in a brand-new SUV loaded with what must have been thousands of records and had given them to the station as a gift. He also left them the vehicle. No fanfare, no PR, no photo op—he just did it and left. He never said a thing about

it to me or to anyone else, as far as I know; I heard the story only because the station staff was fizzing with excitement about it.

After Pahá Sápa, I worked with Jackson a few more times. At the end of 1990, he helped bring my year away from gigs to a close by inviting me to perform at some other events dedicated to progressive causes. In December I played, along with Jackson, Bonnie Raitt, John Trudell, Kris Kristofferson, and others, at a show in Sioux Falls, South Dakota, commemorating the hundredth anniversary of the massacre at Wounded Knee. Also that month, I was part of Jackson's gig in Mesa, Arizona, in support of the Don't Waste Arizona campaign, which was aimed at halting the construction of a toxic waste incinerator.

Jackson also created the annual Verde Valley Music Festival, outside Sedona, Arizona. He organized the event as a benefit for Verde Valley School, a private school his son attended. The school asked him to headline a fund-raiser, but he insisted that it had to be about something more than funding a prep school for rich white kids. The result was a scholarship program for Native American students. Over several years, under the desert sun, I got to play alongside Bonnie Raitt, Neil Young, the Indigo Girls, Lyle Lovett, Shawn Colvin, and of course Jackson himself, among many others. I have played a lot of festivals through the years, but these were among the best.

A fringe benefit of playing the Verde Valley Music Festival was that the school had a fine stable of horses. The first time I went, after a day of air travel, I arrived after 11 P.M. As we were loading my gear into the motel, someone asked me, "You want to go riding?" Half an hour later, I was in the saddle on a pale quarter horse as it picked its way across a moon-washed desert landscape so surreal it could have been the road to heaven.

Jackson might have just called it a road. Of the artists involved in recording *Nothing but a Burning Light*, he was somewhat of an outlier because he was one of the few who did not identify as Christian. He and I mostly talked politics.

With T Bone, things were different. He was drawn to work on the

album at least partly because of the spiritual content of the songs. His casting suggestions suited that side of things. God had maintained a low profile on my eighties albums, though not in my heart, and as I emerged from that decade it seemed time to invite the Divine back into my music. I've already mentioned "One of the Best Ones." It was followed by "Somebody Touched Me," a simple song about a sudden awareness of spirit sneaking up on you. ("I know you're with me / Whatever I go through / Somebody touched me / I know it was you.")

The title *Nothing but a Burning Light* was derived from a line in Blind Willie Johnson's song "Soul of a Man," recorded by him in 1930, which I have loved since I first heard it in the sixties. Sometime during the following decade, I worked out a version of it using a C tuning on the guitar. It doesn't sound much like Blind Willie, but I think it stays true to the spirit of the song. When I went over the list of material with T Bone before recording, he asked if I had anything else I wanted to run by him—older stuff or perhaps a tune by someone else. I had almost never recorded a song I didn't write, but "Soul of a Man" immediately came to mind. It's an intense and soulful piece, a perfect fit for the tenor of the album. "Soul of a Man" also reflected a place I had reached at that time, its basic premise and its reference to travel resonating even more than when I was first captivated by the original recording.

*I've travelled different countries*
*Travelled to the furthest lands*
*Couldn't find nobody could tell me*
*What is the soul of a man. . . .*
*I read the Bible often*
*I try to read it right*
*As far as I can understand*
*It's nothing but a burning light.*

The tune itself was necessarily lean, and we performed it as a trio. I wanted an effect that suggested people playing on the street. I played

my metal-body Dobro, Keltner played drums and a wonderful wash-board, and Michael Been played bass.

The song on *Nothing but a Burning Light* that I most enjoyed writing was "Cry of a Tiny Babe," my attempt to retell the Christmas story in something like modern dress. The Holy Spirit gets Mary pregnant, and of course Joseph is skeptical, suspicious, and hurt; the Magi's visit inadvertently results in the massacre of innocents, and it unfolds like a spaghetti western; the central message of the spirit is freely, but only, available to the humble. I wanted to put recogniz-able flesh on mythic and biblical bones. The Blessed Virgin, for exam-ple, as worshipped in the modern world, bears little resemblance to any Jewish woman I've ever known. (Jesus is looking pretty Anglo these days, too.) It felt good to honour the feminine roots of divinity, an element that has been mostly squeezed out of the narrative. Once you get to the core of the story, you basically have the Goddess giv-ing birth to a Divine being, sending ripples endlessly through time.

*Mary grows a child without the help of a man*
*Joseph gets upset because he doesn't understand*
*Angel comes to Joseph in a powerful dream*
*Says, "God did this and you're part of his scheme"*
*Joseph comes to Mary with his hat in his hand*
*Says, "Forgive me I thought you'd been with some other man"*
*She says, "What if I had been—but I wasn't anyway and guess what*
*I felt the baby kick today"*

*The child is born in the fullness of time*
*Three wise astrologers take note of the signs*
*Come to pay their respects to the fragile little king*
*Get pretty close to wrecking everything*
*'Cause the governing body of this holy land*
*Is that of Herod, a paranoid man*
*Who when he hears there's a baby born King of the Jews*
*Sends death squads to kill all male children under two*

*But that same bright angel warns the parents in a dream*
*And they head out for the border and get away clean*

*There are others who know about this miracle birth*
*The humblest of people catch a glimpse of their worth*
*For it isn't to the palace that the Christ child comes*
*But to shepherds and street people, hookers and bums*
*And the message is clear if you have ears to hear*
*That forgiveness is given for your guilt and your fear*
*It's a Christmas gift that you don't have to buy*
*There's a future shining in a baby's eyes*

*Like a stone on the surface of a still river*
*Driving the ripples on forever*
*Redemption rips through the surface of time*
*In the cry of a tiny babe*

"CRY OF A TINY BABE," 1990

There's another origin story on *Nothing but a Burning Light*, this one of a more recent provenance, a tale that seemed to require exploding rather than honouring. In America's mostly mythical history of its "taming" of the west, the explorer Kit Carson comes out a hero, one of the good guys opening a vast, rich land, wasted on its original inhabitants, to the benevolence of ranchers, bankers, and sod busters. I had seen that version portrayed in the old TV westerns when I was a kid. In Arizona, though, I heard a performance by a Native American satirist named Bob Morning Sky. He painted a different picture, one of Kit Carson as a devious mountebank who befriended the Navajo—or Diné, as they call themselves—who came to trust him to the point of revealing the whereabouts of their villages and waterholes. Carson repaid their trust by guiding the U.S. cavalry in an apocalyptic campaign of conquest. Wells were poisoned, villages burnt, and the Navajo forcibly relocated away from their traditional

lands. A great many died. This pattern was repeated in wars against other tribes, such as the Kiowa and Comanche. Of course, Kit Carson was just one of thousands of self-interested opportunists who plundered Native lands and peoples over generations, but he made himself ripe for the role of archetype. The Diné perspective on his legend cried out for a song. The music is simple and bluesy.

> *And the president said to Kit Carson:*
> *"Take my best four horsemen please*
> *And ride out to the four directions,*
> *Make my great lands barren for me"*
>
> *Kit Carson said to the president*
> *"You've made your offer sweet*
> *I'll accept this task you've set for me*
> *My fall's not yet complete"*
>
> *Kit Carson knew he had a job to do*
> *Like other jobs he'd had before*
> *He'd made the grade*
> *He'd learned to trade in famine, pestilence, and war*
>
> *Kit Carson was a hero to some*
> *With his poison and his flame*
> *But somewhere there's a restless ghost*
> *That used to bear his name*

"KIT CARSON," 1990

Recording *Nothing but a Burning Light* reinforced for me the idea that musicians of huge talent can, and should, go deep into a song without taking it over, adding touches of brilliance and meaning without needing to stand out—which is part of what it means to be a session player at that level. To corral such talent and, in our

case, enthusiasm into a singular musical entity takes a producer of taste, discernment, and instinct, which is T Bone Burnett. With him at the helm, everything rolled into place like the ball in a roulette wheel.

Of course, like everyone, the man has two sides (or more). If he has an opinion about something, you are going to know it soon enough. We went through the ingredients of that album with a microscope, making sure each was what we wanted. That was the Burnett way of doing things. If a song doesn't come out the way he thinks it should, he'll insist on redoing it or throwing it out. He would call me on the music and even the lyrics. Of "Indian Wars," for example, which includes the phrases "A few woolly sheep . . . A few dozen survivors . . . A few simple people," he commented, "There are a lot of 'fews' in there; are you sure you want that, or is it lazy song-writing?" T Bone's input was always worth considering. I thought about it and decided it wasn't laziness; I just liked it that way. I thought the "fews" rolled nicely over and around each other.

No doubt some songwriters would have said, "Who cares? It's a good tune; leave it alone." But to respond to T Bone like that would be to waste a valuable resource. He's too good. His listening skills, his deep experience in the studio, and his sense of what is essential in a song are too acute. He's hearing the slender nuances from each player and combining them into a whole and compelling sound that elicits the best from each musician's individual contributions.

From the start, T Bone emphasized that everything that went onto the tape should be there in service to the spirit of the song. If there was something extraneous in there, he wanted it taken out. That's the leanness people hear in his work. There's no grandstand-ing. If something flashy shows up on the record, you can bet that it's there for a reason, that T Bone has studied it. He's not necessar-ily concerned with limiting flash, technique, or complexity, but the spirit has to be front and centre. I found this aspect of working with him refreshing and educational, and I would take these lessons into future recordings.

Making the album was a joy, though it wasn't always smooth. At one point T Bone became frustrated with a couple of tracks that weren't gelling the way he imagined they should. He waxed peevish when "Indian Wars" balked at coming to life for us. The song was inspired in part by events at Big Mountain, in the Hopi part of Arizona. Traditional people had been forced off their pastures and into suburban slums because they were in the way of the exploitation of fossil fuel resources by Peabody Coal, a company with a long and unsavory history in the region. We were recording "Indian Wars" with the whole band, but T Bone didn't like what he was hearing and thought maybe we should just abandon it. I was attached to the song, though, and wasn't going to discard it. Jackson Browne had come in to overdub harmony vocals, so he was on hand as T Bone fretted over our inability to get it right. Finally he sighed and said to Jackson and me, "Why don't you guys just go in there with guitars and play the thing?" Sounded good to me. Jackson picked up my Dobro and started playing a Mexican rhythmic strum that fit well against my pseudo-fifties rock feel. Mark O'Connor joined in with his violin, and we played the song live as a trio. It worked very well.

*Out in the desert where the wind never stops*
*A few simple people try to grow a few crops*
*Trying to maintain a life and a home*
*On land that was theirs before the Romans thought of Rome*

*A few dozen survivors, ragged but proud*
*With a few woolly sheep, under gathering cloud*
*It's never been easy, or free from strife*
*But the pulse of the land is the pulse of their life*

*You thought it was over but it's just like before*
*Will there never be an end to the Indian wars?*

*It's not breech-loading rifles and wholesale slaughter*
*It's kickbacks and thugs and diverted water*

*Treaties get signed and the papers change hands*
*But they might as well draft these agreements in sand*

*Noble Savage on the cinema screen*
*An Indian's good when he cannot be seen*
*And the so-called white so-called race*
*Digs for itself a pit of disgrace*

*You thought it was over but it's just like before*
*Will there never be an end to the Indian wars?*

"INDIAN WARS," 1990

The album's leadoff tune, "A Dream Like Mine," came out of an invitation Jonathan Goldsmith and I received from a Canadian film company to compose music for their feature. The movie was based on a novel of that title by M. T. Kelly, which imagines the return of a mythic culture hero who sets out to rescue aboriginal forest dwellers from the predations of the timber industry, seeking a return of the land to its sacred status. The song, in turn, attempts to honour the spiritual connection to the land that Native North Americans have always embraced, a dedication that might save humanity and the ongoing biological functionality of the planet if enough of us follow suit.

At our first meeting the film director gave us a synopsis of the plot, and that alone was enough to trigger the song despite the absence of a single frame of film. It was an exciting project, but the chemistry between Jon and the filmmaker got strange. The guy had a somewhat unpleasant demeanor, anyway. It did not come as a shock when we found ourselves dumped from the film without his even having heard the song.

*When you've got a dream like mine*
*Nobody can take you down*
*When you've got a dream like mine*
*Nobody can push you around*

368 ❈ *Bruce Cockburn*

*Today I dream of how it used to be*
*Things were different before*
*Picture shifts to how it's going to be*
*Balance restored*

*When you know even for a moment*
*That it's your time*
*Then you can walk with the power*
*Of a thousand generations*

*Beautiful rocks—beautiful grass*
*Beautiful soil where they both combine*
*Beautiful river—covering sky*
*Never thought of possession, but all this was mine*

*When you know even for a moment*
*That it's your time*
*Then you can walk with the power*
*Of a thousand generations*

*When you've got a dream like mine. . .*

**"A DREAM LIKE MINE," 1990**

# 18

T Bone expressed a strong preference for recording the album in
Los Angeles. This I happily agreed to. After twenty years of
making records in Toronto, I felt ready for a change. New vistas
seemed to be waiting just over the horizon. L.A. was an unknown,
though I had had repeated momentary exposures to it. It turned out
to be surprisingly likable. Something about it felt like a place I had
always known. Right away I was drawn in by the throbbing cultural
nexus that didn't seem burdened by the somber, edge-of-Armageddon
moodiness I felt in New York.

L.A. is, of course, plastic surgery central. The whole place lives on
concealment of its true character. It's a desert, but wherever you look
is greenery, including majestic imported palms. It's a hub of finance,
yet vast areas of miserable poverty dubiously contrast with the most
outrageous excesses. It has a river, but it's a glorified storm sewer. It
has a downtown, but you seldom get to see it unless you're standing
inside the smog screen. Its atmosphere is mellow and friendly, but
there's a big boot heel lurking in the haze, waiting to crush the fingers
of desperate climbers who slip while trying to make it to the top of
the Hollywood heap.

It would take almost three months to record *Nothing but a Burn-
ing Light*, so at T Bone's suggestion and Columbia's expense, I rented
a little suite at the Shangri-La Hotel in Santa Monica, an art deco

gem built in 1939 for the Hollywood crowd and set across Ocean Avenue from a bluff overlooking the pier and the Pacific. My balcony, however, faced the other direction, with a fine view of a multi-story parking garage that served the Third Street Promenade. The muted freeway roar and the cries of wheeling gulls harmonized with the endless echoing of car alarms.

I had performed in LA dozens of times but had never actually stuck around for more than a day or so, so had never really gotten a good feel for the place. The city I discovered during the summer of 1991 was much prettier and more interesting than the stereotype. The people were predictably pretty as well, unexpectedly welcoming, affable, and engaging. I thought I could make friends in LA, maybe develop lasting, growing relationships with new acquaintances who had similar interests but different experiences. All that cosmetic surgery lets you forget you're in a big city that runs on lust for gold.

What I came to understand—and I've heard similar tales from others who have spent time in Southern California—is that the warmth went only so far. There was little depth to the friendships. Maybe it was my own outsider nature, but I came away feeling that some people I had assumed were close friends, people who would have my back if I needed them, weren't and wouldn't. They treated me well, but in the end, with some standout exceptions, I felt I couldn't count on them. Maybe it takes one to know one, but life didn't go very deep for me in LA, or if it did it wasn't so nice. Over time, the charm of the place lost its power, though I still enjoy going there.

Besides the people I was directly involved with, there was another welcoming individual, a woman I met through mutual friends. She was graceful and intelligent, quietly spiritual, dark-haired, with a classy sense of style, a sharp sense of humour, and a gift for painting cleverly ironic pictures of the human world. She was trying to escape the apparent dead-end that her choices had led her into. As was I, though I had not articulated the fact to myself.

I have a keen appreciation of physical beauty. I respond to the same kinds of visual and chemical stimuli as other males of my species. I

am *not* a womanizer, much as I might envy those who wear the label. Throughout my life, loyalty and commitment and the fear of causing pain have always trumped desire. I never imagined myself having an affair. But this woman—whom I will call Madame X—came into my life like lightning that set ablaze everything I thought I'd known. At first I assumed her marriage was healthy and none of my business, but as we got to know each other over a relatively short time, I learned that she longed for something that she wasn't getting from her husband: maybe space in which to grow, maybe a balanced and solid commitment, love without ownership. This was a longing we shared, a longing I had only just begun to allow myself to feel.

The depth of my feeling for Madame X was not reciprocated. Still, I took advantage of every opportunity to be in her company. I thought about her a great deal when I was alone, tried not to when I was busy, and attempted to alchemize my passion into mere friendship when in her presence. One night, at the end of a social engagement, we found ourselves alone together, everyone else having left or gone to bed. I had enough whiskey in my blood to speak uncluttered truth. Intending to make her aware of how I felt, so that if I went all weird on her she would understand why, I began explaining that I was very attracted to her. She stopped me and said, "I find that I'm attracted to you, too." Minutes later we were pressed together, kissing long and deep.

I was floored, baffled. *This can't be happening.* Here we were, a couple of self-professed Christians, committed to relationships with our respective partners, she with her husband and I with Sue, groping like teenagers on the living room couch. Clearly God had put us face to face for reasons of his own. The choices were ours, but it seemed to me that the unprecedented torrent of feelings I was experiencing had been unleashed for important reasons, and from meaningful depths. My best interpretation was that God was allowing me to see what it is to love without reserve—the way he wants us to love him. The obsessive focus on the object of the feelings, the openness to the slightest nuance of any communication from that object, and

the willing abandonment of personal sovereignty were things that by rights belonged to God. In the big picture, Madame X was a stand-in for the Divine. But there was more than that. Madame X was also my missing twin. She had the other half of the ring. Although sexual desire was very much in the picture, the experience transcended lust. I was finally, however injudiciously, opening up, Taser tendrils of actual human feeling welling up and spreading like a conquering horde across the whole landscape of heart and brain.

God set this up. It wouldn't have happened any other way. Maybe he rolled his eyes and sighed at having to resort to such a tactic, as maybe he often does. Somewhere deep in the web of the collective unconscious, our souls were nudged into position to meet and share what little we did during the on-again, off-again year of our affair. The moment felt ordained, profound. Even when we decided to break it off and give ourselves back to our respective relationships, I felt that I must continue to honour and nurture my love for Madame X. It would have been an act of disrespect toward the Divine, and toward the obvious if inexplicable connection we'd found in each other, if I had attempted to uproot or ignore what he'd given me, or tried to water it down.

You're thinking: "Yeah, right, 'God's will.' " But it was. This was no hambone excuse to fool around. Nothing in what happened between Madame X and me constituted "fooling around." The unlikely way we found each other, the people and paths that brought us together, and the sense of the purity of the experience added up to a kind of Arthurian romance. Our encounters were spiritually charged, and we both understood them this way. Our coming together was a gift, and we ran with it.

> *All the days we've been together*
> *All the days we've been apart*
> *Add up to a bunch of nothing*
> *If I'm not still in your heart*
> *I never want you to be*

*Just a page in my history*
*Someone I used to love*

*Your voice breathed in my ear*
*Or on the telephone*
*All the tender things we've whispered*
*To keep from feeling alone*
*May they never come to be*
*Just cold gems set in memory*
*Of someone I used to love*

*This current flows between us*
*That will not be denied*
*You draw me in toward you*
*Like the moon pulls at the tide*
*May no shadow ever fall*
*That will make me have to call*
*You someone I used to love*

**"SOMEONE I USED TO LOVE," 1992**

Of course the shadow did fall, but slowly. It was one thing for me to understand, back in 1980, that God said it was okay to get divorced after Kitty and I promised at his altar that we'd stay together forever. But it was a major leap from that to believing God was saying that it's okay, even necessary, to have an affair with someone else's wife while your woman works the horses at home, that this is the next thing you need to do. But he did, and it was. When it first began, I found myself spinning in a strange spiritual vortex. Madame X triggered an eruption of passion, agony, empathy, and desire straight from a molten core I didn't even know was there. I was never an unfeeling person, and at times my emotions seemed profound. But I now understood that I had allowed myself to be only a pale simulacrum of a truly balanced emotional being.

The house I grew up in was "passionless," which is to say that the feelings were there but never expressed overtly, except by my brother John, the youngest. He challenged the rest of us by always letting us know how he felt. John swung in the other direction, perhaps in a subconscious search for balance. He was an aberration, though, and by the time he came along the family stoicism was firmly embedded in my psyche. In our home, deep feeling was never displayed. I had no model for that. I understood nothing about projection or how I worked in my inner depths—or how anyone else worked, for that matter, because if you don't understand yourself, you can't understand anyone else. I certainly thought I did, but really I had no idea.

My relationship with Madame X kicked down a door of the heart that had begun to creak open a decade earlier in the pathos of the Chanjul refugee camp. It was a most incredible and timely gift, to be nearing fifty years old and suddenly be forced to explore this realm that heretofore was psychically off limits, and I remain deeply thankful for it. If I'm going to believe in an all-powerful God, then I have to believe that this was one of his gifts. Otherwise, what's the point?

Certainly, there was obsession and projection. With hindsight, I came to understand how I had found in this woman an idealizing mirror for the suppressed feminine in myself. She was my Beatrice, guiding me through the nine spheres of Dante's heaven. When she was out of reach, I floated in a void of unutterable loneliness.

*The hills are full of secrets*
*Owls watch by night*
*Down in town the bars are full*
*And the drunks are picking fights*
*These are things I know*
*But the facts are filtered through*
*All the ways I want you*

*2:19 freight train*
*Moaning somewhere near*

*I see you in the distance*
*But I can't get there from here*
*Hard to believe it's happening*
*But my whole world's shrunken to*
*All the ways I want you*

*Stars look down and laugh at me*
*I ought to take a bow*
*Don't have to tell them life's hard sometimes*
*There's one falling now*
*Nobody's here beside me*
*I can talk about it to*
*All the ways I want you*

"ALL THE WAYS I WANT YOU," 1991

I remember thinking, even early in the game, before we knew where it would all go, *this can't have a future.* Still, I felt like it was supposed to happen. Though I've spent a lot of my life feeling that I don't fit well into human society, as long as I can remember I've had the sense that wherever I find myself is where I'm supposed to be. So was God showing me what it is to actually *love* somebody? I think so, but that was just the beginning. The obsession part may have been unhealthy when applied to a human, but I don't think it's out of place if applied to the Divine, which is something I continue to work at. The Spanish mystic Saint John of the Cross recognized the human need to connect with one another in these powerful ways, at times suffering through our intimate relationships, to achieve a richer connection with God. Around 1578, while in prison for espousing reform ideologies, Saint John wrote,

God usually sends these storms and trials in the night of sensory purification. . . . Chastened and buffeted, the senses and the faculties are honed, made ready for union with wisdom, which will be

given there. After all, if, through trials and temptations, a soul is not tempted and tried, if she is not tested and proved, how can her senses be quickened with wisdom? In Ecclesiastes we are asked: "He who is not tempted, what does he know? And he who is not proved, what are the things he realizes?" . . . Those who have greater strength and capacity for suffering God purifies more intensively and more quickly. But the weak ones he keeps for a very long time in this first night, purging them gently, tempting them lightly. He frequently refreshes their senses so that they will not give up. These souls come to the purity of perfection late in life, if at all.

I guess I'd be in that latter category, though I don't think the "purity of perfection," as I understand that phrase, is available to us on this plane. That feels to me more like human hubris. Nonetheless, the power is in the seeking. If you're not growing, you die. If we don't consistently try to make ourselves, and everything else, better, then we're abrogating our core obligation as humans. Should I have responded to temptation by sticking to my dry and defended principles, by refusing an experience that could actually make me a better person? I don't think so. The invitation was to open, to step out of my comfort zone, to trust, to love. Today I don't feel closer to perfection, but I learned something vital about the heart. Some people I care deeply about can get closer to me. I was sent down a new road that hadn't been on any of the maps I had studied, and there found a place of knowledge.

*I see you standing in the door against the dark*
*Fireflies around you like a crown of sparks*
*You blow me a kiss that blurs my vision*
*Blurs the human condition*

*You're the ocean ringing in my brain*
*You are my island ripe with cane*

*Catch the scent of strange flowers when you pass*
*Fluid motion like the wind in grass*

*It's your eyes I want to see*
*Looking into mine*
*Got you live on my mind*
*All the time*

*Light me like incense in the night*
*Light me like a candle burning bright*
*Light me like a searchlight in the sky*
*Time means nothing when I look in your eyes*

*It's your eyes I want to see*
*Looking into mine*
*Got you live on my mind*
*All the time*

"LIVE ON MY MIND," 1993

My feeling for Madame X remained intense long after we stopped
seeing each other. I continued to nurse it lovingly, it seemed of such
momentous importance. I developed my own private cargo cult, not
in the expectation of more romance being airlifted in—though I kept
the embers alight until I knew for sure there was no chance we would
ever come together again. While the glow of these embers illuminated
my lack of understanding of my own psychic processes, and the many
situations into which my misunderstood motives had led me, it also
helped me see that I had an open invitation to learn about the deeper,
often painful places of the soul whose dimensions I had hardly
glimpsed at the conscious level. My empathy with the plight of oth-
ers has always been present, but never so strongly as when I began
to understand the emotional pain of an impossible love.

In the end, what I came away with is that this is the way people

are meant to connect: fully and with open hearts, hearing each other, occasionally risking all for the right reasons, one of those reasons being access to the Divine. If we don't pursue these natural connections, we're likely to forget them—especially in the digital age, when so much interpersonal relationship has been reduced to cyberhugs. Use it or lose it.

Madame X remained dedicated to her marriage. Her husband wasn't a terrible guy, but he didn't always treat her well, and in other ways he didn't seem right for her. She didn't know how to extricate herself from an increasingly difficult scene. They stayed together for a few years after our brief encounter, but eventually broke up.

I don't know what I gave her. The duplicity we engaged in was ugly and deplored by both of us. As discreet as we tried to be, a committed partner is always going to feel uneasy at least. There was a lot of pain for everyone involved, but pain is as much a part of life as being born— just ask the newborn infant, squeezed out of the Eden of the womb in the guise of an angry little old person, resentful at being made to come back. Ask Saint John of the Cross, whose reform activism got him imprisoned in a six-by-ten-foot cell in a monastery basement, from which he was dragged into a public square for weekly torture sessions before he finally escaped. What I received from Madame X was an ability to move forward out of myself, to escape the pain of being trapped inside the nonexpressive structures I'd grown up with, and to see others in this newfound light. How long it had been since the brave words of "Fascist Architecture"! It was probably around this time that I started to really love my audience, too. The world of the heart opened up. It took a bomb, and the bomb was provided.

> *There's a bone in my ear*
> *Keeps singing your name*
> *Sometimes it's like pleasure*
> *Sometimes it's like pain*
> *It's a small voice and quiet*
> *But I hear it plain*

*There's a bone in my ear*
*Keeps singing your name*

*In my heart there's an image*
*Like looking through glass*
*Could be looking at me*
*Could be looking right past*
*I don't like it when*
*I can't tell which is true*
*But I wouldn't trade the world*
*For that picture of you*

*Moon in the water*
*Cold light in the streets*
*Warmth in your fingers*
*Sweat in your sheets*
*Laid out like an offering*
*Where two currents meet*
*The river is dark*
*But the water is sweet*

*Wailing on the mountain*
*Smoke on the wind*
*Can't drown out the whisper*
*Or the scent of your skin*
*Don't know where it came from*
*But I know where it came*
*There's a bone in my ear*
*Keeps singing your name*

"BONE IN MY EAR," 1993

As life (and, according to Saint John of the Cross, God) would have it, I had been heading to this point incrementally. Each previ-

ous relationship created its own opening and taught me about myself and others. For some people, this is all quite obvious: of course we learn and evolve as we go along. But it's not a given that we'll absorb these lessons. I was fortunate enough to have merged my life with that of strong and, each in her own way, caring women—Kitty, Judy, Madame X, even Sue—who were not afraid to take on my reticence, who were willing to work to break me out of it. Apparently they saw something that seemed worth the effort. Each partner pushed together a few more pieces of my psychic jigsaw—a heavily misted landscape, man of a thousand pieces—and contributed to my current condition and level of understanding, such as it is.

In addition to all the spiritual celebrations and contusions, my encounter with Madame X brought me some good songs. Many of them appear on *Dart to the Heart*, the second album I did with T Bone Burnett, recorded in March 1993 and released in 1994. "Madame X songs" also showed up on *The Charity of Night* two years later, and after that on *Breakfast in New Orleans Dinner in Timbuktu*. That *Dart to the Heart* is full of love songs made for some awkward moments, because Sue was under the impression that all the "you" songs were for her, but they were not. Like a lot of my songs, they reflect a state of hunger. Even when the affair was ongoing, physical contact was limited. At times we were in the company of others and couldn't betray our secret. We had some memorable days and nights together, but what might have been remained out of sight behind the horizon.

As expected, T Bone worked magic on *Dart to the Heart*, though this creative excursion wasn't as smooth or as much fun as *Nothing but a Burning Light*. While in production with *Burning Light*, T Bone told me he believed artists and producers should work together only once. As far as he was concerned, it was never as good after that. He said this in passing, and later he wouldn't remember it, but I did. Nonetheless, I had such a good time during that first collaboration that I pushed for him to do the next one as well. Turns out he was telling the truth—his truth, anyway, because a total of five people have produced my thirty-one albums.

The recording of *Dart to the Heart* didn't unfold in the same atmosphere we had enjoyed with *Nothing but a Burning Light*. I was tense throughout. There had been no year off before this album; I'd been touring, writing, and seeing Madame X. I was anguished over her, and there was no one I could talk to about it.

Early in the process, while we were still doing the basic recording in the studio at Bearsville, New York, tucked away in the broccoli near Woodstock, there arose a complicated four-way gripe between Bernie, T Bone, me, and Columbia's financial office about money (of course). The cheque writers at Columbia had been difficult the first time around, but not in ways that mattered much. They took so long to send me the agreed-upon per diem for food that I ran out of U.S. dollars and had to threaten to start holding up milk stores if they didn't hurry things up. More critical was T Bone's gift for running up expenses. He was pretty good at deciding he needed an assistant whom Columbia should pay for, and the assistant was going to cost X amount over and above the original agreement, so he'd get on the phone with somebody at Columbia and push and prod, and he'd get his way. Then Bernie would get grumblings from Columbia that T Bone was costing too much, as if Bernie had any control over that. Then, in private, T Bone would complain to me about Bernie and finances, as if T Bone and I were together holding off the zombie business hordes from our forest hideout. After a while I got tired of hearing the bad-mouthing. I told T Bone that I was as much a part of the goings-on as Bernie and that he ought to quit picking on him. It actually wasn't true; I knew very little about Bernie's role in the finances around the album, but of course I was loyal to Bernie, who in any case is one of the most honest businessmen I know. T Bone's body language suggested that my retort meant something to him. It was never the same between us after that.

The album turned out well anyway, though differently than what either T Bone or I had pictured when we started out. Were I to change anything, it would be to make the rock-and-roll songs a bit more raw. Early on T Bone asked me, "What kind of album do you want to

make?" I thought about the kind of songs I had, and told him I wanted to make something like the Rolling Stones' *Exile on Main Street*. T Bone said, "I've never made an album like that. Let's do it." He came up with a cadre of players based on that idea.

Casting around for a studio, he landed us at Bearsville—a snow-blanketed wonderland where early-morning deer hovered outside, nostrils frosted from foraging frozen ground. A far cry from Keith Richards's basement, but a fine studio. Bearsville was established in 1969 by Albert Grossman, best known for managing Bob Dylan and Peter, Paul and Mary, and less well known for being a mentor to Bernie Finkelstein. In 1986, at fifty-nine years old, Grossman died of a heart attack while crossing the Atlantic on the Concorde. His widow kept the studio running, and it remained an atmospheric and technologically well-endowed recording facility.

For personnel we got the renowned rock drummer Mickey Curry, who had recorded with Bryan Adams, Tom Waits, David Bowie, Alice Cooper, Hall & Oates, Tina Turner, and even Cher. Jazz drummer Chris Parker also played, taking over from Mickey for the last couple of tunes we laid down. The late Jerry Scheff, who had been part of Elvis Presley's live band, played bass. That was our rhythm section.

My gigs in support of *Nothing but a Burning Light* had been evocative and exciting. For the first time in a band setting, I had added another singing guitar player, Colin Linden. He and I met at the Mariposa Folk Festival in Toronto in the early seventies. He'd been mentored by Howlin' Wolf and appeared on the scene as a fifteen-year-old prodigy, playing a deep and wide-ranging style of blues. When I was looking for another player to work with, Colin seemed an obvious choice. In fact, he came with a whole band—Miche Pouliot and John Dymond as rhythm section, and Richard Bell, who had played in Janis Joplin's Full Tilt Boogie band, on organ and piano. Sam Phillips appeared as an opening act in most of the shows, and joined us on the tour bus. This road ensemble enjoyed a rare and lively camaraderie, so it seemed like a good idea to include at least part of it, Colin and Richard, in the *Dart to the Heart* band, infusing

the studio sessions with the collective feel we had developed live.

Greg Leisz played gorgeous, unorthodox pedal steel and Weissenborn guitar. Greg is especially absorbing on "Bone in My Ear," which I wrote during the sessions. I came up with the music using an electric charango built by my luthier friend Linda Manzer. The charango is a lovely Andean instrument that looks a little like a ukulele but has ten uniquely tuned nylon strings. It's pitched high like a mandolin but has a very different timbre. Colin played an actual mandolin as counterpoint to the charango. T Bone himself played a perfect drum part.

It proved unexpectedly difficult to get good performances out of me, which frustrated both T Bone and me. My emotional state had spawned an internal atmosphere of self-sabotage, which had to be worked around. In the end we got what we needed, but it was more arduous than our first partnership.

Once we had solid band performances on all the songs, and satisfactory performances from me, what remained was to overdub harmonies from Sam Phillips, a bit of extra organ from Benmont Tench, and a horn section made up of L.A. session men Darrell Leonard, Christiaan Mostert, and Greg Smith. For that we moved to Los Angeles, where the album was also mixed—or so we thought. We got a good groove with the horns on the opening cut, "Listen for the Laugh," a distinctly nonmeditative meditation on the unpredictability of love and its central function as the glue that holds the universe together. Sam is the angelic presence that pops up on "Love Loves You Too." Pretty much the whole group shows up on "Tie Me at the Crossroads," another raucous "meditation" on death and fame, which I've always thought of as a campfire song for the coming dystopia.

Travelling to L.A. was a solitary pleasure. With all my road travel, I still hadn't done a trip behind the wheel from one side of the United States to the other. I would rectify that. I packed all my gear into the back of my recently acquired black Suburban, leaving just enough room for my camp cot, and headed south and west. As I came out of

the Blue Ridge Mountains into Tennessee, it started to snow. I made it to Nashville about dinnertime, had a bite to eat with my friend Pam Mark Hall, and then, as it was too cold to sleep in the truck, crashed at a hotel near the I-440 bypass. I awoke to find a couple of inches of snow on the ground, which in those parts meant that everything was closed or closing—schools, offices, highways. Behind me, six feet of white stuff had accumulated in the mountains. More might be on the way. At breakfast the TV featured a news anchor explaining that anyone heading outside should wear a hat, and even *gloves*! That had this Ottawa boy shivering in his shoes. Fortunately, I was westbound, and the storm reached to only about halfway between Nashville and Memphis, getting weaker as it went. Even so, for a long time the only things on the road were big rigs and me. There was more snow on the high pass west of Denver, very wet, and a lot of skidding traffic.

Down off the backbone of the continent I soared into the desert for another encounter with a dry, windswept space. I had been reading Tony Hillerman's mysteries involving Navajo tribal police and grew excited at reaching the Four Corners region, recognizing place names and highway numbers. Then into California . . . Needles, Barstow, the exotic array of wind turbines in the hills around Joshua Tree . . . finally coming to rest in Santa Monica.

Once in L.A. I fell heavily into a stressed-out gloom. To be so near Madame X but not to have contact! T Bone noticed it and wondered what was wrong, but having promised her I would say nothing, I said nothing. The work proceeded apace, and the results were good. Joe Schiff, who had engineered the album, produced a finished set of mixes, which were dry and raw and true to the spirit of our original plan to use *Exile on Main Street* as a template. The folks at Columbia didn't like it. Bernie wasn't impressed either. T Bone had adopted a laissez-faire attitude during this phase of the work. It seemed like he had lost interest and wanted to get on to the next thing.

By that time it had become fashionable to mix your album, and then have it remixed, not by a star DJ, as later became the trend, but

by some famous producer. The corporate end of the record industry is very much influenced by what is in fashion. If an important radio consultant directs his client stations to play a remixed record, then all records shall be remixed until the fad is over. Columbia insisted that the album be mixed again. Everybody but Joe Schiff, who was quite proud of what he had done, said, "Oh, what the hell, why not?" T Bone suggested we try British producer Glyn Johns, who was known for his idiosyncratic approach to album making. He'd had great success with albums by Joan Armatrading, the Rolling Stones, the Eagles, Eric Clapton, Linda Ronstadt, the Who, and many others. Glyn was both interested and available. Suddenly I was off to the south of England with massive reels of two-inch Ampex tape that held a couple of years' worth of writing and recording, and a desperate sense that the wretched album might never be done.

Glyn housed his studio in an outbuilding on a farm he owned an hour south of London, where he and his synchronistically named wife, Glynis, received me with warmth. I was shown to a room and given a towel, and then we went to work. Glyn Johns's way of mixing was less technological and more physical than anything I had seen before. His custom-made mixing console, with its array of faders, knobs, meters, blinking lights, and patch bays, curved around him like the dashboard of a starship. Various functions were controlled by means of foot switches. He played the thing as if he were the Phantom of the Opera at the pipe organ, all expressive body language and hands sweeping over the controls. Occasionally his son Ethan and I were enlisted to press a button or move a fader. Each pass through a song was fresh, spontaneous, and creative. Although Glyn appeared to like the record we had made, he could be a crusty character, and some of his judgments were harsh, to the point where on at least one occasion I was reduced to tears when he declared that the sound of the bass on a certain song was unworkable and he couldn't possibly mix it. Later he relented, and it all came out fine. Glyn was eccentric and intense, but he was very musical, and his sensitive touch with the songs was a gift.

There were more tears to come. After we wrapped the album, I went to dinner in L.A. with T Bone and Sam. The evening began cordially enough, with pleasantries all around. But the tension that had been with us through the whole making of the record hung like an aerosol around our table. When I went to pick up the tab, it exploded. T Bone boiled over. The money issue, whatever it was, had been eating at him the whole time.

"You fucking hypocrite, Cockburn!" he shouted at me in front of a sparse weeknight population of diners. Heads turned, then quickly turned away. His face reddened. Sam shrank back. The blast came out of nowhere. We all have our rage; here was T Bone's. The shock wave of his pent-up anger blew the wires that held my own mask of joviality in place. I had been feeling close to these people and hoped to remain friends with them, a hope dashed on the stones of human discourse. I was heart-scraped and vulnerable, and I burst out crying like a baby. Maybe it was about the money, or maybe too it was a vent for T Bone's other stresses.

*It's not the laughter of rain in the drain*
*It's not the laughter of a man in pain*
*It's not the laughter you can hide behind*
*It's not the laughter of a frightened mind*
*Balanced on the brink only waiting for a shove*
*You better listen for the laugh of love*

*It's not the laughter of the gloating rich*
*It's not the laughter of the sacred bitch*
*It's not the laughter of the macho fool*
*It's not the laughter that obeys the rules*
*More of a chain saw in a velvet glove*
*You better listen for the laugh of love*

*It's not the laughter of a child with toys*
*It's not the laughter of the president's boys*

*It's not the laughter of the media king*
*This laughter doesn't sell you anything*
*It's the wind in the wings of a diving dove*
*You better listen for the laugh of love*
*Whatever else you might be thinking of*
*You better listen for the laugh of love*

"LISTEN FOR THE LAUGH," 1992

I wrote "Listen For The Laugh" a week to the day before the 1992 American presidential election, which saw George H. W. Bush, former head of the secret police, ousted from office by Southern smoothie Bill Clinton. I considered the outcome of the election an improvement, though not much of one, but the liberals I knew, most of my U.S. acquaintances, were so excited and hopeful that I seldom voiced my skepticism. It seemed to me that their expectations for a major change in the nation's direction were unduly high. Nevertheless, I tried to embrace their enthusiasm, at least when I was with them. When Grammy-winning bass player Rob Wasserman asked if I would be interested in performing at one of Clinton's inaugural balls, it was easy to accept.

I'd been working with Wasserman occasionally for more than a year, and our relationship became important to some of my upcoming music. In the summer of 1991 I was booked to tour across the United States with him and the Grateful Dead's Bob Weir, playing moderately large outdoor venues, or "sheds," as they are known in the trade. Wasserman and Weir would tour as a duo, with singer Michelle Shocked and me as opening acts. She and I would take turns going onstage first, while the audience was still coming in, which made us cannon fodder; and second, which offered us a chance of actually being listened to. Bob and Rob were friendly and hospitable, not always what you get in the world of rock and roll, and they turned in beautiful performances throughout the tour. I was especially taken with Wasserman's muscular approach to the bass as a

lead instrument. He played fluidly, churning out a big sound on an upright electric.

Later that year I received an invitation from Weir to hang out and write songs with him and Wasserman the following January in Hawaii. It was Bob's idea and invitation, and he paid for Sue and me to fly out, providing us with a rented townhouse we shared with Rob and his girlfriend. The setting was glorious, a welcome break from the Ontario deep freeze. I'd never spent any time on the islands other than what it took to refuel an airplane for a continuing journey to the Southern Hemisphere. Maui was moist and warm, the surf pleasant, and we did some enjoyable jamming. The writing didn't produce much, though, except a stronger relationship with the talented and dynamic musical duo.

In December 1992 Rob and I played together in front of an audience for the first time, albeit an invisible one over the airwaves. It was the second in a series of live radio shows called *Christmas with Cockburn*, a brainchild of the head of radio promotion at Columbia Records, Paul Rappaport. The original show had wrapped up the first leg of the *Nothing but a Burning Light* tour, in the closing weeks of 1991, with a morning performance at the Bearsville Theater, behind which Albert Grossman is buried, just down the road from the studio where we would record the next album. Sam Phillips and T Bone Burnett appeared as guests, along with violinist David Mansfield. I

was into the idea of doing a Christmas show, but I insisted that it reflect the spiritual aspect of the season—no "Jingle Bell Rock" or "Rudolph the Red Nosed Reindeer." There being no objections, the show went on, apparently to Columbia's satisfaction, as it served as a test run for the launch of the

*Bob Weir and I attempting to create, Maui, 1992*

Columbia Records Radio Hour series, which for five years included an annual *Christmas with Cockburn.*

When it came time for show number two, there was no tour in progress, so we had to gather guests from the world at large. I sought out Rosanne Cash (I had recently appeared with her and Lucinda Williams on an installment of the *Austin City Limits* TV show, and contributed a harmony vocal to her album *The Wheel*) and Rob Wasserman. Both said yes. I knew that Rob had played with Lou Reed for many years, so I asked if he could get Lou to join us. A week or so later, I was on the phone listening to the unmistakable voice of

*With Rosanne Cash (left) and Lucinda Williams in the dressing room of Austin City Limits. John Leventhal is in the background.*

Mr. Reed. I explained what the show was all about, and he said, "Well, I'd have to do a Jewish song."

"No problem," I said, "if you can think of anything but 'Dreidel Dreidel Dreidel.' "

"Sure," said Lou. "I'll find something else."

He came off terse, somewhat gruff, gravel in the throat, though civil and less intimidating than I had feared.

Some days later he called and announced, "I'm going to have to do 'Dreidel'—there are no other Hanukkah songs—but I'm gonna do a rock-and-roll version of it." Okay, fine. What could I say? A few days after that, though, he called again and said, "You know, 'Dreidel' doesn't work as a rock-and-roll song, so I can't do it. I'll do something else. We don't have to do a Jewish song."

"I have no problem with Jewish songs," I told him, "but I'm glad you're not doing 'Dreidel Dreidel Dreidel.' " In the end, Lou brightened things up with a song called "Xmas in February," about homeless and addicted Vietnam veterans.

As a climax to the show, we performed a collective rendition of

"Cry of a Tiny Babe," trading verses. It fell to Lou to do the second verse, about King Herod, which, with his sardonic tone and a twinkle in his eye, he pronounced "*He*-rod." He talked it more than he sang it: "The governing body of this holy land / Is that of *He*-rod, a paranoid man." I got so convulsed trying to keep from laughing, I could barely play.

We were a great team for that event, inspiring Rob to reconvene us for one of the Clinton inaugural parties, Al Gore's Tennessee Ball. Rob had connections with the Gore family, and the incoming Clinton administration was pretty hip, so they let him put the concert cast together. Rob called Rosanne Cash and Lou Reed and me, plus he brought in Bob Weir. (Later Rob and Bob would form RatDog.) Rosanne came with a band, including John Leventhal, the talented guitarist and producer she would marry three years later. Rob and I played as a duo, then Rob played with Lou as part of his band.

While Rob and I were onstage, halfway through "Lord of the Starfields," I heard, "Psst, psst, *psst!*" I ignored it. Suddenly there was a stern-faced suit with an earpiece at the rear of the stage, his mouth opening and closing, shaping the words "Get off! Get off!" and making little arm signals. Then Rob began to mutter nervously about stopping. During the instrumental break between verses, I said, "Screw that. We're finishing the song," which we did. This was God I was singing to here! There was only about a minute left to go. Whatever it was could wait.

Ah, the president! That's what it was. We got to the end and everyone was angry at us, glaring blackly as they shouldered us into the wings. Rob and I were held there while the Clintons came out to talk at the crowd. That was all the contact I had with the brand-new president and his shining first lady. They acknowledged us, but just barely. They didn't hang out. He spoke for three minutes and then they left. After that, the show continued like a huge bar mitzvah, revelers on the downside of the rush, itchy in evening clothes, gaping dumbly from the dance floor as if wondering, "Why are we here?" They were there to hear Clinton or Al Gore speak. We all performed

pretty well, but they weren't there for us. A few of them engaged in a feeble, constricted sort of dance. There was a brief stir of excitement when Paul Simon, who was playing some other ball across the hall, dropped by and sat in for the big encore wank at the end, all of us onstage together, but otherwise the crowd might have been happier with a DJ.

For me, the most exciting moment of the night (other than when the Secret Service agent guarding us in the green room caught the grip of his holstered pistol on the back of a folding chair, causing the gun to clatter to the floor) came at the end of the concert. Rosanne's folks were there to hear her play, proud as could be that their daughter had been asked to be part of the show. They made their way to the side of the stage as we packed up. Rosanne introduced us: Johnny and June Carter Cash, he in trademark black and she tastefully glamorous in a blue-patterned evening gown. I was a couple of years shy of fifty. Johnny was as old as the Appalachians.

*With Bruce Hornsby and Jackson Browne,*
*at a benefit in the early nineties*

He shook my hand and said, "Nice playin', son."

By way of thanks, the administration gave us each a nice leather pilot's jacket with the presidential seal embroidered on the inside pocket. I think mine was the only one that actually fit.

The cast for the 1993 *Christmas with Cockburn* was just Jackson Browne and me. These later shows were broadcast from Columbia's own studio in New York, where they'd taken over the old Universal Film building. Under the gymnasium-like floor of the main room, Esther Williams's swimming pool conjured dreams of toothpaste smiles and wet and glistening bodies.

Not being inclined toward religion, Jackson chose to read the meaning of Christmas in political terms. He sang his song "The Rebel

Jesus," accompanying himself on piano, and "All I Want for Christmas (Is World Peace)" by Pat MacDonald of Timbuk3, which features the lines:

*Rock Lord masters of disaster*
*Detonate the ghetto blaster*
*And little black Rambo metal choir*
*Sings deck the halls with great balls of fire*

Jackson made the kind of slip we all dread and sang "Sambo" instead of "Rambo." He was embarrassed about it afterward, but there was no going back because half of the stations that carried these shows ran them live. Which led to the next slip, this one much bigger and all mine.

A little more than a year earlier, PEN (Poets, Essayists, Novelists) Canada had held a benefit at the Winter Garden Theatre in Toronto. I was the token musical act amid a collection of writers that included John Irving, Canadian novelist and poet Margaret Atwood, and my friend Michael Ondaatje, who won the Booker Prize that year for his acclaimed novel *The English Patient.* What nobody expected, and what drew a collective gasp from the audience, was seeing the novelist Salman Rushdie sauntering out onstage. By that time Rushdie was into his third year of living under a fatwa death sentence handed down by His Pomposity the Iranian Grand Ayatollah Ruhollah Khomeini. This was Rushdie's first public appearance since the fatwa, issued for his "blasphemous" satirical novel *The Satanic Verses.* He'd been living on a kind of international Death Row for three years, and the price on his head had recently risen to $10 million.

Rushdie knew that, just for the sake of sanity, he had to appear in public at some point. (In a charming sort of irony, local neo-Nazis were picketing outside because PEN wouldn't support one of their revisionist, Holocaust-denying writers, who was facing some sort of censure for a recent work of pseudo-historical propaganda.) Only Ondaatje, who was hosting Rushdie at his home, and the organizers

*Salman Rushdie and me*

knew in advance the identity of a "mystery guest" we had been told would join us onstage. During the afternoon, bomb-sniffing dogs had given the place a good going-over, so we figured it would be someone interesting, but when Rushdie came out, everyone was stunned. He was humble, humourous, and engaging, contemplating censorship and his clandestine life. Later the premier of Ontario, Bob Rae, came out onstage and embraced Rushdie, becoming the first head of state anywhere in the world to be seen in public with the writer, who had won the Booker Prize in 1981, since the ayatollah had issued his fatwa.

A year later, there I was with Jackson on live radio. We'd just finished performing "The Rebel Jesus," which, as it sounds, is a Christmas protest song, a political take on Jesus's message:

> *We guard our world with locks and guns*
> *And we guard our fine possessions*
> *And once a year when Christmas comes*
> *We give to our relations*
> *And perhaps we give a little to the poor*
> *If the generosity should seize us*
> *But if any one of us should interfere*
> *In the business of why they are poor*
> *They get the same as the rebel Jesus*

After singing the song, Jackson said something like "You know, there are a lot of people from the Christian side of things who might not appreciate that song, but it's great to be able to play it in here and share that message." I said, "Yeah, I know what you mean. Last year I did a gig with Salman Rushdie. Talk about not being appreciated."

I paused, then said, "But you know what? Fuck 'em if they can't take a joke."

In an instant, the faces of the Columbia people became cartoon masks of consternation. There was much buzzing about the hive. The ghost of Esther Williams shook the water from her hair and guffawed. Came the cries from every quarter: "FCC! FCC!" Seems you can't say "fuck" on American airwaves. Nobody paid any attention at all to the content of what I had said. You can host hate radio that worms into the warped minds of people like Oklahoma City bomber Timothy McVeigh, so long as you don't say "fuck." What was of more immediate importance to me was that I had probably just offended the entire Muslim community, a group not widely known for possessing a sense of humour about their faith.

# 19

It's a testament to the quality of life in Canada that, in the fall of 1995, I was able to saunter into the Centre Block of the Houses of Parliament with a bag of anti-personnel mines and nobody stopped me. It was theatre, of course—the land mines, though real, were inert—but no one knew that when I dragged five of them out of my backpack and placed them on the podium at the beginning of a press conference in the basement of the historic building. It was an amusing ploy for a serious cause: a proposed ban on land-mine production and use.

Just before landing at Parliament, I'd wrapped up a series of speaking engagements describing my second fact-finding mission to Mozambique on behalf of Cooperation Canada Mozambique (COCAMO). In 1992, after fifteen years of civil war, the FRELIMO government and RENAMO rebel force signed a peace accord in Rome. By 1990 the two sides were so militarily depleted—especially after the dissolution of the Soviet Union and the collapse of South Africa's apartheid government, which had supported FRELIMO and RENAMO, respectively—and so literally famished that there was no choice but to give up the war. In 1992 a U.N. peacekeeping force entered the country and stayed for two years, leaving shortly after the democratic elections of October 1994. Mozambique was at "peace" for the first time in nearly thirty years, but because all sides in the

war of independence against Portugal, and the subsequent civil war, used land mines as offensive weapons, true peace could not—and will not—be attained in the country until all the mines are removed. COCAMO's efforts would now shift from helping the populace get through the war to the demining and reconstruction of a country whose economy was still largely based on agriculture.

The wars in Mozambique emptied vast areas of countryside. I arrived on September 5, 1995, in the middle of a mass migration, as one and a half million refugees were straggling back to their homes. Crucially, such a return in large part meant addressing the presence of millions of land mines that remained scattered throughout parts of the country.

I flew south out of London at the end of a European tour, changed planes in Harare, Zimbabwe, and landed in Maputo, Mozambique's capital and home to more than one million souls. There were a few days of orientation in the old city, whose architecture includes charming colonial, Stalinist cement-block, and, increasingly these days, modern high-rise. I met Chude Mondlane, daughter of Eduardo Mondlane, who served as FRELIMO's first president for seven years before being assassinated in 1969. Chude, a lively and attractive young woman and a professional singer of great talent, would eventually join our efforts to generate support for COCAMO in Canada. I found a wonderful souvenir in the marketplace: a toy tank made of wicker, with wheels that turned and a swiveling turret complete with cannon.

During a meet-and-greet dinner at a restaurant, I reconnected with some musicians I had encountered in Mozambique during my first visit in 1988. Among them was Zena Bakar, one of the founders of the group Eyuphuro. Things seemed to be falling apart for her. One of the members of her band—which had enjoyed some success not only in Africa but throughout Europe and the United States—had sold all their instruments and with the money bought himself a one-way ticket to Copenhagen, where he was said to have become a street singer and acquired a Danish girlfriend. Zena had undergone a bit of

a breakdown. People whispered that she was possibly also the victim of spousal abuse.

Zena greeted me warmly, then honoured me with a traditional welcoming song, which she performed while kneeling at my feet, singing directly at me. Others at the gathering were not so traditional, and they squirmed in embarrassment. Most compelling, though, was the poignant sorrow in the timbre of Zena's voice, which, springing from the depths of the battered morale she couldn't really hide, seemed to sing for the whole country.

The journey truly began with a flight into the city of Quelimane, a sixteenth-century Portuguese slave-trading post on the central coast of Mozambique, over a thousand kilometres from Maputo. Rex Fyles, COCAMO's man on the ground, had arranged for us to travel by vehicle the 350 miles from Quelimane to Nampula, where COCAMO had its operating base. This was exciting because in 1988 I'd had no opportunity to savor the countryside. The highway was a winding red dirt slash across a landscape of rolling savannah mixed with areas of dense bush. The most obvious evidence of human activity was found in the places where RENAMO had cut wide ditches across the road, which we had to power around with the four-wheel drive in low range. Here were the scenes of past ambushes of vehicle convoys, the road now littered with the twisted remains of rocketed armour and trucks, the husks occasionally populated by scrap metal gleaners picking through the rusted shapes.

Many rainy seasons had come and gone without anyone maintaining the road, which tossed us around no matter how slowly we moved. The rutted track at times wound prettily between groves of mango and cashew trees planted by the colonial masters to draw people to places where their activities could be monitored. Few entered those areas now, as RENAMO had mined them extensively to prevent the harvesting of their fruits.

With the Mozambican economy eviscerated, the postwar government was in the process of restructuring to meet the demands of the IMF and the World Bank, inviting a feeding frenzy of carpetbagger

capitalism—old-school colonialism in a brand-new suit. Foreign inter-
ests gobbled up rights to Mozambique's oil and minerals, timber,
offshore fisheries, the remains of what was once the world's largest
cashew industry, and—in a bitter irony seen often in poor lands with
high food exports—a very hungry labour force. Even the HIV virus,
kept at bay by Mozambique's relative isolation during the war, began
appearing as a colonizer. Underpaid teachers charged students for the
release of their marks, and thousands of demobilized soldiers turned
to banditry to survive, sometimes renting their weaponry from police
officers who themselves resorted to mugging passersby to augment
their wages. About this I can speak with some authority, as I was held
up by two cops near my hotel in Maputo. I was robbed of a hundred
dollars but allowed to keep my knife, Leatherman tool, and passport,
as well as the body parts they threatened to remove. After pocketing
the money the officers became genial, as if we had just done business
together. They wished me a good evening. They probably had not
seen a paycheck in months.

Social spending was nonexistent. When I visited in 1988, during
the civil war, the central hospital in Nampula City was still func-
tional, if poorly supplied. In 1995 it was a cesspool of misery. Mentally
ill patients wandered the hallways, raving and stinking of urine. The
walls were filthy. People brought their own brightly patterned cloth
(if they had any) rather than put themselves in contact with the
hospital bedding. The gurney used to transport patients who couldn't
walk was an old bloodstained stretcher rigged with wheels. Fecal-
smelling wards were crammed with people, many of them fighting
infections acquired at this very institution. If you needed an IV, you
had to pay. If you needed blood, you had to buy it. If you needed
medicine, your family had to comb the pharmacies in town because
all the drugs had been sold off by hospital staff. Yet the government
couldn't raise salaries for fear of losing the support of the World Bank
and the IMF. This was all happening against a backdrop of the near-
total destruction of transportation, schools, and farms in the wake of
war, drought, and, in the north, a disastrous hurricane. The war killed

off the cattle and drove away or killed the wildlife, including the elephants, hippos, lions, warthogs, and antelopes of famed Gorongosa National Park, where RENAMO had its headquarters. It destroyed nearly all the trucks, wrecked rail lines, and left all but the major cities in ruins.

Most pernicious were the land mines, a plague of amputation and death waiting hidden in the fertile soils of this rich and storied African land. The United Nations estimated that, in 2013, between two and three million land mines remained scattered throughout Mozambique. At least sixty million are still buried across the globe, including a staggering twenty-three million in Egypt alone (more than any other nation), alongside unexploded ordnance left from World War II, disallowing use of huge regions in the north and east of the country. Angola is plagued with fifteen million mines; Afghanistan, ten million. Iran and Iraq share twenty-five million land mines still in the ground, and China has ten million. Neighboring Vietnam is thought to still have three million land mines. The small country of Cambodia—which I visited in 1999, just after that country's decades-long war ended—still suffers with six million of the things, an improvement over the estimated ten million, one for every person, that were in the ground when I went there.

Land-mine deaths are bad enough, but the maiming they cause in agrarian countries like Mozambique and Cambodia paints a patina of horror across the landscape. The injured almost always end up disabled and become a burden to their families. They swell the numbers of urban beggars, contributing to the instability of society. Mine victims are most likely to be rural civilians who depend on a degree of physical fitness for their survival. In Quelimane I talked with a one-armed, badly scarred, and blinded youth whose sister led him around to beg from foreigners at a riverfront café. He had hit a mine with his mattock while working his family's *machamba*, or garden plot, well after hostilities had ended.

Mines can lie in hibernation for fifty years or more without losing their potency. They come in many shapes and sizes, but can be loosely

divided into "anti-tank" and "anti-personnel" devices. Anti-personnel mines can be further differentiated as "blast" and "fragmentation." Blast mines, as the name implies, work by releasing a massive energy burst, shattering any proximate parts of the human body. Fragmentation mines work like a big grenade, sending shrapnel over a wide radius. There are various methods of initiating detonation, the most common being foot pressure or a trip wire. Anti-tank mines are designed to blow the track off sixty-ton armoured vehicles and generally require a substantial weight to set them off. The front wheel of a jeep will do it, and there won't be much left afterward. Fortunately, anti-tank mines are present only in small numbers in Mozambique. The real obstacles to social and economic recovery were the anti-personnel mines and the perception of them.

Unlike other weapons, mines are activated by the victim. Nobody is aiming them. Mines are used to deny access to an area, to create a defensive perimeter around a base, business, or town, and to prevent ambushes. These were common applications in Mozambique. During the war of independence (1964–1974), the Portuguese laid mines in this way. In the late seventies, the Rhodesian forces mined the border areas of Mozambique to deter guerrilla incursions. The FRELIMO government, fearing invasion, laid strings of mines around towns, hydro lines, military bases, and key industrial sites. Private companies mined their operations as well. The defunct Canada Dry mineral water bottling plant I visited at Namaacha, near the border with Swaziland, was surrounded by four different rings of anti-personnel mines. For all that, RENAMO was still able to capture and destroy the plant.

Of course, RENAMO received an almost endless supply of land mines from apartheid South Africa and used them liberally as terror weapons. No records were kept as to their placement. Put a couple on the trail where you might expect enemy troops to walk, but also lay some near the local health post or in the schoolyard, or maybe don't lay any, but say you did. RENAMO used a lot of forced labour (and, as noted in chapter 15, child soldiers). In one case, a primary school

teacher was put to work for several days carrying boxes of mines from one of their camps to a farming area. He told acquaintances what he was doing, and the word spread that the region was now unsafe. After the war, locals learned that he had been carrying only crates of rocks. It was a trick. It served the purpose, though—area denial—and I wonder if anyone is farming that land even now. When you've seen what these things do, you're not inclined to take chances. Everywhere I went in Mozambique, I saw land-mine victims with limbs missing, ranging in age from infants to the elderly.

The problem is, when you're a subsistence farmer, you have to grow food or starve. So what do you do? You start to mythologize the danger. Land mines become like an evil spirit, the ogre that lurks under your bed when you're a kid and leaves you afraid to step down onto the floor at night. If your child scampers into the trip wire of a fragmentation mine and is suddenly reduced to a few bloody scraps of clothing, it's because somebody has offended the ancestors. It's not because companies in Russia or India or China or the United States manufactured a lethal device and sold it for five bucks to a low-budget army. It isn't obvious that the manufacturer's government will give its taxpayers' money to the United Nations so the U.N. can hire that same manufacturer to remove that mine for a thousand dollars. All you know is that there has been no war for more than twenty years, yet your daughter, working in a field, was just blown to pieces in front of you.

A group of us visited a U.N. demining site that included the aforementioned mineral water plant. The main building, a large concrete box maybe three storeys high, had one wall blown out. A distorted vestige of the Canada Dry logo was still recognizable. Anything usable inside had long since been destroyed or looted.

A short distance down the road, a couple of dozen men were engaged in sweeping a wide field for mines. They had already lost a team member in the process of clearing the sides of the adjacent road. Each team member had been assigned a "lane" about a metre wide, which it would be his responsibility to make safe. The area overall

was about the size of a football field. We watched, sweating under a sky that seemed to radiate heat, as the men first carefully cut away overgrown vegetation looking for trip wires, then swept the ground closest to them with a metal detector. If there was no reading, they would inch forward to do it again. If the metal detector gave any sort of response, they would mark the spot and begin poking the soil with what looked like overgrown knitting needles, gingerly attempting to ascertain the outline of whatever had set it off. It might be a spent cartridge casing, it might be the lid of a soft drink bottle or a tin can, or it might be a mine.

Determining what a found object is requires exposing it to view, an act requiring archaeological patience using hands and brushes. Some mines have been in the ground long enough to become chemically unstable. Others have triggering devices that are activated by motion. The most common trigger is a pressure switch. A given mine could present a combination of all three. (More recently, deminers in Mozambique and elsewhere have been employing a species of large sub-Saharan rat, harnessed and trained to sniff out TNT, but once a mine is located it still has to be deactivated by a human.)

Demining is very stressful and, much of the time, very boring. By the time you're halfway down your one-meter lane, having turned up nothing but the foil from a cigarette package, you may start to lose your edge. You may get a little careless. While you're on your knees, one of your feet might stray into an uncleared area. You might push your probe a little too hard. There is no margin for error.

As we watched, someone turned up a mine, so we were treated to the spectacle of its destruction. As per the preferred remedy, it was to be surrounded with plastic explosives and blown up where it sat. We all retreated to a safe distance while a charge of C4 was laid next to the mine. On a signal, a team member threw a switch and a patch of ground fifty metres away erupted with a heavy *whump* into a dense cloud of smoke and dust. A staccato rattle of pebbles peppered downward into the silence that followed. The men mopped the sweat from their eyes and went back to their work.

*There's a broad river winding*
*Through this African lowland*
*The moon is held up orange and big*
*See it raise its hands*
*And the last ferry's pulling out*
*With no place left to stand*
*For the mines of Mozambique*

*There's a wealth of amputation*
*Waiting in the ground*
*But no one can remember*
*Where they put it down*
*If you're the child that finds it there*
*You will rise upon the sound*
*Of the mines of Mozambique*

*Some men rob the passersby*
*For a bit of cash to spend*
*Some men rob whole countries dry*
*And still get called their friend*
*And under the feeding frenzy*
*There's a wound that will not mend*
*In the mines of Mozambique*

*Night, like peace,*
*Is a state of suspension*
*Tomorrow the heat will rise*
*And mist will hide the marshy fields*
*The mango and the cashew trees*
*Which only now they're clearing brush from under.*

*Rusted husks of blown-up trucks*
*line the roadway north of town*
*like passing through a sculpture gallery*

*War is the artist*
*but he's sleeping now*

*And somebody will be peddling vials of penicillin*
*stolen out of all the medical kits*
*sent to the countryside.*

*And in a bare workshop they'll be molding plastic*
*into little prosthetic limbs*
*for the children of this artist*
*and for those who farm the soil that received*
*his bitter seed. . . .*

*The all-night stragglers stagger home*
*Cocks begin to crow*
*And singing birds are starting up*
*Telling what they know*
*And after awhile the sun will come*
*And we'll see what it will show*
*Of the mines of Mozambique*

"THE MINES OF MOZAMBIQUE," 1995

In 1992 the Vietnam Veterans of America Foundation (VVAF) spearheaded the creation of the International Campaign to Ban Landmines (ICBL), a coalition of more than fourteen hundred NGOs including Human Rights Watch, the Mines Advisory Group, Physicians for Human Rights, and Medico International. Four years later the government of Canada became the first nation to pick up the issue from the ICBL and convene an international summit. Fifty governments and observers from twenty-four other countries met in Ottawa to develop a treaty to ban land mines. Just a year later, on December 3, 1997, the Anti-Personnel Mine Ban Convention—otherwise known as the Ottawa Treaty—to ban the production, stockpiling, and use

of land mines was opened for signing. It was the most quickly drafted and ratified international arms treaty in history, and it earned Jody Williams, whom VVAF had hired to organize the campaign, and the ICBL the 1997 Nobel Peace Prize.

We staged a celebratory concert during the proceedings, featuring Jann Arden, Jackson Browne, Chude Mondlane, and me. It was in the Ottawa Convention Centre, a couple of hundred metres from Parliament Hill, and was well attended. Bobby Muller, head of VVAF, spoke, as did Lloyd Axworthy, then minister of foreign affairs under Prime Minister Jean Chrétien. One hundred twenty-two nations ratified the treaty right away, and since then another thirty-nine have signed on. Several have not, however, including the obvious suspects: Russia, China, North Korea, South Korea, Cuba, Pakistan, Saudi Arabia, Egypt, Israel, and also, glaringly, the United States.

In 2010, when the Obama administration was making noises about possibly signing the Ottawa Treaty (which, by the end of 2013, it had not), the right-wing Heritage Foundation objected, saying, "Such a ban applied to the U.S. would seriously degrade the ability of the U.S. to defend itself and its allies, particularly in Korea. Furthermore, the very process by which the convention was created is objectionable because it undermines responsible diplomacy and the sovereignty of the United States and other nation-states. The U.S. should shun the Ottawa Convention and the associated process, and instead pursue reasonable arms control through serious diplomacy."

"Reasonable"? The U.S. has more munitions at its fingertips than all other nations combined, yet a lack of land mines would somehow "seriously degrade" its ability to defend itself? Any minute now, one of those Heritage guys is going to propose mining the U.S.-Mexico border.

Fortunately, not everyone in the States is as off-kilter as the Heritage Foundation and its brethren. Whereas the United States has failed to ratify the treaty, land-mine production in the States ended in 1997, and since then the American government has pumped $2 billion into

land-mine removal in several countries, according to the *Los Angeles Times.*

The Ottawa Treaty led to rapid demining in some small nations. According to the *Landmine and Cluster Munition Monitor,* by 2011 fourteen nations had been completely demined, including Nepal, Rwanda, and the Central American countries of Nicaragua, Costa Rica, El Salvador, Guatemala, and Honduras. In addition, casualties from land-mine explosions dropped from 11,700 in 2002 to 4,286 in 2011. (The imperative now is to reduce that number to zero.) The land-mine treaty serves as an excellent example of how humans can reduce military and other threats to their well-being and to our planetary ecosystems.

The 1996 Ottawa summit occurred one year after my land-mine caper in Parliament, which I like to think helped push the process forward. A gentleman from one of the demining NGOs had lent me sample mines for our speaking tour. They were an effective aid in getting the message across to an audience for whom the whole issue is pretty abstract. I was accompanied on the tour by Chude Mondlane and Michael O'Connor, executive director of COCAMO. Each of them spoke passionately on the issue from their own perspective. I'd haul the five land mines around in a satchel and pull them out at a strategic point in my presentation—"here's the Canadian one, here's the Chinese one, these are Russian, that one's American"—a serviceable graphic.

The tour culminated in a visit to Parliament to meet with interested members, in particular those supporting Reform Party MP Keith Martin's private member's bill calling for a land-mine ban, at that time before the House. We also carried a petition, on which we had gathered some sixteen thousand signatures, demanding a land-mine ban. We secured a room in the basement of the Centre Block of the Parliament buildings to hold a press conference and present the petition. I figured my samples would make an effective display for the cameras.

It was easy—a little too easy, really—to stroll into Parliament with

my sack of latent devastation. This is Canada. Nobody carries a gun. There were Royal Canadian Mounted Police officers in the building as well as commissionaires who are partly tour guides and partly security—generally ex-military types who know what they're doing, but overall a very light security presence. I arrived a few minutes ahead of our 9 A.M. press conference, and the "guard" waved me through, bulging bag and all. Today, post-9/11, I'd probably have been handed over to the CIA and rendered to some cattle-prod dictatorship, but everything was more innocent back then.

A dozen journalists drowsed in folding chairs, some behind TV cameras. They were bored, expecting little, licking doughnut frosting from their fingers. We took up our position on the podium, and I pulled mines from the bag and plunked them onto the heavily varnished plywood table surface. *Thunk! Thunk!* Cameras closed in. The reporters, suddenly awake, craned their necks to see. The two security men at the back of the room, discreetly outfitted in grey flannels and blue blazers, looked at each other in a charming caricature of apprehension. We made our statements, answered some questions, and then left.

Around noon I returned to Parliament for a planned lunch with some MPs. Carrying the same shoulder bag, I arrived punctually. This time they saw me coming. A security agent in a different uniform approached and said, "Mr. Cockburn, can we see you for a minute?" Instantly I was encircled by six more like him. It had been a long time since I'd felt this much at home in Ottawa.

"Can we look in your bag, please?"

"By all means," I said, "but before we do that, I think we should move down the corridor. Passersby might be nervous about the contents." Tense, scattered glances all around—isn't this the guy who wished he had a rocket launcher? "I've got inert land mines in my bag," I said, "but you know that—that's why you're here, right?" We moved, them shuffling as a unit to keep me surrounded, ten feet down the hall. One of the officers said, "Are you *sure* these things are inert?" I couldn't help myself. "Oh yes! I'm pretty sure they are, really," I said, then pulled them out and held them up. No one relaxed.

Five little pretend bombs. I was earnestly admonished not to bring them with me again.

I've mentioned that I don't go to war zones looking for song material. That said, I try not to block ideas if they come. I wrote "The Mines of Mozambique" on September 11, 1995, in a sparsely furnished hotel room in Quelimane. For a complex song, it came rather quickly. The issue was compelling and the images strong. That song, and parts of "The Coming Rains," poured out over the course of an all-night vigil by my wide-open window.

I enjoyed traversing the countryside and meeting the inhabitants, even though they were to a great degree demoralized and self-contained. A vestigial sense of humour had survived. At one point I found myself amid a tiny cluster of houses where the old folks poked me and said, "Hey, I'm really glad you're here because the little kids have never seen a white person." Then, to the kids, "See, that's what they look like"—*poke*—"that's one there." As the newly arrived exotic, I got to sit in the only chair they had in the village. First they had to go and fetch the thing, which took about half an hour, while I stood around and wondered what they were doing. Eventually someone showed up with a little wooden school chair. They plopped it down under a big shade tree. An elder smiled and gestured and said, "Sit down," so I did. Soon they began preparing lunch, which was preceded by a little boy chasing a chicken around the yard. He speedily captured the bird and deftly decapitated it with his bare hands.

These folks were canny. They understood that if you can afford a plane ticket to get to this little village in the middle of the bush, you must be good for more than just teaching the kids what a white person looks like. They asked me for a bunch of stuff that I couldn't possibly deliver, but it was in these moments that I rededicated myself to committing time and media capital to ridding their homes of the land-mine scourge. They had paid many times over for that and more.

No matter how lightly you travel, your baggage always comes with you. I spent three weeks on the east coast of Africa living out of a small backpack and a guitar case, but the loneliness I've borne from birth, and the bruises and stretch marks the experience with Madame X left

on my heart, remained present. We can't deny our own stories, no matter where we are. So even in Mozambique, I found myself haunted.

*All day the mountains rose behind a veil of smoke from burning fields*
*And road dust dyeing black skin bronze and the road rolling*
*like a rough sea*
*It's quiet now, just crickets and a dogfight somewhere in the far away*
*In my heart I hold your photograph*
*And the thought of you comes on like the feel of the coming rains*

*Hot breeze ran its fingers through the long grass of a thatched roof eave*
*They stuck me in the only chair they had while they cooked cassava*
*And a luckless hen*
*They asked for one well three lanterns and 200 litres of fuel and*
*I said, "Who, me?"*
*And the time for planting's coming soon*
*And the thought of you comes on like the feel of the coming rains*

*In the town neon flickers in the ruins*
*Seven crows swoop past the luscious moon*
*If I had wings like those there'd be no waiting*
*I'd come panting to your door and slide like smoke into your room*

*All day the mountains rose behind a veil of smoke from burning fields*
*And road dust dyeing black skin bronze and the road rolling*
*like a rough sea*
*It's quiet now, just crickets and a dogfight somewhere in the far away*

*In my heart I hold your photograph*
*And the thought of you comes on like the feel of the coming rains*

*And the time for planting's coming soon*
*And the thought of you comes on like the feel of the coming rains*

"THE COMING RAINS," 1995

From the wreck of a nation, I returned home to one of the world's wealthiest countries (today Canada generates more landfill trash per person than anywhere else on earth) and the wreck of my romantic life. Back at the horse farm, I became increasingly withdrawn. Before leaving for Mozambique, I had written a song called "Pacing the Cage," which more or less expressed my ever-darkening mood. Sue heard me practice the piece. Later she said, "I knew we were finished when I heard that song. A happy person is not going to write something like that."

*Sunset is an angel weeping*
*Holding out a bloody sword*
*No matter how I squint I cannot*
*Make out what it's pointing toward*
*Sometimes you feel like you've lived too long*
*Days drip slowly on the page*
*You catch yourself*
*Pacing the cage*

*I've proven who I am so many times*
*The magnetic strip's worn thin*
*And each time I was someone else*
*And everyone was taken in*
*Powers chatter in high places*
*Stir up eddies in the dust of rage*
*Set me to pacing the cage*

*I never knew what you all wanted*
*So I gave you everything*
*All that I could pillage*
*All the spells that I could sing*
*It's as if the thing were written*
*In the constitution of the age*
*Sooner or later you'll wind up*
*Pacing the cage*

*Sometimes the best map will not guide you*
*You can't see what's round the bend*
*Sometimes the road leads through dark places*
*Sometimes the darkness is your friend*
*Today these eyes scan bleached-out land*
*For the coming of the outbound stage*
*Pacing the cage*

"PACING THE CAGE," 1995

Of course "Pacing the Cage" wasn't just about me and Sue, or the horse farm, or even my impossible longing. When you compose a song, it's likely to be very personal, very specific. Once you throw it out into the world, everyone who hears it perceives it through the filter of his or her own feelings and experiences. It becomes universal, touching some common wound we all bear. As always, I took what was in front of me and put it on the page, then spun it: I really did look at the sunset and see the suggestion of an angel weeping, holding a bloody sword; I really did tire of showing or swiping my ID at every airport or checkout stand, as if I didn't exist without such proof; I really had come to understand that the dark of night is as likely to hold protection as threat.

In 2008 singer-songwriter Jonatha Brooke, who contributes so soulfully to the album where these songs appear, kindly described "Pacing the Cage" as "one of the all-time best-written songs." I do think it's one of *my* better songs. An upset fan, by a lamp-lit stage door after a show somewhere, said, "It sounds like a suicide note." Sue had had a similar reaction. In a metaphorical way, I suppose it was. I wasn't contemplating suicide, but the song *is* about waiting to get out of here. Is "out of here" out of your skin, out of a situation, out of town? You choose.

It's not an accident that "Pacing the Cage" and the opening cut, "Night Train," are on the same album. They might be thought of as companion pieces. "Night Train" was something of a personal man-

ifesto summing up my worldview at the time. Not much has really changed, at least with respect to the external images the song employs.

Despite its complexity and length, "Night Train" came to me quickly. It revealed itself over the course of one long night. It was one of the few times I have sat down with the deliberate intention of writing a song from scratch, rather than just snagging a passing idea and running with it.

There was a madness to my method: friends in Toronto were making absinthe using wormwood grown in their backyard, various herbs in accordance with old recipes they had dug up, and high test grain alcohol, which you could buy by the gallon in liquor stores in Quebec. As soon as I tried it, I asked if they would give me as much as they could spare.

Absinthe is a peculiar drink—one with a reputation, however unfounded, for inducing insanity, which resulted in a century-long ban in many countries until recently. From wormwood comes thujone, a ketone that is responsible for the drink's supposedly psychotropic effect. But because absinthe typically comes with alcohol concentrations somewhere between 50 and 75 percent, the drinker is likely to be completely shit-faced before the thujone kicks in, meaning it might not be felt at all.

That said, I had read up on absinthe, about Rimbaud and van Gogh, Satie and Toulouse-Lautrec, all major artists who were heavily into the "green fairy" and who believed it affected their art. So I thought, "What the hell, I'm going to see what all the fuss is about." I set myself up at my desk with my bottle of absinthe, a beaker of water, and a bucket of ice, told Sue not to wait up for me, and commenced to consume the bitter beverage. I didn't bother with the extra ritual of pouring ice water over sugar. I found that when watered down to the proper degree, it was palatable enough. The thujone first announced its presence in the sudden, sweet musicality of ice cubes tinkling against the side of my glass. I sat sipping, pondering, refilling the vessel. For a while it seemed like my experiment would come to naught. I happened to glance up at the shelves of poetry above the

desk. My eye fell on Juan Felipe Herrera's *Night Train to Tuxtla.* Suddenly everything was there. The song unfolded like a dream: a verse or two, then a pause, another verse. It came with a visual, a mental scenario for a video, which I also wrote down and hoped to use, but which was killed by the powers that control videos. (The video that eventually did come out of the song worked out well, and of course it included a train.)

In the treatment I wrote, a uniformed policeman walks into a seedy bar alongside the railway tracks, takes off his hat, sits down at a table, and has a drink. Around him is a motley collection of rough-looking people, mostly men. It's shot film-noir dark, shadows clinging to the edges of every person and object. He's there to collect his protection money, which is delivered to him in a paper bag, as if takeout food. In due course he leaves, but he is slugged on the head as he crosses the shadowed railway track. He falls to the ground, unable to stop his assailant from grabbing the bag of money and running off. In the last shot, his head is on the track, his eye in line with it, and we see the steel rail from his perspective, disappearing into the out-of-focus distance. I would have cast myself as the cop.

*Not a knife throw from here you can hear the night train passing*
*That's the sound somebody makes when they're getting away*
*Leaving next week's hanging jury far behind them*
*Prisoner only of the choices they've made*
*Night train*

*Ice cube in a dark drink shines like starlight*
*The moon is floating somewhere out at sea*
*I'm an island in the blur of noise and colour*
*Alcatraz, St. Helena, Patmos, and the Château d'If*
*Night train*

*And everyone's an island edged with sand*
*A temporary refuge where somebody else can stand*

*Till the sea that binds us like the forced tide of a blood oath*
*Will wear it down—dissolve it—recombine it*

*Anyone can die here they do it every day*
*It doesn't take much effort though it goes against the grain*
*And the ultimate forgetfulness of violence*
*Sweeps the landscape like a headlight of a train*
*Night train*

*Ice cube in a dark drink shines like starlight*
*Starlight shines like glass shards in dark hair*
*And the mind's eye tumbles out along the steel track*
*Fixing every shadow with its stare*
*Night train*

*And in the absence of a vision there are nightmares*
*And in the absence of compassion there is cancer*
*Whose banner waves over palaces and mean streets*
*And the rhythm of the night train is a mantra*

"NIGHT TRAIN," 1996

We all make choices, and we have to live with them. Sometimes those choices are neither wise nor fruitful. In the song the train starts off as a getaway vehicle, an escape from external bonds. One of the seductive aspects of travel is the illusion of freedom, but on the road we're trapped just as much as at home. Our demons travel well. No man is an island. At the subatomic level we are as connected to each other, and to everything else, as if we all share organs. At this level, prayer, as a focusing of spiritual energy, has tremendous power. This is where we find Charles Williams's Co-inherence, the unified Divine presence that exists in each other. To the extent that we are not conscious of that, we *are* islands. We live in the illusion of separateness. The islands in the song are not vacation spots. Alca-

traz, St. Helena, Patmos, and the Château d'If are all prison islands.

Everyone exists to some degree, at some point, as an island, iso-lated, and as such we make up a bizarre, often dark but just as often beautiful human archipelago.

We also have death in common, an island all to ourselves. "Anyone can die here, they do it every day." We try to ignore it, we play it down, but in fact it's like Ambrose Bierce's collection of darkly ironic stories, *In the Midst of Life*, a book that made a strong impression on me when I read it as a teenager. All of the tales are actually about death: death by hanging, death from the predations of a supernaturally fearsome wildcat, death by death. Bierce took his title from an eighth-century Christian aphorism (often confused for a Bible quote), "Even in the midst of life we are in death." It's so utterly inescapable. Every now and then we notice it. Most of the time we try our damnedest not to.

"Night Train," "Pacing the Cage," "The Coming Rains," and "The Mines of Mozambique" all appear on my 1996 album *The Charity of Night*. Several important elements coalesced on this record, includ-ing some of the finest musicians and singers in North America. It was also the first collaboration between Colin Linden and me as coproducers. I insisted on the "co-" designation because I wanted to be in the driver's seat, but Colin did most of the work. He was the one with the studio expertise—knowledge of microphones, how to get desirable drum sounds, and the like. We kept up the charade for a couple of albums and then dropped it, subsequently listing him as producer. I have as much control over what happens during the mak-ing of an album as I've ever had and have ever needed.

*The Charity of Night* was my second recording with Toronto's Gary Craig (the first was *Christmas*), one of the best groove drum-mers on the planet, and he has appeared on every album since. Gary is a gifted musician, very tasteful, and he can be subtle or explosive where needed. I was excited to bring in Rob Wasserman as bassist. The folds and textures of Rob's playing are bold and magical through-out the album. He is a master bassist, highly individual, melodic, adept at playing in and around other sounds. Janice Powers added

lovely, atmospheric keyboard on four of the tracks, and classical accordionist Joe Macerollo played on the title song. We were also blessed with beautifully creative background vocals by Jonatha Brooke and Patty Larkin, and Ani DiFranco. Bob Weir made a guest appearance, which we recorded at his house in Marin County. While we were there, Maria Muldaur happened to drop by, and her soulful voice became part of the mix.

The album's "foil" was vibraharpist Gary Burton. I had thought that the sound of vibes would complement Wasserman's upright bass sound, each of them bracketing the guitar with its distinctive colour.

*Me, Gary Burton, and a fine burgundy during the recording sessions for* The Charity of Night

I thought if we were going to have a vibes player, we might as well ask the best one. Right away he said yes, and he's present on about half the record. His countermelodies and riffs on *The Charity of Night* are sublime.

Burton was a dean at the Berklee College of Music when he recorded with us. He's a brilliant musician and theorist, and a champion multitasker. Because the vibraharp is a subtle instrument, we put him in an isolation booth, and when he wasn't playing we'd hear him through the live mics, clacking away on a laptop. When it was his turn to play, the laptop would go down and the mallets would come up, and he'd be perfect.

He and I play an instrumental duet, "Mistress of Storms." What you hear on the album is a first take, which is remarkable enough, but the first time Gary heard this complex piece was ten minutes before we recorded it. I played it for him, and as fast as I was playing he was scribbling down the notes. By the time I was finished, so was he. I couldn't believe what I was seeing. He got one note wrong: a C sharp instead of a C natural. Then we recorded, and Gary nailed it.

Another guest artist on *The Charity of Night* played on just one song, but her part is a highlight of the album: Bonnie Raitt contrib-

uted slide guitar on "The Whole Night Sky." Inviting Bonnie to play caused a minor stir in our musical family, because Colin Linden is among the best slide players in the world. He was a bit put out that I didn't want him to play on the song, but if you're going to be supplanted by someone, it might as well be Bonnie Raitt, who is a very soulful and intuitive player and, of course, she's Bonnie Raitt. What she gave to that song no one could have duplicated, it came from such a deep place in her heart.

I used to run into Bonnie in the seventies at folk festivals. At that time Kitty had a flirtation game going with Bonnie's bass player, Freebo. Bonnie and I got reacquainted in the late eighties, when we were on the same bill at a couple of festivals. A dedicated environmental and human rights activist, she has organized and more than once been arrested at rallies and protests. Like Jackson Browne, she is one of those high-profile performers who leverage their fame to benefit good causes.

*Sitting in with Bonnie Raitt, mid-nineties.*

Bonnie is deservedly known as a singer and has had her share of hits, but she has long since proved herself as an exciting and soulful blues guitar player as well. I thought, "Bonnie's so famous now, a million people must ask her to sing on their records. I wonder how many people ask her to play guitar?" Even though we were pretty small potatoes in her world, I thought she might get a kick out of the invitation, and she did.

Bonnie was nervous about her part, which we recorded at the Record Plant in Sausalito, California. The Record Plant was a historic establishment that had been the scene of much psychedelic music making in its heyday. It still had decor featuring curvy, swollen

mushrooms. We were proudly shown the echo chamber in which Jim Morrison shuttered himself to perform the vocal on something or other. Sausalito, with its stereotypical Bay Area beauty, is a wealthy and once-hip Marin County village fronted on the shore of San Francisco Bay by a flotilla of houseboats, just two miles from the Golden Gate Bridge. We played the track while Bonnie sat there with her guitar and listened, her face framed by crimson hair with its distinctive silver streak. She stuck a finger in the slide and stroked out a gorgeous set of riffs. She didn't think it was good enough. She went at it a few more times. It kept getting better, and we ended up with the heartbreakingly haunting cry you can hear on the album. We were in there for a while. She felt like she had taken so much of our time that she offered to pay for the whole session herself, which of course we wouldn't let her do. What she did for that song would have been worth days of recording, even at the Record Plant, which was not cheap. (The studio closed in 2008.) Bonnie left us with a plaintively lovely guitar part that sings as much as I do about the melancholy chambers of the heartbroken soul.

*They turned their backs*
*I made it too hard*
*Every place they touched me*
*Is a laceration now*

*Sometimes a wind comes out of nowhere*
*And knocks you off your feet*
*And look, see my tears*
*They fill the whole night sky*
*The whole night sky*

*Derailed and desperate*
*How did I get here?*
*Hanging from this high wire*
*By the tatters of my faith*

*Sometimes a wind comes out of nowhere*
*And knocks you sideways*
*And look, see my tears*
*They fill the whole night sky*
*The whole night sky*

"THE WHOLE NIGHT SKY," 1994

What doesn't kill you makes for songs. All the angst I lived with through the nineties fed some pretty good songwriting. *The Charity of Night* might be my finest record, a pronouncement I don't make with any attachment because these things are so subjective, but others besides myself have thought so. In 1997 *The Boston Globe* called it my "sterling new album," and the *Houston Chronicle* said it offers "a deeper vision of what contemporary music can be." The hometown press was quite kind, with the *Toronto Star* reporting, "There will be many Canadian worldwide record releases this year, but none is likely to resonate with the haunting, expansive heft of this one. Probing imagery of darkness with the flashlight of hope, Bruce Cockburn's *The Charity of Night* is likely to be remembered as one of the most devastating musical metaphors of the 1990s."

*Charity* was recorded aggressively, with relatively little overdubbing, so it has the vitality of a live recording. T Bone's influence contributed something as well—though I'd gotten over the notion of writing "simple" tunes, and I brought jazz back into the sound.

Mostly, though, *The Charity of Night* and the next album, *Breakfast in New Orleans Dinner in Timbuktu*, reflect, in a time-lapse manner, the slow unfurling of a life. I wrote songs when they needed writing; I played them where and when I could, but mostly where and when I wanted. I didn't want to be a Jimi Hendrix, strung out on a plane for months on end. I was conscious of listening and looking out for the next important thing. I have neither sought nor even really wanted fame, but I have always been grateful that my modicum of commercial success has allowed me, my entire adult life, to explore

and experience music in all the forms that I could engage with.

At the same time, I wanted to know neighbours, women, children, God. I wanted to see the world. I did all of these things while harnessing creative energies when they came to me. There was no rush in any of it, much to Bernie's chagrin. Change is good and history is now. I needed to take these things at my own pace, along my own evolutionary track, and I think my albums reflect this patience as well as a few things learned along the way.

The song "The Charity of Night" offers three separate vignettes spanning thirty years. It has already been quoted twice in this book, with scene one describing the predator on the Stockholm bridge in 1964, stalking the nineteen-year-old boy who happens to have a pistol in his pocket. Scene two was Honduras in 1985, as a bemused traveller watches the government of El Salvador bomb its own people. And the third scene? The journeyers meet, "can't say when" or where, embracing the slow turning of the Wheel of Life, classically immersed in the painful, beautiful, and never-ending process of growing.

*Pacific glimmers silver*
*Moon full over shadow mansion*
*West coast—Can't say when*
*There is incense and the heat-driven scent of flowers*

*Tongue slides over soft skin*
*Love pounds in veins brains buzzing balls of lust*
*Fingers twine in wet hair*
*Limbs twist and roll*

*On the dresser wax drips in slow motion down the long side of*
*A black candle*
*Ecstatic halo of flame and pheromone*

*Wave on wave of life*
*Like the great wide ocean's roll*

*Haunting hands of memory*
*Pluck silver strands of soul*
*The damage and the dying done*
*The clarity of light*
*Gentle bows and glasses raised*
*To the charity of night*

"THE CHARITY OF NIGHT," 1994

*The Charity of Night* represents an evolution of songwriting and collaboration, and may be viewed as the record of a personal journey involving love, mystery, knowledge, and energy. While the songs stand on their own, they are also intimately connected with my past and the lives of many others, a cinematheque of lovers, landscapes, war zones, books, art, history, ideas, trauma, joy, friends, enemies, families, fear, enthusiasm, and music. There is refuge in the darkness, light in the music, and life in the amative soul. Though unnamed, Ani DiFranco makes an appearance in "Birmingham Shadows," an account of our perambulation through the orange vapor-glow haze of a muggy Alabama industrial park after a festival gig. It's a tale I tell at a walking pace about my strong but star-crossed wish to be closer to this gyre of seemingly boundless creative energy.

Mozambicans are in the studio with us, fused with Madame X, Bernie, Mayans and Nicaraguans, Jesus at the altar, Kitty and Jenny, Judy and Sue, mountains, weapons, Chileans, my parents and brothers, lovers and stalkers, Toronto, Italy, Atlantic freighters, jet fighters, and the last wild hot spring. Jonah shows up too, not sleeping through the tempest but lashed to the wheel, whipping *into* the storm, agape at refinery flames rising broken, red, and riveting. A glass of fine red wine gently tosses back the sparkle in the centre of my lasered eye, while the other warily watches a cop's thumb release the safety on his submachine gun. The album is backlit by black candles brightly burning. It's imbued with mysteries and scouring secrets, as well as sometimes soothing expeditions of the searching Fool. These songs,

their stories, come from life. They are not reproductions of life. They spring from a confidence that God, in leading me beside what at times have been very strange waters, knows what he's doing.

> *I've seen a high cairn kissed by holy wind*
> *Seen a mirror pool cut by golden fins*
> *Seen alleys where they hide the truth of cities*
> *The mad whose blessing you must accept without pity*
>
> *I've stood in airports' guarded glass and chrome*
> *Walked rifled roads and land-mined loam*
> *Seen a forest in flames right down to the road*
> *Burned in love till I've seen my heart explode*
>
> *You've been leading me*
> *Beside strange waters*
>
> *Across the concrete fields of man*
> *Sun ray like a camera pans*
> *Some will run and some will stand*
> *Everything is bullshit but the open hand*
>
> *You've been leading me*
> *Beside strange waters*
> *Streams of beautiful lights in the night*
> *But where is my pastureland in these dark valleys?*
> *If I loose my grip, will I take flight?*

"STRANGE WATERS," 1995

# 20

"Strange Waters" is the closing song on *The Charity of Night*. When I was in public school, it was still the norm to have a religious component of primary education. The twenty-third Psalm was a significant part of that, though I don't think I understood much of the King James English. It was a mystery to me why I would not want the Lord my shepherd. ("The Lord is my shepherd; I shall not want.") And why would I want to eat dinner in the presence of mine enemies? ("Thou preparest a table before me in the presence of mine enemies.") Reciting it always left me with a dark, moody feeling.

Similarly, one November night, as I was watching a river of Toronto headlights rush along the 401, North America's busiest highway, a parallel Psalm took shape in my mind. There were no still waters. All was turmoil, strangeness. I started listing scenes, moments, reflections. Where I stood did not feel like any kind of resting place. I barely recognized the person who stood in my boots, yet I was gripped by the understanding that all was familiar. My Psalm was addressed to the same God as "Lord of the Starfields," twenty years before, but a lot of river had passed under the bridge. So much learned, so far to go.

The words that came wanted the edginess of electric guitar and drums. They felt best against the hollow tone of a National Resolectric guitar. We overlaid a crunchy rhythm part, and I gave myself the present of an electric lead, something I never get enough of.

Harmonies by Jonatha Brooke and Patty Larkin are spooky and glorious, floating above the rumble of Rob Wasserman's bass and Gary Craig's drums.

The song was meant as a prayer, but it's also something of a stock-taking: here's some pretty cool music, plus a window into where I've been, what I've done, whom I've loved, what I've seen—it doesn't get much stranger than this. Funny, though, I hadn't yet been to Mali, Vietnam, Venezuela, Iraq, or Afghanistan, hadn't seen Angkor Wat or the Mount of Olives, and it would still be five years before I'd find myself racing to cross the Canada-U.S. border on September 11, 2001. "Strange" is relative. I also hadn't yet walked away from the horse farm.

Brave as she was when it came to all things equestrian, Sue felt threatened by the world in which I literally travelled, the musician's touring life, which had resumed in earnest upon the release of *Nothing but a Burning Light*. She mistrusted my relationships with my friends. Her idea was to create a nest for me to shelter in when I came home, but as time went on the nest acquired a psychic barbed-wire boundary, outside of which I was supposed to leave everything else that I considered valuable. I didn't want the shelter of a "nest" at all. After the fact, it slowly became clear to me that Sue and I should never have been together in the first place. Seven years had to pass before I worked up the clarity and the nerve to extract myself from a situation that over time had come to feel more and more like starvation.

One day in the summer of 1995 we had been grumbling at each other about something, and Sue confronted me about my ongoing lack of spark.

"Why are you here?" she asked.

"I'm here because I said I'd be here."

"Well, don't do me any favours!" she said. "Love comes and love goes."

It certainly does. It took me more than a year after that to put the *going* into motion. It was a crisp January night, and while the year that ensued had seen some laughter and affection between us, clearly nothing had gotten any better.

"Well, what's going on?" Sue asked.

"I don't think I love you anymore."

Pain shot across her face, immediately replaced by a blaze of bitter anger.

"Well, you better get out then," she said.

The next day I was gone. I called a moving company and put all my belongings, except for clothes and instruments, into storage. I called my friend Linda Manzer and asked if I could stay in her extra room for a while. Between Sue and me there was almost no dialogue: no explanation, no conversation, nothing. Later we talked, but more about the technicalities of the breakup, how to settle the business end of a failed relationship. Issues of the heart went unplumbed. She had horses to feed. I gave her all the money I had. I moved out virtually penniless but wide open to a beckoning future. I raised my sights from the psychic forge and locked onto a new day.

I didn't care much about the money, though I had gotten used to a certain level of the sort of security we think it brings. I gave it up with some trepidation, but I had God and I had me—and though I'd experienced many doubts about myself, I trusted that I would end up where I was meant to be. If I were destined for a downward spiral into obscurity and penury, so be it. I had always been homeless in my heart. The streets were not alien territory.

The farm, the horses, and the pets were memories now, each painted with a spatter of pain. My heart and thoughts remained true to Madame X, my grail. She had been a gateway leading out of a lifetime of imprisoned emotions, and I loved her, but I would never have a life together with her. Someone said to me, "The swiftest bird flies alone." I took flight.

Linda had recently purchased the old rooming house in Cabbagetown, the partly gentrified neighbourhood of Toronto, where she'd

been living and was gradually converting it back to a single-family dwelling. She and I had been acquainted since the seventies, when she was apprenticing with guitar maker Jean Larrivée. Eventually she established herself as a luthier in her own right. We got to know each other better in the late eighties, when I commissioned a couple of instruments from her. The three acoustic guitars with which most people will picture me were built by Linda Manzer.

Linda still had a ground-floor room with its own shower. She had built in a loft bed, constructed with predictable precision. This she said I could have, so I ended up living there for a year. Bernie, bless him, artfully kept the business going for me, but for a while I was very careful about how I spent my money. I discovered that I had unknowingly accumulated quite a few bonus points on one of my credit cards, and with those I bought a pressure cooker and a few other useful items. Later, in some Montreal bar with Jenny, listening to an all-girl punk band, I realized, in an epiphanous moment, that I could cut my own hair and stop having to put out hairdresser's fees. I've been cutting my own hair ever since.

I took on an attitude of waiting. Somewhere I ran into Martha Ross, another refugee from the horse world and a broken marriage. We went out a few times, which helped stave off loneliness somewhat for both of us. Linda and her partner, Sarah, proved themselves to be true friends, as did the little posse of people I had hung with through the eighties: the Cade sisters, Jonathan Goldsmith, and Hugh Marsh. And John and Matt, my sources of absinthe. A lot of people were there for me. After a while, they all knew the broad outline of the Madame X story, though not her identity, which I had sworn not to reveal. I kept up regular visits to the gun club. I toured. I appreciated my friends and family.

It was three years from the millennium, but I noted parallels to when I had dropped out of Berklee, despite the wide gulf in years and circumstance. Both were major life transitions, running leaps into the unknown, and in both cases I knew they were exactly what I needed to do.

The differences were pronounced as well. This time I was deep into career, about to turn fifty-three. My daughter was twenty and starting to thrive, as I'd always wanted her to, as I'd prayed she would. I had a bunch of decent records circulating among my fellow earthlings, though I wasn't even sure I would continue to write songs. Parting company with Sue seemed like the end of a particular road, the end of choices made for reasons I could not clearly articulate or understand. There was nowhere left to go in that direction. I welcomed the transition and determined to no longer live in a state of alienation from my own feelings or the feelings of others. I would dissolve the psychic restrictions that held me back.

I was conscious of embracing renunciation. Renunciation means different things to different cultures, but the basic idea is that you free yourself from the attachments to all the material junk in your life, which is almost everything, in order to be open to, and aware of, the workings of the Divine. Renunciation allows the cosmos and one's uncrowded mind to decide the next move. I was staring into a welcoming but also frightening dark current, which I insisted on fording alone.

On tour in Europe in early 1997, it occurred to me that perhaps loneliness was the proper state of the artist, or at least *this* artist— that loneliness is the penalty for the selfishness inherent in the job and its accompanying public position. Travelling across the Old World, the pages of writing I put into my notebooks bled out of that solitude— lyrical but not lyrics, poem fragments, fears, fleeting love. . . . I clutched at a cathartic countdown toward whatever might be next.

---

*The train is full of lovers as I go back to my room under the eave,*
*on the eve of the millennium, now almost two thousand years*
*from when the Christ was probably not born, son of Adam son of Eve,*
*dark Madonna of the earth —*
*and to the earth we shall return, flames of Eden lighting our way.*
*Rain crashes in the street like bullets.*

*In a doorway lovers press together, everything glistens. The sewers roar. Thawed ground squishes underfoot.*

*I gaze at the rune thinking hard of you. The stone shouts joy.*

*Out of heaven's wet matrix rushes beautiful rain beautiful rain beautiful rain. You're a knife in the heart of my life, gushing crimson spring.*

*The flower of passion, of longing, blooms against my heart, carved from ancient bone, passed from hand to hand, finally yours to mine.*

*Cascading images from Neruda, read and reread (the yellow heart!), drench me, merge with the red rush to feed a sea where I float.*

*I can't find anyone.*

*I've torn apart cities looking and I can't find anyone like you.*

*When I find what prison you're in I'll breach it, kill the jailers, or maybe they'll be powerless and I won't have to.*

*When I'm gone and the silence remains, me not even a shadow flash-burned on nuclear-blasted wall, will I still have some meaning for you?*

*Distracted from thought or intent by some quick flicker of passing light or unexpected spike of pain, will you see me, if only faintly?*

*Picture me smiling—I know you've seen it.*

*Picture what my tongue said to you before the brain and life got in the way. Evidence keeps appearing of the great web of love with which God has surrounded us.*

*Love at arm's length—the kind I can reciprocate without hurting anyone.*

*Where are you?*

*No contact.*

*How are you?*

*No contact.*

*How do you feel about me? Now?*

*No contact.*

*When does it become too much and I just shut down?*

*I waited as on Circe's isle, refused to turn into something I couldn't*

*recognize, waiting for the right wave. When it came I rode it to the*
*open sea. I didn't know where it would take me. I stood and waited*
*for the sign, never strayed back from the edge, now it's time and I*
*leap into the arms of the whirling sea —*
*on the bottom or the other shore I'm going to find you.*
*Nothing is pure, nothing is sure.*
*I try to picture you. You're clouded by distance, by my fear for your*
*welfare. I see you as I last did, eyes filled with sadness, enigma.*
*I want to see you laughing in the light, each golden candle flame a*
*rainbow nimbus gleaming off shiny miracles.*
*For defense: A bullet of pure turquoise to pierce the spirit of whoever*
*would hold you back.*
*Tiny flower of bone or ivory, silver setting, pressed to my breastbone,*
*instead of you.*

---

In "Fascist Architecture," I had written that Kitty "tore me out of
myself alive." The same thing happened with the Madame X experi-
ence. It was cycles later and at a different level, but both left me raw
and in a kind of spiritual growth spurt. It was as if God were oversee-
ing my basic training. The military tears you down to nothing and
then rebuilds you in the mold they want. The fires of crisis often
afford an opportunity to rebuild ourselves, to move forward from
the embers into the arms of God.

*You knelt on the carpet, crimson and stained*
*Light trickled over your black dress like rain*
*Your lips were hot and my shocked heart screamed*
*And I can't scrape my eyes free of this dream*

*We each occupy the same space/time*
*Matter, anti-matter, tangled like vines*
*And the awful tolling, and the cold rain outside*
*And I cannot scrape this dream off my eyes*

*And the embers of Eden burn*
*You can even see it from space*
*And the great and winding wall between us*
*Seems to copy the lines of your face*

"EMBERS OF EDEN," 1997

One hopes it doesn't take too many more of these cycles. "Embers of Eden" is on *Breakfast in New Orleans Dinner in Timbuktu*, my twentieth studio album (and twenty-eighth album overall) in twenty-nine years. It emerged as something of a sequel to *The Charity of Night*. *Charity* reflected a clinging to fugitive bits of light in the dark. The new album was about healing, and the record is infused throughout with elements from my past. There was a scouring of old drawers for things to mix with the present. As with all the music I make, *Breakfast in New Orleans* reflects an organic, almost biological urge to produce art from the life around me—an urge that, so far, I have been able to satisfy.

*The Charity of Night* and *Breakfast in New Orleans* are really band records in a way that owes much to the T Bone influence. The band albums from the eighties, maybe with the exception of *Inner City Front*, aren't like that. They're slicker, more arranged, more pieced together, which was fine for the sound we were after. But for these last two nineties albums it felt right to loosen the reins, just letting the musicians play into their muse. We'd all go over things a couple of times to figure out what we wanted, then I'd turn them loose in the studio. The sound is dynamic, the energy high.

*Breakfast* was fresh, an enjoyable album to make. As the title suggests, in early 1998 I travelled from the Mississippi delta metropolis of pre-Katrina New Orleans to the southern Saharan nation of Mali—not in the same day, of course, but close enough. New Orleans is a delightful hodgepodge of culture, politics, history, music, and nature. It's where the vast Mississippi River takes its final turns before nurturing, and simultaneously poisoning, the

Gulf of Mexico. There is vast juju in New Orleans, dark magic, blessed voodoo, all kinds of occult elements mixed with tourism, corruption, violence, and eccentric grace. New Orleans music throbs with an ancient groove, mixing church and brothel, African and no-longer-staid European, tribal and cosmopolitan, lamentation, celebration, incantation, jazz, funk, and blues in a modern and sometimes very weird-tasting stew. The magic of the place got under my skin while we were mixing *The Charity of Night* there at Daniel Lanois's Kingsway Studios.

For months I'd been trying to drag Ani DiFranco into the goings-on, having met her at the Telluride Bluegrass Festival in June 1995. Hearing her perform hit me the same way that hearing Bob Dylan had long before. I wanted to put some of her inspiring energy on the album, in any capacity, but she was never available. I suspected she had a certain reluctance to get involved. During a break in the mixing routine, Colin, John Whynot, and I strolled down to Kaldi's, a nearby café. We had barely settled with our coffees when a couple walked in. The woman seemed familiar, but I had not gotten a good look at her. I thought, "Man, that sure looks like Ani, but no, the hair's different." Then she turned around and we both laughed. Turns out she was driving back to New York after finishing a record of her own in Austin.

"Well," she said, "I guess I'm supposed to be singing on your album!" We returned posthaste to the studio, and Ani added distinctive and luscious harmonies to what Jonatha Brooke had done on "Get Up Jonah." It was a gift. It would have been a perfect meeting of spirits, except I had to play the more or less finished version of "Birmingham Shadows" for her. She was not aware of the song until that moment. I got all shy and tongue-tied at the end of it. I said, "There it is—it's yours." Then I thought that sounded like there was some obligation attached to it, which there was not, so I added, "Well, not yours exactly, it's mine, but . . ." and I trailed off. It felt inappropriately intimate to be standing there while she listened to this declaration of admiration. I felt embarrassed, exposed. I immediately

regretted having inflicted the awkwardness of the moment on her. She went on her way. The song remained, as did "Get Up Jonah," significantly stronger for her presence in it.

*I woke up thinking about Turkish drummers*
*It didn't take long—I don't know much about Turkish drummers —*
*But it made me think of Germany and the guy who sold me cigarettes*
*Who'd been in the Afghan secret police*
*Who made the observation*
*That it's hard*
*To live*

*Then I was reminded of the proprietor of a Vietnamese*
*restaurant in Quebec who used to be head of the secret police*
*in Da Nang—and it occurred to me I was thinking about*
*all this stuff to keep from thinking about something else. . . .*
*Isn't that just what secret police are all about???*

*Somebody stands in a window*
*Watches the river roll*
*Trains rumble in the foreground*
*With the weight of approaching dawn*

*Flames from the refinery*
*Rise broken, red and riveting*
*And the high vault of heaven*
*Looks far away and cold*

*There's howling in the factory yard*
*There's pounding in my head*
*I'm swollen up with unshed tears*
*Bloated like the dead. . . .*

*Blood and ashes—time burning*

*On the skyline dark against the stars*
*A solitary horseman—waiting*

*Lashed to the wheel*
*Whipping into the storm*
*Get up, Jonah*
*It's your time to be born*

"GET UP JONAH," 1995

My social skills served me better in the greener and cooler wilds of the northeastern United States. In June 1996 I played Ben & Jerry's One World, One Heart Festival near Warren, Vermont. A woman had written to me in advance of the event, introducing herself and inquiring whether I might have a chance to meet up. In a rare instance of postal responsiveness, I wrote back saying, "Why not?" There was no sense in those letters that either of us was looking for a date. After my set, word came backstage that Sally Sweetland was asking for me. I walked over to the gate and met the painter, a fit blonde of about forty, and her five-year-old son, Carson. There was a spark between Sally and me, for certain, and though we both chose to ignore it, neither of us forgot it.

I remembered it well enough that in the summer of the following year—after the relationships I had been in, both the actual and the unrequited, were as behind me as they would get—I wrote to her again. Why had I kept her address? Some unexamined impulse, some hunch. This time, when we met in Burlington, it *was* a date, the first of many. In a few months I was in a relationship again. Getting to know, and letting myself be known by, Carson was a new challenge. I made an effort to be kid-friendly. The gap between me and my inner child was such that the effort felt somewhat artificial, but soon enough a comfort zone presented itself and there we resided. In the process the gap may have shortened by a tiny increment, just as my psychic doorway to the outside world was cracking open wider.

*Slid out of my dreams like a baby out of the nurse's hands*
*Onto the hard floor of day*
*I'd been wearing OJ's gloves and I couldn't get them off*
*It was too early but I couldn't sleep*
*Showered and dressed, stepped out into the heat*
*The parrot things on the porch next door*
*Announced my arrival on Chartres Street*
*With their finest rendition of squealing brakes*

*Down in Kaldi's café the newspaper headlines promised new revelations*
*About Prince Charles's Amex account*
*A morose youth in old-time Austrian drag*
*Stared past his mustache at the floor*
*And last night's punks and fetish kids*
*All tattoos and metal bits*
*And in the other corner (wearing the white trunks)*
*Today's tourists already sweating*

*Deep in the city of the saints and fools*
*Pearls before pigs and dung become jewels*
*I sit down with tigers, I sit down with lambs*
*None of them know who exactly I am*

*I've got this thing in my heart*
*I must give you today*
*It only lives when you*
*Give it away*

*Languid mandala of the ceiling fan*
*Teases the air like a slow stroking hand*
*Study the faces, study the cards*
*Study the shadow creeping over the yard*

*I've got this thing in my heart*
*I must give you today*

*It only lives when you*
*Give it away*

*Trouble with the nations, trouble with relations*
*Where you going to go for some illumination?*
*Too much to carry, too much to let go*
*Time goes fast—learning goes slow*

*But I've got this thing in my heart*
*I must give you today*
*It only lives when you*
*Give it away*

"WHEN YOU GIVE IT AWAY," 1997

The "Dinner" part of the album appeared without warning in the form of a phone call from filmmaker Robert Lang. Was I interested in going to Mali? Bob dangled this land of adventure and music in front of me like a carrot on a walking stick. Music alone was a significant carrot, as Mali is justly famous for its musical heritage, and part of the trip would involve collaborating with the country's fantastic musicians.

Bob had directed the many promotional TV spots I had made over the years for the Unitarian Service Committee, or USC Canada. In cahoots with that organization, he was leading a crew to Mali to survey the effects of desertification and investigate the measures that farmers were employing to live with it. We would make a documentary about the issue, with me as the curious Canadian asking questions on camera.

USC could provide access, as they had been running food security-related projects with area farmers for some years. By the late nineties they were working with Malian farmers to identify crop strains that could withstand the increasingly severe conditions wrought by global climate change, and to develop new strategies for growing and stor-

ing grains. Along the way we would visit the fabled city of Timbuktu, on the southern verge of the Sahara desert. I had never seen the Sahara, except as a distant shore across a fifty-mile stretch of sea from the Canaries.

In addition to accessing Mali's music, the African journey appealed to my curiosity about what we can expect when things dry up, which it seems they likely will. The world was already embroiled in wars over oil (with the biggest such conflicts hovering just a few years out), but it seemed clear to me that these conflicts would soon be accompanied, if not overshadowed, by wars over water. The coming scarcity of such a vital necessity is not only potentially devastating but increasingly lucrative. According to a 2013 article in *Harper's*, the amount of money controlled by "water-focused mutual funds . . . ballooned from $1.2 billion in 2005 to $13 billion in 2007," owing in large part to Al Gore's climate change film *An Inconvenient Truth*, released in 2006. Around the same time a Goldman Sachs report called water "the petroleum for the next century," and noted the investment opportunities inherent in the "major multi-year droughts" occurring in Australia and the western United States. Wars over the *economy* of water will be horrific enough. What happens when there simply isn't enough of it to go around? You can live without oil for quite a while—forever if you're able to give up all the crap it affords— but you can forgo water for only a couple of days before you start to die. When the taps run dry in Phoenix and Riyadh, watch out.

Our small group (Bob Lang and his two-person crew—Friederike Knabe, director of programs for USC Canada, and me) was in Mali for a month. In the process we produced a pretty good film called *River of Sand*, which I narrated, for Canada's Vision TV. I co-wrote the narration with writer/filmmaker Heather MacAndrew, with whom both Bob and I had worked on other projects. I was assigned the role of the dopey, wide-eyed Canadian going around saying, "What's that? What's that?" What emerged was an intelligently pro-duced documentary that blends the imagery, causes, and sociopo-litical effects of desertification with the suggestion of an antidote and

a look at the vibrant culture of the Dogon people with whom we worked. The country's accomplished and soulful musicians figure prominently in the film.

In Mali as elsewhere, desertification and drought have led to crop failure, causing economic difficulties and an associated exodus of traditional villagers, especially young people, from the countryside to urban centres or even other countries. USC Canada has a program called Seeds of Survival that helps rural people develop and preserve crop strains, farming methods, and irrigation systems that can turn back the devastating impacts of desertification, ideally stemming the flow of environmental refugees that rips apart communities and over-burdens cities. These efforts are obviously critical for local people, but they are also important on an international scale. All over the planet, in thinly as well as densely populated areas, the soil that grows the world's food is wearing out from overuse, deforestation, and drought. The earth has long been losing its ability to support life, and now climate change is accelerating the process. Unless this trend is reversed, widespread and devastating famines will occur increasingly in many parts of the world.

Our journey began in Bamako, Mali's capital, a city that seemed gentler than many of its Third World counterparts. It sits on the banks of the Niger River, a huge and critical artery that extends through five West African nations. The Niger is Africa's third-largest river, behind the Nile and the Congo, and it follows an odd path, beginning in the western highlands of Guinea just 150 miles from the Atlantic Ocean. From its headwaters the Niger flows northeast straight inland, making a boomerang shape through landlocked Mali, past Timbuktu, where it turns southeast through Niger, Benin, and Nigeria toward the South Atlantic Ocean and the Niger Delta, an area ravaged by oil companies.

In Bamako we hooked up with Toumani Diabaté, a master of the kora, the twenty-one-string classical harp of West Africa. It's a gorgeous-sounding instrument that I first encountered in the 1970s and have loved ever since. Toumani is an inspired player, lithe and

intuitive. It was stimulating to cross such great physical and cultural distances to find that, at his modest family compound, we were able to connect musically without any rehearsing. Like many Malian musicians, Toumani had traversed similar terrain from his side. I was so smitten by the sonority between the kora and the guitar that, after returning to Canada, I wrote some songs designed to include it. I was hoping for Toumani as well. His playing is rooted in Malian tradition but progressive, and his ear is very keen. When asked, he agreed to record with us. We arranged for his flight to Canada and a visa that would allow him to work, but when we went to the airport in Toronto to pick him up, he wasn't there. He simply didn't show. No call, nothing. Someone on his end claimed that he'd gone to the Canadian embassy, but they wouldn't issue him the visa. The embassy told us he never showed up. Shortly after that, he was on tour in the United States with Taj Mahal. We speculated that Taj wanted an exclusive arrangement with him. But who knows?

Once again we found opportunity in adversity, because Jon Goldsmith knew another fine kora player, Daniel Janke, a Canadian who had been playing the kora since 1976, when he studied for five months with Jali Nyama Suso of Gambia. Though he appears on only three songs on *Breakfast in New Orleans*, the kora was my intended foil for that album. The songs "Mango" and "Let the Bad Air Out" were constructed to accommodate the kora, and they turned out as I had hoped. The latter was a second stab at finding music to carry those lyrics, which had been around for a few years. "Mango," lyrically speaking, flew in straight from Vermont. It's a paean to female sexuality, a small attempt to offset, with something respectful, some of the garbage that's sung by men about sex.

I have no problem with people singing about sex. It is about as central to the human experience as things get. Without it, said experience would have been very short-lived. Sex is wired into our souls, beautifully, powerfully, and inextricably intertwined with spirituality. When coupled in sexual bliss, or even angst, we can make ourselves utterly vulnerable to each other, more than in any other

exchange, and in this space pursue the most elusive depths of human promise. Or, as the saying goes, "Sex is the most fun you can have without laughing." (Though I'm not clear on why laughter should be excluded.) Like any other element of life as a human, sex warrants being sung about, but I needed to ease the subject out of the sweaty grip of vulgarity.

> She's got a mango in the garden—sweet as can be
> She's got a mango in the garden—full of mystery
> She's got a mango in the garden—from the original tree
> She's got a mango in the garden—shares it with me

> Humid gleaming precious well
> Love to drink that water
> Parallel worlds when the sun goes down
> The atmosphere grows hotter

> I slid through the glistening gate
> Tide began to pound
> Tears of light poured over me
> And ricocheted all around

> She's got a mango in the garden—sweet as can be
> She's got a mango in the garden—full of mystery
> She's got a mango in the garden—from the original tree
> She's got a mango in the garden—shares it with me

"MANGO," 1998

We piled ourselves, our gear, eighteen cases of bottled water (two cases of which broke atop the vehicle on Mali's treacherously bumpy roads), and a satellite phone into two Land Cruisers and headed east out of town. For two days we bounced and swayed across four hundred miles of dust-blown roads that were sometimes no more than barely

visible tire tracks in the sand. Without the skill and experience of our local drivers, we'd have been stuck or lost or both. I watched a curtain open on a new world. Nomadic Peul herders coaxed herds of cattle and gangly, goatlike sheep from well to precious well across thorn-strewn gravel plains dotted with acacias and baobabs and odd-looking forked palms. Every day brought blasts of heat that reached well over one hundred degrees Fahrenheit, the air so dry you never felt a drop of sweat. As we passed through this surreal landscape, blurred with blowing sands and the ghosts of salt caravans, gold traders, and fallen empires, the mythic, once-great city of Timbuktu waited somewhere over the next low rise. I could feel it.

Like Mali's farms, Timbuktu itself has, over the past half-century, been filling with sand from an ever-encroaching desert. Veteran North Africa reporter Serge Daniel, writing for Agence France-Presse, provides a neat synopsis of Timbuktu's history that illustrates how the ancient but now crumbling city was able to embed itself in humanity's collective consciousness: "Founded between the 5th and 11th Centuries by Tuareg desert nomads, Timbuktu became a meeting point between north, south and west Africa and a melting pot of black Africans, Berbers, Arabs and Tuareg desert nomads. The trade of gold, salt, ivory and books made it the richest region in West Africa and it attracted scholars, engineers and architects from around Africa, growing into a major centre of Islamic culture by the 14th Century. Some 25,000 students were said to attend the University of Sankore at the time. The legend of Timbuktu began in 1324, when the Malian emperor Mansa Mussa (1307–1332) made a pilgrimage to Mecca via Cairo with [a retinue of] 60,000" people, including some 12,000 slaves, each of whom carried three kilogrammes of pure gold, which Mussa said came from Timbuktu. "This amount of gold caused the Egyptian currency to lose its value, according to the U.N. cultural agency UNESCO, and put Timbuktu on the map as a mysterious African city of gold." I had first heard of the Tuaregs from reading Tarzan comics when I was a kid.

Timbuktu is in the Sahel, a semiarid region that forms a band

across Africa immediately south of the Sahara. When we arrived, there was no gold in sight; in fact, the great city barely existed. Many of Timbuktu's ancient sandstone buildings were inundated with the sands of the expanding desert. We met Mohammed Ali—not the famous boxer, but a local Tuareg elder. Standing near a twelfth-century mosque, Ali explained that until 1972 a twelve-mile canal ran from the Niger River to Timbuktu, but since then it had fallen into disrepair and filled in with sand. Ali remembered a time when large trees grew from the outskirts of town one hundred miles toward the open Sahara. By the time we came along, the trees were virtually nonexistent and the desert was taking over the city.

Timbuktu remains a destination for the more adventuresome type of tourist. Soon after our arrival a small caravan of Americans showed up, flown in from Bamako. The great Malian bluesman Ali Farka Touré was scheduled to play for them that night in the hotel where we were all staying. We were hoping to meet him, and did, in a chance encounter in the courtyard, where he informed us that Mali is "the roots of what we call the blues." He was tall and fit, good-looking, and dressed just like John Lee Hooker. That night I sat in with him, and he put on a powerful performance, his haunting guitar sound evocatively standing in for the ancient aura of gold and learning.

In Timbuktu and larger towns the sounds of people were incessant, and I found myself with little solitary space. Someone's radio or motorbike, the pounding of grains and clank of pots, the gull-cries of playing children, pulleys creaking as villagers drew well water: that's town. In the desert I found solitude, insects and wind, sand and rocks, baobab exoskeletons. It was a beautiful and imposing landscape, and it offered space for the imagination to fly free.

Our first adventure after leaving Timbuktu was a slow boat ride across the wide Niger, with both Land Cruisers rolled onto a decrepit old car ferry: rails bent and twisted, engine exposed and dead for years. The ferry was moved along by a pirogue, one of the long dug-out canoes used up and down the Niger for centuries, powered by a single Yamaha thirty-five-horsepower outboard motor. Fifty feet off

the dock we got stuck on the first sandbar, forcing the ferry crew into the waist-deep river to rock the boat back and forth until freed. Farther into the river a clutch of hippopotami eyed us skeptically, and I was reminded that they are the most dangerous of Africa's large mammals, each year reportedly killing more humans than does any other animal on the continent.

We putted along for three hours, eventually landing precariously where there was no dock. While the boatmen held the rusted vessel in place, the vehicles rolled down a short ramp into the shallows by the shore. Then, kicking up loose sand from spinning tires, the cars scrambled up the sloping bank to a purported road on the flat above.

From the river we headed south, eventually hitting the highway to Douentza, the town where USC had its base of operations and a house, out of which we would be working. This was one of the poorest areas in a very poor nation. Friederike's colleagues from USC Mali arranged introductions to Dogon farmers.

The Dogon are traditionally secretive and disinclined to welcome strangers. Roughly analogous to the Hopi of the American Southwest, Dogon people are hunters and gatherers as well as farmers. They once lived almost exclusively in cliff dwellings along the Bandiagara Escarpment, a stunning sixteen-hundred-foot cliff that rises like a monolith out of the flat desert and runs for a hundred miles. Villages hidden in the high rocks look out over broad plains that spread to the horizon as if to the edge of the world. Before the French took over the region in the late nineteenth century, the Dogon would kill anyone who happened to discover one of their towns because they felt that their survival hung on their invisibility.

The Dogon culture embraces a complex cosmology. Some Dogon believe that they came from the star Arcturus and that Earth was twice colonized by extraterrestrials. The first time they created a whole society, but God became displeased with it thanks to Jackal, the trickster, who adulterated it by creating his own people. One striking feature of the African landscape is its very large, somewhat clitoral-looking anthills, often six feet or more in height. In the myth,

Jackal has sex with one of these and impregnates the Earth, and a race of demonic hybrids is born. God decides he's going to wipe them out and start over, and he sends a flood. The next humans arrive as twelve sets of twins, each pair male and female. The twins breed and create the twelve tribes of the Dogon. Later, yet another visitation occurs when a figure from Sirius, the Dog Star, shows up to teach the art of metalsmithing.

We found our focus in a community about an hour and a half from Douentza, called Ibissa. It was built a century ago in its current location—a small indentation, perhaps a mile and a half deep, in a hidden setting high on the frowning escarpment. At that time the French colonial government ordered it moved, under threat of artillery assault, like all similar Dogon towns. France was seeking to exercise greater control over the population. They succeeded.

Part of the outcome was positive, though. The settled Dogon and the nomadic Peul, longstanding enemies acting out the seemingly eternal conflict between farmer and herder, were forced to stop warring and learn to share the meager resources peacefully.

The villagers allowed us to film them only because the eighty-nine-year-old chief, whose surname was Coulibaly, gave us permission. In granting it, he said, "May God help you to realize your wishes, and may he accompany you in all you do."

During our daily "commutes" from Douentza to Ibissa, the winds flared continually out of the northeast. Things and people appeared and disappeared in the layers of fine airborne dust particles. In this foglike atmosphere a turbaned, indigo-clad rider on a white camel materialized, as if by magic. He carried a sword and a rifle and looked like Time Immemorial, except for the transistor radio that bounced against his chest, tuned to the pan-African soccer championships then in progress in Nigeria. Just as quickly as he appeared, he was gone.

Not much of Ibissa is visible from the road. The highway, at this point, paralleled the escarpment a mile out on the plain. Turning onto the short road that leads to the village, we passed the "women's gar-

den," an interface between the horizontal sand and the vertical rock. Until recently, cultivating the soil was the province of men. Women had a critical role as haulers of water and wood and bearers of babies, but in recent years the understanding had grown that survival might depend on expanding cultural roles. Prompted by an interestingly atypical young Dogon woman working with USC, who had learned agronomy in France, the women of Ibissa campaigned to have their own patch of land to work. After much discussion, the men in charge relented and designated an area where the women could farm. From the point of view of history, this was an experiment, one that proved successful both in increasing the food supply and, since the surplus could be sold for cash, in empowering the women by giving them a significant financial boost.

It's worth noting that Ibissa, unlike most villages in the region, is home to a spring, which fountains out of the ground near the bottom of the cliff, becomes a stream, winds through a lush, cultivated area, and flows past the sloping, rubbled sides of the little canyon and the clustered houses before running on downhill to disappear into the beige blotter of the desert. We asked the chief if we could film the spring itself, a sacred place. He thought about it for a while and consulted with his peers. In the end they approved, and we were led to the spot. As I sat beside the clear pool I felt the spirit of the place, an energy that was soft and benign. Later I remarked on the presence of this spirit to Chief Coulibaly. He said there was once a time when they would perform an annual sacrifice of a lamb to the spirit of the spring.

"But that was in the old days," he said, "before we had the Faith. We don't do that anymore. Now we only sacrifice a chicken."

A couple of hundred yards from the town's very public latrine (rarely used by the people of Ibissa; it was most likely built to please some foreign NGO) is a large livestock trough, fed by a deep well punched hundreds of feet down to the water table. The pump is powered by a jewel-like array of photoelectric cells that shines sapphire behind a chain-link fence high enough to keep the goats from destroying it. Years earlier, on the orders of some past president, area villages

had each received one of these solar water systems. All but Ibissa's had ceased to function, as the development scheme that put the things in did not include instruction in their use and maintenance. Our hosts, however, sent a villager to the city to receive the training necessary to maintain the pump. That man had died, but he passed his knowledge on to a successor, who now lived in a little shack close by, as Keeper of the Well. The villagers collected a modest rent from their traditional foes, the Peul, whose passing herds of cattle and sheep depended on the precious water.

I was constantly dazzled by images of daily life: women grinding millet, three to a big mortar, pounding in sequence with huge pestles and singing to the rhythm; gardeners, both men and women, hoeing in the heat behind living fences of dense thornbushes; the goatherd guiding his flock down from the heights by means of coded whistles; deer hunters gathered in the main pathway, mixing gunpowder to load into homemade flintlock rifles behind stone bullets; the complete absence of modern dress. All of it, especially juxtaposed with the crystalline solar array, played into an end-of-the-world feeling I couldn't shake the whole time we were in Mali. In the ever-expanding desert sands surrounding Ibissa, I envisioned a planetary future bleak but inevitable. Some would be lucky, like these Dogon villagers, who were doing all right. But overall, water and food for the swelling legions of the world's poor continue to run out, which paints a grim picture for everyone.

Working with USC Canada and USC Mali, the villagers— reluctantly at first—started growing new crops suited to the increasingly harsh conditions of the region. The old chief told us that when he was a boy, dense forests had thrived in and around his village, and lions, antelopes, and elephants had roamed nearby. Everything had been green, trees all up and down the cliffs, but the villagers had cut it all for firewood and building material. Now the trees are gone, along with much of the wildlife.

For the past two decades, however, the people have been planting trees and rotating crops to retain soils and nutrients, as well as main-

taining gene banks of locally adapted seeds. The Dogon of Ibissa and people in a few other regions of Mali have successfully begun to reverse the desertification that threatens their existence. It's a lesson for all of us, as vast expanses of once arable land are lost across the planet to industrial agriculture, soil erosion, and excessive pesticide use. Time is running out and we are, whether we like it or not, in this together. Taking care of this one small corner of the earth matters in Mali, just as it matters everywhere.

The dry heat continued unabated, so we didn't suffer from mosquitoes, but by night, enormous tropical cockroaches came up from inside the latrines at the USC house, where they found shade and humidity during the day's heat. We happened to arrive at the beginning of the season of the Harmattan, a strong trade wind that fills the air with fine sand from a thousand miles away and carries it on for a thousand more. The Harmattan is associated with seasonal epidemics of meningococcal meningitis, which have impacted the Sahel region—the "meningitis belt"—of Africa for more than a century. None of us contracted the disease, but while we were in the region the air was constantly hazy. Vestiges of trees, dried up and dead, alongside thick-trunked baobabs that looked as if they were dead even when they weren't, and an enormous space framing a throbbing orange sun—all added to a surreal landscape and stirred the seeking soul. It was the vista of a dying planet, and we used it, fittingly, as a backdrop to film a video on the side for my song "Last Night of the World."

Thoughts of the coming millennium, and the media saturation of doom-laden speculations about what it might bring, had conjured the song. It had little directly to do with the Sahara, but the atmosphere of Mali offered a perfect frame in which to hang it. The song's refrain was inadvertently suggested by Sam Phillips while we were on tour together. One night after a show we took a walk around some town. I was lugging the shoulder bag that I generally carted around, loaded with notebook, pens, flashlight, knife, energy bars, gaffer tape, water, all sorts of stuff.

"What are you carrying in that thing anyway?" Sam asked me.

"Everything I need for the apocalypse," I told her.

She looked at me and stopped, hands on hips, eyebrow raised quizzically. "What do you need for the apocalypse," she asked, "besides champagne and a couple of glasses?"

*I'm sipping Flor de Caña and lime juice, it's 3 A.M.*
*Blow a fruit fly off the rim of my glass*
*The radio's playing Superchunk and the Friends of Dean Martinez*

*Midnight it was bike tires whacking the potholes*
*Milling humans' shivering energy glow*
*Fusing the spaces between them with bar-throb bass and laughter*

*If this were the last night of the world*
*What would I do?*
*What would I do that was different*
*Unless it was champagne with you?*

*I learned as a child not to trust in my body*
*I've carried that burden through my life*
*But there's a day when we all got to be pried loose*

*If this were the last night of the world*
*What would I do?*
*What would I do that was different*
*Unless it was champagne with you?*

*I've seen the flame of hope among the hopeless*
*And that was truly the biggest heartbreak of all*
*That was the straw that broke me open*

*If this were the last night of the world*
*What would I do?*

*What would I do that was different*
*Unless it was champagne with you?*

"LAST NIGHT OF THE WORLD," 1998

What I brought home from Mali, among other things, was a sense that, for all the historical continuity that was evident, I was looking at the future. Small, desertified villages were emptying as young people abandoned increasingly harsh lives in response to the seductive call of the city. They were looking for gadgets and money and the easier life that a new mythology told them were out there, but they were leaving behind the ancient knowledge required to live in community on the edge of the desert. With some notable exceptions, most of the people in the villages we visited were children or middle-aged and older. Teens and twentysomethings had migrated elsewhere. At the other end of the exodus (which is exactly what the villagers call it) are the shantytowns that surround Bamako, where the young people wash up like so much flotsam. Insecurity is rife. Maybe you'll get a job, maybe you won't. Maybe you'll get money, maybe you won't, most likely you won't. Poverty becomes endemic, struggle the norm. Desertification in Mali provided a clear window into one possible global future.

I get a similar feeling when thinking about the tar sands in northern Alberta, an energy boondoggle that's carving the wastes of Mordor out of what once was beautiful woodland. The mining and processing of tar sands are an attack on ecosystems not only in Canada, but also wherever the thousands of miles of oil pipeline go. The pipes will inevitably fail and leak (if they're not sabotaged) as the project grinds on. The massive tanker vessels to which the pipelines lead will sooner or later spill their contents. Then there's the burning of fossil fuels. The tar sands are but one link in a chain of interconnected crises, a hundredth monkey of planetary destruction.

Activist and author Bill McKibben calls the Alberta tar sands the world's biggest "carbon bomb" that is still left in the ground. There

are many other carbon bombs, including deforestation in the Amazon basin, the world's largest carbon sink. The Amazon is essential to balance the overflow of carbon we're pumping into the atmosphere, yet Amazon rain forests are falling and burning (another carbon contributor) faster than ever in history. Wealthy nations and people, those contributing the most to this mess, don't seem to be as alarmed as the situation might merit, maybe because we don't live where the impacts are directly felt . . . yet. Everybody in Canada, for instance, in a sense lives in Bamako—the moist, subtropical capital, reasonably well equipped, in a landscape that is mostly desert. But the desert is catching up, and there's no way to outrun it. We have to turn and stand and defend our land, our atmosphere, our children, from the elemental demon our hubris has loosed. We have to live like the Dogon, who are humbly planting the future.

At the time of our trip, Mali was one of the rare countries in Africa from which war was virtually absent. It's true that there was an ongoing Tuareg rebellion against the central government, whose attempt at modernization was forcing them to abandon their traditional ways, but it was small and localized in a remote part of the country, and seemed then to be almost over. It had to have been of greater import than it seemed, as it became the excuse for a military coup in 2012, which created a wave of instability that gave the rebellious groups an edge. They were joined by hard-core Islamists, who quickly seized control of the movement's direction. Timbuktu and Douentza became scenes of wanton destruction of historical artifacts, and of violent and repressive attempts to impose the fundamentalists' interpretation of Sharia law. A year later the French military intervened and sent most of the militants scurrying, but a difficult life in the Sahel had been made harder, and it seemed there would be no turning back from that.

Not unexpectedly, I brought home from Mali the makings of a song, a poem of the moment. The sands that surround us, metaphoric and literal, will not wait around. It's a law. The hourglass trickles; deserts grow. Everything is temporal. When the Harmattan blows,

we really do choke on the dust of fallen empires. Peoples have come and gone throughout human history, yet in Mali, marginal as life might be, there is a promise of hope, as the herders I saw were roaming the Sahel as their ancestors did seven thousand years ago, when it was grassland. Like most people of the earth, they have always lived in the present, and I will honour that in this way: if there's something you need from me, get it now.

> *There's a black and white crow*
> *on the back of a two-toned sheep*
> *in a field of broken yellow stalks*
> *below looming cliffs.*

> *High above the plains*
> *little grey houses blend*
> *with giant jagged boulders*
> *and pale weathered stumps.*
> *Life in the ghost of the bush.*

> *Wind whips the acacias and strange forked palms*
> *That cluster around the water hole*

> *Suddenly, out of the blowing sand*
> *A milk-white camel appears.*

> *Turbaned rider, blue robe billowing,*
> *bounces with the shambling trot;*
> *wears a sword and a rifle on his back,*
> *and hanging from his neck, a transistor radio. . . .*

> *You blink and like ghosts, they're gone*

> *Under the wan disc of sand-masked sun*
> *A woman grins—spits expertly*

*Into the path of a struggling black beetle*
*Six feet away*
*Hoists her water bucket onto her head*
*And strides off up the trail. . . .*

*Sun a steel ball glowing*
*Behind endless blowing sand*
*Sun a steel ball glowing*
*Dust of fallen empires slowly flowing through my hands*
*Use me while you can*

*Pearl held in black fingers*
*Is the moon behind dry trees*
*Pearl held in black fingers*
*Bird inside the rib cage is beating to be free*
*Use me while you can*

*I've had breakfast in New Orleans*
*Dinner in Timbuktu*
*I've lived as a stranger in my own house, too*
*Dark hand waves in lamplight*
*Cowrie shell patterns change*
*And nothing will be the same again*

*Bullet in a sandstorm*
*Looking for a place to land*
*Bullet in a sandstorm*
*Full heart beats an empty one*
*In the deck they dealt to man*
*Use me while you can*

"USE ME WHILE YOU CAN," 1998

# 21

By now billions of people have seen the images, in videos and photos, of the second plane, a passenger jet banking hard at 466 miles an hour, appearing diminutive against the massive Manhattan skyscraper into which it disappears, spilling fountains of flame out the opposite side and spitting debris all the way to Brooklyn. The building's adjacent twin was already belching fire and slate-grey smoke from its upper floors, where the first plane went in. The second plane dissolved the theory, which lasted all of seventeen minutes, that on a beautiful September 11, 2001, at 8:46 A.M., the North Tower of the World Trade Center was hit accidentally.

From the street a thousand feet below, or from perches in nearby office towers, but mostly on television, people gazed in horror at the grim spectacle of flames engulfing the upper sections of two of the world's tallest and most iconic buildings. Closer inspection—and many cameras were pointed at the Manhattan skyline that day, making it a tragedy that unfolded in real time across the globe—divulged human beings clinging to the sills of broken windows, fruitlessly waving garments to summon rescue, desperate on manmade cliffs as fire and smoke pumped heat into and sucked oxygen out of the upper floors that had not already been vaporized by the fully fueled passenger jets. More than two hundred of these souls would eventually

jump, not choosing to die but choosing *how* to die. As almost every-one in the world knows, after being skewered by jets, both of the 110-story World Trade Center skyscrapers imploded and disappeared into the air and onto the streets of lower Manhattan. The nearly 3,000 people who died on September 11—including 227 passengers and 19 hijackers on four airplanes (one of which was piloted into the Penta-gon, killing 125 people in that building, and another of which crashed in a Pennsylvania field, killing all 44 on board)—constitute the high-est death count of any foreign attack on U.S. soil.

On the morning of 9/11 I was at the house I rented on Rue de Bullion in Montreal, loading my van for a visit with Sally Sweetland in Vermont. The phone rang just before 9 A.M., as I was about to lock my front door. It was Sally.

"You'd better turn on CNN," she said.

I switched on the tube just in time to see the second plane hit. I thought, "They're going to close the border. I'd better get down there right now." If I was going to be stuck on one side or the other, I wanted to be on the U.S. side, with my girlfriend and her son.

I jumped in the van and headed south on Autoroute 15 as fast as I could go. The American border guards seemed to be in a state of shock, dazed and reeling. Men in body armour with straining dogs inspected commercial vehicles, but disconsolately, as if they were heartbroken. The anger that would surely come had not yet materi-alized. I approached the guard at a booth. He looked tired, worried.

"Man, I'm so sorry."

"Thank you," he said. "Where are you going?" I told him, and he waved me on.

My instinct about the border was correct: they closed it the next day. It remained closed for a few days, and for a long time afterward it remained difficult to cross. Even leaving the States, you had to go through an inspection by U.S. Border Patrol officers before they'd let you out of the country. You'd be required to pull over into a special lane, at which point they'd grill you about where you had been and why. Once in a while they'd do a cursory search of my van. I didn't

fit any sort of profile, so they never really went to town on me, though I saw other vehicles rifled with an earnest rigour.

By the time I got to Sally's place in Waitsfield, the towers had fallen and the TV coverage had acquired a glossy sheen, with stirring theme music and dramatic graphics, as if the video footage didn't offer drama enough. During the ensuing days Sally and I kept tuning in, along with everyone else, watching the planes and the flames, again and again, morbidly fascinated by the literal height of human ingenuity, and hubris, crashing to the ground in free-falling pyres. In slow motion, each tower left in its wake a column of smoke, as if a burnt offering to the demon lords of empire.

It seemed clear that the long-running assumption of safety that most Americans carried around with them had been forever shattered. The further erosion of this security—made manifest in the subsequent adoption of a permanent war footing and a metastasizing police-state mentality—represents one of the greatest ongoing losses suffered by U.S. society that day.

I wrote "Put It in Your Heart" more than two months after 9/11, and it was presented to the world in 2003 on the album *You've Never Seen Everything*. The song is a response to that awful day. My initial reaction was that it would be pathetic to address such an event in a song. I felt impotent having no quick response to offer, and the form didn't seem as though it would be up to the task—an assumption confirmed by the various offerings showing up in the weeks following the attack. One day, back in Montreal, I was attempting to meditate, following instruction from my yoga teacher. As I sat and let thoughts and images rise to the surface of consciousness, the phrase "put it in your heart" floated past. It was something another teacher, Marc Bregman, with whom I do dream analysis work, had said a short time before. He was offering a means of facing the buried sources of pain that we were unearthing through the work. I realized that the concept could apply just as well to emotional pain from outside

sources. Without thinking only of 9/11, I began to put images and feelings together, and the song took shape. I rethought my original reaction to the tragedy. Maybe, to put such an atrocity into perspective, only art would do. Music is my art. I would sing.

> *As I stare into the flames*
> *filled up with feelings I can't name*
> *Images of life appear —*
> *regret and anger, love and fear*
> *Dark things drift across the screen*
> *of mind behind whose veil are seen*
> *love's ferocious eyes, and clear*
> *the words come flying to my ear*
> *"Go on—put it in your heart —*
> *Put it in your heart"*
>
> *Terrible deeds done in the name*
> *of tunnel vision and fear of change*
> *surely are expressions of*
> *a soul that's turned its back on love*
> *All the sirens all the tongues*
> *The song of air in every lung*
> *Heaven's perfect alchemy*
> *put me with you and you with me*
> *Come on—put that in your heart*
> *Come on, put it in your heart*

"PUT IT IN YOUR HEART," 2001

The biggest surprise of 9/11 is not that it happened. The New World Order has not been universally welcomed. Given the untold millions of lives around the planet wiped out, with apparent indifference, by the United States in the span of a single lifetime, the bigger surprise is that something like it didn't happen sooner.

There can be no justification for the indiscriminate destruction of innocent lives that was the World Trade Center attack, but the nation that Dr. Martin Luther King Jr. called "the greatest purveyor of violence in the world" has perpetrated thousands of 9/11s across the globe. There's bound to be some blowback. The attackers were Arab, but they could have been from any number of places, including but not limited to Korea, Cuba, the Dominican Republic, Lebanon, Colombia, Brazil, Chile, Argentina, Vietnam, Cambodia, Laos, Indonesia, Nicaragua, Guatemala, El Salvador, Egypt, Chad, Congo, Bosnia, Somalia, Haiti, Iran, Afghanistan, or Iraq. They could have been generationally oppressed and disproportionately incarcerated African American youth from Harlem or Watts or Cabrini-Green, or a few of the millions of Americans who live in poverty, their children experiencing hunger every day while their not-very-distant neighbours quaff $10,000 French wines on million-dollar verandas overlooking the East River. (A 2012 study by New York University economist Edward N. Wolff found that 20 percent of Americans own 89 percent of the country's wealth, a perfect recipe for conflagration, as demonstrated time and again throughout history.) Yet it turned out that most of the hijackers, as well as their purported "leader," Osama bin Laden, were from Saudi Arabia, a U.S. ally and one of the world's wealthiest countries. What *is* that? Wasn't this family on hand-holding terms with then president George W. Bush? Something fishy was going on in Texas.

What's also unsurprising, however deplorable, is the way that the U.S. government is now significantly turning on its own people. Not just dissenters, but *everyone*, through comprehensive and unprecedented surveillance systems as disclosed by National Security Agency leaker Edward Snowden in May 2013. (Snowden also revealed similar hanky-panky on the part of the agency's British and Canadian equivalents.)

And in June 2013, the *New York Times* reported that, in addition to spying on its own people and purported enemies, "the N.S.A. has bugged European Union offices in Washington and Brussels and, with

its British counterpart, has tapped the Continent's major fibre-optic communications cables." This comprehensive spying operation, even of its closest geopolitical allies—which attorney Michael Ratner, president emeritus of the Center for Constitutional Rights, called an "illegal program . . . [a] huge, massive surveillance system of every single person in the world, conceivably"—should have been predictable (and, in fact, has been predicted by any number of speculative fiction writers, from the fifties onward) because a state lurching toward totalitarianism, as the United States might be, will seek to accrue to itself ever greater power in all forms, and information *is* power.

Unless U.S. policy makers take action to prevent the consecration of a permanent surveillance state, such accrual will likely lead to an ever-tighter lockdown on the basic rights fought for and long enjoyed by Americans. At that point, the enviers of America will have succeeded. As Snowden himself said, the Obama administration, even more than that of George W. Bush, has laid the foundation for the implementation of "turnkey tyranny." History is now.

Contributing to the sense of being stuck in a horrid dream was the image of President Bush, on 9/11, sitting in a Florida classroom full of little kids, reading a children's story called *The Pet Goat* for a full seven minutes after being informed by his chief of staff, Andrew Card, that "a second plane hit the second tower. America is under attack." (Bush was told about the first plane while en route to the school.) You'd expect the commander-in-chief to leap up and scramble the fighter jets or at least get on the phone . . . to someone. Maybe he didn't want to alarm the children.

According to a 2004 investigation by the *New York Times*, Bush "was told more than a month before the attacks of September 11, 2001, that supporters of Osama bin Laden planned an attack within the United States with explosives and wanted to hijack airplanes." The *Times* reported that intelligence operatives delivered this news during a "secret briefing that Mr. Bush received at his ranch in Crawford, Tex., on Aug. 6, 2001." He was on vacation.

If he didn't know what to do in the first minutes after the attack, or during the month when he had advance warning of it, Bush seemed to have it figured out shortly thereafter: "The search is under way," he said, "for those who were behind these evil acts. We will make no distinction between the terrorists who committed these acts and those who harbour them. Make no mistake, the United States will hunt down and punish those responsible for these cowardly acts." He should have added "or anyone who resembles them," because whereas Bush never really did accomplish this goal, the United States did indeed hunt down plenty of people and punish them, mostly hundreds of thousands of innocent Iraqis—some estimates put the toll at more than one million souls—who died during the U.S. invasion of 2003 and subsequent occupation.

Even at the time, it seemed clear that Iraq had nothing to do with 9/11 and that the Bush charges of "weapons of mass destruction" and "harboring terrorists" were fabricated. That Iraq had a lot of oil, and that Vice President Dick Cheney had a conspicuous fondness for the stuff and for the riches it brought his companies and cronies, were threads largely sidestepped by the mainstream media. The connections were obvious enough to millions of other people across the globe, though, including many independent media sources, which reported on them in real time. (According to investigative reporter Jeremy Scahill, KBR, a subsidiary of Cheney's company Halliburton, was the "single greatest beneficiary of the U.S. wars in Iraq and Afghanistan," earning a tidy $32 billion from 2001 through 2009. Scahill writes that in May 2009, April Stephenson, director of the Defense Contract Audit Agency, "testified that KBR was linked to 'the vast majority' of war-zone fraud cases and a majority of the $13 billion in 'questioned' or 'unsupported' costs." In 2007 Halliburton sold off KBR, which then won another contract, this one worth $50 billion, for military support services in the Middle East.)

America's assault on the Middle East was strikingly biblical. The Tigris and Euphrates Rivers, the lifeblood of Eden, ran red with the

blood of innocents. Mesopotamia was set on fire as two-thousand-pound bombs hammered at the birthplace of civilized law. Eleven thousand cluster bombs shredded the children of Abraham. Depleted uranium (and possibly white phosphorus) munitions caused birth defects among people whose forebears discovered aspects of modern medicine more than one thousand years before Christ. In 2013, Al Jazeera reporter Dahr Jamail told *Democracy Now,* "We are seeing a rate of congenital malformations in the city of Fallujah that has surpassed even that in the wake of the Japanese cities of Hiroshima and Nagasaki that nuclear bombs were dropped on at the end of World War II." For most Iraqis, the "liberation" of their country brought only pain.

What we saw in Iraq was the world's most muscular military unleashed by avaricious plutocrats, hiding behind the schizophrenic proclamations of a cartoon president. "Our enemies are innovative and resourceful," said Bush. "They never stop thinking about new ways to harm our country and our people, and neither do we." (That trenchant observation was delivered during the 2004 presidential signing ceremony for a $417 billion defense spending bill.) He squinted and grinned and gaffed, hunted down "evildoers . . . bad guys" he'd seen on the "internets," and unleashed terror from his command post at the golf course. The Bush cabal wielded Texas-style justice all the way to Cayman Islands tax shelters. Hi-yo, Silver. "Bring 'em on." The world wept.

> *The village idiot takes the throne*
> *His the wind in which all must sway*
> *All sane people, die now*
> *Be lifted up and carried away*
> *You've got no home in this world of sorrows*

> *There's a parasite feeding on*
> *Everybody's bag of rage*
> *What goes out returns again*

*To smite the mouth and burn the page*
*Under the rain of all our dark tomorrows*

*I can see in the dark it's where I used to live*
*I see excess and the gaping need*
*Follow the money—see where it leads*
*It's to shrunken men stuffed up with greed*
*They meet and make plans in strange half-lit tableaux*

*Under the rain of all our dark tomorrows*
*You've got no home in this world of sorrows*

"ALL OUR DARK TOMORROWS," 2001

A couple of people have asked me, "What does that mean, 'All sane people, die now'?" I was thinking of the Federico Fellini movie *Satyricon*, which captured, in a droll historical metaphor, the nature of seventies Western culture. *Satyricon* was set in a fictionalized ancient Rome, but it portrays modern forms and sources of angst that people confront today. The only characters in the movie who seem at all sane are a wealthy couple who live in a villa outside Rome. They commit suicide because they see no place for themselves in a world falling into madness around them. Their only choice is to depart. "All sane people, die now." Get out while you can, because it's not going to get any better. Which is not at all a recommendation.

I wrote "All Our Dark Tomorrows" in the art studio Sally and I shared in Montpelier, Vermont, two years before the United States invaded Iraq. Montpelier is forty miles from Burlington and is surrounded by woods and state parks. It is the only U.S. state capital in which you can't get a McDonald's hamburger. While Sally painted in her disciplined way, I pretended to write songs, as I was in something of a dry spell. But pretend long enough and you become it, so I got a few decent songs out of the time spent.

Sally is the photographer who provided dozens of images for the

*Breakfast in New Orleans Dinner in Timbuktu* album package design by Toronto graphic artist Michael Wrycraft. In 2007 Wrycraft's striking creation—which superimposed the title across the entire cover, each letter incorporating a different photograph—enjoyed some cross-cultural attention when the Museum of Modern Art, in New York City, featured the album in its fifty-year celebration of Helvetica, the sans serif font created in 1957 by Swiss typeface designer Max Miedinger.

A welcome creative catalyst for the record was the unexpected invitation from Andy Milne, a skillful and interesting young jazz pianist and composer, to collaborate on a couple of song ideas he had. I had done almost none of that sort of thing since the sixties, and the time seemed opportune. Andy, a Canadian based in New York, was thirty-one years old when we met. We got together at the home of a friend of his in New Hampshire and spent an afternoon poking and prodding at whatever themes came to us. Andy wanted to make a song about economics and greed. He wrote out some lines of lyrics, but I couldn't step into his vision enough to figure out how to develop them further. I had the germ of a concept for a song on a similar theme: a riff on fashionable economic theory that became the song "Trickle Down," which he liked enough that he was able to turn it into the kind of exciting and rhythmically challenging composition he and his band, Dapp Theory, were known for. Our other collaboration was written from scratch from a set of reflections on the motion of subatomic particles as symbolic of, and related to, the pas de deux between each of us and the Divine. It started with a few lines, and ran with it, giving birth to "Everywhere Dance." We tweaked the songs some and then recorded them for Dapp Theory's 2003 CD *Y'all Just Don't Know*. We recorded quite different versions for *You've Never Seen Everything*.

> *Picture on magazine boardroom pop star*
> *Pinstripe prophet of peckerhead greed*
> *You say, "Trust me with the money—the keys to the universe*
> *Trickle down will give us everything we need"*

Brand-new century private penitentiary
Bank vault utopia padded for the few
And it's tumors for the masses coughing for the masses
Earphones for the masses and they all serve you

Trickle down give 'em the business
Trickle down supposed to give us the goods
Cups held out to catch a bit of the bounty
Trickle down everywhere trickle down blood

What used to pass for education now looks more like ignoration
Take the people's money and slip it to the corporation
Yellow rain golden shower pesticide firepower
Summon feudal demons of sweatshop subjugation

Workfare foul air homeless beggars everywhere
Picture-phone aristocrats lounge around the pool
Captains of industry smiling beneficently
Leaky hull supertanker ship of fools

Trickle down give 'em the business
Trickle down supposed to give us the goods
Cups held out to catch a bit of the bounty
Trickle down everywhere trickle down blood

Takeover takedown big-buck shakedown
Schoolyard pusher of the anything-for-profit
First you got to privatize then you get to piratize
Hooked on avarice how do we get off it?

Trickle down give 'em the business
Trickle down supposed to give us the goods
Cups held out to catch a bit of the bounty
Trickle down everywhere trickle down blood

"TRICKLE DOWN," 2001

Sally and I had some really good years together. We shared an appreciation of dark humour. She was good medicine for my battered psyche. She introduced me to yoga, which I practiced assiduously for a number of years. She also hooked me up with Marc Bregman and his Jungian-based therapy, a connection that continues to offer ever-deepening understanding of how spirit and body work.

In early 1999, Sally and I were part of a small group that ventured to Vietnam and Cambodia on a "fact-finding" excursion on behalf of the Vietnam Veterans of America Foundation. I was recruited by VVAF founder Bobby Muller, a dynamic former U.S. Marine lieutenant who, in 1969, while leading an assault in North Vietnam, was shot through the chest and paralyzed from the waist down. Not long after returning to the States, Muller founded the Vietnam Veterans of America, then the Vietnam Veterans of America Foundation, a politically edgier spin-off of the former. He was also a cofounder of the International Campaign to Ban Landmines, which is how we met.

Muller invited me to witness firsthand VVAF's work in Vietnam and Cambodia, where, as in neighbouring Laos, American forces left

*Meghann Ahern, daughter of Emmylou Harris and Brian Ahern, and I jamming with a Cambodian musician blinded by a land mine*

millions of tons of unexploded ordnance, including land mines, scattered across farms and villages.

In Vietnam, "800,000 tons of unexploded ordnance [is] thought to remain hidden in the grass and jungles," according to a 2012 report by *The Christian Science Monitor*. "In 2007, the Vietnam Ministry of Labor reported that there had been more than 104,000 civilian casualties due to contact with UXO, with more than 38,000 people killed. In Quang Tri province, 84 percent of land is affected by UXO, making it the worst-hit in Vietnam."

Then there's Cambodia, which not only endured a massive U.S. bombing assault during the Vietnam War era, but subsequently suffered under a lunatic dictator, Pol Pot, who murdered and starved to death nearly two million people in four years. Cambodia then fought a war against Vietnam until the signing of a Paris peace agreement in 1991. Despite the agreement, Pol Pot's Khmer Rouge forces maintained a guerrilla insurgency until 1997, when the Cambodian government declared a general amnesty for the fighters, virtually all of whom turned in their weapons and melted back into the population. The amnesty finally ended three decades of war initiated by the United States, which itself followed ninety years of French occupation that ended in 1954 with the battle of Dien Bien Phu.

In 2010 Ben Kiernan, professor of international and area studies and director of the Genocide Studies Program at Yale University, and Taylor Owen, research director of the Tow Center for Digital Journalism at the Columbia School of Journalism, analyzed formerly classified data released by the Clinton administration that showed that the "secret" U.S. bombing of Cambodia between 1964 and 1973 saturated the small country with 2,756,941 tons of explosives dropped during 230,516 sorties on 113,716 sites. This is far greater than the entire estimated two million tons of bombs—including the nuclear attacks on Hiroshima and Nagasaki—dropped by all sides during World War II. In other words, it was the heaviest bombing campaign in the history of the world.

And that was just in Cambodia, a country the size of Oklahoma.

Add in the two million tons dropped on Laos and up to three million tons dropped on Vietnam, killing an estimated four to six million people in the three countries, and what you have is one of the worst slaughters in all of human history. In 1995 the eminent linguist, philosopher, and MIT professor Noam Chomsky wrote, "The toll of Indochinese dead during the U.S. wars is impressive even by twentieth century standards. For these dead, the U.S. bears responsibility."

The ugly spectre of empire still squats over Southeast Asia. Flying in a small aircraft over Cambodia, we saw a landscape made of bomb craters, albeit softened with the green of thriving vegetation, that pocked vast tracts of rich agricultural soil. The American bombing campaign plunged the country's rural youth into an enraged collective madness, leaving them ripe to be consumed by the egomaniacal pathology of Pol Pot. This tiny nation suffered the full spectrum of human indecency, and yet, following the war, the prevailing atmosphere was one of quiet determination to move forward—not ignoring the past, but leaving the dead to bury the dead. There was talk, among international bodies, of war crimes trials or some legal reckoning with what was left of the Khmer Rouge. The Cambodian government made some noises about it too, but people we met showed little enthusiasm for the idea. The absence of recrimination seemed miraculous. Whether out of forgiveness or simply a need to forget, the people were looking ahead, toward a life of peace most had never experienced.

In Cambodia I began a long lyric, collecting what we'd found in that devastated nation of beautiful, mostly young people who were beginning to stumble from the abyss toward a way of life their country hadn't known for two generations. It took me awhile to complete the piece, another effort at poetic reportage.

*Abe Lincoln once turned to somebody and said,*
*"Do you ever find yourself talking with the dead?"*

*There are three tiny death's heads carved out of mammoth tusk*
*on the ledge in my bathroom*

*They grin at me in the morning when I'm taking a leak,*
*but they say very little.*

*Outside Phnom Penh there's a tower, glass paneled,*
*maybe ten metres high*
*filled with skulls from the killing fields*
*Most of them lack the lower jaw*
*so they don't exactly grin*
*but they whisper, as if from a great distance,*
*of pain, and of pain left far behind*

*Eighteen thousand empty eyeholes peering out at the four directions*

*Electric fly buzz, green moist breeze*
*Bone-coloured Brahma bull grazes wet-eyed,*
*hobbled in hollow of mass grave*
*In the neighbouring field a small herd*
*of young boys plays soccer,*
*their laughter swallowed in expanding silence*

*This is too big for anger,*
*it's too big for blame.*
*We stumble through history so*
*humanly lame*
*So I bow down my head*
*Say a prayer for us all*
*That we don't fear the spirit*
*when it comes to call*

*The sun will soon slide down into the far end of the ancient reservoir.*
*Orange ball merging with its water-borne twin*
*below air-brushed edges of cloud.*
*But first, it spreads itself,*
*a golden scrim behind fractal sweep of swooping flycatchers.*

*Silhouetted dark green trees,*
*blue horizon*

*The rains are late this year.*
*The sky has no more tears to shed.*
*But from the air Cambodia remains*
*a disc of wet green, bordered by bright haze.*
*Water-filled bomb craters, sun-streaked gleam*
*stitched in strings across patchwork land*
*march west toward the far hills of Thailand.*
*Macro analog of Angkor Wat's temple walls'*
*intricate bas-relief of thousand-year-old battles*
*pitted with AK rounds*

*And under the sign of the seven-headed cobra*
*the naga who sees in all directions*
*seven million land mines lie in terraced grass, in paddy, in bush*
*(Call it a minescape now)*

*Sally holds the beggar's hand and cries*
*at his scarred-up face and absent eyes*
*and right leg gone from above the knee*

*Tears spot the dust on the worn stone causeway*
*whose sculpted guardians row on row*
*Half frown, half smile, mysterious, mute.*

*And this is too big for anger.*
*It's too big for blame*
*We stumble through history so*
*humanly lame.*
*So I bow down my head,*
*say a prayer for us all.*
*That we don't fear the spirit when it comes to call.*

"POSTCARDS FROM CAMBODIA," 1999

Like "Put It in Your Heart," "Postcards from Cambodia" references dream work, which was the source of the line "don't fear the spirit when it comes to call." It's a plea that we remain open to the touch of the Divine, a reality that is so much bigger than our day-to-day selves. We spend excessive energy shutting ourselves off from spirit, distracting ourselves from it, and hiding from our inner workings, and it costs us dearly. The absence of a relationship with spirit allows us to do things like murder each other by the hundreds of thousands and play foolish power games among ourselves and between nations. The song is political and historical, yet it also exalts the beauty that humans are somehow able to maintain even in the face of misery. How can the two coexist?

Many of us believe that there's a lot more going on right in front of us, within us, and in the cosmos than our rational minds can grasp. To access this reality requires surrender—the death, or at least the substantial reduction, of ego. It may require prayer—though, like "understanding" or "love," the idea of prayer can mean any number of things. Even if it's just gazing at the night sky, being awed by the scale of everything, savoring the perception that we are a tiny but unique part of the flow of an infinite universe, we can receive this profound and beautiful mystery.

Unfortunately, humans have an instinct built into us that drives us to tell others about our spiritual discoveries and beliefs and convince them that they need to see what we're seeing, and in the same way, or they are wrong. If they don't agree with us or conform, we have to fight them.

Over and over, we repeat our mistakes. Genghis Khan killed ten million souls and apparently sired half of Asia. Just doin' his job. This is the history of humankind. We were born, as a species, with the paranoia of prey and the aggression of predators. As soon as we became societies, with surplus, we found more reasons for fighting each other. We must always have had it in us, but it started meaning something in a big way when there were larders to raid. During this approximately ten-thousand-year period, humans have enjoyed peace for only short periods or in particular places; war appears to be our

default condition. The inclination to war may have begun as an aberrant mutation, but it has proved itself to be a dominant trait.

Should we give in to this tendency and stop putting energy into the attempt to find another way of being? Absolutely not. Somewhere in the din, God is trying to reach us. We have a place in the cosmos, but we won't find it through fighting. Fighting is perhaps our most effective distraction from our proper duties as human beings. It cuts us off and prevents us from listening to the whispers of the spirit, as well as listening to our neighbours. We hear the distorted voice, the one that told Gaddafi he was the saviour of Africa, the one that sends us out to battle so often for nothing. But the real voice, that of the spirit, is saying to us: Be quiet, listen, feel. Be kind. Accept differences, even those of Divine belief, for there is no "truth" in these things, only lessons. Learn from the differences. Feed your neighbour. Take your anger out on an untilled field. Liberally apply compassion, especially to yourself, for if we're not compassionate about our own foibles and screwups, then we can't authentically be compassionate toward others. We're all in the same foundering boat. It's our scars that unite us.

For me, the scale of the horror of Cambodia transcended any presumed or predictable reaction or emotion. For the victims, the people confronted by it directly, blame and anger might very well be a part of the picture, but we didn't encounter much of this sentiment. As in southern Mexico in 1983, it seemed as though I felt it more than the victims. I haven't got a very good handle on this aspect of large-scale violence, but it seems that a sympathetic person once removed is more likely than are the victims of violence to be driven by a kind of proxy sense of outrage, to seek vengeance, retribution, or "justice." Perhaps it is something akin to survivor's guilt.

In Cambodia we found a stillness, a remove from the horrors of the recent past. Even the tower of skulls memorializing the killing fields somehow radiated peace. Cattle grazed on the mass graves; boys played soccer on them. In the hospital for amputees in Phnom Penh, what we saw, in addition to the ingenuity brought to bear on the

manufacture of prostheses, was a joyously raucous game of wheel-chair basketball.

The exception, maybe the worst place I've ever visited, was Tuol Sleng, the onetime high school converted by Pol Pot's regime to an interrogation/torture centre. Tuol Sleng is a black hole that sucked all human goodness into it, leaving an event horizon of pure evil that chills the heart of everyone who goes there. In four years the Khmer Rouge "processed" 20,000 people at the prison, each victim beginning his or her final journey by being photographed. Today visitors peel through albums of mug shots, peculiarly formal portraits document-ing an endless procession of goggle-eyed souls who well understood the short future that awaited them. The Khmer Rouge ran 158 such prisons from 1975 to 1979, and created 309 mass-grave sites and an estimated 19,000 grave pits to accommodate the results, each pit hold-ing dozens or hundreds of souls.

Today Tuol Sleng is just a building; most of the rooms are empty. But visitors are inevitably enveloped by a darkness that overpowers even the brightest of days. It's not just knowing what happened there. You can go a lot of places and know what happened, like the Get-tysburg monument, a memorial to the fifty-one thousand people who died in that horrific battle of brethren. But Gettysburg doesn't have that feeling. It, too, is now just a field—a former killing field, to be sure, but among the heroic statues and rigid obelisks and complaining tourists, you don't *feel* what took place there. Tuol Sleng has not shed its menace. The pain, the fear, the screams, the horrid indignities, the torturer eating lunch between electric shocks—it's all there, clinging, palpable, personal.

In my personal frame of reference, the only thing that can compare with Tuol Sleng is the former Gestapo headquarters in Cologne, a typical small office building with a basement full of barred cells, in which, during the Nazi period, hundreds of prisoners languished, awaiting interrogation. The city of Cologne has preserved the prison as a museum. You can enter a couple of the cells, walls covered with graffiti in every European language, people writing to loved ones

they will never see again. I went there twice—the second time with Colin Linden, who cried.

On the first occasion, I was accompanied by an elderly volunteer docent who had been an inmate. She had been, and remained, a Communist and was interrogated under torture for it by the Gestapo for a couple of months. They eventually sold her as a slave to the Ford Motor Company. She spent about a year working for Ford, and then Ford sold her to a family that had a dry-cleaning business. She said that was better because the family was kind and treated her well. The Ford connection shouldn't surprise anyone familiar with the allegiance of large corporations to profit, no matter the human cost. In 1998 *The Washington Post* reported, "When the U.S. Army liberated the Ford plants in Cologne and Berlin, they found destitute foreign workers confined behind barbed wire and company documents extolling the 'genius of the Fuehrer,' according to reports filed by soldiers at the scene. A U.S. Army report by investigator Henry Schneider dated September 5, 1945, accused the German branch of Ford of serving as 'an arsenal of Nazism, at least for military vehicles' with the 'consent' of the parent company in Dearborn [Michigan]."

In Cologne, as in Cambodia, the anger had nowhere to land. There is no one to blame, just the sad immensity of the human capacity for ruin.

We eventually made it to Angkor Wat, the twelfth-century Buddhist temple and the world's largest religious monument. Our guide at Angkor Wat was a twenty-two-year-old Khmer man who had known only two years of peace during his lifetime—the preceding two years. He took us on a tour that skirted the numerous areas around the ancient temple complex that were mined. I said something about getting your leg blown off, and he said, "It doesn't really blow off. It's more like it gets jellied." (Our discussion was translated by Luong Ung, a Khmer-American woman who worked for VVAF and was the national spokesperson for the International Campaign to Ban Landmines.) Our guide said he had once been walking with some other children and one of their mothers, and the lady stepped on a

mine. It didn't blow her leg off; it just kind of mashed it from the knee down so that it had to be amputated. This happened, and continues to happen, to many thousands of people in Cambodia and other places polluted with land mines. (The problem was aggravated in postwar Cambodia by the grim phenomenon of some farmers digging up mines and replanting them to keep neighbours' cattle out of their pastures.)

People think of this stuff, create these instruments of destruction and pain, then go home to their families, pets, hobbies, and "reality" shows. Yet a country like Cambodia, which is finally finding itself in a state of peace, can't live that peace, can't grow food, and can't get its economy going again, at least not in any sustainable way, until the mines are cleared, which takes an agonizingly long time. Meanwhile, the Gap, Nike, Walmart, and other corporate vultures swooped to set up sweatshops in Cambodia shortly after the 1997 amnesty. To such entities, the inability of people to feed themselves merely makes for a cheap labour pool.

At the time Emmylou Harris added her gorgeous vocal harmonies to "Postcards from Cambodia," she too was deeply involved in the campaign against land mines, as the *Chicago Tribune* noted when it interviewed her before a concert: "[J]ust hours before the show, Harris did not choose to talk about her 27 Top 10 hits, her 8 gold records, her triple platinum album, or her 7 Grammys. Instead, she spoke of . . . her involvement with the International Campaign to Ban Landmines." By then, several of us in the "entertainment" industry were likewise badgering whatever media might listen, and our audiences, to encourage the United States and any other country that hadn't yet signed the Ottawa Treaty to do so.

The following year, Emmylou joined Steve Earle and Bobby Muller in organizing a series of shows called Concerts for a Landmine Free World. I was honoured to be on the bill for many of these events, along with Mary Chapin Carpenter, John Prine, Nanci Griffith, Guy Clark, Patty Griffin, Gillian Welch and David Rawlings, Kris Kristofferson, Sheryl Crow, and others. The concert series commemorat-

ing the signing of the treaty ran every fall for several years, until President Bush's war agenda rendered pointless the efforts to get the Pentagon to consider dropping a weapon from their arsenal.

At the same time, my own concerts following the release of *You've Never Seen Everything* may have bordered on bleak for some listeners. To the extent that there is a "message" in the songs, it is one of hope, I think, though it's hope in the face of a pretty dark local reality. When I perform songs I feel what's in them, and I performed all the dark stuff, including the title cut—written one month before 9/11—along with "Postcards from Cambodia" and "All Our Dark Tomorrows." There was balance with other songs from the album— "Open," "Don't Forget About Delight," "Everywhere Dance," "Messenger Wind"—but the shows weren't as cheery as some might have wished. People would enter the venue in a mood of happy expectation, and then, "Ohhhh." Still, some listeners tell me that they find even the darkest songs uplifting, as they verify our feelings and soothe them with the balm of community. That is the hoped-for reaction.

The darkness is there because it exists, and what exists is what I try to write about. I learned long ago not to be afraid of the dark, that it can sometimes be a friend. Fans who have stayed with me over time have shown an admirable capacity for putting up with my shifts and changes in direction, and the occasional long-exposure snapshots of darkened rooms infused with hypodermic light. They get it, and I'm grateful for that.

*Nobody's making me say this*
*I'm talking to you*
*Been travelling seventeen hours*
*Irradiated by signals, by images*
*of viruses, of virtues*
*like everyone*
*Like exiled angels we swing out of the clouds*
*Above night city —*
*Fields of light broken by the curve of dark waterways*

*On the other side of the world*
*an unhappy teenage girl sets fire*
*to herself, her house, her neighbourhood, and some that dwell therein*
*Sorry simulacrum of sad dawn*

*You've never seen everything*

*Sleep of the just, sleep of reason, any damn kind of sleep please!*
*I'm trying to balance on a sloping bed in Naples*
*or is it Skopje? I forget*
*Through the thin hotel wall a man groans in his dreams*

*And on the other side of the world*
*the drug squad busts a child's birthday party*
*Puts bullets in the family dog and the blood goes all over the baby*
*And the Mounties are strip-searching schoolgirls*
*because they can*

*And a car crashes and burns on an off-ramp from the Gardiner*
*Two dogs in the backseat die, and in the front*
*a man and his mother*
*Forensics reveals the lady has pitchfork wounds in her chest —*
*Pitchfork!*
*And that the same or a similar instrument has been screwed to the dash*
*to make sure the driver goes too*

*You've never seen everything*

*I see:*
*A leader of the people with a ring in his nose*
*And the leaders of business tell him which way to go*
*With tugs on the golden chain which once led the golden calf*
*And we're supposed to be impressed with their success*
*But my mind goes blank before the unbelievable indifference*

*shown life*
*spirit*
*the future*
*anything green*
*anything just*

*Bad pressure coming down*
*Tears—what we really traffic in*
*Ride the ribbon of shadow*
*Never feel the light falling all around*

*Years ago when my brother was in India*
*A small-town baker got a bright idea*
*He cut his flour with pesticide*
*and sent a bunch of neighbours on their longest journey*
*He was just being cheap—trying to make a profit*
*Didn't even have shareholders to answer to*

*But it's worth remembering, as we sell off the forest*
*gene-splice the world's food into an instrument of control*
*maim and destroy as acts of theatre,*
*what came next —*
*That when the survivors looked around*
*and understood what had been done*
*they butchered*
*that baker*

*Snow swirls in the parking-lot light like flour*
*like pesticide*
*There's a trade war brewing—or at least that's the face they paint on it*

*But it's only more transnational manipulation*
*It's all bad magic and gangrene politics*
*Hormone disruptors and carcinogenetics*

*Greed twists eternal in the human breast*
*But the market has no brain*
*It doesn't love it's not God*
*All it knows is the price of lunch*

*Here I sit*
*Staring at my own shadow*
*Feeling my blood move*
*Trying not to have a drink*
*Trying to find somewhere to put the rage I'm carrying*

*Bad pressure coming down*
*Tears—what we really traffic in*
*ride the ribbon of shadow*
*Never feel the light falling all around*
*Never feel the light falling all around*

*You've never seen everything*

"YOU'VE NEVER SEEN EVERYTHING," 2001

# 22

One morning in Toronto, I awoke to the realization that I had lived in the city or its environs for twenty years. This was 2000. "Come the millennium" was a good time to move. I could have gone anywhere, but for very good reasons I chose Montreal. I was craving a new landscape to explore, but the move also put me close to Jenny, who, having gone to Montreal for college, had made it her home. It was also five hours closer to Sally, less than an hour from the border of Vermont.

Yet during the four years I lived in Montreal, I found myself mostly alone. I set up the sunniest room as a studio for Sally, but she rarely visited, and never for long enough to paint, so the row house I rented, which was about 150 years old and not very big, became a "man cave," a receptacle for my pack-rat assemblage of belongings: instruments and amps, books, CDs, a rambling collection of knives and swords, clothes, art, ironic war toys from odd places (a scrap-metal machine gun from Mexico, a wicker tank from Mozambique), and a couple of rifles but no handguns. Unlike in Ontario, possessing handguns in Quebec would have required a police inspection of my house by members of a force that had a reputation for being difficult to deal with. That didn't sit well with me, so I gave away most of the handguns to shooting friends and sold the rest. The house had almost no furniture. Sally gave me a

set of quality pots and pans to replace the camping gear I mostly cooked with.

Montreal is Canada's second-largest city and the home of a vibrant arts scene. When I got there I anticipated absorbing the arts and plenty of music, improving my French, hanging out with people. The first person I went out to hear play was Howard Levy, a harmonica player of staggering prowess, in a bar not far from my house. The proprietor made a fuss about my being there, bought me a drink, got me a table, and made sure everybody noticed. I didn't want to sound ungrateful—it's nice to be appreciated—but I had to tell him, "Thanks, but I just want to sit in the back and get into the music. I don't want to be part of the show." It was embarrassing. It's even uncomfortable to put it in print—oh, the poor celebrity, the rigours of fame, etc. But that wasn't it at all. I felt the same aversion to attention that I've carried all through my life. The result was that the whole four years I lived in Montreal, with the exception of street fairs and the jazz festival, I never again went out alone at night to hear music. I'd go to a movie or occasionally join Jenn and her friends, but just showing up by myself and risking being centred out was too uncomfortable. Eventually I made a friend in photographer Zoi Kilakos. We would get together for dinner now and then and hang out for an evening.

Daytime was different. I rode my bike a lot, even in winter if the pavement was not too icy. I'm a big fan of the bicycle. It provides a semblance of freedom in an urban landscape while moving us along at speeds that make sense to human physiology. The bike also promises adventure, which is easily found when the temperature is hovering around minus twenty degrees Celsius.

*Past the derelict mattress*
*and the overgrown pavement*
*over the tracks*
*and through the hole in the fence*
*Past graffiti-bright buildings*

*and the junkyard alarm bell*
*and the screaming police cars*
*and it's all present tense*
*It's my beat*
*In my new town*
*Past the drunk woman reeling*
*with her bag of provisions*
*Down through the tunnel*
*with the stink-fuming bus*
*Onto the bike path*
*where it's something like freedom*
*and the wind in my earring whispers*
*Trust what you must*
*It's my beat*
*In my new town*
*Ancient and always*
*The wheel's ever whirling*
*Today I'm riding*
*Tomorrow I walk*
*Step through forever*
*into this very moment*
*The heart is pumping*
*and the heart rocks*
*It's my beat*
*In my new town*

"MY BEAT," 2001

The solitude of Montreal was at least productive for writing and practicing the songs that ended up on *You've Never Seen Everything*. The house came with a downstairs neighbour who was almost unnaturally tolerant of my noises. A guitar, especially an electric one, played in a detached house torments few neighbours, but amplify it in an apartment and people end up hating you. The woman who lived

in the basement never complained, even when I asked her about it. In fact, when she moved, she told me she would miss the music. I think she was being nice.

Songwriting isn't pretty; it's not a concert or CD. You play the same riff over and over for an hour. When I lived with Judy in Toronto, the woman through the wall was refreshingly honest about it. "Before living next door to you," she said, "I had no idea what a painful process songwriting is."

The music magazine *Paste* called *You've Never Seen Everything* "easily one of the highlights" of my career. Gary Craig brought back his riveting drums, augmented by young Toronto jazz drummer Ben Riley and additional drums and percussion by Stephen Hodges, known for, among other things, his work with Tom Waits. (Hodges also played marimba on "Messenger Wind.") John Dymond, Larry Taylor, Steve Lucas, and Rich Brown played bass. Colin Linden, who once again contributed his strong ear and technical gifts as coproducer, played electric mandolins and a small bass part. As usual, we brought in some ringers to add vocal harmonies, including Jackson Browne, Sarah Harmer, Emmylou Harris, Sam Phillips, Jonell Mosser, and two guys from a young Toronto band called the Supers, Maury Lafoy and Graham Powell. John Whynot beautifully engineered the sound and added some perfectly mysterious whistling on "Messenger Wind."

The magic of what violinist Hugh Marsh contributed can't be overstated. Hugh is on all the songs but one, gracing them with his alternately funky and painterly violin. It was my first album collaboration with him since *Big Circumstance* in 1988, a fifteen-year gap it felt good to bridge. Hubie and I and Gary, who played the role of human beat box on a very unorthodox drum kit made up of odd percussion instruments, performed all the songs as a trio. All the other elements were then added, though Colin and I briefly considered leaving the tracks in their trio form, as the material shone brightly in that spare setting. In the end, we opted for a richer palette.

As mentioned earlier, guests on *You've Never Seen Everything*

included pianist Andy Milne, coauthor of two of the songs. With Andy came a fellow Dapp Theory band member, Swiss harmonica prodigy Grégoire Maret, who played on "Everywhere Dance" and "You've Never Seen Everything."

We had recorded the "real" version of "Trickle Down" for Andy's album with Dapp Theory. Nearly all the pieces on that record had unusual time signatures. The musicians could play in seven-four time, then in five for a couple of bars, then a bar of eleven, whatever, and they could groove through it without even thinking. The effect is very strong, but I couldn't do it. I was able to mostly fit in when I played with them on their versions, but mine had to be simpler. I had to be able to get the words out over whatever I was playing. Andy agreed to my altering the music of the verses, but I don't think he was all too happy with how I did it. His enthusiasm on the album, though, came through undiminished.

"Open," the second song on *You've Never Seen Everything,* wrote itself very quickly. I woke up one morning holding my breath. The little deep-set, arched window in my bedroom was blowing in light spiced with early-morning street sounds. I started cataloguing the sounds and what I was feeling. I felt like I wanted to be open to it all. I'm still working on that. Outside our collective darkness lives something that touches the core of us, perhaps what we call "love." I embraced and understood this feeling as a holy and benevolent force, perhaps because it contrasted so well, and so often, with the many dark mansions of my own life and those of my brethren. I had a glimpse of humanity poised to experience a spiritual coalescence, open enough to invest ourselves in nurturing relationships with each other and with the beautiful creatures of this planet, with the cosmos, with God. The song was an encouragement to all of us, especially me, to keep trudging in that direction.

"Open" followed "Tried and Tested," the songs intentionally juxtaposed as a marriage of dark and light elements, which are important on this album. Yet "Tried and Tested" is not necessarily a "dark" song. The tune itself is intentionally upbeat. We are often—some of

us perpetually—tried and tested by the times, by history, by bullies and fakes, by our own foibles and weaknesses, by our neighbours and families, by tragedies we encounter or create. I don't think I'm alone in this. The song carries these challenging elements of my life onto an audio tableau as something to be addressed, assuaged, and set toward light. We have to acknowledge and understand these things in order to get to light, to remember delight, to be open.

*Tried and tested*
*Tried and tested*

*By the cries of birds*
*By the lies I've heard*
*By my own loose talk*
*By the way I walk*
*By the claws of beasts*
*By the laws of priests*
*By the glutton's feast*
*By the word police*

*By the planet's arc*
*By the falling dark*
*By the state of the art*
*By the beat of my heart*
*By dark finance*
*By the marketing dance*
*By the poverty trance*
*By the fateful glance*

*Tried and tested*
*Tried and tested*

*By the pressure to rhyme*
*By the wages of crime*

*By the drop of a dime*
*By the ghost of the times*
*By the spurs of desire*
*By "What does love require"*
*By what I waited for*
*By what showed up at the door*

*Tried and tested*
*Tried and tested*

*By the nation wide*
*By the tears I've cried*
*By the lure of false pride*
*By the need to take sides*
*By the weight of choice*
*By the still small voice*
*By things I forget*
*By what I haven't met yet*

*Tried and tested*
*Tried and tested*

*Pierced by beauty's blade and skinned by wind*
*Begged for more—was given—begged again*
*I'm still here*
*I'm still here*

"TRIED AND TESTED," 2002

During the same period that Andy and I were writing "Trickle Down," I was inducted into the Canadian Music Hall of Fame. The ceremony took place in Hamilton, Ontario, on March 4, 2001, during the thirtieth annual Juno Awards. While deeply honoured, I felt the induction seemed somewhat premature. Wasn't I supposed to be dead

first? Well, no, apparently not—artistic taxidermy not required. As I told a *Toronto Star* reporter at the time, "If age means shutting down, closing the heart, relying on past habits to get you through, it'll be a problem for any kind of creative work. So far that hasn't been the case. I feel as if I'm learning at the same rate as I always have, but I'm more aware of it now, and able to appreciate it more. My models for graceful aging are guys like John Lee Hooker and Mississippi John Hurt, who never stopped working till they dropped. Eventually time is going to get everyone, but . . . you don't have to stop maturing just because you become mature."

I was nervous at the Junos, more nervous than I was when threatened with castration in Mozambique. Not only was it the first time

in twenty years that I would attend the awards ceremony, but I had to make a speech *live* on *national television.* A couple of months later, I would discover that the stress I felt had given me an atrial fibrillation that wouldn't go away ("the beat of my heart"). All that day, I was aware of feeling more apprehensive than I had ever been, which is saying something. I was in and out of the bathroom every half hour. At the awards show itself, in spite of Sally's efforts to calm me down, the pattern continued. I threw down quite a bit of questionable bar Scotch, to no avail.

The producers of the show had put together a very nice segment honouring me. Bono, Jackson Browne, Margo Timmins of the Cowboy Junkies, and Peter Garrett of Midnight Oil said nice things about me in video testimonials. The Barenaked Ladies (all of whom were men in normal clothing) performed "Lovers in a Dangerous Time"

(which had been their first top-forty hit, in 1991), Jann Arden and Terri Clark sang "Wondering Where the Lions Are," and Sarah Harmer sang "Waiting for a Miracle." (A year and a half later, Sarah kindly dropped by the Clubhouse recording studio in Toronto and added harmonies to several songs on *You've Never Seen Everything*.) Gordon Lightfoot, the archetypal Canadian singer-songwriter, and scientist and environmental activist David Suzuki "inducted" me. (I had worked with Suzuki the previous year on an effort to pressure the government of Canada to address climate change.)

Then it was my moment. As I walked to the gleaming Lucite lectern, the quaking in my knees ceased. I felt a rush of clear energy flood my system and thought, "Geez, I know how to do this!"

Thank you. It's a thrill to be included in the incredible company of artists who make up the Hall of Fame. It's been my privilege to be one voice in the human choir during a period which I think will turn out to have been a formative one for English Canadian culture. Over the years there has been a wonderful flowering of creativity and spunk in our music scene, paralleling, often reflecting other currents flowing around us.

In the sixties, when I was just beginning to play for people and write songs, the world began to recognize its oneness. We had McLuhan, Vatican II, we had Swami Vishnu Devananda dropping chrysanthemums from the air over Belfast and Suez. We had a generation of people, worldwide, who began to appreciate their common burdens and strengths instead of fixating on what separated them. This spirit has developed into a widespread embracing of each other's music and cultures, at least important aspects of them. Some people are afraid of this, but to me it's a positive thing. There is a dark side—that is, the promotion of uniformity by those whose interest is power by profit. Their job is easier if we're all the same—if we all like whatever they tell us to like, so much so that they sometimes act like we are all subscribers to the same shaky pyramid scheme with them at the top. It's this thinking that

has led to the weakening of national sovereignty, of democratic principles—that has, in effect, hijacked the movement to global community and tried to turn it into commerce under the name "globalization."

To thrive, society needs a sense that we're looking out for each other, needs to know where it came from and what sacrifices were made to create it. It needs to be literate as well as web-wise. We have to stop the hemorrhaging in health care and education, the shrinking of environmental safeguards. We've got to get past the fad of privatization—the mercantile system sucked when they tried it in the 1700s, and it sucks now. It's our community, it's our world. My job is to try and trap the spirit of things in the scratches of pen on paper, in the pulling of notes out of metal. These become songs, and the songs become fuel. They can be fuel for romance, for protest, for spiritual discovery, or for complacency. That's where you all come in. You decide how a song will be heard and felt. I'm filled with gratitude that so many of you have let my songs touch you. To all of you who have done me the honour of listening to what I have to say, thank you. I love my job, I can't wait to see what I'm gonna do next. I love you.

An irony lost on few industry people at the time was that, even as I was being inducted into the Canadian Music Hall of Fame, my new songs were receiving very little airplay in Canada. As Craig MacInnis wrote in the March 4, 2001, *Ottawa Citizen,*

If there is an off-key note to Bruce Cockburn's induction into the Juno Hall of Fame, it is that it comes at a time when his new music is no longer being played on Canadian radio. Sure, you might hear one of his "golden oldies" like "Wondering Where the Lions Are" or "The Coldest Night of the Year" on one of the classic-rock stations. But a new song, like, say, his gorgeous 1999 duet with Margo Timmins on the old Fats Domino standard, "Blueberry Hill," fails to fit into Canada's ever-narrowing radio formats. "Very rarely

do you hear a Bruce Cockburn song on the radio in Canada, yet he's probably making the best music of his life," says [Larry] LeBlanc [Canadian editor of *Billboard* magazine]. "You hear him on CBC, and that's it." The irony is that Cockburn—a performer who never left Canada, a performer who continues to champion Canadian causes in his music—has been embraced by American radio even as Canada's stations have written him off. The Triple-A format (Adult Album Alternative) that exists in the large U.S. markets, but not in Canada, provides Cockburn with an important commercial outlet for his music in centres like Minneapolis, Chicago, Denver, Seattle and New York. "I live in Nashville six months of the year and I hear Bruce on the radio down there all the time," says [Colin] Linden.

In the same article MacInnis was kind enough to report, "The Who's Pete Townshend, in a surprisingly smart discourse on Canadian music, once raved to me about Cockburn's 'lethal intelligence' on the guitar. Bono is another longtime admirer, as is David Crosby of CSN&Y, as was the Grateful Dead's Jerry Garcia."

In the face of such praise, a Hall of Fame induction, and a fall from Canadian airwaves, it might be easy to kick back with a bottle of Caol Ila, recycle the old sounds, and call it good. But there's a sort of death in that approach, though many performers do choose it (or perhaps it chooses them). This is not a path I will limp down no matter how old I get. Why would I want to sound the same? Life is never the same. Sameness itself might be viewed as a form of death. In fact, because I believe in a higher realm, in a God that travels with us before, during, and after this mortal life, I would add that even actual death doesn't necessarily excuse a ceasing of all forward progress. As I told the writer, "Everything in life is about growth. Growth is a continuing process that I personally believe doesn't stop when we die. Death is a major graduation point as I see it. That'll be the big one. The Juno Hall of Fame may suggest death in an oblique sort of way, but it just isn't the same thing."

While I deeply appreciate the Hall of Fame induction, an honour I hold dearer came from the nation itself. On May 1, 2002, Governor General Adrienne Clarkson officiated over an advancement of my status in the Order of Canada from "Member" (which I received in 1983) to "Officer." (Joni Mitchell was upgraded to "Officer" on the same day.) The Order of Canada is a manifestation of the nation's historical ties with Britain and its traditions. Some feel that having the throne of England hold the hind end of the nominal head of the Canadian state is anachronistic, and we should let it go. I don't feel strongly about it one way or the other, but I think it's healthy to have an image, or perhaps a symbol, that Canadians can rally around rather than investing some "mere mortal" with the larger-than-life qualities often identified with nationhood. In Canada you won't hear, "Our prime minister, right or wrong!"

According to the governor general's website, "[T]he Order of Canada is the centrepiece of Canada's honours system and recognizes a lifetime of outstanding achievement, dedication to the community and service to the nation." The Order of Canada's motto, *desiderantes meliorem patriam* ("they desire a better country"), is taken from Hebrews 11:16: "But now they desire a better, that is, a heavenly *country*. Therefore God is not ashamed to be called their God, for He has prepared a city for them."

It might seem ironic that I would value a government-issued honour more than others. I have nothing against government . . . as long as it does what I think is right and it leaves me alone! Government can and should be a great thing. It's the corruption, greed, and hubris of individuals in government who are bought and sold for private gain that is so destructive. I remain surprised and chagrined to witness the ongoing elevation to leadership of people so obviously willing to be bought.

Nonetheless, while I have taken issue, sometimes vociferously, with the government's policies and actions through the years, I know very well how fortunate I am to be Canadian, to hold citizenship in a nation that still generally respects the rule of law as it pertains to

protecting the rights of most people at home and abroad. It is a nation that has generally refrained from wielding its great wealth in a militaristic fashion. It's a nation that has embraced, or at least accepted, the critical work of people like Lieutenant General Roméo Dallaire and Tommy Douglas, the premier of Saskatchewan who in effect gave us universal health care. So while there's plenty in Ottawa to do and to fix—such as halting the vicious assaults on the country's vital ecosystems, honouring aboriginal rights, and aiding a growing class of poor and underprivileged residents who are suffering from cuts to social services—things could be much worse, as they are in far too many places. There are times when I feel quite proud of my country.

It says something very positive about Canada that someone like me could receive one of the country's highest civilian honours *and* be placed on a postage stamp, which occurred in 2011. Not only in song but in numerous public statements I have been highly critical of certain Canadians as well as other world leaders and systems. Yet I have not been shunned or stifled (or worse) by the government, as could have occurred in a lot of other places.

One month after receiving my Order of Canada promotion, in June 2002, I took my medal into political battle and joined demonstrations aimed at the annual G8 summit meeting, held that year in Canada. The G8—or "Group of Eight"—is an elite clique of leaders from the world's wealthiest nations (Italy, France, Germany, Japan, Canada, the United States, the European Commission, and, for the first time in 2002, Russia) who meet in secret to forge agreements for the movement of goods, capital, and human beings, a system of world domination that I called out in my 1980 song "Grim Travellers." Not much had changed since 1980 except that their agenda had become further entrenched, marked by a rise in social and environmental destruction resulting from these sordid geopolitical alliances.

The 2002 G8 attendees included President Bush and his secretary of state, Colin Powell, who was just eight months away from his infamous and foul-smelling emission before the United Nations about Iraq's nonexistent "weapons of mass destruction," greasing the path

toward another war. It was an opulent two-day affair held in Kanan-askis, Alberta, some thirty miles southeast of Banff, in the Rockies. The government of Canada spent $300 million on security, which was far less than the reported $1 billion spent the previous year in Genoa, Italy, where some three hundred thousand protesters, in the fine Italian tradition, turned out for violent clashes against the world's most powerful gatekeepers.

Security may have been cheaper in Canada than in Genoa because no one was allowed anywhere near the summit. All land and air approaches to the gathering were blocked by police and troops for a four-mile radius. A defensive roof was provided by F-18 jet fighters. Military helicopters swarmed the rafters. Rumour had it that ground troops were patrolling the bush around the conference site under shoot-to-kill orders. Protesters were allowed to gather in Calgary, an hour away, and they were peaceful, primarily because the forces of "law and order" were peaceful. Plenty of extra police were brought in from all over the country, but instead of riot cops with shields, batons, and shotguns, street protests were met by Calgary's bicycle patrol officers. There was no herding of people, except to keep the anarchist crowd away from Starbucks. Even then, the would-be assault was fended off by a phalanx of cops in bike helmets holding their cycles in front of them as shields. Many were smiling. No sup-pression, no riot cops, no riot.

The one major problem with our protest was highlighted when a reporter said to me, "If you guys have another one this dull, we are not going to cover it anymore." Maybe it would be more exciting for reporters if they actually investigated the G8 countries' contributions to famine, loss of water rights, proliferation of slums and sweatshops, child labour, death squads, torture, aerial bombardment, climate change, and one of the greatest extinction events in planetary history. But the media need not have worried. Subsequent meetings of the G8 and its less exclusive spin-off, the G20, have been met with enough spectacular repression to get any William Randolph Hearst wannabe licking his lips.

As a flexing of political muscle, the G8 protest of 2002 had little effect—one protest is never going to change the course of events—but as a voice that continues to be aired, it will make itself heard over time. That voice must be kept alive even if it's swallowed in the din of indifference or the dungeons of state-imposed silence, and even if reporters, who can be numb to all but the tenor of an action flick, can't hear it. The people do hear it, and as they hear it they speak it, and the voice grows louder and can't be ignored, at least as long as politicians depend on public approval for their jobs.

Protest leaders asked me to join a June 21, 2002, press conference in Ottawa on behalf of groups gathering for the upcoming Calgary "countersummit." A great darkness was about to fall, as America's King of the Fools was setting the stage for an imperial assault and occupation of Iraq. Eighteen months after I made this speech, and nine months after the American invasion of Mesopotamia, I would witness His Highness's work in Baghdad, then considered one of the most dangerous places in the world. To the assembled media people, I offered the following:

I'm here as a concerned citizen to lend my support to what I believe is a vital exercise of the democratic right of dissent. The silencing of dissent by various means—the attempted elimination of one whole side of the globalization debate—is a worrisome sign of worse to come. I've done a fair amount of travelling in "developing" countries, much of it related to the work of various charitable organizations. I've seen what the kind of top-down "aid" advocated by the G8 has done to people. It doesn't look like development to me. The current fashion in the corridors of power, of reducing everything to the terms of the marketplace, is heartbreaking for the poor of the world, for those of us committed to seeking something like justice in human affairs, for those of us concerned about the environment that gives us life—and for those of us who grew up in a Canada where freedom was a cherished value, where a government which was accountable provided some of the necessities

of life for those in need. When a nation's government hands over the reins of all its functions to the private sector, what's left for it to run except the army and the police? I worry that the Canada I learned to love growing up will not be what my grandchildren, if I have them, are going to encounter. There are other ways of doing things, and we must encourage our leaders to find those ways and pursue them. Otherwise we can look forward to a Moebius strip of more inequity, more anger, more violence, more erosion of our civil liberties in the name of security, more anger, more violence. The G8 leaders are facilitating the degradation of my country and my planet. I have to protest this! Globalization as currently understood is, to me, an evil thing, but that's not to suggest that all global connections are bad. There's so much we can all share to our mutual benefit. One important thing I learned in the early eighties, hanging with dissidents in Pinochet's Chile, where dissent really meant risking your life, is that when you resist evil you are in fact celebrating life, and it's okay to have a good time.

# 23

From time to time, acerbically and without warning, Sally would write someone out of her life. She would tire of some aspect of a friend, or of the relationship she had with them. Some switch in her head would flip, and the bewildered friend would be bluntly informed that there would be no more relations between them. This tendency created some awkward moments for me, as I had also become friends with some of these people.

In due course, in the spring of 2003, my number came up. I arrived at Sally's place, having driven down from Montreal, to be informed that as far as she was concerned our relationship was over. I had not seen it coming, but I had observed the phenomenon enough times that I wasn't really surprised. By this time I had been through enough of these episodes that I was starting to grow calluses. Really? Another failed relationship. Another twist in the road. I felt hard done by, but I wasn't expecting fairness anyway.

I left with a feeling more bleak than tearful. There was lots to miss in Vermont, not the least of which was the degree of warmth that had grown between the boy Carson and me, but there was a new horizon beckoning to be floundered toward.

In 1995, the U.N. Food and Agriculture Organization reported that 567,000 Iraqi children under the age of five had died as a result of

U.N. sanctions imposed on Iraq after Saddam Hussein's 1990 invasion of Kuwait. On May 12, 1996, viewers of the American news program *60 Minutes* heard a rare demonstration of candour on the part of a sitting U.S. official when Madeleine Albright, then the U.S. ambassador to the United Nations, described the country's foreign policy initiatives in the Middle East. Interviewer Lesley Stahl asked her, "We have heard that a half million children have died. I mean, that's more children than died in Hiroshima. And, you know, is the price worth it?" (It's actually five times the total death count of Hiroshima.)

Albright did not refute the number. Instead she said, "I think this is a very hard choice, but the price—we think the price is worth it."

*We think the price is worth it.* Half a million children dead as punishment for the actions of yet another despot formerly empowered by the very government that employed Albright. And this was just 1995; sanctions would remain in place for another eight years, to be followed by a massive U.S. bombing campaign and occupation.

In her 2003 memoir, Albright claimed that the *60 Minutes* segment "amounted to Iraqi propaganda. . . . Nothing matters more than the lives of innocent people. I had fallen into a trap and said something that I simply did not mean."

Whatever the truth of that assertion, her government meant it, because everyone in Washington was quite aware that sanctions were killing one hundred thousand children every year, but there was no effort on the part of the United States to relieve Iraqi suffering. Indeed, the United States and Great Britain consistently opposed any effort by the U.N. Security Council to lift the sanctions, even after the brief but devastating U.S.-led war against Iraq ("Desert Storm") effectively crippled that country in 1991. So the sanctions remained in place until after the next war against Iraq, which began on March 20, 2003, under the made-for-TV catchphrase "shock and awe." In under two months the United States flew one hundred thousand sorties and dropped nearly ninety thousand tons of bombs on a virtually defenseless Iraq.

For me, it was more like shock and disgust. What perturbed Albright was not that she misspoke, but that she spoke truth without meaning to—a glaring bureaucratic gaffe. But she needn't have worried. Excellent reporting by *60 Minutes* notwithstanding, mainstream media had her back. Virtually no other news outlet cited the interview after it aired. The U.S. media watchdog group Fairness and Accuracy in Reporting concluded, "The inference that Albright and the terrorists may have shared a common rationale—a belief that the deaths of thousands of innocents are a price worth paying to achieve one's political ends—does not seem to be one that can be made in U.S. mass media." Less than one year later, President Bill Clinton picked Albright to be his secretary of state, the first woman ever to hold the office.

We'll never know the exact death toll because the U.S. invasion destroyed the Iraqi government's capacity to keep its own tally, and the U.S. government apparently wasn't interested in knowing real numbers. ("We don't do body counts," General Tommy Franks, who led the invasions of both Afghanistan and Iraq, famously said.) After three years of war, a 2006 *Lancet* survey put the number of Iraqi dead at 654,965. The following year the London-based polling company Opinion Research Business determined that 1,220,580 Iraqis had died due to the war. And the killing hasn't stopped. At this writing, sectarian violence in Iraq is vastly worse than when I visited nine months after the war began, with the partitioning of the country seeming likely. Yet in a certain sense the exact number of dead is not as important as the understanding that the U.S. government, hiding behind the imbecilic edicts of a half-wit Texas oilman, believed the Iraqi death toll was "worth it" to secure petroleum reserves.

> *Tell the universe what you've done*
> *Out in the desert with your smoking gun*
> *Looks like you've been having too much fun*
> *Tell the universe what you've done*

*Tell the universe what you took*
*While the heavens trembled and the mountains shook*
*All those lives not worth a second look*
*Tell the universe what you took*

*You've been projecting your shit at the world*
*Self-hatred tarted up as payback time*
*You can self-destruct—that's your right*
*But keep it to yourself if you don't mind*

*Tell the universe where you've been*
*With your bloodstained shoes and your dunce's grin*
*Got to notify the next of kin*
*Tell the universe where you've been*

"TELL THE UNIVERSE," 2003

I wrote those words one month after the invasion and about two weeks after the staged photo op of "Iraqis" toppling a statue of Saddam Hussein in Baghdad's Firdos Square. (Later, on December 30, 2006, at the Iraqi-American military base Camp Justice, during the beginning of Eid ul-Adha, the Muslim holiday commemorating the day that Abraham agreed to sacrifice his son, the statue's model would hang.) It was the other side of the "Put It in Your Heart" coin. The absence of real information about what was happening in Iraq, except for the reports of "embedded" journalists, set me to thinking about going there. I hadn't taken the notion very far until I happened to have a night off during a tour in the fall of 2003. I was having dinner with my friend Linda Panetta, the Philadelphia human rights activist and photojournalist. Partway through the meal, the reason for her apparent state of suppressed excitement revealed itself.

"We're going to Baghdad," she said. "Want to come?"

An invitation like this from Linda was very real. She's a purposeful and adventuresome woman who has put her life and well-being

on the line in world hot spots to grab images and gather information, for print and public presentations, to raise awareness about the suffering of the world's poor. I knew Linda as a longtime opponent of the School of the Americas, now operating as the Western Hemisphere Institute for Security Cooperation, the military training centre at Fort Benning, Georgia, that conducts classes for interested parties in the Western Hemisphere in how to disrupt societies, torture dissidents, and orchestrate coups, among other geopolitical fields of study.

Linda garnered a small amount of fame in early 2009, and a death threat that brought the FBI into the picture, when the right-wing blogosphere claimed that she was the daughter of President-elect Obama's proposed CIA chief, Leon Panetta. (She is not.) The blogs showed a picture of Venezuelan president Hugo Chavez with his arm around her, standing next to Nicaraguan president Daniel Ortega. This much was true, but nothing else was. One blog has yet to take down a photo and story that says, "[W]e think senators should ask the nominee to be the next CIA chief about his daughter's support for sworn enemies of the United States." Accuracy in media indeed.

Linda was working with a friend, Bishop Thomas Gumbleton of Detroit, a founding president of PAX Christi USA, who was planning the trip to Baghdad to see how his friends and contacts were faring during the war. Tom had been arrested several times for civil disobedience, including as a protester against the Iraq war—the only U.S. Roman Catholic bishop to do so. Previous peace missions had taken him to Vietnam, Iran, Nicaragua, El Salvador, Hiroshima, Haiti, Mexico, Guatemala, Peru, and Colombia. Prior to the journey we would take together in 2004, Tom had visited Iraq seven times from 1990 to 2003 in conjunction with Voices in the Wilderness, an activist group that, among other actions, ferried crucial medical and food supplies to Iraq in defiance of the embargo.

Rounding out our little gang of four was Johanna Berrigan (no relation to the famous activist brothers, Catholic priests Daniel and Philip Berrigan), a cofounder of Philadelphia's Catholic Worker Free

Clinic and founder of the House of Grace Catholic Worker House, which assists Philadelphia's large homeless population. By 2003 Johanna had been to Iraq four times with Voices in the Wilderness.

Getting into Iraq was surprisingly easy, as border security in early 2004 was nonexistent. Thanks to Tom's church connections, we were

*Homeless families demonstrate in front of the Green Zone, while their children make their own playground, Baghdad 2004.*

able to board a U.N. flight from Amman, Jordan, to Baghdad. We could have gone by car, but that would have been foolish. Not only was there no security at the borders, but there was no security anywhere in the country. Besides the chaos of the war itself, banditry was rife along the five-hundred-mile desert highway.

The flight in was adventure enough. The plane took off from Amman's Civil Airport, as expected, then flew east-northeast toward the Iraqi capital, but when it came time to land, the pilots, to avoid ground fire, flipped the twin-engine Beechcraft on its side and into a quickly descending corkscrew spiral—like those motorcycle daredevils careening inside the tightly circular walls of tiny steel tanks I saw on the midway as a kid. We kept spinning until we'd almost touched down, and the plane flattened out for landing. Looking out the window, straight at the turning face of the twilit landscape, I watched what at first looked like an oval racetrack expand into the main runway.

Everything at the airport was shaded brown, threaded by a line of olive-drab Black Hawk helicopters and a few grey C-130 cargo planes. Prior to the war, this had been Saddam Hussein International Airport. The Americans had put up a shiny new sign: Baghdad International Airport. Open for business, but eerily quiet. The only people in the terminal were the dozen or so passengers on our flight, a few uniformed immigration officers, and a number of Asian-looking guards who turned out to be Gurkhas, members of the elite Nepalese military caste. The Gurkhas wore khaki overalls and carried kukris (the traditional Nepali curved knife) and MP5 submachine guns. Their ball caps read "SECURITY" on the front and, in smaller lettering on the back, "Custer Battles," a Rhode Island–registered private security firm that distinguished itself by becoming the first American contractor in Iraq to be sued by the U.S. government for fraud under the False Claims Act. (In 2012 the U.S. Justice Department also sued KBR for submitting false claims. You'd think that for $82 billion, a company could get it right.)

The most dangerous journey of our week in Iraq was the drive from the airport into Baghdad, as the road was a virtual free-fire zone. In spite of the threat of ambush, improvised explosive devices, and panicked "friendly" fire, traffic was heavy and, in the absence of functioning stoplights, chaotic. There was the expected conspicuous military presence. Before we had even left the airport parking lot, a Marine in full battle kit spotted Linda's cameras and called out, without apparent humour, "Yo! You a photographer? Take my picture. Make me a star!"

Tom had arranged for a couple he knew from the American Friends Service Committee, based in Baghdad, to help organize meetings and get us around. Rick and Mary picked us up and delivered us safely into town, where we settled into a small hotel well away from the official Green Zone. (The Green Zone is the heavily fortified four-square-mile section of central Baghdad that primarily houses government buildings, including the headquarters of the Iraqi Governing Council.) Since we lacked official status, our best defense against

attack was to keep a very low profile. I never felt safe in Baghdad, though I was never aware of a direct physical threat. We hit the country during a relative lull in the fighting, but the mission never really was "accomplished," despite Bush's fatuous proclamation aboard the USS *Abraham Lincoln* aircraft carrier, anchored off the California coast, on May 1, 2003. The proud banner behind Bush momentarily obscured an asymmetrical war that continues to rage right up to the present moment.

Before the invasion Baghdad was apparently a very livable city, a thriving hub of culture and commerce. It was functional and modern, with palm trees giving it a semitropical feel and the older buildings displaying a distinctive Middle Eastern style. It was a secular city in a conservative Arab world, known as a party town, where tourists from the region could openly dance in nightclubs without worrying about religious backlash.

There were no tourists when we arrived. Evidence of bombing was everywhere. Daylight shone through modern office towers pierced by cruise missiles. Whole city blocks consisted only of piles of rubble. Much of Baghdad was in ruins, society completely upended. People were mired in mourning, poverty, and constant fear. Just outside the downtown core we visited a squatter camp. Five hundred families, some two thousand people, were living in the remains of a bombed-out former police training centre. They appeared to be mostly middle class, part of a new community of at least fifty thousand who had lost their homes. Many had also lost their jobs. There was a rumour of reconstruction going on, plus other forms of employment, but anyone who had been a member of Saddam's Baath Party (as were most of those who had had jobs) couldn't get hired. So in 2004 labour was being imported from outside Iraq, further feeding Iraqis' indignation and rage.

The squatters seemed organized. Their former comfortable status was evident from their clothing, but also from the presence of the occasional fine (and now useless) floor lamp or expensive sofa, placed for privacy in the corners of the shattered concrete rooms. Two mil-

lion people had managed to flee to neighbouring countries, but these folks either had nowhere to go or had no means to get anywhere.

The Iraqi Governing Council, which was what passed for a government, had decided that the Baghdad police should get their building back. Under threat of forced expulsion from their only shelter, the families were preparing to resist. All the men were armed. The hulking ruin was full of AKs. In the hope of finding a way to avoid what would surely be a bloodbath, the squatters organized a demonstration at the gates of the Green Zone, asking the Provisional Authority to intervene so they could remain in relative safety in the only home they had. We went along.

At an intersection, in front of a steel gate in a wall twelve feet high, a couple of hundred people gathered. They chanted and waved placards in Arabic. About twenty minutes after we got there, the gate opened wide enough to permit four U.S. soldiers to pass through. Three of them spread out around the entrance. The fourth, clearly in charge, strode up to a man in the centre of the front row of demonstrators. Standing quite close to the man, he said in a loud voice, "Sir, I'm going to have to ask you to clear the road." The man shrugged and turned toward those near him as if to say, "What does he want?" When he didn't get the response he wanted, the sergeant brandished his rifle and said again, more loudly, "Sir! I'm going to have to ask you to CLEAR THE ROAD!" Like almost all U.S. troops, he wore sunglasses. Iraqis generally don't wear sunglasses. They think it rude to hide your eyes. They want to see who they're dealing with.

For a few minutes it seemed as though something really bad might happen. The protesters weren't moving. The soldiers were getting tense and looking around aggressively. Then the Iraqis found somebody in the crowd who spoke English and could translate. As soon as they understood what was being asked of them, the protesters, without objection, relocated themselves onto the verges of the road, leaving it clear. It took awhile. The Americans moved about, trying to hustle people along. They started hassling our two Iraqi drivers, who were trying to stay close to us. As the sergeant approached the driv-

ers, I tapped him on the shoulder. He whirled to face me, then relaxed
when he saw a non-Arab. I explained what we were doing, and that
those men were working for us. He said, "Okay, no problem, but get
those cars out of there right away." I assured him we would. Linda
was deep in the crowd, camera to her face. "Sorry to tear you away,"
I said, "but we have to go. Now."

Two trillion dollars for the war, but no one at the front speaks
Arabic?

The faintly positive outcome of all this was that the squatters were
given a month's reprieve. They had time to find other accommoda-
tions. Only there were no other accommodations, and even if there
had been, there was no way to get anywhere else. For a while, back
home, I scanned the news for stories of a firefight in a Baghdad home-
less encampment but, seeing none, I assumed they had secured some
other solution.

Everybody in Baghdad seemed to be armed. The nicer neighbour-
hoods were patrolled by local residents or hired security men toting
automatic weapons. We met women whose husbands, leaving home
to seek work or food or water, had been shot by hypertensive U.S.
soldiers. Carjackings and kidnappings were routine. Bombs obliterated
wedding parties, then more bombs decimated survivors as they
mourned at funerals. We learned of one family whose five children
had been kidnapped the week before our arrival, kids being more
lucrative ransom targets than adults.

Iraqis were clear about their unfortunate position as impediments
to an easy resource grab. They were living with uncertainty, and the
possibility of bloodshed, every minute of the day. Violence—past,
present, and imminent—was palpable. We heard gunfire all the time.
Some of the fusillades, though, were celebratory. One evening in the
dining room of our hotel, which was also the bar, the dozen or so
non-Shiite patrons, ourselves included, were lounging about eating,
drinking, and talking when we were startled by the sudden *bap-bap-
bap* of automatic weapons right outside the window. Everyone hit the
deck. In Baghdad the drapes are always closed in case of flying glass,

so we couldn't see what was going on. A woman crawled over to the curtain and peeked out through a crack. "It's okay," she called out. "It's just a wedding!"

The Baghdad sky was smudged with diesel exhaust. Everyone who could find and afford a generator had one running in front of their house, to provide heat and light and refrigeration. Deliveries of water and electricity were sporadic, if they occurred at all. With only occasional electricity, there was no way to effectively pump sewage, so it pooled untreated in the streets, along with the rubble and the uncollected trash. And here, at the end of the cycle, were the children, playing in it. While mountains of money were being shoveled into the country, newly "liberated" Iraqis scrambled on dangerous streets for basic necessities such as food and water. (Even the bottled water wasn't necessarily safe. When we arrived, our hosts suggested we give our water containers a squeeze to make sure the seals were intact and the contents uncontaminated.) Irony fell in layers over daily routines. The whole thing was about oil, but one of our drivers had to wait thirty-six hours in a half-mile line of cars to fill his fuel tank. The absurdity of such an ordeal in an oil-rich country was not lost on Iraqis.

The Iraqis we met were well educated. Under Saddam's rule, college education was free, so everybody who wanted one got it, and most people did. That probably did not apply to the Shiites, though, who were hated by Saddam and his ruling Sunni minority. Saddam killed Shiites, and Kurds, whenever he felt like it. One of the more interesting developments in Iraq was that Shiite pilgrims, mostly from Iran, could now enter Iraq to visit Shiite holy sites. Every day another busload would turn up at our hotel. The little lobby was always bustling with conservatively attired, sober, somewhat surly men, and women clad in the all-concealing chador.

Shiites were quite relieved that Saddam was gone. In fact, few people outside the Sunni elite were sorry to see him go. Many Iraqis told us that immediately after the Saddam regime fell, they felt they *had* been liberated. Had the United States actually overthrown Saddam to assist a transition toward true democracy, the illegal invasion

of a sovereign country, though based on lies, might have had a silver lining. But self-rule seemed to be the last thing American policy makers wanted in Iraq. We were told repeatedly by people of all affiliations that if the United States didn't handle things correctly Iraq would end up in a civil war, which nobody wanted, but that's exactly what they got—an ongoing, horrific bloodletting that has now lasted ten years and continues to prevent stability from taking hold.

Through it all the people remained impressively lucid, sane, and gracious. I got stared at a lot—I seemed to be an atypical Anglo in Iraq—but once I said hello, people smiled and offered whatever English words they might know. I jammed with a young virtuoso oud player, which was pure, transported pleasure. I also gave a guitar seminar at an alternative art school, exchanging ideas with very intelligent and polite young people, mostly boys, who were earnest and inquisitive and seemed grateful for the distraction. The people I met were remarkably civil. At one point a guard apologized for having to search my guitar case. "Very sorry, sir," he said.

If you were in a car that innocently passed an American convoy, you could be fired upon. Even those waved along by the Americans sometimes got "lit up." A neurologist working at a hospital we visited said it was not unusual to encounter truckloads full of dead and injured people pulling up to seek help. Orderlies separated the dead and buried them on the hospital grounds. Every day new corpses littered the streets. The religious sectarianism was "new and dangerous," one Iraqi told me.

Saddam's reign had been brutal; no one spoke in favour of it, except in contrast to the anarchy wrought by the Americans, which actually made some Iraqis pine for the old mustachioed tyrant. "Under Saddam we felt more free," one Iraqi woman told me. "Now we're just here as puppets, and we feel like we're living in an endless nightmare. We would like to live our lives as human beings. Our children don't know anything but violence and fear." Not long after we left Baghdad, the situation got much worse.

The United States arrested tens of thousands of people during the occupation. A lot of them went to Abu Ghraib, the largest and most notorious U.S. prison and torture centre in Iraq. Iraqis were quite aware of the abuses occurring at Abu Ghraib, which came to light internationally on January 16, 2004—the day after we arrived—when the U.S. Central Command announced that it was investigating allegations of maltreatment at the prison, an inquiry undoubtedly inspired by the understanding that *60 Minutes* and *The New Yorker* would soon be breaking the story. The Bush administration attempted to paint the crimes at Abu Ghraib as an aberration, but since then it has become clear to all (just as it was clear in the moment to those who were paying attention) that the abuses accurately reflected U.S. policy with regard to the occupation of Iraq and Afghanistan, a policy also represented by its rendering of prisoners to "black sites" for torture and by its maintenance of the abhorrent prison at Guantánamo Bay, Cuba.

We visited a pediatric cancer ward where doctors were unable to rely on equipment—including X-ray and radiation treatment machines, among many other crucial services—because electricity was sporadic during the day and shut off completely at 7 P.M. every night. We were told that after the first Gulf War, in 1991, "Saddam had the power back on in a week."

Doctors were making $150 a month for their thirty-six-hour shifts, and there was a shortage of nurses and medicine. It's hard to overstate the bitter frustration felt by such highly trained professionals making almost nothing in a starved and devastated country, their own families at home and at risk, while the war itself was obviously so expensive and the attackers were not coming through with promised relief.

Today Iraq remains an impoverished wreck. One can only hope that the *$40 billion in cash* that the U.S. government flew into Baghdad, on pallets, between 2003 and 2008 made it into some needy hands. No one really knows if it did, because almost all of it simply disappeared. In 2011 CNBC called the cash airlift "the largest airborne

transfer of currency in the history of the world." The shipments of cash, said CNBC, "included more than 281 million individual bills weighing a total of 363 tons. But soon after the money arrived in the chaos of war-torn Baghdad, the paper trail documenting who controlled it all began to go cold."

Money by the ton. Yet the quantity pales compared with the overall cost of the U.S. Middle East adventure. "The US has already spent close to 2 trillion dollars in direct outlays for expenses related to Operation Enduring Freedom (OEF), Operation Iraqi Freedom (OIF) and Operation New Dawn (OND)," according to a March 2013 report for the Harvard Kennedy School by Linda Bilmes, a Harvard professor and coauthor of *The Three Trillion Dollar War: The True Cost of the Iraq Conflict.* (The book's coauthor is Nobel Prize–winning economist Joseph E. Stiglitz, an outspoken critic of "free market fundamentalists" at the World Bank and the IMF. Bilmes was the 2008 recipient of the American Friends Service Committee's "Speaking Truth to Power" award.) The twenty-two-page Harvard report concludes, "There will be no peace dividend. . . . [T]he legacy of Iraq and Afghanistan wars will be costs that persist for decades. [These] conflicts, taken together, will be the most expensive wars in US history— totaling somewhere between $4 to $6 trillion. This includes long-term medical care and disability compensation for service members, veterans and families, military replenishment and social and economic costs. The largest portion of that bill is yet to be paid."

Meanwhile, at home, much of the United States continued to slide into dire financial straits even as the federal government pumped those trillions of dollars into overseas wars. On July 18, 2013, the city of Detroit, $18 billion in the red, became the largest American municipality ever to declare bankruptcy, one of three dozen U.S. cities to go under in three years. Certainly, Detroit—the "birthplace of the middle class" and a thriving industrial city, despite the riots, when I first visited there in 1967—could have used a pallet of cash. If only the city had been a bank, or perhaps General Motors, which has helped eviscerate Detroit by moving jobs overseas, yet in 2010

received a $50 billion bailout from the U.S. government.

As the bumper sticker says, freedom isn't free. But the "price" often far exceeds anything financial. Since World War II, millions of people have paid for American "freedom" with their lives. Beginning in 2003 it was Iraqis who paid the price, and two years before that it was Afghanis, though at least the United States had some justification for tearing up Afghanistan in search of the murderers of three thousand Americans. The ghost of William Walker, summoned up, stumbled in the streets of Baghdad, to the sound of the trumpets of fading empire.

*Everything's broken in the birthplace of law*
*As Generation Two tries on his tragic flaw*
*America's might under desert sun*
*I saw her frightened eyes behind the muzzle of her gun*
*Uranium dust and the smell of decay*
*Sewage in the street where the kids run and play*
*Not enough morphine and not enough gauze*
*Firefight in darkness like snapping of jaws*

*This is Baghdad*

*You couldn't see the blast—the morning was bright —*
*But some radiant energy flared up into the light*
*Like the sky throwing its hands up in horrified dismay*
*Or the souls of the dead as they sped on their way*

*Car-bombed and carjacked and kidnapped and shot*
*How do you like it, this freedom we brought*
*We packed all the ordnance but the thing we forgot*
*Was a plan in case it didn't turn out quite like we thought*

*This is Baghdad*

"THIS IS BAGHDAD," 2004

The "blast" in "This Is Baghdad" was a suicide car bombing at Assassins' Gate, an entrance to the Green Zone near the palace housing the Coalition Provisional Authority. We had been lucky with respect to violence while we were there. Everyone told us that the week was unusually quiet. I was on my third-floor hotel balcony when the bomb went off. Twenty-four people died and 120 were injured, most of them Iraqis lining up for work in the Green Zone. This was a Sunday—a regular workday in Muslim countries—near the end of our trip, at eight in the morning. We were scheduled to visit the Green Zone that day to hear the Baghdad Symphony practice, but because of the bombing the rehearsal was cancelled. The previous day we had driven by Assassins' Gate four times. We never did get into the Green Zone.

*The intrepid adventurers: Johanna Berrigan, Bishop Thomas Gumbleton, Bruce Cockburn, and Linda Panetta*

*The intrepid adventurers meet the papal nuncio Archbishop Fernando Filoni.*

I was a couple of miles from the blast, so I couldn't see it. But I certainly heard it, a punch in the eardrums, a massive release of energy radiating like a heat wave into the bright morning sky. What was stunning, aside from the explosion itself, was the reaction of the people in my field of vision: nothing. The street was full of people scurrying to work, and nobody even looked up despite the magnitude of the blast. This lack of curiosity about an obviously massive catastrophe occurring not that far away said more than I wanted to know about what Iraqis had been through.

With Bishop Gumbleton at the helm, we met with several prominent Christians. These included the patriarch of the Chaldean Christian Church, an institution I had not known existed: in effect, the Pope of Baghdad. He was formal, elderly, robed in red with gold decoration, and quite rigidly conservative. There was the faint sense that he felt spending time with us was beneath him. The papal nuncio, Archbishop Fernando Filoni, was, by contrast, dynamic, warm, and very Italian. His English was excellent.

Archbishop Filoni was worried. Crime was flourishing, he said, and gangs roamed the streets. Hunger was epidemic; chaos reigned. The occupiers could not control what they'd wrought. Filoni, who had defended the rights of Christians under Saddam, was outspoken about the need for American forces to depart. "In Washington, they still don't understand that they will never be loved, and that the people of Iraq will not tolerate the occupation," he told *Catholic World News* in April 2004, adding that the United States should "have the courage to transfer power immediately." He was the only foreign ambassador who had not fled the country.

Saddam, whose regime enforced a strong secularism, did not feel threatened by the Christian community and afforded it a degree of exemption from his wrath—with the exception of the Kurds (a minority of whom are of the faith; most Kurds are Sunni Muslim), who were murdered in the tens of thousands during the 1980s, during the Iran-Iraq war. (Remember the chemical weapons Reagan and Rumsfeld sold to Iraq? Saddam used them on the Kurds.) In return, few Christians challenged his rule. Christians generally prospered. They tended to have professional careers: businessmen, doctors, lawyers, engineers. Tariq Aziz, who served as foreign minister and deputy prime minister under Saddam, was a Christian.

Christians were still doing as well as anyone when we were in Baghdad—but not long after we left, Iraqi Christianity found itself in the crosshairs. Churches started coming under attack, and church leaders were abducted and killed by Muslim fundamentalists. Filoni himself just missed being killed by a car bomb in 2006. This was

without precedent. In 2007 *60 Minutes* reported, "From the time of Jesus, there have been Christians in what is now Iraq. The Christian community took root there after the Apostle Thomas headed east in the year 35. But now, after nearly 2,000 years, Iraqi Christians are being hunted, murdered and forced to flee—persecuted on a biblical scale in Iraq's religious civil war. You'd have to be mad to hold a Christian service in Iraq today. . . ." The Reverend Canon Andrew White, an Anglican priest who was dubbed the Vicar of Baghdad, told the CBS news crew, "In the last six months things have got particularly bad for the Christians. Here in this church, all of my leadership were originally taken and killed." White said that life was much better for Christians under Saddam and that the American invasion had set them back two thousand years.

In the place of a relatively stable secularism, a de facto form of Sharia law has taken hold in Iraq. Under the American occupation the freedoms of religion once enjoyed by most Iraqis have been eaten away, religious intolerance is now the norm, and the "tyranny" that the Bush junta purportedly wanted to vanquish is now actually stronger in parts of the country than it had been.

Our week in Iraq, as packed with meetings and stress as it was, seemed like a month. Then we traipsed back to Baghdad International for the long journey home. The near total lack of airport security was amusing. Luggage was laid out on the pavement twenty yards from the entrance, where it was gone over by bomb dogs. At the door a guy in a black T-shirt with a pistol in a shoulder holster said, "Got any guns?" I shook my head no and he waved me on. That was it, like passing from Oregon to California at the agriculture inspection station. I could have had knives in my boots, or a bag of Colin Powell's infamous Nigerian yellow cake, the mythic material that got the whole show rolling. This time there was a concession open in the terminal. Linda bought me a present: a black knitted Shiite skullcap and a black and grey cotton scarf.

Back in Amman, exhausted, we all crowded into a single hotel room to rest up. We had hours to wait for the various flights that

would take us the rest of the way. Linda and Bishop Gumbleton arm-wrestled after a lunch of falafel, apples, cucumber and carrots, and tea flavoured with sage. Herbie the Volkswagen was on the TV, with Arabic subtitles. Abundance and Disney and madness and evil—an incomprehensible juxtaposition of the brutal and the bizarre.

The skinny young Jordanian at the front desk asked us, "Have you smoked *hubblybubbly*?" What? "You are in Jordan. You must smoke *hubblybubbly*!" His shift had just ended. He insisted on taking us all to a café he knew where we would sit and smoke a multi-stemmed water pipe charged with apple-flavoured tobacco. I put on my new Baghdad airport headgear. He looked at me and said, "I don't think you should go out wearing that Jewish hat." Never mind that all the Shiite men in our Baghdad hotel had worn the same thing.

As we sat chatting under a shape-shifting cloud of grey smoke, I said, "I've never done this, but I learned the word 'hookah' for this type of pipe." He replied, "In Egypt they call it that. In Jordan we call it *hubblybubbly*!" Whenever he said the word, it sounded as if it were followed by an exclamation mark.

Back home, I pored over my notes from the trip, scraping at memories, trying to figure out how to make a song out of all the information. It took some time because I didn't know exactly what to put in it. The bleak absurdity, the sorrow, and the stories of Baghdad were so big they defied my ability to address the reality of what was right in front of me, similar to the difficulty of writing post–9/11. Three months later, on April 19, 2004, I finished "This Is Baghdad."

The next day I wrote another song. You could think of it as an unintended companion to the previous day's work, an offering of light against darkness. I was captivated by the idea that we as a species are engaged in a race between our attraction to *thanatos*, to self-destruction, and the recognition of our interdependency on each other and the planetary systems that provide the necessities of life, between the narrow, selfish everyday-ness of materialism and the willingness to embrace the Bigness of things. The song came out of a sense that no matter what, as we live and we die, we are always

moving toward a sort of mutual absorption of and by spirit; that my soul remains rooted in the Divine; and that life is, or ought to be, ruled by love. Who or what God might be, what the cosmos actually consists of, how love and evil are so regularly conjoined in the human heart—all are questions that hail from a deep and overarching mystery that has forever teased and haunted us.

That mystery, as the universe keeps reminding me, deepens and opens with every breath.

> *You can't tell me there is no mystery*
> *Mystery*
> *Mystery*
> *You can't tell me there is no mystery*
> *It's everywhere I turn*
>
> *Moon over junkyard where the snow lies bright*
> *Snow lies bright*
> *Snow lies bright*
> *Moon over junkyard where the snow lies bright*
> *Can set my heart to burn*
>
> *Stood before the shaman, I saw star-strewn space*
> *Star-strewn space*
> *Star-strewn space*
> *Stood before the shaman, I saw star-strewn space*
> *Behind the eye holes in his face*
>
> *Infinity always gives me vertigo*
> *Vertigo*
> *Vertigo*
> *Infinity always gives me vertigo*
> *And fills me up with grace*
>
> *I was built on a Friday and you can't fix me*
> *You can't fix me*

*You can't fix me*
*I was built on a Friday and you can't fix me*
*Even so I've done okay*

*So grab that last bottle full of gasoline*
*Gasoline*
*Gasoline*
*Grab that last bottle full of gasoline*
*Light a toast to yesterday*

*And don't tell me there is no mystery*
*Mystery*
*Mystery*
*And don't tell me there is no mystery*
*It overflows my cup*

*This feast of beauty can intoxicate*
*Intoxicate*
*Intoxicate*
*This feast of beauty can intoxicate*
*Just like the finest wine*

*So all you stumblers who believe love rules*
*Believe love rules*
*Believe love rules*
*Come all you stumblers who believe love rules*
*Stand up and let it shine*
*Stand up and let it shine*

"MYSTERY," 2004

# FINALE

So . . . the book stops here. After this point, Big Circumstance spun my life off in another new direction, and it's too soon to see where that tale leads. A quick synopsis though:

MJ and I, having originally met during the land-mine campaign, when she worked for VVAF, started dating shortly after the Baghdad trip. We had been heading in that direction for a number of months. We spent time in Kingston, Ontario, and Brooklyn, briefly in Buenos Aires. We visited Jerusalem and Barcelona and Amsterdam. We moved to San Francisco. The dream work deepened. There was another journey to Nepal, which became the subject of a documentary film. "This Is Baghdad," "Tell the Universe," and "Mystery" found their way onto a CD, along with other songs. Linda Panetta and I observed an election in Venezuela. Later came another couple of albums and a documentary film about me on tour. There was plenty of touring, and the arrival of more grandchildren. There was also the arrival, by way of seventy-five hours of hard work on the part of MJ, a delightful new daughter. Jenny was excited to have a sibling after all those years.

None of us has the capacity to stand far enough back from the picture to really see how the parts of our lives intersect. We're all tiny figures in the jigsaw flux, tossed about within ourselves and with each other. One benefit of a relationship with God is that he does provide at least a sense of the whole picture. If I go by my deepest, truest, most open feelings, which I trust emanate from the Divine or at least are open to the spirit, I can receive that guidance, even if I don't know that I'm getting it. That's God talking. But it's a fragile connection. It has to operate through the static of our thoughts and our personalities and our brain chemistry. It can easily be diverted or distorted. We have to remain true and open to whatever guidance the spirit offers us, and use it in combination with material forms of information. With this openness comes a freedom I have consciously known a few privileged times in my life.

I'm not the first person to utter these notions. They are part of the mystical end of every religious faith: Sufism, the Kabbalah, Christian mystical tradition, Shinto, Taoism. People express it differently, because we experience it in the context of our own cultures. But knowing that it's there, that guidance and insight are available for those who look and listen patiently, also means knowing that the mystery will never completely unfold. This is a good thing. It's the mystery that holds it all together, keeps us together, and connects us with coming generations. My not knowing exactly what I'm talking about is essential to leave room for what flows from the spirit. If a preacher or anyone else tells you he knows exactly what's going on in the spirit world, walk away.

Our spiritual quests need not be religious. In fact, the two are sometimes antithetical. Doctrine can be a great thing to hide behind when faced with the unanswerable questions of which life is full. Politically, dogma is often a pretext for the imposition of authoritarian measures. Anytime you find yourself confronted by someone who claims the power to dictate the rules and limitations of *your* spiritual quest, defining for you exactly what the spirit world consists

of, requiring you to uphold judgment and punishment, and leading you along a path that pits your community (or country) against another, walk away.

Strict religious doctrine works for some, but it can also be an obstacle to developing a relationship with the Divine, or at least to doing so at your own pace, in your own space, and under your own and God's terms. Freedom to study, freedom to pray, and freedom to weigh what comes in are essential if we are to maintain the necessary state of openness to the promptings of the Divine.

Over and over, we have seen religion used as a vehicle for charlatans and kooks to manipulate populations for political power, or ego gratification, or simply money. Don't get me wrong: the world is full of examples of wondrous work by people and organizations that are deeply religious in nature. But these efforts are fragile because they are carried out by the mechanics of our personalities, our brain chemistry, and myriad interpersonal complications. Formalizing it all doesn't help. And when the formal meets the ambitious or the insane, we get misguided believers destroying priceless antiquities, phalanxes of the fearful slaughtering the innocent to "stop the spread of Communism," and Muammar Gaddafi earnestly declaring, "God sent me here to save Africa from the white man." We get reactionary Islamists so offended, on God's behalf, by smoking, shoplifting, having children out of wedlock, or even music that they whip the offenders or amputate hands or feet or heads. Truly crazed believers, for whom the world is an infantile projection of themselves, often seek and sometimes seize power. There never seems to be a shortage of them, and the suffering under such people has been prodigious. They are not always religious. The same could be said of the devotees of secular doctrines, e.g., Maoism or neoliberalism.

There are many good reasons to attend churches, synagogues, mosques, viharas, temples, and shrines. Praying in the company of others can be nurturing. The sense of belonging can be affirming and comforting. Engaging in ritual can feel like participation in the deep workings of the cosmos. But the power and grandeur of institution-

alized religion also appeals to the insecure assumption that a relationship with God must be hierarchical. The opposite is true. A relationship with God starts with the *one*, with the individual, and flows outward from there.

Religion is what its practitioners want it to be. God, on the other hand, is not a social being. Personally, I prefer the God of compassion and love to the wrathful, fearsome, repressive one. There is such contrast between our many cherished concepts of the Divine that it almost seems more accurate to do as some traditions have done—the Hindu, for example—and give them all different names. It is commonplace for us to feel we know what God has in mind for us. The operative word there is "feel." We seldom *know* what gifts or challenges await us. We project our limited imaginings onto the screen of our lives. We can't help it. We do well, though, to remain gently detached from these stories we tell ourselves.

Sometimes, at moments you least expect and for reasons not necessarily explicable, a quiet prompting can well up from the murk of the unconscious. It's clear and compelling and comes from who knows where, but there it is in front of you, undeniable. It could be called intuition or a gut feeling, but might it not be information from those depths of your being where the Divine operates? I've had moments in my life when I knew that a thing had to be done, but there was no explaining how I knew. I had to leave Berklee when I did. It was not a position arrived at by rational thinking. I wasn't even halfway through my four-year program; I was studying music, which I loved; and my parents, who were paying my way, had high hopes. I just knew it was time to move on. I was newly an adult with no money, and my only choice was to head back to Ottawa, where no paying job awaited. Yet in my heart it was an easy good-bye and a welcome hello to my true path. I didn't know it then, but today it's clear that I was guided. I have had a few moments like this, for which I am grateful.

Artists have the power to influence and feed each other. The thrill I got from hearing the interplay between Gabor Szabo and Charles

Lloyd on those mid-sixties Chico Hamilton records put a virus in my brain that is still there. Bob Dylan rattled my understanding of what a song could be not only by calling out injustice and war, but by the language and imagery that poured from him.

Artists create and reflect trends, techniques, and ideas not only for each other but for society at large. Elvis said it was okay to cut loose

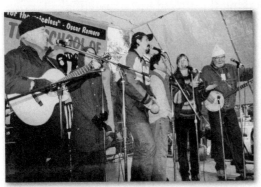

*Performing with Pete Seeger at the annual School of the Americas protest in Fort Benning, Georgia*

and dance, and shimmy your hips to tunes like "Hound Dog," which hit the airwaves when I was eleven years old and changed my life. Pete Seeger put politics into popular music, as did Woody Guthrie before him, and Dylan took it even further before largely abandoning politics for other foci, including Christianity. "If I Had a Rocket Launcher" was not directly influenced by Dylan, but he was certainly embedded in the cultural evolution that allowed me to perform and record that song.

*With the godfather of singer-songwriters, Pete Seeger . . . and a fine burgundy*

When I wrote it in 1983, I was trying to share the shock I felt in grasping that had the means been at hand, I was willing to kill Guatemalan soldiers who were perpetrating atrocities against new acquaintances with whom I felt empathy. To me, those men in uniform had forfeited any claim to humanity and should be put down

like rabid animals. I was wrong, of course. Far from forfeiting their humanity, they were expressing it. And so was I.

I imagine God surveying his beautiful and lively earthly creations, and I wonder what might be his ultimate reaction to his intended pride and joy, humanity, taking the gifts of life, of potential, of *intelligence,* and squandering them so wantonly. Would he "go Old Testament" on us, turning his back in a cold rage to busy himself with new creations elsewhere in the multiverse? Perhaps there would be a call to Kali, the Hindu goddess of two realms, ferocious and loving mother with a string of fifty human skulls for a necklace, one skull for each letter of the Sanskrit language. Aroused by the scent of all the death and pain we have caused, would she wield her sword, a destroyer of false consciousness, and finish what humanity has started?

How terribly sad it is that we have so pissed away those gifts as to threaten even our own existence. If we do ourselves in, can we say we had it coming? Certainly, though unfairly, because not everyone does. Equally unfair is our impact on the other species with which we share our little vessel.

> *There's a knot in my gut*
> *As I gaze out today*
> *On the planes of the city*
> *All polychrome grey*
> *When the skin is peeled off it*
> *What is there to say?*
> *The beautiful creatures are going away*

> *Like a dam on a river*
> *My conscience is pressed*
> *By the weight of hard feelings*
> *Piled up in my breast*

*The callous and vicious things*
*Humans display*
*The beautiful creatures are going away*

*Why? Why?*

*From the stones of the fortress*
*To the shapes in the air*
*To the ache in the spirit*
*We label despair*
*We create what destroys,*
*Bind ourselves to betray*
*The beautiful creatures are going away*

"BEAUTIFUL CREATURES," 2004

I don't buy the argument that because humans are a part of nature, and because extinction has been a part of evolution for the past four billion years, the current crisis—what scientists are calling the sixth major extinction event in world history—is also somehow natural, or that God ordains it. We can and should be putting forth policies to save ourselves and this beautiful earth, but where is the will? Where is the Manhattan Project for the planet, the Marshall Plan for humanity? It's chilling to witness the indifference shown by so many powerful world leaders to this greatest crisis of all time.

Are we heading into a time of tribulation? Perhaps, though not necessarily *the* Tribulation, as some of our fundamentalist friends believe. It's not our job to second-guess God. But tribulation in the form of massive and rapid changes appears to loom on our collective horizon. There is a very strong chance that in the lifetime of my first daughter, Jenny, most people in the world will experience the grim price of the Industrial Revolution in the form of shortages of food, water, shelter, clean air, and peace. In the lifetime of my second daughter, Iona, born almost two generations after Jenny, we could

see the whole grand and beautiful human experiment come crashing down, like the *Titanic* with the band playing, like Icarus flying too close to the sun. It doesn't have to be that way. Just as I pray that humans soon change course, I also commit a small portion of my focus, energy, and political capital (such as it is) to assisting whatever forces might be actively trying to forestall such a future.

People who maintain a relationship with the Divine—no matter the religion or sect or specified belief system—will bear a special

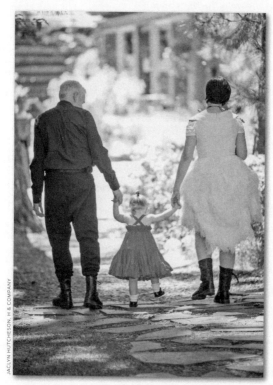

*Me, Iona, and MJ*

burden. It's the burden of healing that is so needed after our poor stewardship of this blessed earth and of each other. Between the dogmatism of fear-based fundamentalism and the *Battlestar Galactica* new-aginess of Hollywood, down there in the cracks, there is room, there is a *necessity*, for the sharing of real, personal, and experiential knowledge of God—of love. That is our mission, should we choose to accept it: to get that experience, to be fueled by that love, and to go forth and share whatever insights and inspiration we may have gained, while simultaneously supporting our communities and families in all ways feasible. We don't need to worry about making converts. If we go out there shining with the light of God and brimming with love, it will be noticed. A door will

be opened for the spirit to walk through. Whether that spirit gets discussed in Islamic, Jewish, Christian, or any other religious terms is not really material. It's being awake to its presence that counts.

It's recognizing that from the first to the last we are all one in the gift of grace, and that if we hold this gift dear we can be whole again.

*Shaman clambers up the world-dream tree*
*Looking for clues about what is to be*
*Chants and trances give his spirit wings for flight*
*Wings still shackled to history*
*The chain of events ain't broken so easily*
*Oh, let me rest in the place of light*

*Skull-drum skin stretched tight*
*Sends out ripples in the gathering night*
*The deepest darkness breeds the brightest light*
*Music rising from the bones of saints*
*From the pungent smell of sad sweet poems and paintings*
*Oh, let me rest in the place of light*

*God waves a thought like you'd wave your hand*
*And the light goes on forever*
*Through the seasons and through the seas*
*The light goes on forever*
*Through the burning and the seeding*
*Through the joining and the parting*
*The light goes on forever*

*Gypsy searches through the cards for truth*
*Alchemist searches for eternal youth*
*Human reaching almost makes it but not quite*
*And so strikes out at what the wind blows by*
*You live and it hurts you, you give up you die*
*Oh, let me rest in the place of light*

*Fugitives in the time before the dawn*
*Backed up to the wall with weapons drawn*
*Like mounted nomads always ready for a fight*
*This creature that thinks and so can fake its own being*
*Lightless mind's eye not much good for seeing*
*Oh, let me rest in the place of light*

*God waves a thought like you'd wave your hand*
*And the light goes on forever*
*Through the people and through the walls*
*The light goes on forever*
*Through who obeys and who does not*
*Through who gets rich and who gets caught*
*The light goes on forever*

*Uptight lawyer on Damascus road*
*Becomes a nexus where the light explodes*
*Concentrated, overpowering sight*
*Two-way whirlpool churning up all time*
*Infinity stoops to touch the human mind*
*Oh, let me rest in the place of light*

*God waves a thought like you'd wave your hand*
*And the light goes on forever*
*Through the buildings and through the hills*
*The light goes on forever*
*Through the struggles and the games*
*Through the night's empty doorframe*
*The light goes on forever*

**"THE LIGHT GOES ON FOREVER," 1980**

# ACKNOWLEDGMENTS

A word of heartfelt thanks is hereby shouted out to the following:

Roger Freet, editor, whose idea this was, and his extremely helpful staff: Hilary Lawson, Natalie Blachere, and Sherri Schultz

Mark Tauber, publisher, for his support of the idea

Bernie Finkelstein

Linda Panetta

The Cockburn Project and Bobbi Wisby

Gavin's Woodpile and Daniel Keebler

The Archives of McMaster University and Rick Stapleton

MJ and Iona, for love and for putting up with my semi-absence throughout the writing process

# DISCOGRAPHY

Studio Albums

*Bruce Cockburn*, 1970
*High Winds White Sky*, 1971
*Sunwheel Dance*, 1972
*Night Vision*, 1973
*Salt, Sun and Time*, 1974
*Joy Will Find a Way*, 1975
*In the Falling Dark*, 1976
*Further Adventures Of*, 1978
*Dancing in the Dragon's Jaws*, 1979
*Humans*, 1980
*Inner City Front*, 1981
*The Trouble with Normal*, 1983
*Stealing Fire*, 1984
*World of Wonders*, 1985
*Big Circumstance*, 1988
*Nothing but a Burning Light*, 1991
*Christmas*, 1993
*Dart to the Heart*, 1994

*The Charity of Night*, 1996
*Breakfast in New Orleans Dinner in Timbuktu*, 1999
*You've Never Seen Everything*, 2003
*Life Short Call Now*, 2006
*Small Source of Comfort*, 2011

## LIVE ALBUMS

*Circles in the Stream*, 1977
*Bruce Cockburn Live*, 1990
*You Pay Your Money and You Take Your Chance*, 1997
*Slice O Life*—Solo Live, 2009

## COMPILATIONS

*Résumé*, 1981 (United States only)
*Mummy Dust*, 1981
*Rumours of Glory*, 1985 (Germany only)
*Waiting for a Miracle: Singles 1970–1987*, 1987
*Anything Anytime Anywhere: Singles 1979–2002*, 2002
*Speechless*, 2005